Romanesque Ireland

Romanesque Ireland

ARCHITECTURE AND IDEOLOGY
IN THE TWELFTH CENTURY

Tadhg O'Keeffe

FOUR COURTS PRESS

This book was typeset in 11/14pt Garamond
by Carrigb oy Typesetting Services, County Cork for
FOUR COURTS PRESS LTD
7 Malpas Street, Dublin 8, Ireland
e-mail: info@four-courts-press.ie
and in the United States for
FOUR COURTS PRESS
c/o International Specialised Book Services,
920 N.E., 58th Avenue, Suite 300, Portland, OR 97213

© Tadhg O'Keeffe 2003

A catalogue record for this title is available from the British Library.

ISBN 1–85182–617–3

SPECIAL ACKNOWLEDGEMENT

This publication was grant-aided by the Academic Publication Scheme 2002/03, University
College Dublin and by the Heritage Council under the 2003 Publication Grant Scheme.

AN
CHOMHAIRLE
OIDHREACHTA

THE
HERITAGE
COUNCIL

Printed in Great Britain
by MPG Books, Bodmin, Cornwall

For Margaret.
Beauty is indeed a rare thing.

Contents

Illustrations

9

Plates appear between pp. 192 and 193

Preface

There are measures by which any century of the Christian era could be described as especially important, but perhaps there is no century of the middle ages for which such a claim has been made more frequently than the twelfth century. It has of course been given a rather unfair advantage by historians, among whom it is sometimes described as one of the 'long' centuries of the middle ages, not because it was more incident-packed than any other century but because many of the cultural phenomena which we associate with it actually began in the eleventh century and spilled into the thirteenth. This perception of the twelfth century underscores the point that, with notable exceptions such as AD800, the year of Charlemagne's coronation, or AD1000, the millennium year, those dates which bracket centuries are not of themselves of any great significance, and that breaking up historic time into hundred-year units ignores the realities of the ebb and flow of history.

The twelfth century certainly stands out as prominently in Irish history as it does in European history, but here it could perhaps be regarded as a 'short' century, framed by two watershed events only seventy-odd years apart: the Synod of Cashel, which is frequently identified as the opening shot in a long-gestating reform of the Gaelic-Irish Church, marked a beginning in 1101, while the arrival of the Anglo-Normans (or Cambro-Normans, or Anglo-French, or Cambro-French, or plain English, depending on who you read or who you ask!) marked both an end and another beginning in 1169. The period between those dates saw the flowering in Ireland of that strain of architecture and architectural sculpture which is popularly described as Romanesque. This is a book about that material.

* * *

A passing interest in Romanesque while an undergraduate student deepened to become a passion by the experience of seeing Durham Cathedral for the first time in October 1985. Epiphanies of such spectacular nature often seem an invention of memory, but Durham Cathedral was the first Romanesque cathedral I ever visited, and once I recovered from its sheer visceral impact – and anybody who has been inside it will know exactly what I mean – I started to think about Romanesque in Ireland. My research interests at that time were almost exclusively in settlement archaeology, so I saw the general Romanesque phenomenon in both England and Ireland in the context of settlement history: Romanesque churches can be dated fairly precisely, so they offer some fixed chronological points in the study of settlements and landscapes. But I recognized also that they were part of the aesthetic of settled life, and I therefore regarded their forms and sculptures as legitimate things for a settlement archaeologist to think about. Finally, I saw in Durham a most powerful expression of *normanitas* using a stylistic medium that was almost exclusively pre-Norman in Ireland. Of course, the Anglo-Normans did not arrive in Ireland until eighty years or so after construction work started at Durham, so there was no great discovery there, but the fact that Gaelic Ireland had adopted this evidently multi-national medium entirely of its own volition, without even the mediating presence of a colonial population on the island, struck me then, and strikes me far more forcibly today, as extraordinarily interesting from the perspective of cultural history.

I certainly had not realized from the literature on Ireland's Romanesque just how important a signifier of cultural change was this new architectural way of thinking. Harold Leask, a much-respected figure in the historiography of Ireland's architecture, had adopted an almost teleological approach to the phenomenon in Ireland, as if the Irish had adopted Romanesque because in the twelfth century that was the natural, even predestined, order of the world, or was part of the natural trajectory of stylistic development. But this view was clearly flawed: 'styles', whatever they are, change when people decide on change, and in Leask's account of the origins and development of Ireland's Romanesque there was no hint that decision-making had informed any part of the process. In fact, his was a Romanesque without people. On the other hand, the late Liam de Paor, who squeezed huge amounts of research into one relatively small but profoundly influential paper on the subject, had offered a 'big-bang' interpretation of the origins of the Irish Romanesque, which was that one politically important site, one spectacular building, and one far-sighted patron, could make everybody feel that they too needed a Romanesque church. It certainly seemed a good idea in 1985 while I sat on buses and trains back to my Durham college having journeyed to 'son of Durham' churches like Dunfermline and Pittington, but it still left one key question unasked and unanswered: 'why?'

Six years later my burgeoning interest in Romanesque was translated into a PhD thesis in University College Dublin. The present book is not the publication of that thesis but a newly written work, parts of which recycle and develop material I have published, and ideas which I have communicated in lectures, since the late 1980s. But I have not attempted here a kind of 'grand history' of Romanesque Ireland in which all the conceivable issues are addressed, with all the sites with Romanesque remains catalogued and mentioned somewhere in the narrative, every reference cited, every source and tangential issue accounted for in footnotes, every point of view acknowledged, and some ultimate truth delivered at the end. Rather, from the very outset I envisaged this book being a series of long, relatively self-contained but also interlinked essays which attempt, first, to reveal and structure the complex character of Ireland's Romanesque heritage, thereby offering a framework for future work, and second to answer some questions and question some answers about its 'meanings' within its contemporary cultural milieu. I hope that it proves a useful addition to the historiography of the twelfth century, that it paves the way for other specialists in architectural history to rethink some of these buildings and their contexts again and again (as I will continue to do), and that it encourages specialists in the other Romanesque media – metalwork, manuscripts, free-standing sculpture – to tackle them at a similar scale.

The book's main title is largely self-explanatory, at least insofar as a word like Romanesque can be self-explanatory, but I have chosen to use the word *ideology* in the sub-title because, while this book is ostensibly about *things* which can be visited, entered into, or touched, it is also a book about the social, aesthetic, religious and, especially, political *ideas* and *discourses* – together the domain of ideology in its very broadest sense – which gave those things shape in the first instance, and which shape the ways in which those things were and continue to be experienced and understood. We need only think of Walt Whitman's snappy aphorism – architecture is what we do to a building when we look up at it – to realize that in the middle ages people looked up, and that builders knew they would look up. Therein lies architecture's claim to have been active, not passive, central, not peripheral, in the medieval world. However, although ideology is absolutely central to what follows, I do not explore it as a subject-matter in its own right explicitly here. The potential for a theoretically grounded study of Romanesque on its European canvas, viewed specifically through the lenses of the different understandings of ideology, from Karl Marx most obviously to, say, Fredric Jameson, is a project in its own right, and one which I have begun to pursue as I write this preface, but it is a project which will bring us further away from the buildings than is appropriate to, or than I would like for, this particular book.

The opening chapter interrogates the idea of Romanesque, reviews the material which forms the core matter of this book, examines the reform

movement within the Gaelic-Irish Church and the careers of its advocates and participants during the 1100s, and finishes with a lengthy historiography. Readers will note from the outset that county names are not given for sites, except where the same site name occurs in more than one county; instead, county provenances are given in the index. Architectural traditions in Ireland up to early twelfth century are discussed in Chapter 2. Two Romanesque traditions that stand outside the main lines of indigenous architectural development but are not connected to each other – the Hiberno-Scandinavian and the Cistercian – feature in Chapter 3. Cashel stands tall, literally and metaphorically, among those sites of twelfth-century Gaelic-Irish kingship where the intersection of ecclesiastical and political agendas had a demonstrable material expression, and the key building here is Cormac's Chapel. Much of Chapter 4 is devoted to an analysis of it. Its wider Munster context is discussed in Chapter 5, and the subsequent development of an architectural (and architectural-sculptural) tradition during the 1100s in Leinster, the Midlands, and Connacht is taken up in Chapter 6. These two chapters are partly travelogue in style and are description-heavy. The material contained within them is ordered geographically; no attempt is made to cover every church, either in terms of architectural or historical context. There is necessarily a good deal of dry, detailed description in these chapters – it is included on the grounds that specialists do sometimes have reason to read such stuff. Chapter 7 is a synthesis of sorts: it pulls together some of the ideas and interpretations presented in the course of the book.

The book finishes with a brief epilogue on the question of meaning within the context of the epistemology of Romanesque studies. After writing it I toyed with the idea of leaving it out and using it as the opening gambit in the next projected publication. But I opted to retain it, even though it may seem an inappropriate ending to the book. Scholarly publications should have a value beyond the explanation of their subjects; they should also, I think, illuminate the inner workings – and that includes the tensions – of the intellectual process itself. So, the epilogue is retained because of what it illuminates: a tension between, on the one hand, my experience of having written the preceding six chapters using material which was gathered (and therefore conceptualized) within the context of a fairly traditional architectural-historical framework, and, on the other hand, my more recent experiences of teaching certain archaeology courses which, with their anthropological themes and explicit usages of social theory, gnaw away at my confidence that the traditional approaches and concerns which we have inherited from older scholars have survived the test of time because they alone have custody of access to the 'truth'.

* * *

I am extremely fortunate to work in a happy, research-driven, university department, and I am delighted to have an opportunity to acknowledge my friends and colleagues on the teaching staff, and to thank especially my senior colleagues, Professors Barry Raftery and Gabriel Cooney, for their motivation and support. I wish to express particular gratitude to Professor Michael Herity, now retired from the department, without whose guidance, encouragement and generosity during my undergraduate and postgraduate years I would never have reached the stage of writing this or any book.

I have happy memories of Durham University and the Centré Médiévale of the University of Poitiers, two of the places at which I studied when I held the National University of Ireland's Travelling Studentship in Archaeology in the mid- to late eighties, and I would like to thank Professors Rosemary Cramp and Brian Roberts, and Piotr Skubiszewski and Marie-Thérèse Camus, for looking after me so well.

Other friends within the academy but outside the field of Romanesque studies whom I would like to mention here are Professors David Austin and Matthew Johnson of the universities of Lampeter and Durham respectively, who opened my eyes to the real potential of medieval archaeology to be more than the 'bridesmaid of history', and Professor Anngret Simms in UCD, a dear friend around Belfield's corridors for over twenty years.

Funding from UCD in 1994 gave me the opportunity to travel to see sites in Germany, and I should like to express here my gratitude to the university.

My thanks to Michael Adams at Four Courts for taking on this project and for waiting patiently while it circled in the skies as other things were being cleared from the runway, and to Martin Fanning for being so skilled a pilot.

Finally, I'd like to thank little Evan, even if his arrival delayed the book's delivery considerably. And Margaret. It sometimes seems that authors try to outdo each other in expressing how great was the sacrifice and forebearance of their spouses in the face of the anti-social behaviour which is book-writing. Mine has also had to tolerate, even learn to love, the Ornette Coleman quartet performing nightly in my end of the house. Non-cognoscenti will applaud her achievement and agree that the dedication is the very least I can give in return! But there are countless other reasons besides …

CHAPTER I

The Romanesque construct: history and historiography

The great city of Toulouse, located on the river Garonne nearly halfway between its source in the Pyrenees and its estuary near Bordeaux, had impressive historical credentials as the first Christian millennium rolled into the second. It had been the capital of the Roman province of Narbonensia, and briefly of its successor, the kingdom of the Visigoths, and having fallen to the Franks in AD507 it later became the *de facto* centre of their duchy of Aquitaine. It had a local saint, Sernin (Saturninus), erstwhile bishop of the city who allegedly achieved his martyrdom when shackled to a wild bull galloping along the Rue du Taur in AD257. In the eleventh and twelfth centuries Sernin's grave was located in the womb of one of the great European churches of the middle ages.[1]

The basilica of St Sernin was served by Cluniac monks, members of the great monastic organization which had emerged at Cluny in Burgundy in the tenth century and had spread across much of western Europe carrying with it the Rule of St Benedict, a set of regulations for the proper conduct of monastic life. Pope Urban II, himself a Cluniac, had dedicated the basilica's high altar in 1096. The contemporary town community was, in its own way, as distinguished as the church: steadily usurping local princely authority through the later 1000s and early 1100s, it effectively transformed Toulouse into an independent city republic, rich in Latin-using legal institutions and in the literary traditions of troubadours.

Many of those who entered the basilica to venerate Sernin were not Toulousain but from further afield, and most of them were *en route* to an even more famous place, Compostella in northern Spain. The body of St James the Apostle had been 'discovered' there in the ninth century, and a great church, quite the equal of the basilica of St Sernin in size and opulence, marked the spot and drew in the crowds. Even semi-restored, the basilica of St Sernin remains a

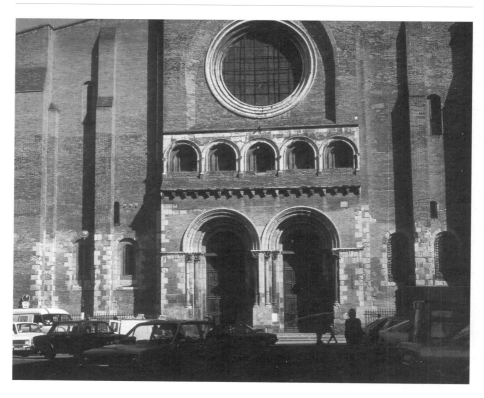

1 The west façade of St Sernin, Toulouse.

remarkable testimony to the importance of pilgrimage in the high medieval world-view, as well as to that period's extraordinary artistic vision and technical know-how. It is a very important survival; the contemporary churches dedicated to St Martial (a contemporary of Sernin) and St Martin (a fourth-century bishop) in Limoges and Tours respectively, both associated again with the medieval *pèlerinage* through France to Compostella, and both very similar to St Sernin's, have not survived.[2]

Three- and four-storeyed buildings erected in Toulouse between the 1700s and 1900s lessen from afar the visual impact of St Sernin's, and we depend today on the massive octagonal crossing tower and steeple erected in the thirteenth and fourteenth centuries to guide us to it through the city streets. But the church stood out more proudly in the twelfth century. Pilgrims approaching it from the west came upon a massive façade arranged around a central pair of doorways (**Fig. 1**); it may have reminded some of them of Roman architecture, especially its free-standing triumphal arches (**Fig. 2**). Inside they found a vast, brightly-lit, stone-roofed space, its side walls formed like Roman aqueducts and pinned together by high arches crossing at intervals from one side to the other. In a crypt at the far end of the church was the saint's shrine itself, along with a host of relics, including parts of the True Cross and the Crown of Thorns. The shrine was

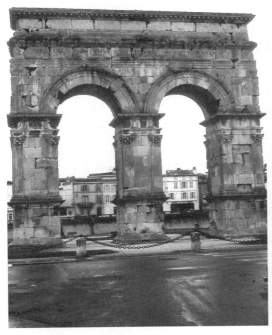

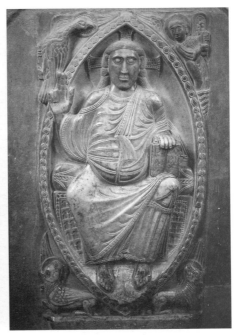

2 Triumphal arch at Saintes.

3 Figure of Christ from St Sernin, Toulouse.

screened off by a wall in which was set a series of quarter-life-sized marble sculptures, Christian in theme and, again, classical in execution (**Fig. 3**).[3] The route out of the daylight into the darkened church interior, and from there down into the darker crypt, and back up again and out into the daylight, was marked out clearly, if only by lines of pilgrims. Year in, year out, Toulouse saw constant pilgrim traffic.

* * *

Toulouse has little direct significance for Ireland; Irish pilgrims did of course go to Compostella,[4] although this city was not on their regular route. But Toulouse and its great church provide the opening images for this book because it is one of those places – and there are many across the Continent – at which a number of the major topics in any study of the twelfth century converge and are illuminated. We could dwell, for example, on the act of pilgrimage itself, or on the place of monasticism and the role of the papacy in contemporary Christian politics and practices, or even on the rise of burghal power and its promotion of law and letters. But it is the building and the sculpture which provide the most tangible modern witness to how the world of the eleventh and twelfth centuries viewed itself and to what it regarded as important. Here, the same cognizance of the Roman past which had informed so many intellectual endeavours of the later

4 The gatetower of Exeter Castle, *c*.1070 (*left*), and the west side of Charlemagne's palace chapel, *c*.800, with later alterations (*right*).

1000s and early 1100s found an extraordinary visual expression in stone: the church's transeptal, basilican, ground-plan had obvious classical antecedents, and its superstructure was provided with elements of classical architecture, such as columns and round arches, grouped in places in a recognizable classical formation. Yet, crucially, this was not a classical or even a neo-classical building. It was different in its spatial organization, in the rhythm of its structural and sculptural elements, in the articulation (or emphasizing) of its surfaces and details, and in the abstract and figurative sculpture which festooned its key parts, the latter narrating the scriptural tale of salvation rather than a tale of imperial triumph. A time-travelling Roman would have found it familiar but alien.

A pilgrim passing through Toulouse in, say, 1140, however, might have been staggered by its sheer scale, but he or she would have seen similar things elsewhere, and not just along the routes to Compostella: aisled, basilical churches with vaulted roofs, semi-circular ambulatories, and round-arched openings throughout, were serving as cathedral churches in large towns across Europe, or as monastic churches in almost-countless rural settings, while scaled-down versions served the many thousands of parishes across Europe. Contemporary palaces and castles even used the same forms and ideas, so that when a lord or king held court he often did so surrounded by some of the same visual appurtenances as a bishop celebrating mass in a cathedral. Here one might think

of, say, Norwich Castle *donjon* (or 'keep', in more traditional parlance) from
c.1100, which is elaborately decorated with arcading similar to that in the nearby
cathedral, or the stone gatehouse of Exeter Castle, commissioned by William the
Conqueror in 1068 and possibly modelled on the great arch leading into
Charlemagne's chapel at Aachen (**Fig. 4**).

These eleventh and twelfth-century buildings, and the many works of art –
in stone, metal, wood, textile – which were created at the same time and often for
display on or within them, constitute the body of material which, in homage to
Antiquity, we know as *Romanesque.*

EUROPEAN ROMANESQUE AND RENAISSANCE IN CRITICAL FOCUS

The buildings and art-objects which are described as Romanesque have, then,
been a material part of European heritage for nearly a thousand years. But the
word Romanesque itself is of more recent origin. It came into circulation nearly
two hundred years ago in tandem with, and as an expression of, an acceptance
among scholars that in the eleventh and twelfth centuries Europe's artists and
masons created work which can legitimately be gathered together under a single
heading. Comparatively few modern writers about this period and its artistic
products are concerned with the word and its modern origins, preferring instead
to focus their energies on the analysis of the material itself. But since it is not
possible to speak of European civilization in part of the central medieval period
without using the word Romanesque, it is desirable that we first reflect on its
meaning and on the implications of its use.

The interpretation of fifteenth- and sixteenth-century Italian art as the art of
'renaissance' was already a century old in 1927 when Charles Homer Haskins
popularized the idea that the twelfth century was an era of renaissance in Europe.[5]
Applying the model of the later renaissance to the period from *c*.1050 to *c*.1250,
but especially to the central hundred years of this time-span, he identified patterns
and processes of re-birth in a whole spectrum of cultural activities within Latin
civilization, from visual art, architecture and science, through law and theology,
to learning and literature. Haskins's alleged renaissance in the arts of this period is
represented by that complex stylistic movement to which early nineteenth-century
antiquarians like William Gunn and Charles de Gerville, building on the
pioneering critical traditions of earlier antiquarian generations, had attached this
title of Romanesque.[6] While the word's allusion to *romanitas* was deliberate, their
use of it was not actually to celebrate a reborn classicism in eleventh- and twelfth-
century art and architecture but the opposite: it communicated their idea of 'opus
romanum dénaturé ou successivement degradé par nos rudes ancêtres'.[7] Even so,
by demonstrating the connectedness of their Romanesque to the ancient Roman,

this antiquarian scholarship facilitated the eventual liberation of a high medieval stylistic tradition from the Dark Age basement into which it had been consigned, and its subsequent identification in the twentieth century as one of the peaks of medieval cultural endeavour.

Haskins's vision of the 1100s as a period of renaissance which was inspired by Roman precedents has proved rather enduring, surviving, for example, a vigorous debate in American scholarly literature half-a-century ago, as well as a thorough examination in 1977 on the fiftieth anniversary of his book.[8] In fact, this grand narrative of twelfth-century renaissance has been reinforced over the years by attempts at synthesized histories of medieval Europe. The reason is that a coherent narrative on such a large geographic and temporal scale as 'medieval Europe' requires the formulation of cause-and-effect models to bond meaningfully their diversity of peoples and places, and the model of renaissance, like that of conquest or of colonization, fits the bill very nicely for the twelfth century. It is also worth noting in this context that the use of the Romanesque construct to embrace so much material from such scattered lands is, by its very nature, reductive, so it tends to privilege the idea of unity over disunity; even the very conceit of the pan-European written survey of Romanesque[9] preserves the idea of a centrifugal pan-Europeanism, a unity of conception across the western world to which even the most modest and idiosyncratic of local variations – like some of those in Ireland – are fundamentally hitched.

But if Haskins's general model of a multi-element renaissance in the twelfth century in which the international Romanesque style is now firmly ensconced has enjoyed the sanction of its own longevity, it is not resistant to scrutiny and even criticism. On the contrary, its very status as a form of grand narrative within which all cultural actions can be explained renders it especially vulnerable in this age of postmodern critique. Such a critique is a project in itself, and should head the list of 'things-to-do' in twenty-first century Romanesque studies, but some scrutiny is a necessary prolegomenon to any book which addresses Romanesque identity in any of its constituent geographic parts.

How real was the twelfth-century renaissance?

Robert Swanson, in a most valuable recent survey, has observed that a close examination of the boundaries of the renaissance will consign some cultural activities to what he describes as a 'non-renaissance shadow-land', and he points out that the inclusion of certain activities within those boundaries while others are excluded may suggest that 'the time has come to discard the notion of a single, all-embracing twelfth-century renaissance, whose impact is assumed to be Europe-wide'.[10] He argues, furthermore, that there were actually several renaissances, among which 'the educational and theological renaissance remains as the central

trend'.[11] This is a strongly stated and reasonable position, and is informed in part by a short but laudably critical reflection on the perceived unity of the Romanesque style. It represents, in a sense, a refinement rather than a substantial rethinking of the renaissance paradigm, thus leaving it as the privileged idea to be negotiated in any study of the twelfth century, but this is perhaps how it should be. Perhaps this *was* the project of those eleventh- and twelfth-century writers, artists, and builders to whose historicizing discourses[12] in verbal and pictorial, and monumental and literary, media we owe the idea that there was renewal or rebirth in this period in the first instance. It is probably not in our imagination alone, then, that this was an era of significant transformation.

We could end this short comment with that simple conclusion, but there is a further interesting question to be asked about this notion of renaissance. Was that transformation of which we speak here primarily one of ideas which gained its political force by being translated into a set of material expressions with Roman allusions, or did those material practices of élite culture actually generate the ideas of renewal or rebirth? Which, in other words, came first? Were we able to engage in the scale of interrogation of the evidence which providing an answer would necessitate, we would doubtless find that the answer is not simply the first or the second but that each informed the other in an endlessly cyclical manner. In this context, though, a classic Marxist reading of the Romanesque renaissance offers an interesting perspective. It would favour the latter, that the material has primacy over the idea. In fact, it would go much further. It would not identify the twelfth-century idea of Latin renewal as a reflection of, or as an explanation of, that period's historicizing tendency in art and literature. Rather, it would recognize the explicit referencing of Antique Christian culture, as well as its contemporary intellectual justification, as a discourse which, by design or imagination, acted as a screen between the social élite and lower social levels, convincing those lower social levels that the conditions of their existence were the natural order, thereby preserving that élite's own hegemony. It would locate Romanesque within the political strategies of feudal culture, reading it as ideology as much as style. When we consider that the idea of a twelfth-century renaissance as communicated to us by its contemporary world, or as represented in our own modern historical literature, reflected the world-views of a relatively small part of the medieval population, such a reading has the clear attraction of providing an alternative context in which to place, say, the early eleventh-century prayerful assemblies,[13] the rise in pilgrim activity, and even the 'revolutions' in agriculture and technology.

Romanesque as an historiographic artefact

Romanesque, we have noted, is the style-name given to the visual-artistic and architectural endeavours of this renaissance, and this usage of the term can be

traced back to the early nineteenth century and earlier. The acceptance by those scholars of two hundred years ago of the phenomenon of a Roman-like style in the middle ages was enhanced by their observation that the wide distribution of the art was paralleled by the distribution of romance languages. Thus, they inferred that the former had the same relationship of vulgarity to parent Latin forms as had the latter.[14] There is no doubt that the twelfth-century interest in 'Latin' (ancient Roman) art and architecture should be seen hand-in-hand with that same period's concern with Latinity, even if the processual connections which early scholars postulated between these two primary human endeavours, communicating and building, were the products of gross over-simplification. And certainly there are issues in the study of Latinity – the transmission of texts, the regularizing of orthography from Carolingian times onwards, the drift in the quality of spoken and written Latin downwards from the level of the élite and intellegensia – which should resonate in the minds of scholars of Romanesque art and architecture. But as early as the middle of the nineteenth century the clarity of the relationship was unravelling, with Jules Quicherat suggesting, first, that the two categories had different relationships with the Roman past, and second, that Romanesque was an independent style between the Roman and the Gothic which should be defined by reference to those two periods.[15] Despite Quicherat's clarification of its integrity and its significance, however, the Romanesque style continued to be seen in terms of debasement, and so suffered unfair comparison with Gothic up to the early part of the twentieth century, with the latter increasingly identified as the visual apogee of medieval civilization. The energy of many historians and art historians up to the late 1800s was channelled into Gothic's exploration, rather than that of Romanesque.[16]

Even so abbreviated an overview of the early history of Romanesque research as has been presented here underscores an important point: however accurate or legitimate is the term as an expression of a stylistic connection between Antiquity and the twelfth century, Romanesque is, first and foremost, an historiographic artefact, a device of scholars who, although very distant in time from the circumstances of the creation of the art and architecture in question, felt that the material on which they were reflecting was understood at last and that they had provided it with a terminology which captured its very essence. The key players in Romanesque's earlier historiography, such as Gunn and de Gerville, or Arcisse de Caumont, seem almost as distant from us as they themselves were from the twelfth century, and their analytical strategies and the scholarly language through which they disseminated their results are firmly rooted within an early nineteenth-century intellectual environment. Yet, even though it is incontestable that we exceed our predecessors in the subtlety and sophistication of our understanding

of the material which the label Romanesque represents, we still use their terminology, and we use it to describe more or less the same body of material.

Is this a problem? It is clearly not a problem for most students of the 1000s and 1100s. But the following quote, the opening words of a general survey by George Zarnecki, a respected senior scholar in the field, highlights a significant problem at the root of the Romanesque construct:

> For various reasons, the chronological limits of the Romanesque period cannot be clearly defined. First of all, they vary from country to country. Secondly, the Romanesque style is not easy to define and its beginnings, especially, are imperceptible, so that it is often impossible to state categorically that any given work is already Romanesque. Similarly, at the other end, the change from Romanesque into Gothic did not occur overnight, and the period of transition varied in duration from region to region. Generally speaking, however, bearing in mind the imperfections of any firm definitions, it can be said that, by the middle of the eleventh century, the Romanesque style was already firmly established, after a preliminary period of about fifty years, during which the style had gradually evolved.[17]

A reading of this passage – and passages from other writers could be quoted in its place – shows just how thoroughly Romanesque has become reified over the past two centuries. It is written about as if it actually existed as a real, tangible, phenomenon, rather than as a construct which carries a name which is neither medieval nor a modern translation of a medieval word. We are told in this passage that the Romanesque style is not easy to define, and that neither its beginning nor its end can be easily pinned down for the purposes of dating or example-identification. A bright young student new to this field might well ask the most obvious question: if we cannot define it, and cannot establish where and when it started and finished, how do we know that it existed? This is an entirely valid question, neither unnecessarily nor excessively pedantic. Terminology is, by its nature, reductionist; while it can pick up some of the long shadows cast from macro-scale distinctions, it can simultaneously mask subtle but no less significant micro-scale variations, and just as it reflects how we view any body of material, it also dictates how we interpret it. So the bright student is quite entitled to balk at those opening words and refuse to accept its hidden message of 'we know what we're talking about so let's just move on'.

The full implications of this problem of definition, raised directly by the continued use of a nineteenth-century construct, is not addressed within most Romanesque scholarship, perhaps because this a specialization which has not

developed a self-reflexive dimension; outward-looking and constantly engaged with the empirical, it rarely turns back in the opposite direction to consider its own epistemology. Therefore, rather than address that crucial question of definition, or even recognize that it is crucial, most Romanesque scholarship shifts our attention away from the fuzzy, uncertain, edges towards a notional core over which there seems to be no dispute. In the fields of Romanesque architectural and sculptural studies that core is chronological (the later eleventh and early twelfth centuries), spatial (Italy, France and Germany, Spain and England, in that order), and canonical (pilgrimage churches on the roads to Compostella, like St Sernin, abbey and cathedral churches in Italy, the Rhineland and the Norman territories, theophanic portals in France, sculptured cloisters in Spain, and so on).

Zarnecki is certainly not alone in regarding an adequate definition of Romanesque as something perpetually elusive, but the quote from his book is used here as an illustration of how problems of definition and dating are accepted, not as inherent problematics of the concept of Romanesque itself, but as a challenge to the scholarship that is concerned with it. Romanesque, in other words, is presented here as real, and it follows from this that one of our jobs, as students of it, is to locate the boundaries of its reality rather than challenge that reality. Subdivisions of Romanesque into phases of development – for example, Kenneth Conant's categorizations of 'Carolingian', 'pre-', 'proto-', 'Earlier' and 'Mature' Romanesque architecture(s) in his *Carolingian and Romanesque Architecture* – could be understood as implicit attempts at such a project. To repeat, the reification of Romanesque is inadvertent, but it is nonetheless a feature of much of the literature. Suffice it to say here that as a construct of scholarship's creation rather than an immutable historic fact, Romanesque requires, as do all such constructs, constant reassessment. It qualifies as one of those 'intellectual categories' within scholarship which, to paraphrase Ernst Gombrich, were created before their value 'in contact with the facts of the past' was proven, and which may well 'fit' those facts but which may equally need 'radical revision'.[18]

A starting point would be to recognize that, notwithstanding a certain homogeneity in the formal and conceptual aspects of art and architecture across eleventh and twelfth-century Europe, an actual *core* of Romanesque pan-Europeanism might be a chimera. Can we demonstrate that there was an original, 'classic', or core Romanesque tradition from which the many local and regional variations peeled away in the 1000s? The phenomenon which we describe as Romanesque is not singular but is comprised of local or regional traditions, the foci of which were rural parishes with low populations as often as they were great metropoliti. These local or regional traditions have interconnecting forms and concepts of art and design, many of them derived undoubtedly from ancient Roman exemplars, but, given that there were 'court styles' (such as the Carolingian, Ottonian

and Asturian) scattering a neo-classical vocabulary around Europe before 1000, there is, I think, no single progenitorial template anywhere – even Italy – in early eleventh-century Europe for what we see in the late 1000s and early 1100s. So, while some of the identified Romanesque traditions of Europe may appear to have more in common with Antiquity than others, none can be regarded as 'purer' than another. Therefore, when Clapham described Ireland's twelfth-century tradition as 'an example of a remote and local adaptation of Romanesque forms, combined with features which are of purely native origin'[19] he was, of course, essentially correct, but he was not correct in implying that this made it special or different: he might have added that all so-called Romanesques – Irish, Norman, Spanish, Provençal – are products of an interaction between older indigenous and newly-gestated international traditions. The balance between these will shift from one place to another depending on a whole series of factors, such as resources, access to exemplars, or intellectual climate, but local and older ingredients are ever-present, and this is how we tell the buildings of different areas apart. All Romanesque is local.

By deconstructing the idea of a chronological/spatial/canonical core of Romanesque pan-Europeanism we actually deconstruct the idea of *the* Romanesque style itself, even of a pluralist Romanesque style. If we abandon, therefore, the use of Romanesque as a bounded style-name prefixed by the definite article, which was the sense in which it was used in the Zarnecki quote, we can stress instead the other sense in which the word is used, which is contextual. In this event, its meaning is not literal – we forget the suggestion of 'Roman-ness' – but semiotic: we use it *adjectivally* as a sign or label to denote a particular understanding of a particular work of art or architecture, or a particular corpus of art or architecture, or even simply a motif, of which the following is the case:

1 it is a product of the 1000s or 1100s, although the date range naturally varies from one area of Europe to another;
2 the particular political and intellectual culture in and for which it was created was informed by, or at least created with some cognizance of, contemporary international contexts;
3 it is discursive with respect to this political and intellectual culture: it does not just reflect a world of issue extrinsic to it but is a medium for, and a form of, commentary on those issues. It is, in other words, a form of discourse;
4 intrinsically it represents or embodies some rapprochement between past and present on the one hand, and between local and international scales on the other. That rapprochement might be stylistic (involving forms and motifs) or conceptual (involving ideas), and it might be acquiescent, in which new forms or ideas are readily embraced, or resistant, meaning that new forms and ideas are rejected.

The description of some architectonic (or structural) or ornamental device as 'Romanesque' in a formal sense is not invalidated by such a contextual understanding. On the contrary, it signals the context of which the device in question is a product.

Such a reformulation, or clarification of the formulation, does not resolve the problems inherent in Romanesque as a category, but this sort of contextual understanding of Romanesque – that any art or architecture of this period for which the circumstances of production are demonstrably connected to wider artistic or intellectual impulses can be described as Romanesque, regardless of whether strong classicizing features are present or absent – has some value for this book's study area, Ireland. Here, corpora of later eleventh- and twelfth-century material could conceivably be denied the label Romanesque on the basis of a lack of the 'neo-classical' features of allegedly 'classic' Romanesque style on the one hand, and on the presence of Scandinavian and Hiberno-Scandinavian motifs on the other; Peter Harbison's very interesting and important characterization of twelfth-century Irish art as 'other'[20] suggests as much. But by conceiving primarily of Romanesque *contextually* rather than *formally*, the Irish material becomes as Romanesque as any material in Europe.

There are two specific reasons why this is so. First, the political and intellectual circumstances of the production of the Irish material place it firmly within a pan-European milieu; Ireland was not isolated from the wider international world. Secondly, and fundamentally, the Irish material articulates through its formal character a world-view which is demonstrably responsive to that international world and its trends, even if that response was partly one of resistance. So, while we can easily identify the erection of round-arched doorways decorated with chevron as reflecting positive, embracing, attitudes to overseas impulses among the twelfth-century Irish, we can legitimately postulate that the retention of earlier or traditional forms and motifs during the same period were acts of resistance against such impulses. Thus, by recognizing the general absence of the 'neo-classical' in twelfth-century Ireland as a product of politically motivated decision-making, we reinforce rather than undermine its right to be described as Romanesque. Perhaps resistance is the one denominator common to all of Europe's Romanesque: no core Romanesque identity ever emerged in Europe because in every part of Europe there were agents resisting any centripetal impulses which might lead to homogeneity.

GAELIC-IRISH ROMANESQUE:
AN INTRODUCTION TO ITS FORMAL REPERTOIRE

The contexts for which Romanesque can be used as a label vary in scale. Used as an adjectival noun on its own, Romanesque locates us in a time – the late 1000s

and early 1100s – but not necessarily in a particular place other than a vaguely defined 'Europe'. So Romanesque still requires some cultural or geographic specificity. We will tackle that issue here solely with respect to Ireland.

The difference between the phrases 'Irish Romanesque', 'Hiberno-Romanesque' and 'Romanesque in Ireland' is self-evidently not confined to a simple choice of words. The last-named contains no assumption of authorship but simply communicates the idea of Romanesque which is *in Ireland* rather than in some other country. Ireland, in other words, is nothing other than a location. 'Hiberno-Romanesque', a frequently used formulation, is a little subtler. It literally suggests Romanesque which is *of* Ireland, meaning that the character of the work which is labelled Romanesque owes something to the provenance of its production and location. While it actually makes no explicit reference to the political or ethnic identity of its 'authors' within Ireland, it is mainly used in the literature to refer to work produced by 'native' – Hibernian – Irish. So, its meaning in practice is a little more specific than its literal meaning. 'Irish Romanesque' is less satisfactory because it can be read literally to mean both the Romanesque of Ireland and the Romanesque *of the Irish*, even though the contexts of its usage suggest that the latter is usually the intended meaning. My preference is for a new term, 'Gaelic-Irish Romanesque', to express the idea of work which is contextually Romanesque, which is found in, and is a product of, Gaelic Ireland, itself constituted by Gaelic-speaking people, and which, finally, is fundamentally different from the Romanesques of other places and other populations precisely because it is located in Gaelic Ireland, and has been transformed in some formal or conceptual way by that location. Yes, to a great extent this is simply 'Irish Romanesque' or 'Hiberno-Romanesque' by another name, but it has the advantage of carrying no historiographical baggage; it is given its meaning at this very moment in this book, rather than acquire it casually over time as have the other terms.

The Gaelic-Irish Romanesque repertoire is manifest in the four principal media of manuscript art, metalwork, stone sculpture and architecture (**Fig. 5**); we should also imagine more numerous wall paintings than survive, as well as woodcarvings and textiles.[21] The first two categories are mobile by their nature: the likelihood of them remaining permanently in their place of production (or of their first display or use) is very slim indeed. Stone sculpture is surprisingly mobile: individual carved stones from architectural contexts can turn up out of context, as the recent discovery of a remarkable sculptured block of possible twelfth-century date from Carrowcullen makes clear,[22] while High Crosses also move, as witnessed by the small diaspora of items around and out of Kilfenora.[23] Complete architectural works, by contrast, are fairly immobile – the portal from Old Kilcullen is an exception which proves the rule (see p. 250 below) – so they

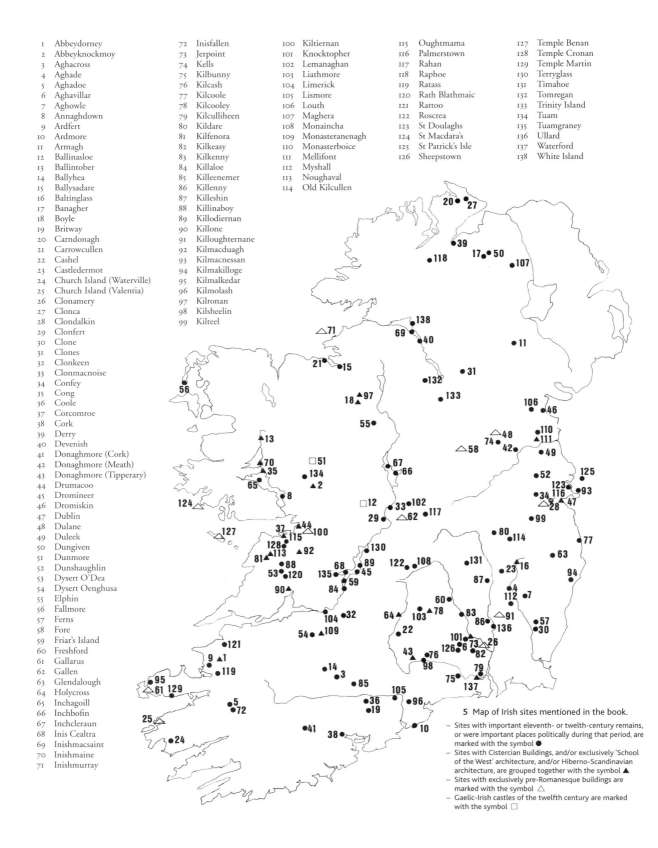

1	Abbeydorney	72	Inisfallen	100	Kiltiernan	115	Oughtmama	127	Temple Benan
2	Abbeyknockmoy	73	Jerpoint	101	Knocktopher	116	Palmerstown	128	Temple Cronan
3	Aghacross	74	Kells	102	Lemanaghan	117	Rahan	129	Temple Martin
4	Aghade	75	Kilbunny	103	Liathmore	118	Raphoe	130	Terryglass
5	Aghadoe	76	Kilcash	104	Limerick	119	Ratass	131	Timahoe
6	Aghavillar	77	Kilcoole	105	Lismore	120	Rath Blathmaic	132	Tomregan
7	Aghowle	78	Kilcooley	106	Louth	121	Rattoo	133	Trinity Island
8	Annaghdown	79	Kilculliheen	107	Maghera	122	Roscrea	134	Tuam
9	Ardfert	80	Kildare	108	Monaincha	123	St Doulaghs	135	Tuamgraney
10	Ardmore	81	Kilfenora	109	Monasteranenagh	124	St Macdara's	136	Ullard
11	Armagh	82	Kilkeasy	110	Monasterboice	125	St Patrick's Isle	137	Waterford
12	Ballinasloe	83	Kilkenny	111	Mellifont	126	Sheepstown	138	White Island
13	Ballintober	84	Killaloe	112	Myshall				
14	Ballyhea	85	Killeenemer	113	Noughaval				
15	Ballysadare	86	Killenny	114	Old Kilcullen				
16	Baltinglass	87	Killeshin						
17	Banagher	88	Killinaboy						
18	Boyle	89	Killodiernan						
19	Britway	90	Killone						
20	Carndonagh	91	Killoughternane						
21	Carrowcullen	92	Kilmacduagh						
22	Cashel	93	Kilmacnessan						
23	Castledermot	94	Kilmakilloge						
24	Church Island (Waterville)	95	Kilmalkedar						
25	Church Island (Valentia)	96	Kilmolash						
26	Clonamery	97	Kilronan						
27	Clonca	98	Kilsheelin						
28	Clondalkin	99	Kilteel						
29	Clonfert								
30	Clone								
31	Clones								
32	Clonkeen								
33	Clonmacnoise								
34	Confey								
35	Cong								
36	Coole								
37	Corcomroe								
38	Cork								
39	Derry								
40	Devenish								
41	Donaghmore (Cork)								
42	Donaghmore (Meath)								
43	Donaghmore (Tipperary)								
44	Drumacoo								
45	Dromineer								
46	Dromiskin								
47	Dublin								
48	Dulane								
49	Duleek								
50	Dungiven								
51	Dunmore								
52	Dunshaughlin								
53	Dysert O'Dea								
54	Dysert Oenghusa								
55	Elphin								
56	Fallmore								
57	Ferns								
58	Fore								
59	Friar's Island								
60	Freshford								
61	Gallarus								
62	Gallen								
63	Glendalough								
64	Holycross								
65	Inchagoill								
66	Inchbofin								
67	Inchcleraun								
68	Inis Cealtra								
69	Inishmacsaint								
70	Inishmaine								
71	Inishmurray								

5 Map of Irish sites mentioned in the book.

– Sites with important eleventh- or twelfth-century remains, or were important places politically during that period, are marked with the symbol ●
– Sites with Cistercian Buildings, and/or exclusively 'School of the West' architecture, and/or Hiberno-Scandinavian architecture, are grouped together with the symbol ▲
– Sites with exclusively pre-Romanesque buildings are marked with the symbol △
– Gaelic-Irish castles of the twelfth century are marked with the symbol □

provide the key distributional evidence for the centres of aesthetic creativity in the twelfth century. It must be noted, however, that many of the works of architecture which interest us here, such as the Killeshin portal or the Ardmore façade, show signs of having been reconstructed between the twelfth and nineteenth centuries; although not discussed here, the apparently widespread phenomenon of reconstruction is deserving of study in its own right, if only for the light which it sheds on later medieval, and maybe especially seventeenth-century, world-views.

The connectedness of Gaelic-Irish Romanesque art to the Insular art of earlier centuries is perhaps most apparent in those illuminated manuscripts of the 1000s and 1100s that combine decorative conventions with quite long ancestries, such as elaborated initials, decorated margins, and full-page evangelist images, with various contemporary devices in the so-called 'Ringerike' and 'Urnes' styles.[24] There are four illuminated manuscripts firmly dated to these centuries, with at least fourteen more attributable stylistically and palaeographically to the period. Two of the four were illuminated around 1100: Lebor na hUidre (the Book of the Dun Cow), a collection of verse and prose, was produced at Clonmacnoise shortly before 1106, while the other manuscript, Egerton MS 3323, probably produced at Glendalough, is represented by two folios, one of which has decoration and contains a death notice which allows it to be dated to 1106. The decorated Gospel Book known as Harley MS 1802 is dated to 1138 and attributed to a scribe at Armagh on the basis of colophons. Finally, the Book of Leinster, a collection of sagas and genealogies, is known from two of its entries to have been written at Terryglass between 1151 and 1161. Another two manuscripts might be included here: the Chronicle of Marianus Scottus (Moel Brigte) of Mainz and the Epistles of St Paul by Marianus (Muiredach) of Ratisbon were produced in the 1070s by Irish scribes working in *Schottenkirchen* in central Europe and contain a mixture of Insular and Continental devices in their script and decoration.

Items of eleventh- and twelfth-century metalwork are far more numerous, with more than five dozen items, including individual pieces or fragments as well as composite and complete or near-complete works like shrines or reliquaries.[25] Inscriptions on the metalwork do not include actual dates, but references to individuals – patrons and/or artists – allow certain items to be dated with some accuracy. The earliest is the Soiscél Molaisse, a book-shrine, which was made between 1001 and 1023, probably at Devenish. Among the principal items in the corpus are the shrine or *cumdach* of the Stowe Missal, made by a monk of Clonmacnoise between 1026 and 1033, the *cumdach* of the Cathach, made at Kells between 1062 and 1098, the Shrine of St Patrick's Bell which was made, probably in Armagh, between 1094 and 1105, the Lismore crozier was made around the same date, 1090–1113, and probably at Lismore itself, and the Shrine of St Lachtin's

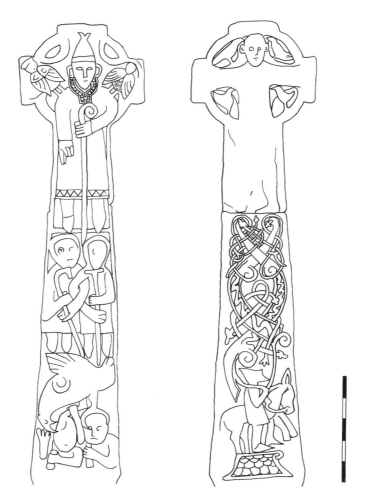

6 The west and east faces of the 'Doorty' cross at Kilfenora. Scale bar = 50cm.

arm, which was made in Munster for the monastery at Donaghmore (Cork), and is fairly exactly dated to 1118–21. Finally, the best-documented item is the so-called Cross of Cong, a processional cross-reliquary, a product of the same workshop in Tuam or Roscommon which produced the so-called St Manchan's Shrine. It was made to contain a relic of the True Cross which Toirrdelbach Ó Conchobair of Connacht obtained from a larger portion which was brought to Ireland in 1119; the exact date of manufacture of the cross is not clear but it was certainly finished by 1136 (when the artist died) if not 1127 (when the bishop under whom it was made became abbot at Clonmacnoise). It might be noted, first, that virtually all these dates are generally earlier than the building of Cormac's Chapel, the most famous of all Irish churches of the period (see Chapter 4 below), and second, that much of the metalwork was produced north of the main distribution area – mainly the southern half of Ireland (see **Fig. 5**) – of the period's architecture.

The third category – the High Crosses – is more pertinent to the study of the architecture.[26] Inscriptions date three of the crosses. The earliest is on Inis Cealtra: this has a *terminus ante quem* of 1111, the date in which the annals record the death of Cathasach, by whom it was erected according to its inscription. The other two crosses are at Tuam; both mention their donors, an abbot of the monastery who is known to have succeeded to the abbacy in 1122, and the king, Toirrdelbach Ó Conchobair, who is known to have died in 1156, and they must therefore date to within that forty-year period. The other crosses can be dated by stylistic comparisons with the dated crosses and with art in other media. These Romanesque High Crosses differ from the earlier medieval examples in morphological form and figural style. The ring which distinguishes the earlier crosses was sometimes abandoned by twelfth-century carvers. The proportions of the

7 The east face of the west cross at Kilfenora. Shading represents ornamented surfaces. Scale bar = 50cm.

later crosses are at variance with those of the earlier tradition, with the shafts generally lengthening and the arms of the cross-heads shrinking. The differences in the organization of the figure sculpture are even more pronounced: whereas the earlier crosses had complex iconographic programmes involving numerous figural images arranged in sequences, the iconographic imagery on the Romanesque crosses was generally more restricted, with a single large figure tending to dominate the centre of each face (**Fig. 6**); there is also a far greater amount of abstract or zoomorphic forms on the shafts, bases and cross-heads on the later crosses. The modelling also changes: in the early crosses the relief is low – the figures generally do not project any further than the planes of the outer mouldings of the crosses – and the surfaces are flat rather than rounded, with details such as clothing sometimes incised rather than sculpted, but in the twelfth century the figures are more three-dimensional and project boldly from the faces of the crosses. As well as a change in modelling there was an increase in the scale of the figures: even on the flattest twelfth-century sculpture to be found on a Romanesque High Cross – the crucified Christ on the westernmost cross at Kilfenora, for example (**Fig. 7**) – the arms are moulded in the round and the head projects forward; the statuesque form which this sculpture can sometimes take is well demonstrated by the mortise and tenon joints by which parts were attached to the crosses, as is the case with the High Cross of Dysert O'Dea, where Christ's

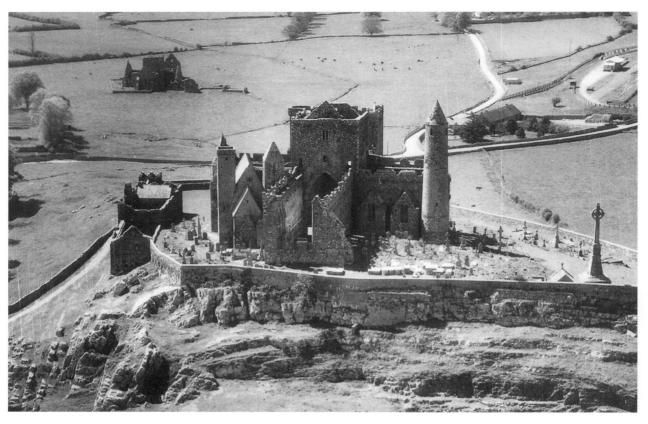

8 The summit of the Rock of Cashel from the north-east. The site is dominated by the thirteenth-century and later cathedral, but tucked into the return angle of its roofless choir and south transept is Cormac's Chapel. The ruins of Hore abbey, a later thirteenth-century Cistercian abbey, are visible in the background (photo: The Françoise Henry archive, Department of Archaeology, UCD).

head and right arm were carved on separate stones. A final difference between the High Crosses of the two periods is in the use of the panel as a field for sculpture. Its abandonment on the twelfth-century crosses is perhaps explained by the desire to decorate the crosses, first with the larger-scale figural forms which were achieving popularity in contemporary Romanesque work overseas,[27] and second by the expansive Scandinavian-derived patterns then popular in other art media.

Despite the diversity apparent among them, the later eleventh- and twelfth-century High Crosses can be drawn together as a fairly homogenous group, their common elements outnumbering their differences. Ireland's contemporary buildings, which constitute our fourth group and which have a more explicitly stated pedigree in overseas stylistic traditions, especially in the broadly defined Norman world,[28] form a rather more heterogeneous group – a situation happily accommodated within a conceptualization of Romanesque as contextual – and much of this book is devoted to scrutinizing that corpus to try to understand in detail the mechanisms of its formal and contextual evolution. Cormac's Chapel, one of the buildings on the summit of the Rock of Cashel (**Fig. 8**), is dated historically to between 1127 and 1134, and is invariably identified as the key

9 Killeshin church from the south-west.

monument, not just in terms of its architectural and sculptural splendour but also in regard to its chronological significance. A small art-historical industry has grown up around this monument and the influence which it exerted on the subsequent development of Ireland's twelfth-century, pre-colonial-era, architecture. Amidst the various conflicting views there is consensus on one point: Cormac's Chapel is absolutely *not* typical of what was built in Ireland in the 1100s.

Typicality is a dangerous idea, and a slightly nonsensical one in the context of a rather heterogeneous tradition, but were we to select one monument to illustrate the type of architecture which was being made in twelfth-century Ireland Killeshin would be a candidate, as Harold Leask, whom we will meet below, acknowledged.[29] Killeshin church (**Fig. 9**) was built in the middle of the twelfth century, which is around the beginning of the era of greatest building activity, and is located in the southern part of Ireland, the main distribution area of new or refurbished churches in that era. It is a nave-and-chancel building, entered through its west wall. The chancel was probably added after the twelfth century, suggesting that the original church was a single-cell building, which was a common form among the Irish churches of the period. Killeshin's west-wall entrance is also quite

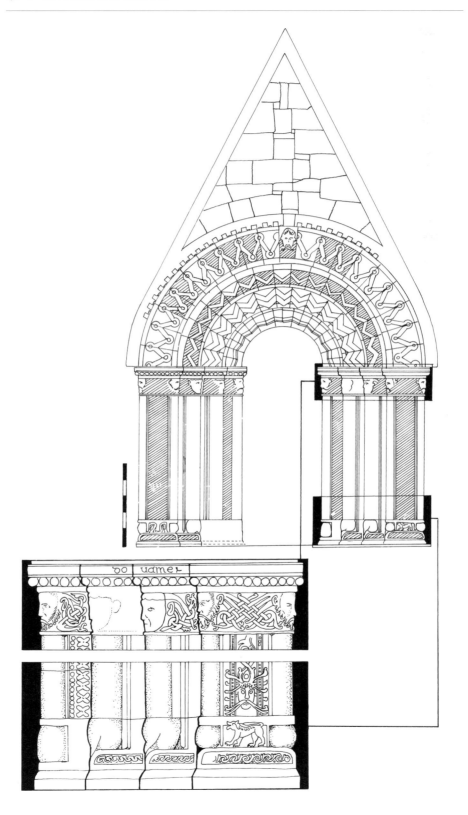

10 Outline drawing of
the west portal of
Killeshin church;
shaded surfaces are
those with traces of
sculptural detail.

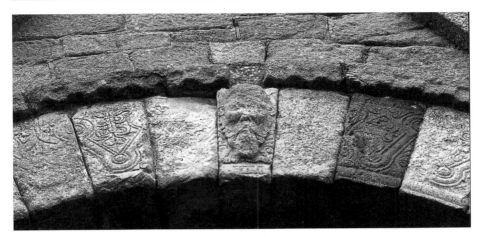

11 Detail of the Killeshin portal. This close-up shows how lightly incised is the decoration on this great portal. Two details to notice are the head, which is relatively large and projects slightly, and the fillet on the edge of the arch.

normal – comparatively few contemporary churches have side-wall entrances – as is the domination of the visual aspect by the main portal, and its possession of the greatest amount of carved stonework. The west façade is flanked by antae, flat-ended projections of the side walls past the end walls. The original east wall would have had these also, as antae are features of both ends of the churches in which they are found. They are especially common in pre-Romanesque contexts in Ireland, and when they are found associated with Gaelic-Irish Romanesque features they often indicate the twelfth-century reuse of older structures, although they can often be of twelfth-century date, as in the case of Killeshin.

Killeshin's great portal is round-arched with four orders and a pediment above (**Fig. 10**). Pediments are not a frequently recurring feature of Gaelic-Irish Romanesque, but some of the larger portals, as well as a couple of smaller ones, do possesses them. The round arch, supported on carved door jambs and bearing sculptural decoration, is the classic, international, signifier of Romanesque. That ornament used to embellish the Killeshin portal is fairly shallow, almost incised (**Fig. 11**), and is comprised of motifs which are quite common in contemporary work outside Ireland, such as chevron, billet, and head-capitals, and other motifs which are derived from indigenous Gaelic-Irish and Hiberno-Scandinavian decorative traditions. Many of the motifs will also be found in art in other media, and so, for example, the step-patterns on the portal can be paralleled in contemporary metalwork such as the Shrine of St Patrick's Bell, and the small animal representations have the quality of painted images in contemporary manuscripts. At Killeshin, as at many other Irish sites, those motifs with overseas comparanda have in some way been transformed in their details, their execution, or their combinations (**Plate 1**). Even more striking a characteristic of Gaelic-Irish Romanesque work is how the classic English and Norman Romanesque angle-shaft, which sits into the return of a door or window jamb, is widely (though not always) eschewed in favour of a roll-moulding on the outer edge of each jamb,

thus giving the entire architectural composition a much shallower appearance; the frieze-like forms and arrangements of capitals enhance this impression of shallowness. One could hardly confuse, then, an Irish portal like Killeshin with some English or northern French Romanesque portal. Equally, one could not claim that a place like Killeshin is entirely the product of indigenous creative processes: a package of design ideas of non-Irish origin was clearly delivered to Killeshin at first- or second-hand, if not at third- or fourth-hand, just as it was to other sites.

There is a final point to be made about Killeshin before we leave it temporarily, and it is a reiteration: there are some buildings in Ireland which belong within the Romanesque as it is defined contextually but which do not possess any of the devices, or indeed virtually any devices at all, of elaboration which characterize churches like Killeshin; we will meet some of these in Chapter 3. To describe Killeshin as *typical* of Gaelic-Irish Romanesque architecture, then, would be quite misleading; its typicality is only with respect to the corpus of works of similar date and distribution.

THE IRISH CHURCH IN THE TWELFTH CENTURY: THE REFORM

Gaelic-Irish Romanesque was not an exclusively ecclesiastical phenomenon, but the overwhelming majority of the new architectural and sculptural works of twelfth-century Ireland of which we have knowledge were created for ecclesiastical contexts. The reform of the native Church in the 1100s emerges as the obvious historical framework for their explanation: virtually all the main players in the contemporary political arena are implicated in its gestation and actualization, and virtually all the work discussed in this book was created for, or at least used by clergy of, the reformed institution.

Central to the story of the Irish Church between the ninth and eleventh centuries – the Viking Age – is its relationship with the structures of secular power, and its increasing authority and independence within that relationship. By the 1000s the Church had wriggled free of its obligations of tribute and service to secular lords; its saints, increasingly invoked to resolve disputes and avenge enemies, had their relics enshrined with gusto under secular patronage, and its scribes busily engaged in adding historical chronicles to the scriptural and devotional writings which were their longer-established stock-in-trade.

Canterbury and the reform

Ostensibly the stimulus for a reform designed to bring the post-millennium Gaelic-Irish Church's structures and practices into line with those of the contemporary

Church elsewhere in Europe came from outside Ireland, and principally, though probably not exclusively, from the newly-established Norman Church in England; Irish monastic clergy in reformed Benedictine houses in Germany were doubtless communicating reform ideas around the same time. Such outside stimuli are enormously significant in the understanding of the stylistic transformation which we describe as Romanesque.

The connection with England was specifically with Canterbury. This ancient see's interest in Irish affairs seems only to have begun in the later 1000s. In a letter to Pope Alexander II in 1072, Lanfranc, its Italian-born first Norman archbishop (1070–1089), had named Ireland as part of the territory over which he claimed authority for Canterbury.[30] His making of this claim for primacy was precipitated by some uncertainty about the relative positions within the power structure of the English Church of its two archbishoprics, York and Canterbury, while his specific inclusion of Ireland within the patriarchate under Canterbury control was informed by some of the material – notably Bede's *Ecclesiastical History of the English People* from the early eighth century as well as early tenth-century royal diplomata[31] – which he read in preparing his position. But Lanfranc's interest in Ireland was not simply one of expedience for his claim of authority over York; as one of the great contemporary thinkers he would have been quick to identify and condemn irregular or unconventional social and ecclesiastical practices, and Ireland would have been within his sight. He appraised Pope Alexander's replacement, Gregory VII (1073–85), sufficiently well of matters Irish that immediately after his elevation to the holy see Gregory wrote to Toirrdelbach Ó Briain, the king of Munster, and 'the archbishops, bishops, and abbots of Ireland' offering any assistance which they might need in the project of eliminating such unacceptable practices.[32]

Gregory extended to Lanfrance the appropriate legatine power over Ireland.[33] Lanfranc was able to exercise this power in a practical manner as early as 1074 when, at the request of the people of Dublin, he consecrated Gilla Pátraic (Patrick), who had trained among the Benedictines at Worcester, as their second bishop.[34] Nine years later, 'at the request and choice of *Terdyluacus*, king of Ireland, and the bishops of Ireland, and the clergy and people of the aforesaid city [of Dublin]', Lanfranc consecrated the next Dublin bishop, Donngus, whom bishop Patrick appears to have sent to Christ Church in Canterbury for training.[35]

Through Bishop Patrick Lanfranc dispatched a letter to Toirrdelbach, *magnifico Hiberniae regi*, on the matter of the ordination of bishops and priests in Ireland, advocating 'a holy assembly' of bishops, other religious, and the king's own advisors, to 'strive to banish from your kingdom these evil customs and all others similarly condemned by canon law'.[36] In 1080 a synod was convened in Dublin and was attended by Toirrdelbach, and presumably also by his son

Muirchertach, installed as king of Dublin in 1075, and by clergy from Munster, including Domnall Ó hÉnna, a senior Dál Cais bishop.[37] This synod seems to have been a direct response to Lanfanc's exhortation, and during its course queries were sent to Lanfranc concerning the baptism of children and 'problems of profane learning'. Lanfranc's plan – which ultimately came to nothing – was for Patrick to become the metropolitan for the ecclesiastical province of Ireland under Canterbury's primacy.[38]

Lanfranc's successor, Archbishop Anselm (1093–1109), maintained both the practice of consecrating the bishops-elect of Hiberno-Scandinavian sees and the pressure for reform. The key year during the Anselm years, if one can be isolated, may be 1096. In that year he consecrated two bishops – the St Alban's-educated Samuel Ó hAingliu for Dublin and the Winchester-educated Malchus (Máel Ísu Ó hAinmere) for Waterford – at the request of Toirrdelbach's son, Muirchertach, among others, and he also wrote to Muirchertach protesting about Irish marriage law and inappropriate practises in the consecration of bishops.[39] Significantly, that year also saw a national council gather in Munster, probably in Waterford,[40] as a crisis-response to a plague which had ravaged the country during the previous year. This was not the first such gathering in Ireland to addresses a natural or social crisis: for example, one was held in Killaloe in 1050, and it may well have been inspired by the 'Peace of God' assemblies which convened in Europe in the early eleventh century as popular responses to deliverance from bad harvests on the one hand, to millennial apocalypse on the other.[41] But the 1096 council stands out because it was convened in Munster with a full consciousness of the urgings of Lanfranc and Anselm for reform assemblies. And a mere five years later its convenor, Muirchertach, presided over another assembly in Munster, this time with an explicit reform agenda: the synod of Cashel.

Cashel, 1101

Although the gathering at Cashel in 1101 is not known to us from extant documentation of contemporary age but from later sources,[42] its decrees are known and its ostensible purpose seems clear enough. Eight reform measures, mainly addressing ecclesiastical practices, issued from the synodal assembly. These measures amounted largely to a reiteration of older aspirations and legal positions within the Irish Church with respect to its freeing from secular tribute, the protection from abuse of its rights of sanctuary, the tightening of native laws of marriage, and the regulation of ecclesiastical appointments.[43] But hierarchic territorial restructuring, necessitated by the sheer number of bishops and ever-changing bishoprics of the pre-reform Irish Church,[44] was not on the Cashel agenda.

Muirchertach used the opportunity of the synod to make a grant of Cashel – St Patrick's Rock itself – to the Church. Interestingly, several annalists took note

of this,[45] even though they were otherwise vague on the happenings at Cashel. Muirchertach's commitment to reform can hardly be doubted, and the grant should be understood primarily in that context, but the political agenda which ran in tandem with his reform agenda is especially transparent in this grant. Here was the ancient centre of rival Eóganacht power. In one swoop he derailed any ambitions they might have had to return to it one day as their *caput* while simultaneously drawing considerable kudos for his own Dál Cais dynasty out of the generosity of his actions.[46]

Muirchertach's *largesse* was very likely also motivated by his vision of a future territorial structure for the reformed Church. His grant of Cashel not only qualified as a gift, and therefore carried with it some obligations of reciprocity from the Church, but it had a subtext of military protectionism – how else could the Church really be guaranteed possession in perpetuity? – which left him and his dynasty ideally placed for the immediate future. Significantly, then, when a diocesan territorial structure was created at a synod a decade later (see below) its 'architect' was a bishop, Gille or Gilbertus, whom Muirchertach had consecrated for Limerick in 1106 by Mael Muire Ó Dúnáin, the 'archbishop for Munster'.[47]

Although he was the bishop for a Hiberno-Scandinavian town, and moreover the town in which Muirchertach himself resided following the synod of Cashel, it is clear that Gille was not consecrated in Canterbury or by the Canterbury prelate.[48] This was a departure from earlier practice. Flanagan has suggested possible explanations: tensions between Muirchertach and Henry I in 1102, which were caused by matters not directly relevant to the Irish reform story, may have dissuaded the Munster king from having Canterbury so closely involved in Ireland's episcopal consecrations; in any case, Anselm was in exile from England between 1103 and 1106.[49] But the fact that Gille's authority did not come from Canterbury draws our attention back in time to a crucially important aspect of the 1101 Cashel assembly: the role – or, rather, the non-role – of Canterbury. Given that the 1101 synod brought to some fruition the plan which Lanfranc had communicated to Toirrdelbach, Muirchertach's father, a quarter of a century earlier, and that Anselm, from whom Muirchertach had received communications on the very matter of a synod or council, was in Canterbury in 1101, we can only conclude that Canterbury's exclusion was deliberate. Its views were not sought; it did not have a representative at the synod. This was no oversight: Muirchertach consciously and strategically disengaged Canterbury from the process of Irish reform. This had political consequences, as will see here. Perhaps it also had the consequence of derailing any progression towards a greater 'Englishness' in Irish art and architecture in the twelfth century.

This exclusion of Canterbury did not precipitate an end to the English archbishops' involvement in Ireland: in 1121, for example, the townspeople and

clergy of Dublin claimed their right to nominate and have the English arch-
bishop consecrate their own bishop, and so they successfully dispatched Gréne
(Gregorius), a sub-deacon, to England for ordination as a priest and later
consecration by Archbishop Ralph of Canterbury as a bishop.[50] However,
Canterbury's influence quickly diminished as the twelfth century started to
unfold. It remained an option for dissenting voices, as revealed by the appoint-
ment of Gréne in Dublin (and also of one Patricius as bishop for Limerick in
1140)[51], but the real action was elsewhere. The Munster-led reform movement
quickly embraced Armagh in the aftermath of the 1101 gathering. Cellach,
appointed abbot of Armagh in 1105, was consecrated bishop of Armagh while
on a visitation to the churches of the Patrician *paruchia* in Munster in 1106.[52]
Another senior northern clergyman to operate within Munster was Malachy
(Máel Máedoc Ó Morgair), bishop of Down and Connor from 1124, archbishop
of Armagh from 1132 to 1136, and then bishop of Down until his death in
1148. He was, according to his obit, 'the man who restored the monastic and
canonical rules of the Church in Erinn'.[53]

Ráith Bresail, 1111

A territorial organization comprised of dioceses was the project for the synod
which, ten years after Cashel, gathered at Ráith Bresail.[54] Analysis of the inner
workings of this, the most famous of the twelfth-century synods, is rendered
especially difficult by the third-hand (at least) rather than first-hand provenance
of the textual material: the *acta*, or written records, were copied into the long-lost
'Annals of Clonenagh', and from there into Geoffrey Keating's *Forus Feasa ar
Éirinn* of c.1635.[55] This is compounded by the problem of dating Ráith Bresail.
The date is not recorded in the surviving material, but a range between 1106 and
1119 can be deduced from the details: Muirchertach seems to have still been alive
when Ráith Bresail assembled, which explains the latter date, while the three
recorded signatories of the *acta*, Gille (bishop of Limerick and papal legate),
Cellach (coarb of Armagh and primate of Ireland), and Malchus (archbishop of
Cashel), indicate that the synod was held no earlier than 1106. Most scholars
assume it to be the same synod as that which a number of annalists recorded at
Fiad mac nAengussa in 1111, and so we have the conventionally accepted date
of 1111. That date is used here, although David Dumville regards the view that
Fiad mac nAengussa and Ráith Bresail are the same synods as 'fundamentally
mistaken', suggesting instead a possible date of 1118 for the latter.[56]

Inspired by the vision of Gille, one of the principals, and by the reality of
two political hegemonies on the island – the south under Muirchertach Ó
Briain of Dál Cais and the north under Domnall Mac Lochlainn of Cenél
nÉogain[57] – the Ráith Bresail reformers divided Ireland into two provinces

under the primacy of Armagh, with the northern half ruled over directly by Armagh and containing thirteen sees, and the southern half ruled over by Cashel and containing twelve sees. The comparison with the English Church and its division into Canterbury and York provinces is apparent. An independent gathering at Uisneach in 1111 addressed the specific organization of the dioceses of Meath, dividing that kingdom into two dioceses, Clonard and Clonmacnoise.[58]

The absence of a metropolitan for Connacht in 1111, striking in view of that province's prominence in twelfth-century Irish history, is easily explained. At the time of Ráith Bresail the province was largely within the political ambit of Munster; its king, Toirrdelbach Ó Conchobhair, was appointed by Muirchertach Ó Briain in 1106.[59] Toirrdelbach emerged as a figure with national aspirations only after Muirchertach's death in 1119 and the subsequent collapse of Ó Briain fortunes. In 1123 he was styled 'king of Ireland' in the annalistic record of his sponsorship of a circuit of Ireland of the 'Cross of Christ', and of his commissioning of a Connacht workshop to make a shrine – the so-called Cross of Cong – for part of it; he is similarly styled in the inscription on the great processional cross itself.[60] The very act of having such a cross made illuminates not just his wide kingship ambitions and his metropolitan ambitions for Connacht, but amounts to a *de facto* repudiation of the diocesan scheme worked out at Ráith Bresail.[61] At the next great synodal gathering Tuam was given its metropolitan status.

Dublin was not listed among the dioceses at Ráith Bresail presumably because the synod's apparent intention was that it be incorporated into the diocese of Glendalough once Samuel, its Anselm-consecrated bishop, died. The Dubliners' appointment of Gréne scuppered that plan, but only in the short term, and in 1152 Dublin became a metropolitan see; half a century later again the erstwhile diocese of Glendalough was consumed by it.[62] Waterford, another pre-reform see of the Hiberno-Scandinavian community, became the diocese of 'Lismore or Port Láirge'. Its post-Ráith Bresail status is somewhat confusing.[63] The inaugural bishop of Waterford, Malchus, is the same Malchus who was styled archbishop of Cashel at Ráith Bresail, suggesting that he had relinquished his original see by 1111, but within a decade he is recorded as the bishop of a united diocese of Lismore and Waterford, and he died as octogenarian 'bishop of Port Láirge' in 1135.[64] Meanwhile, there are obits for bishops of Lismore in 1113 and 1119, the first of whom, Neil Mac Meic Aeducáin is named on the Lismore crozier as its patron.[65] It seems reasonable to imagine that the crozier had been completed by 1111 and that, as an item of *art mobilier*, it had been brought to Ráith Bresail by a Lismore delegation knowing that their claim to diocesan status independently of Waterford was certain to be on the agenda.

Reformed monasticism

Difficulties of chronology and exact detail notwithstanding, Ráith Bresail is a candidate for the time and place where the politics and political geography of the Irish Church were utterly transformed, where the early medieval Irish Church metamorphosed into the high medieval Irish Church. But no less significant is the appearance of reformed monasticism in Ireland in the decades immediately after 1111.

Monasticism in Ireland had, of course, a long history by the twelfth century, and, in keeping with a core value in the universal monastic tradition, the various monastic communities through time followed sets of regulations – Rules – for the organization of their spiritual and communal lives. There were very many different sets of rules which could be followed in medieval monasticism. Those which were most widespread, easily breaching political, cultural and linguistic boundaries, originated in the writings of the early Church's intellectual and spiritual heavyweights, such as St Augustine of Hippo and St Benedict of Nursia of the fifth and sixth centuries respectively, but there were also rules of more restricted geographic spread, such as those which were followed in pre-reform Ireland.[66] The Rule of St Benedict re-emerged in Continental Europe in the tenth century to become the favoured Rule by which the new monastic organizations of the eleventh and twelfth centuries led their lives.[67] It made a fleeting appearance in late eleventh-century Dublin, specifically during the episcopacy of Donngus,[68] a measure of English influence on the Hiberno-Scandinavian Church at a time when the letters of Lanfranc and Anselm had yet to bear any tangible fruit in the Gaelic-Irish Church. Surprisingly, while Benedictine monasteries are a striking feature of contemporary Europe, comparatively few were founded in the aftermath of the reform of the Gaelic-Irish Church in the early 1100s; indeed, the Anglo-Normans founded only a small number in Ireland after 1169.[69] However, a version of the Rule of St Benedict was observed in Ireland among the congregations of Cistercians, an order of reformed monks which came here from France in the 1140s (at the invitation of the resolutely pro-reform St Malachy), diffusing widely across the island, spreading itself among Gaelic-Irish and Anglo-Norman communities after 1169, and establishing itself as the wealthiest monastic institution by the thirteenth century.[70]

As important as Cistercianism in defining and understanding reformed monasticism in twelfth-century Ireland is the Rule of St Augustine, a more loosely structured set of regulations than the Rule of St Benedict, largely because it was not composed by the saint himself but had been cobbled together by the twelfth century from various views about monastic life which he had expressed in letters.[71] The importance of the Rule in Ireland is that, following its early twelfth-century introduction, again by St Malachy and again in the context of his vision of

reform, it was embraced by many native monastic communities with long histories stretching back into the pre-reform half-light.[72]

The synod of Kells/Mellifont

Ráith Bresail was not, meanwhile, the last word on a diocesan structure. In 1152 another great synod, again concerned with territorial issues and again presided over by a papal legate, was held at Kells or Drogheda/Mellifont.[73] The background to this is Canterbury's continued, if reduced, involvement in Irish episcopal affairs during the first half of the 1100s.[74] The Irish Church had dispatched Malachy, then bishop of Down, to the second Lateran council in Rome in 1140 to obtain pallia for those Armagh and Cashel archepiscopal sees which had been decided on at Ráith Bresail. Pope Innocent II, perhaps informed by Canterbury that some Irish sees were disputed, turned down the request, offering to reconsider if the Irish Church would hold a council, resolve any disputes pertaining to episcopal authority, and make a 'united' request. Dublin was clearly the problem here; Lanfranc had presumably inculcated an ambition that it would have primacy within the Irish Church, and such notions were holding out against the reality of a reformed Church with Armagh almost universally accepted as its primatial see. The pope's direction to Malachy suggests that he envisaged a united church under Armagh, not Dublin, as does his granting legatine power to the Armaghman. A synod in 1148 on St Patrick's Isle off the Dublin coast devised a solution to the problem by suggesting a Dublin metropolitan under Armagh. Thus Dublin's senior cleric was to achieve authority beyond the city, and Armagh's senior cleric was to achieve the desired unity in the Irish Church.[75] Malachy died en route to petition Eugenius III, Innocent's successor and a Cistercian, to this affect, but the petition was delivered anyway and it drew a more positive response. A new papal legate, Cardinal Paparo, identified by contemporary English writers as no friend of Canterbury, was sent to Ireland to preside over a new synod at which the archbishops of Armagh and Cashel, and of the new provinces of Dublin and Tuam, would each receive their pallium. That was held in 1152.

We have annalistic details of this synod, and Keating's transcriptions of material from the so-called 'Annals of Clonenagh',[76] but no *acta*. Nonetheless, we know that the synod had two specific and hugely significant outcomes. The first was a complex diocesan geography (**Fig. 12**). The number of ecclesiastical provinces was enlarged from two to four by the addition of Tuam and Dublin, a number of small dioceses were created anew, and a couple of other dioceses had their independent, post-Ráith Bresail, claims to diocesan status either ratified or rejected. It may be no co-incidence that the majority of historically dated or stylistically datable Romanesque churches post-date 1152.[77]

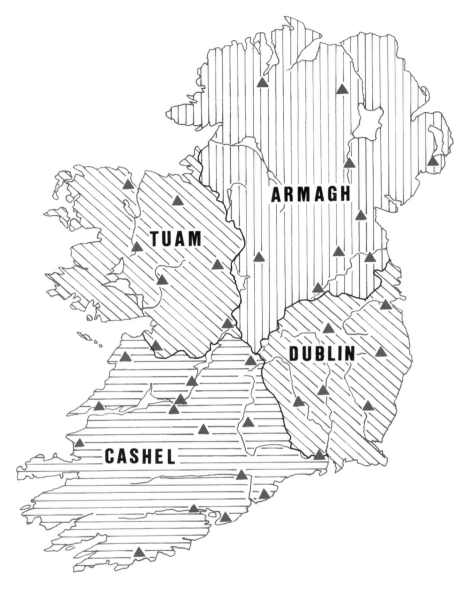

12 The dioceses of later twelfth-century Ireland. The centres of the dioceses recognized or claiming recognition at the synod of Kells/Mellifont (1152) are marked here, with the provincial structure of *c*.1300 – the exact 1152 diocesan boundaries are not recorded – overlain.

The second outcome of the Kells/Mellifont synod was the securing of papal approval for the independence of the Irish diocesan structure. The door now closed on Canterbury. The English churchmen did try to prize that door open again in 1155 when they obtained papal authorization – the famous papal bull *Laudabiliter* – for an intervention in Ireland by the English king, Henry II, but it came to nothing.[78] Henry did not involve himself directly in Ireland until his subjects, Diarmait Mac Murchada's hired hands from south Wales, began to carve up parts of the island among themselves between 1169 and 1171.

ROMANESQUE ARCHITECTURAL STUDIES IN IRELAND SINCE 1845

Three phases of research can be identified in the historiography of the Romanesque architecture and associated sculpture in Ireland. The first phase embraces the nineteenth and early twentieth centuries. The second is book-ended by the publication in 1933 and 1970 of two seminal works by Françoise Henry, but includes key works by Harold Leask and Liam de Paor; this phase is characterized by works of synthesis – much of de Paor's short paper is actually synthesis – and the key works are discussed in some detail below because they are so frequently referenced. The third phase features more recent work. This review is far from comprehensive; rather, it selects the major writers about Romanesque architecture and isolates what can be regarded as their most significant contributions to the field. Its aim is to place this book within its intellectual context, and its intended readership is comprised mainly of those not already *au fait* with Romanesque Ireland or its historiography.

1845–1933

The first important figure in the early years of Romanesque research is George Petrie, whose mid-nineteenth-century essay on Round Towers in 1845[79] presented a detailed account of church architecture and a great wealth of historical information. Petrie was aware of the English Romanesque affinities of much of Ireland's Romanesque architecture, but he was misguided in matters of context and chronology, attributing works to periods according to the most tenuous of historical evidence. Additional architectural material was documented and historical material compiled by Lord Dunraven and prepared for publication by Margaret Stokes in the 1870s,[80] as well as by Stokes herself, and Robert Brash.[81]

Arthur Champneys's study of Irish ecclesiastical architecture from 1910,[82] based on articles published between 1905 and 1907, is an outstanding work of scholarship; a survey of medieval church architecture in Ireland up the end of the middle ages, its scope is greater than that of any earlier work, and the arguments presented within it are based on mature observation of the material and an awareness of context and comparanda. On the subject of Romanesque, much of Champneys's text offered some resolution of problems which he identified in the work of earlier writers, particularly Petrie. More positively, he made three contributions to the study, each of which was developed in the later studies. The first was the identification of a group of what he described as 'elaborated' churches, such as the largest of the Oughtmama churches (**Fig. 13**) and Banagher, and his placement of them in a category which he located chronologically between the main bodies of pre-Romanesque and decorated Romanesque architecture. This group is rather heterogenous and its individual buildings are

13 The chancel arch (looking east) of the largest of the churches at Oughtmama.

difficult to date, so it is doubtful that it constitutes a group and we will not be concerned with it as such in this book. An arch like that at Oughtmama, for example, is not easily dated since its 'simplicity' could be taken to indicate an early or a late date, and that problem is not helped by the fact that the wall in which it originally belonged was substantially rebuilt. One should probably regard round arches like it as belonging to a later twelfth-century date, their simple lines reflecting familiarity rather than unfamiliarity with Romanesque forms; the arch at Inchbofin, for example, is of the same type as Oughtmama and is evidently contemporary with the church's late twelfth century east window (**Fig. 14**). The second was the recognition that in the twelfth century it was the sculpture rather than the architecture which articulated Ireland's link with overseas stylistic traditions; he saw the architecture as providing evidence of continuity with the indigenous tradition. This is still a tenable position. Finally, he established the English Romanesque background to much of the Ireland's Romanesque architectural sculpture, and within this context of English Romanesque influence he tentatively offered the idea, now very familiar, that Cormac's Chapel might have inspired many other buildings.[83]

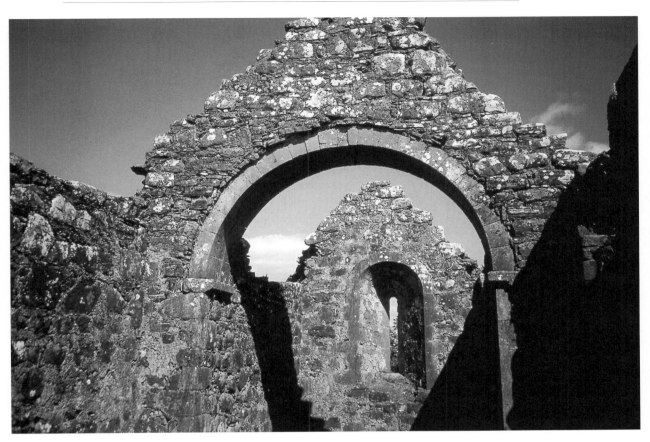

14 The chancel arch, Inchbofin.

1933–1970

The publication in 1933 of Francoise Henry's doctoral dissertation on Irish medieval sculpture marks a new era in Romanesque studies.[84] Henry was trained by Henri Focillon, one of the outstanding art historians of the first half of the twentieth century, and those parts of her thesis which deal with Romanesque reveal that cognizance of Continental, particularly French, Romanesque traditions which could reasonably be expected from one of his students. Thereafter, Henry's focus remained firmly on Ireland and its pre-colonial-era traditions of Christian art and architecture, fields of study to which she made a still-unequalled contribution; she never attempted to emulate her teacher's great sweeping survey of European art or his philosophical reflections on the nature of art, nor did she follow her fellow-student Jurgis Baltrušaitis in attempting to establish 'laws' of sculpture.[85]

The lack of an English-language translation from the original French reduced the influence which Henry's great survey might have had on contemporary Irish

studies of medieval art; the only substantial work of scholarship on Ireland's Romanesque until the 1960s by an author other than herself, the first volume in Harold Leask's trilogy on medieval Irish church architecture,[86] made little reference to it. In the decades after *La Sculpture Irlandaise* Henry published a number of papers focussing on aspects of Irish twelfth-century art, as well as an important paper in the late 1950s on Romanesque arches decorated with human and animal heads, written in collaboration with George Zarnecki.[87] In the early 1960s she published three French-language volumes in the *Zodiaque* series on Irish medieval art up to the Anglo-Norman invasion, with the third volume of the trilogy devoted to the Romanesque, and this celebrated series was made available in an English-language edition within a few years.[88] By this time Harold Leask and Liam de Paor had made their major statements on Ireland's Romanesque buildings, but Henry's third volume is very firmly rooted in her earlier research so it can be discussed out of chronological order.

That third volume, published in 1970, ranged from a general historical context and a review of the sites, to accounts of manuscripts, metalwork, High Crosses, and churches. Close reading of Henry's chapter on the churches reveals a focus on five general issues: the transformation in native architecture in the twelfth century which is manifest in the addition of Round Towers to churches and with the adoption of Continental-type barrel-vaults; a regional school of architecture and sculpture in the Shannon valley; Cormac's Chapel and the group of churches which she saw as having the chapel at its core; portals and chancel arches decorated with heads; and, finally, the Romanesque churches of the Cistercians. On the matter of stylistic influences coming into Ireland from elsewhere Henry was emphatic about the role of the western French Romanesque tradition in the development of Irish architecture's sculptural decoration. This she identified in the animal-head voussoirs which she published with Zarnecki in 1958, in the 'scalloped' form of the Dysert O'Dea arch, and in the barrel vaulting at Cashel, all of which we will discuss below.

We must set these observations against two shortcomings in Henry's work. First, there was a great imbalance in her treatment of the overseas elements in Ireland's Romanesque churches: while she acknowledged the English Romanesque contribution – 'the chevrons, dog-teeth and chains of lozenges can only have come from that direction, and the same is true of scalloped capitals'[89] – she did not properly acknowledge that proportionately it was a far greater contribution than the French. Secondly, she presented a somewhat static model of overseas contact: she offered no synchronic framework around the arrival and adoption of ideas from overseas, and so her observation that, for example, the Clonfert portal is 'a meeting point of Continental Romanesque and Irish art', or her description of Cormac's Chapel as 'one of the most surprising anthologies of Romanesque

art',[90] raise but leave unanswered important questions of process. These criticisms aside, Henry's book remains a treasure trove of observations and ideas to which one can return again and again.

Harold Leask's synthesis of early medieval and Romanesque Irish architecture and associated sculpture was published in 1955 as the first of two intended volumes; he later expanded to two volumes his proposed second volume on Gothic, thus completing a trilogy.[91] His book was a substantial expansion of a summary he published about twenty years previously,[92] and was the first comprehensive English-language synthesis of any aspect of Irish church building since Champneys's book in 1910. The core of Leask's discussion of the Romanesque material is a 'scheme or plan of architectural development from simple, not highly adorned, work to that elaborately decorated, and beyond this again to over-elaboration,' and for this he made 'the general assumption that this progression has chronological significance,' even though he acknowledged simultaneously the paucity of a secure historical chronology.[93] The scheme he proposed has three phases.[94] Phase I is characterized by shallow decoration confined to capitals and bases, and he dated it to the late eleventh and early twelfth centuries; Phase II, which is the 'classic' phase, has all-over, though still shallow, decoration, and he dated it to between c.1120 and c.1165; Phase III, dated to between the 1160s and the start of the Gothic style, is characterized by over-elaborate decoration for the most part, though with a tendency towards austerity in the latest works.

Leask found support for this scheme in two of the three annalistic dates he accepted as secure. Both the 1158 date of Aghadoe 'Cathedral' and the 1166–67 date of the Nuns' Church at Clonmacnoise indicated to him 'a degree of over-elaboration at the cost of the interruption of the architectural line' in the middle of the twelfth century, which he took to be characteristic of Phase III.[95] Leask's third dated church was, of course, Cormac's Chapel (1127–1134), and this he interpreted, revealingly, as an intrusive building within an already-established sequence. While this is not an entirely unreasonable position to adopt, as we will see, it was very much at odds with the structure of his phasing, which is a simple, unilinear, continuum from early to late. The availability of historical dating to c.1130 may have been the deciding factor in the chapel's inclusion in an already-formed phase, despite his extraordinary protestation elsewhere[96] that having a date for the chapel is not very useful given the building's exotic quality!

Leask's scheme invoked a notion of organic growth within the architecture, or, more precisely, within the sculpture. In its infancy the sculpture is small-scale and its sub-ordination to the architecture is manifest in the buildings themselves: it is restricted to a small number of points or positions in the architecture. Maturity in the style is achieved when the quantity of sculpture increases per building, and it is wedded to the architecture in a balanced,

aesthetically pleasing, synthesis. Old age is that phase in which the architectural logic of features such as portals is disguised by the richness of the sculpture: sculpture effectively 'kills' the style at the end of Phase III because it destroys the integrity of the architecture.

Leask's scheme is flawed in almost every conceivable way. Some conceptual problems are especially transparent. No explanation is given, for example, for the choice of the manner in which decoration is deployed on architectural features as the basis of the scheme, rather than, for example, the form of the decoration itself. No support is offered for the contention that decoration is a chronological indicator; there is no recognition that the extent to which decoration covers surfaces and disrupts the 'architectural line' cannot be used deductively for building chronological models except in tandem with other variables. The statistics also undermine the credulity of the scheme. Leask referred to two, twenty-three and thirteen churches or fragments respectively in his sections on the three phases. He mentioned a further twenty-nine churches or fragments, twelve of which he discussed before he introduced the phasing, with the remaining seventeen treated as 'some fragments and exceptions' at the end of the chapter. So, a little less than half of the Romanesque buildings or fragments mentioned in the book are not accounted for within the three-phase sequence, and that number rises from twenty-nine to thirty-four, which is just over half the total, if we exclude Cashel and its supposed derivatives from Phase II.

Perhaps all the problems can be reduced to just two. First, there is the scheme's indefensible insularity: Leask treated Ireland's Romanesque as if there was no other Romanesque tradition, so his three-stage vehicle blithely – and uselessly – skated past the complex chronology and patterns of development of architecture and sculpture elsewhere in Europe. Second, Leask created his model not out of an observed pattern of development which could be corroborated independently using historical dates, but out of a particular, de-humanized, conception of history; his particular historicist perspective did not require him to account for the dynamic of change in the material, so he saw the material's passage from infancy to death as intrinsic to it, with the patrons, architects and sculptors helplessly acquiescent in this passage. Not surprisingly, Leask's phases have not been used by experts in the Romanesque field. Conceptually weaker than the other syntheses of Irish Romanesque architecture published in the twentieth century, the value of his work lies in its compilation of information and presentation of illustrations. Faint praise, but it would be unfair to Leask not to add here that the standard of his work rose significantly in the other two volumes of his trilogy, and that he certainly deserves his reputation as a scholar on their account.

In a short article on the beginnings of the architectural tradition, based on research originally conducted for an M.A. thesis, Liam de Paor, a scholar of

15 The pedimented portal of Clonfert Cathedral, one of a number of such portals identified by Liam de Paor as having a common source in Cashel.

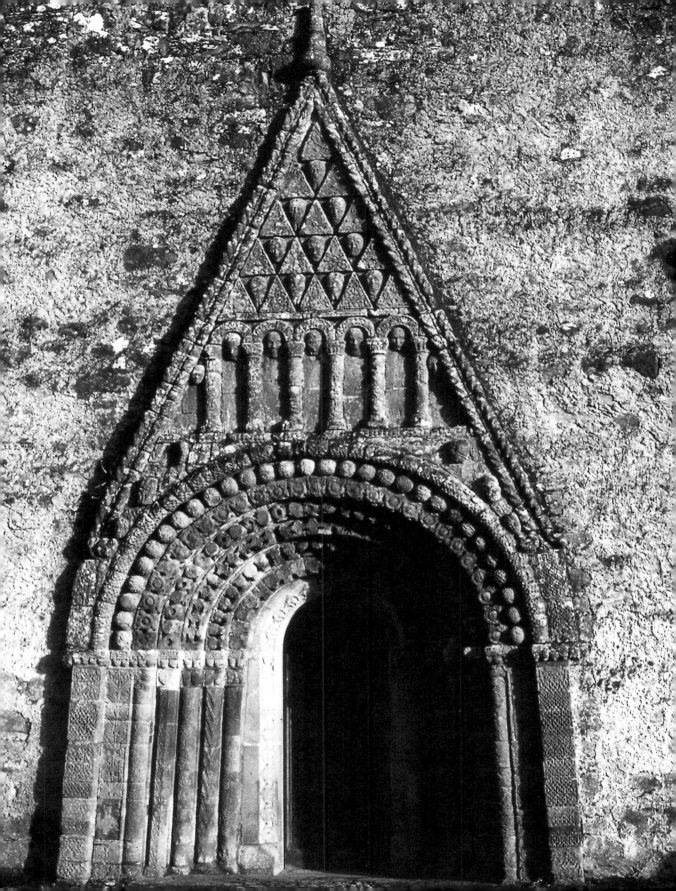

extraordinary versatility, developed Champneys's suggestion that Cormac's Chapel was the critical building in the architecture's early history.[97] The main foundations of his argument were that Cormac's Chapel is the earliest dated example of Romanesque architecture in Ireland, and – in an unspoken alliance with Pevsner's dubious dictum that 'a bicycle shed is a building; Lincoln Cathedral is a piece of architecture'[98] – that it is the only church in Ireland, apart from those of the Cistercians, which might be described as Romanesque *architecture* in all its aspects. In addition to arguing the primacy of Cashel, de Paor valuably distinguished between regional schools in Munster, the Midlands and the West, supporting the distinction by listing features found in each area. His argument that there is a chronological dimension, with Munster having the earliest churches and Connacht the latest, is based on the few historical dates available and on a limited stylistic analysis, but in general it can be supported.

De Paor traced the influence of the chapel in the same buildings as Leask had earlier described as being its derivatives, and also in the single architectural motif of the pedimented portal (**Fig. 15**). But it could be argued that he did not actually demonstrate the primacy of the chapel: the formal similarities between its features and those of other buildings can only be interpreted as evidence that the buildings are linked to Cashel, rather than parallel developments with it as a common source. While a general comparative analysis does support de Paor's idea that Cormac's Chapel is 'at or near the beginning of the Irish Romanesque series',[99] his statement of the extent of its impact on the formal development of the style cannot be substantiated. These criticisms aside, the 1967 paper is justly celebrated by all subsequent writers about the architecture.

1970–

Since 1970 the emphasis has shifted away from description and synthesis towards problem-orientated studies of individual monuments, some of which have been examined by more than one specialist. Short overviews of the field have been published by a number of writers, as have accounts of the churches of reformed monastic communities, most notably Cistercian; in fact Ireland's Cistercian abbeys have, individually and collectively, been the subject of much literature over the past three-quarters of a century, but Roger Stalley's majesterial survey from fifteen years ago[100] supersedes virtually all previous work, at least within the architectural-historical field, while Britta Kalkreuter's recent publication of a specialized study of a twelfth-century Cistercian house in Connacht and its regional context[101] probably makes this the most thoroughly investigated sub-field in medieval architectural studies in Ireland.

Peter Harbison's study of Gallarus oratory in 1970[102] is an appropriate point of departure for this third phase, since it challenged the basis on which this iconic

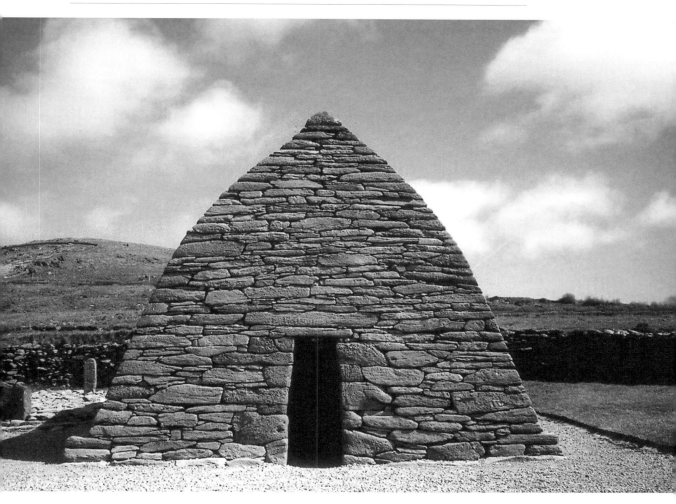

16 Gallarus: a twelfth-century oratory?

building (**Fig. 16**) had been dated to the early middle ages, introducing in the process the possibility – not universally accepted though[103] – of a twelfth-century date. Harbison has been as prolific in the Romanesque field as he is in other fields, publishing both general surveys and articles which deal with specific buildings and architectural sculptures, as well as thought-provoking articles which address some general problems. Roger Stalley's publishing career within this field began about the same time, and he has produced a steady stream of elegantly written work over the intervening thirty years. His extensive bibliography includes detailed studies of individual items and brief general surveys, but no substantial synthesis of the Irish material – his *Early Medieval Architecture* covers Europe – other than that already-mentioned study of Cistercian monasticism.[104] Stalley's familiarity with the English and Continental Romanesque worlds and how they 'worked' is apparent in all his writing, and if one particular contribution of his to

Romanesque scholarship were to be picked out – and there are many to choose from – we might isolate the restoration of the importance of that Ireland–England connection which had been so striking a feature of Champneys' book back in 1910. Susanne McNab, at one time a student of Stalley, has made a significant contribution to the study of Romanesque architectural sculpture in particular, as well as to figural style in early medieval (including Romanesque) Irish art in general. Tessa Garton's published work includes a forensic examination of the Killaloe portal and its comparanda.[105] Finally, my own published work over the past thirteen years includes some surveys of general issues,[106] including the possibility of more than one Gaelic-Irish Romanesque tradition, as well as studies of individual sites or groups of sites, and of patterns of patronage.

Romanesque genesis: Irish ecclesiastical architecture to AD 1100

Our understanding of twelfth-century Irish architecture is contingent in large measure on our understanding of the corpus of buildings which preceded it. But in recent decades that corpus has not really received the attention which is surely its due, given that it was created contemporaneously with some of early medieval Europe's finest art-works: church buildings have been described and discussed in accounts, both general and more specialized, of the archaeology of early Irish Christianity, in monographs on key church-sites, and in various local and county surveys, but some relatively condensed and general works specifically on ecclesiastical architecture, and two monographs on Round Towers,[1] hardly represent a substantial follow-through of synthesis on the first half of the first volume in 1955 of Leask's famous trilogy.

Peter Harbison's already cited paper on Gallarus oratory, now more than thirty years old, underscores both the importance of an accurate reading of 'pre-Romanesque' architecture for twelfth-century studies and the difficulty of making that reading. By exposing the assumptions which underpinned the conventional dating of this internationally recognized building to the 'early Christian' period, he was able to argue that this supposed icon of an Ireland of pre-Viking sainthood and scholarship might belong to as late a date as the twelfth century. Now, this position was itself flawed: Harbison disallowed the importance of the recurring association of buildings like Gallarus with small *leachta* (altars) and cross-slabs of indisputable pre-Romanesque age,[2] and in doing so he denied Gallarus its one certain chronological anchor, allowing it instead to slide freely down the time-line as far as the twelfth century. But the point about his paper is that it illuminated the difficulty of knowing how to put exact dates on churches that clearly date from the pre-colonial era and are non-Romanesque in form but are not

17 The west front of St Feichín's church, Fore (later tenth century?) showing antae. Scale bar = 5m.

documented in any way and lack the types of detail which might permit dating on the basis of comparative analysis. Thirty years later we are still some distance from resolving this problem.

Twenty years ago Harbison offered a categorization of pre-Romanesque stone churches[3] which is useful in that it offers structure to the corpus of early medieval Irish churches – Round Towers are excluded, just as they were by Leask – up to and including the twelfth century:

1 rectangular oratories of the Gallarus type, built in the corbelling technique;
2 simple rectangular structures with upright walls, subdivided into two groups according to the type of roofing used: (a) with timber roofs covered with thatch or shingles, and (b), with stone roofs supported by a stone vault;
3 simple rectangular structures with upright walls, with the addition of antae (shallow, flat-ended projections of the side walls past the end walls of a church: see **Fig. 17**), again sub-divided into two sub-groups according to the type of roofing used;
4 churches consisting of a rectangular nave with a contemporary but smaller chancel.

Every pre-Romanesque stone church in Ireland could be described as belonging within one of these categories, but there is a weakness inherent in such a formalist categorization: variables such as shape, roofing, and the presence or absence of antae, each of which Leask had regarded as significant in understanding church architecture (without being able to demonstrate why they should be so regarded), are central to such a categorization, and yet we do not know that the method by which a church was roofed carried meaning for patrons or was noticed by congregations, or if the presence or absence of antae was more significant than, say, the use of a lintel or a monolithic arch over an east window. Harbison's scheme fulfils a basic function of typology by providing us with what might be characterized as a descriptive shorthand, but it does no more than that.

In fact, the traditional strength of the formalist approach in architectural-historical studies of early medieval Ireland may have acted *against* the project of explaining the character of the corpus of buildings, as witness Michael Hare's

analysis, made from what he describes as an Anglo-Saxon perspective.[4] It was surely no surprise to anybody familiar with the formal characteristics of ecclesiastical architecture in Ireland and her nearest island neighbour that Hare found comparatively few similarities between the churches of the two places, or that he observed that, for example, 'the double-splayed form of window is not found in Ireland, nor is there anything analogous to the double belfry window so common in Anglo-Saxon towers', or that 'the rich architectural sculpture of Anglo-Saxon England is not to be found in Ireland'. The problem is that such observations are not ends in themselves but pointers to crucial, but unasked, questions. Why are Ireland and England so different? Are we witnessing here differences of fashion (or taste), of access to Continental sources, of wealth, of chronology, or of function? Should we ever have expected to find formal similarities between Irish and Anglo-Saxon churches?

Our challenge, then, in approaching Ireland's early medieval ecclesiastical architecture is to guard against qualitative judgements of the buildings, and to allow instead that these simple churches might reflect deeply embedded aesthetic and iconographic values. The key points are these: first, the more we juxtapose in our minds' eyes the great richness of the *arts mobiliers* with the great simplicity of the contemporary churches in early medieval Ireland the more we might consider that architectural simplicity to be a product of choice rather than a reflection of some technological ineptitude, and secondly, the more conservative these buildings seem to be in this juxtaposition, the more we might consider that conservatism to have been in some way ideologically-charged.

TIMBER AND STONE CHURCHES

It is well recognized that the two principal terms used by Irish writers and chroniclers of the early middle ages to describe churches were *dairthech* and *damliac*, signifying wooden churches (literally 'oak-houses') and stone churches (literally 'stone houses') respectively, but that other materials were also used for church buildings, such as turf and woven twigs.[5] References to examples of wooden churches are generally found earlier than references to stone churches, but both types of structure co-existed in the centuries either side of AD 1000.[6] Very small churches of timber, sometimes with floor areas of even less than ten square metres, have been identified from posthole arrangements at a number of excavated rural church sites, mainly in western Ireland; they were buildings of comparatively little structural sophistication, with walls of wattle or mud built in short stretches between earthfast uprights.[7] But timber churches at great ecclesiastical centres may have been more substantial, carpentered, buildings, reflecting a greater availability

of resources and a greater need to accommodate large numbers of people; the seventh-century description of a very large church at Kildare – probably, but not certainly, timber-built – hints at what might have existed in special circumstances in special places:

> Neither should one pass over in silence the miracle wrought in the repairing of the church in which the glorious bodies of both – namely Archbishop Conleth and our most flourishing virgin Brigit – are laid on the right and left of the ornate altar and rest in tombs adorned with a refined profusion of gold, silver, gems and precious stones with gold and silver chandeliers hanging from above and different images presenting a variety of carvings and colours.
>
> Thus, on account of the growing number of the faithful of both sexes, a new reality is born in an age-old setting, that is a church with its spacious sitet and its awesome height towering upwards. It is adorned with painted pictures and inside there are three chapels which are spacious and divided by board walls under the single roof of the cathedral church. The first of these walls, which is painted with pictures and covered with wall-hangings, stretches widthwise in the east part of the church from one wall to the other. In it are two doors, one at either end, and through the door situated on the right, one enters the sanctuary to the altar where the archbishop offers the lord's sacrifice together with his monastic chapter and those appointed to the sacred mysteries. Through the other door, situated on the left-side of the aforesaid cross-wall, only the abbess and her nuns and faithful widows enter to partake of the banquet of the body and blood of Jesus Christ.
>
> The second of these walls divides the floor of the building into two equal parts and stretches from the west wall to the wall running across the church. This church contains many windows and one finely wrought portal on the right side through which the priests and the faithful of the male sex enter the church, and a second portal on the left side through which the nuns and congregation of women faithful are accustomed to enter. And so, in one vast basilica, a large congregation of people of varying status, rank, sex and local origin, with partitions placed between them, prays to the omnipotent Master, differing in status, but one in spirit.[8]

There is comparatively little mileage in the archaeological record of pre-Romanesque timber churches because we have so few excavated examples, but we know quite a bit about them from the written record. In the early eighth century the Venerable Bede made a distinction between 'Roman' and 'Irish' manners of church-building, remarking that Benedict Biscop, founder of the monastery of

Wearmouth, went to Gaul for 'masons who could build for him a stone church in the Roman manner which he always loved', whereas Finian, an Irish bishop, built a church at Lindisfarne 'after the manner of the Irish, not of stone but of split oak'. The distinction Bede made between the technologies must be understood not as definitive statements about contrasts in materiality and technique between the two islands but, as Richard Gem has shown, as a metaphor for the divergent practices and observances of the Irish (or 'Celtic' – though this word is best avoided) and English churches in the post-Whitby era.[9] As late as the twelfth century St Malachy is recorded as having built a timber oratory 'not devoid of beauty' which St Bernard of Clairvaux, in his

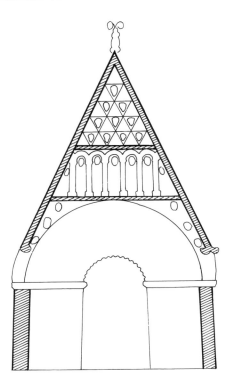

18 Schematized drawing of west portal, Clonfert Cathedral. Not to scale.

Vita of the Armaghman, described as 'Irish' work,[10] thus preserving Bede's equation of technology and national identity.

The importance of materiality in the iconography of early churches is apparent from the testimony of Bede. We see it again, albeit in a different form, in the near-contemporary 'imitation' in stone of High Crosses of wooden type, as at Ahenny, for example.[11] These stone crosses surely do not reflect a limited imagination among stone-carvers taking over a cross-making industry which hitherto relied on carpentry skills, but fulfil a desire (from the eighth century at least) to preserve, or even construct, a memory of timber crosses, of which Jesus's cross at Calvary was the originator. Just as church sites could, in their geography and in their multiplicity of altars, be imitative of the holy places of Christ's lifetime, the stone crosses may represent an enactment through materiality of the concept of *translatio*. By the same token, perhaps, skeuomorphic architecture may have been intended to remind spectators and users of antecedent and venerated timber structures: examples might include the Clonfert Cathedral portal, the outlining elements of which resemble a timberwork form executed in stone (**Fig. 18**), or the small church known as Teampall na bhFear ngorta on Inis Cealtra, which has a plinth and shallow, squared-off, corner projections reminiscent of timber construction, or the nave of Dungiven church, where

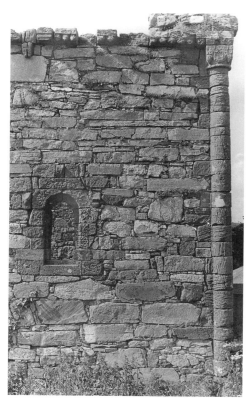

19 The east end of the nave of Templenahoe, Ardfert, showing 'quoin-columns'.

shallow antae-like features metamorphose into horizontal stone courses at intervals. Similar concepts of imitation may better explain, say, the metalwork character of certain carvings in Tuam or the manuscript-like carvings at Killeshin,[12] than the idea that other media simply inspired a range of motifs among the stone-carvers. And is it possible that the 'quoin-columns' on the nave of Templenahoe (**Fig. 19**) and the chancels of Tuamgraney (**Fig. 20**) and Monaincha imitate tubes of metal which bind the corners of shrines? It might be relevant to note here that at Monaincha the quoin-columns are confined to the chancel – the altar-containing part of the church – even though that church's nave is contemporary. Finally, we might note the strong evidence that the presumably twelfth-century stone sarcophagus which is under the shadow of the Round Tower in Clones is based on a metal shrine type.[13]

The idea that materiality is iconographic and metaphoric opens up exciting new avenues for the study of early churches, and not least the study of the pertinent documentary record, as a comment on the timber 'oratory' described in the seventh-century poem *Hisperica Famina*[14] makes clear. The appropriate section of this poem is between lines 547 and 600 of an extant Latin text (the so-called 'A-Text') of the poem, and the following is Michael Herren's translation:

This wooden oratory is fashioned out of candle-shaped beams;
it has sides joined by four-fold fastenings;
the square foundations of the said temple give it stability,
from which springs a solid beamwork of massive enclosure;
it has a vaulted roof above;
square beams are placed in the ornamented roof.
It has a holy altar in the centre,
on which the assembled priests celebrate the Mass.
It has a single entrance from the western boundary,
which is closed by a wooden door that seals the warmth.
An assembly of planks comprises the extensive portico;

there are four steeples at the top.
The chapel contains innumerable objects,
which I shall not attempt to unroll from my wheel of words.

Elsewhere in the same work, lines 62–3, is a reference to the tradition of building churches in wood:

Do you hew the sacred oaks with axes,
in order to fashion square chapels with thick beams?

The closing lines of the principal section – the poet's admission that he will not try to describe what is inside the chapel – leads us to believe that it was the structure, not the contents, which was most remarkable. That structure has been analysed by Peter Harbison and, more recently and more comprehensively, by Niall Brady.[15] Although they do not make an explicit statement to this affect, both writers seem to imagine the writer standing in front of an actual building, wishing to describe it, and searching hard for appropriate words; they treat the passage as reportage, as an objective description. One could query, however, whether a building conforming to the description actually existed, but still interpret the passage as an attempt to render in words an impression of how a carpentered church of that period might have looked. But a literal reading of the passage may not be what the poet expected of his audience, since the entire text of the poem is rich in cosmological allusions, often using exactly the same terminology and constructions as are used in the description of the oratory.[16] Is it too far-fetched to suggest that the author of the 'description' of the oratory in *Hisperica Famina* be regarded as its builder? I mean this metaphorically: he 'built' the image of the oratory on his page by choosing his words as carefully as a carpenter might choose timber, and by arranging those words in a certain configuration, again just as a carpenter would. But I also mean it somewhat literally: what

20 The east end of Tuamgraney church showing 'quoin-columns'.

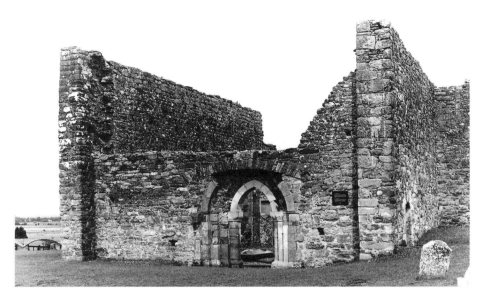

21 Clonmacnoise
Cathedral

we see in this excerpt is a conscious construction of a metaphor of cosmological space, not an objective description which may conjure up a visual image of a particular church for those of us not privileged to see it in reality.[17] One further observation about the *Hisperica Famina* 'oratory' is that its 'builder', as we have styled the poet in this analysis, seems to have been at pains to let us know that it was not a stone church, again reinforcing the point that its material was a significant element in its iconographic intelligibility.

Turning now to the stone churches, the earliest use of the term *damliac* is in 724 as a place-name in Meath, the modern recension of which is Duleek, and the very fact that a place bore the name 'stone church' suggests that churches of this material were unusual at that time.[18] The term was used by annalists more than forty times between the middle of the eighth century and the middle of the twelfth.[19] One of the earliest buildings described as a *damliac* was the 'great church' at Clonmacnoise, erected about 909. Still standing, albeit much altered (**Fig. 21**), this was originally of rectangular plan, 18.8m by 10.7m internally, with antae at its eastern and western ends, and it was entered from the west, probably through a lintelled doorway.[20]

This 'great church' at Clonmacnoise is a rare Irish instance of an historically documented early medieval church being identifiable with an extant building. Historical sources often record the existence, normally at moments of con-secration or burning, of churches on many church sites, but it is rarely possible to equate those churches with buildings which still stand, in part because there

was often more than one church on each site, and in part because there are occasionally multiple references to a church. Multiple references to conflagrations at church sites are equally frustrating because it is not always clear what was destroyed and what therefore needed rebuilding. St Feichín's church at Fore (**Fig. 17**), for example, bears clear evidence of having been destroyed by fire at some stage of its history but historical references to conflagrations at Fore are so numerous – they are recorded in 771, 830, 870, 1025, 1069, 1095, 1112, 1114 and 1169[21] – and so vague as to be of little value to the archaeologist.

Small stone-built 'oratories' such as that at Gallarus could perhaps be described as examples of the *damliac* category, but it is probable that the annalists who used this word reserved it for buildings like the church at Clonmacnoise: vertically walled mortared buildings (though not necessarily with antae) which, like the word itself, give a hint of *romanitas*; in any case, Gallarus-type oratories are confined to the west (especially to the south-west) coast of Ireland where their existence was probably unknown to the annalists. They can be regarded, whatever their date, as examples of a local building tradition which had no obvious impact on architectural development elsewhere in Ireland,[22] and they remind us that regionalism is as important a theme in pre-Romanesque architectural studies in Ireland as it is in Romanesque studies.

Other terms used to refer to churches in early medieval Irish sources are *oratorium* and *teampall*, and possibly *cill*.[23] The *reiclés* referred to in annalistic sources are especially problematic, but Aidan Macdonald's careful study has revealed their essential reliquary-church character.[24] One word which was in circulation in early medieval Ireland was *basilicum*, the use of which indicates a church containing corporeal relics.[25] Although none of the small number of documented examples survives, the Irish basilicas may have had their pedigree in the Constantinian and post-Constantinian practice of erecting basilical halls for the celebration of the mass directly above the burial-places of martyrs, thus forging a direct spatial and ritual relationship between the martyr's grave and the altar of the church above, while ensuring also a symbiosis of church and martyr-shrine in later architectural developments in the middle ages.[26]

Prior to the eleventh century, stone-built churches in Ireland were apparently all single-celled and rectangular in plan. The smallest examples, such as Teampall Dhiarmida on the Lough Ree island of Inchcleraun, measuring only 2.5m by 2.1m internally, or Teampall Chiaráin at Clonmacnoise, measuring about 3.8m by 2.5m internally, are best regarded as the tomb-churches of the saints who founded the monasteries in which they are located.[27] Radiocarbon-dating of their mortar[28] indicates that these might actually be the oldest mortared buildings in Christian Ireland, and it is tempting to think that the genesis of the *damliac* lies in this funerary architecture.[29]

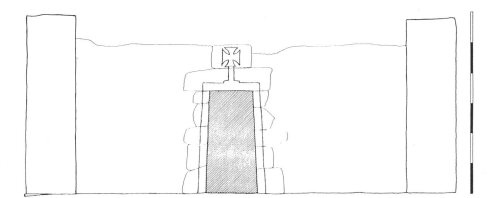

22 The west façade of Clonamery church (eleventh century?). Scale bar = 5m.

The fact that a number of these tomb-churches have antae may provide a valuable clue in our attempt to understand these rather curious features. Antae usually rose no further that the point at which the ascending walls of the east and west ends of the church met the level of the wall-head along the sides. This is a point of natural degradation, especially once a church loses its roof, so most antae are either rather battered at their tops or show signs of having been tidied up and levelled off at some later stage. We know surprisingly little, therefore, about how antae were 'finished off' originally, and that fact, as much as anything else, makes us unsure of their role. Leask suggested that antae were likely to be 'translations into stone of the corner posts of timber prototypes',[30] but none of those excavated structures in Ireland which have been identified as wooden churches has yielded any evidence for wooden antae, and one has to search outside Ireland to find possible examples of wooden churches with antae-like features.[31] The more pragmatic function which has sometimes been suggested is that antae supported the end timbers or barge boards of roofs,[32] but those tomb-churches with antae are so small that the bulky projections almost overwhelm their west façades and east-wall elevations, and this must be taken as an indication that these projections are not simple roof supports. In any case, if a church had barge boards needing support a set of four corbels projecting from the top corners of the end walls could do the trick; the late eleventh-century churches of Reefert and Trinity in Glendalough, for example, have precisely such features. We might consider instead the possibility that horizontal beams, themselves supporting crosses and other iconographic forms, were suspended on the tops of the antae; the crosses carved on the doorway lintels in some churches may reflect such a tradition (**Fig. 22**). The fact that the earliest examples of antae are found on buildings containing corporeal relics may be an indication that later churches which are so adorned also contained relics. Is it stretching credulity too far to suggest that tomb-churches with antae were inspired by types of grave in which the long walls

(the side walls) were simply sealed at either end by closing stones? We might note that 'slab-shrines', simple stone canopies over high-status graves in the early Church in western Ireland, are essentially of this form, and that one could sometimes reach a corporeal relic by passing one's hand through one end of the structure.[33]

Leaving aside those buildings which are obviously tomb-churches, most of other early medieval parish[34] churches in Ireland range in scale between, say, Killoughternane, which is 5.7m by 3.65m internally, and Tuamgraney and Fore, each a little over 11m by 7m internally. The largest examples are Clonfert Cathedral, Clonmacnoise Cathedral and Glendalough Cathedral, internally measuring 20m by 8.25m, 18.8m by 10.7m, and 14.75m by 9m respectively. There appears to be a general relationship between the absolute size and relative proportions of the buildings: those less than 5m long appear not to have ratios of more than 1:1.5, while slightly larger churches with lengths of between 5m and 11m range between 1:1.4 (suggestively close to the Vitruvian proportion of 1:$\sqrt{2}$ or 1:1.414) and 1:1.7 (a little less suggestively close to the Golden Section of 1:1.618) in their proportions.[35] Churches built *ab initio* in the twelfth century with decorated Romanesque detail do, however, tend on average to be larger in their absolute measurements and longer in relative proportions than earlier buildings, although Clonfert and Clonmacnoise Cathedrals are exceptionally long for Irish pre-Romanesque structures.

Prior to the twelfth century the (lintelled) doorways of all of these churches were in their west walls; the church described by Cogitosus at Kildare is the only known exception. Every church has or had a single east window, either round-arched with a monolithic head, as at Killoughternane, mentioned above, or triangular-headed and formed of two stones, as at Kiltiernan and the smaller of two churches at Coole. Temple Benen on Inishmore, the largest of the Aran Islands, has a single window which, because the church is oriented north-south, is in the side wall. A similar building might have been the *Cell trasna* listed in the later twelfth-century Martyrology of Gorman and explained in a gloss as 'a transverse church, whose orientation is north and south, not east and west'.[36]

One term of particular interest is *erdam* (or *erdamh/airdamh*). Only half a dozen references to this feature are known, and they range in date from 825 to 1156.[37] Manning suggests that five of the six instances of its use indicate that it was a free-standing structure. Interpretations of its meaning vary. It was understood to be a 'side-house, or [a structure] against a house externally' in the so-called Cormac's Glossary (Senas Cormaic), the dictionary of terms which was compiled by a bishop-king, Cormac Mac Cuillennain, who died in 908.[38] There have been many suggested interpretations: George Petrie interpreted it as the Irish equivalent of the Latin *porticus*, noting that the Irish translation of Bede's *porticum martyrii*

from De Locus Sanctis was *irdum* in the fourteenth-century Leabhar Breac; Radford also regarded *erdam* as equivalent to *porticus*; in the context of Kells, where it was described as being the 'western *erdam*', Hamlin interpreted it as a western 'annexe'.[39] The fact that the Book of Kells was stolen from the Kells *erdam* in 1007 suggests that this was a structure with an upper storey, rather like the two-storeyed Anglo-Saxon *porticus* as defined by Arnold Klukas.[40] Although I have elsewhere interpreted *erdam* as a substantial structure projecting westwards of a church, rather like a very modest *westwerk* in north Continental Europe,[41] it might be better in the absence of less ambiguous evidence in the annalistic sources to understand *erdam* in terms of liturgical or sepulchral function rather than to regard it as a particular form of building. Therefore we cannot rule out the possibility that an *erdam* could sometimes be a Round Tower.

TRANSFORMATIONS IN THE TENTH AND ELEVENTH CENTURIES

By the middle of the tenth century a new monument type had appeared on the Irish landscape: the free-standing Round Tower (**Fig. 23**).[42] These monuments are recorded as bell-houses in the annalistic sources. The earliest documentation for one relates to Slane in 949, and the record is of its destruction rather than construction.[43] The fact that there are references to Round Towers either being built or destroyed at steady intervals from this date on suggests that this monument-type first appeared in the tenth century. References to individual towers increase during the 1000s and 1100s, with one instance of a tower being constructed in the thirteenth century (at Annaghdown).[44] The documented structures represent quite a small proportion of the sixty-odd complete or fragmentary towers which are still extant, and the twenty or so examples which are known to have been destroyed before the age of modern recording. This clustering of references to Round Towers in the eleventh and twelfth centuries is fairly consistent with the impression we get of their chronology from their architecture and sculpture. Up to a dozen towers have Gaelic-Irish Romanesque architectural details, ranging from minor mouldings to embellished cornices to spectacular portals, and date therefore from the 1100s, while nearly thirty towers have fairly plain, round-arched doorways, with or without architraves, which can be dated with reasonable confidence to the eleventh century and which may be the earliest attestable 'proper' true-arch (or voussoir-formed arch) openings in Irish ecclesiastical architecture.[45]

What is most extraordinary about this chronology is that during its span of three centuries – from the time of the Viking resettlement at Dublin and other coastal places, through the Gaelic-Irish Romanesque phase, and finishing around the time of the Anglo-Norman advance west of the Shannon – the need for

23 The truncated Round Tower at Oughterard.

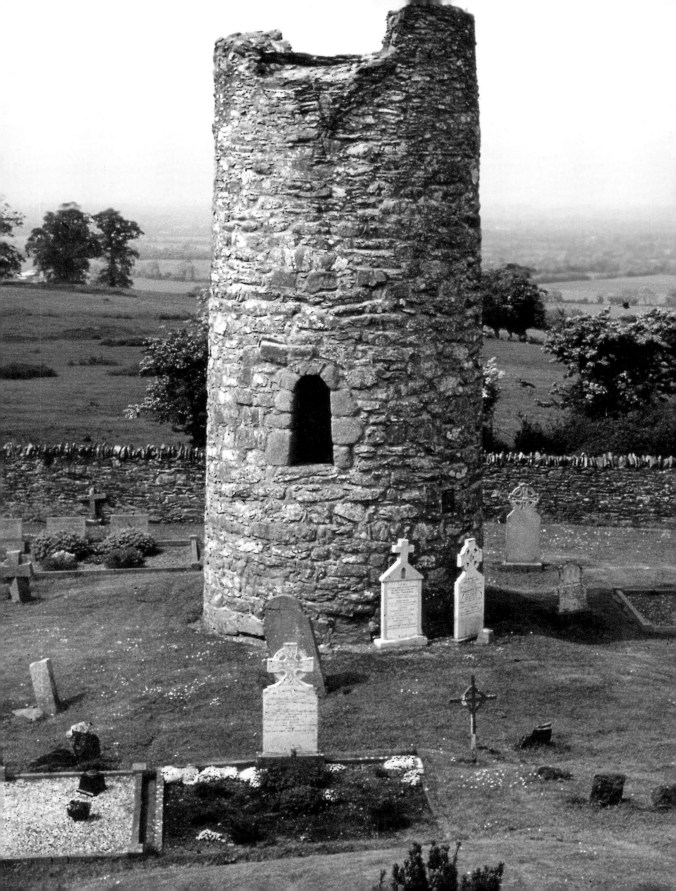

Round Towers of the same basic design remained, regardless of changing social and historical circumstances.

What was that need? The references to towers as bell-houses seem to indicate their primary function, and to suggest that they were associated with rituals of time-marking and assembly, rituals that were unquestionably central to medieval monastic community life. Where they survive in original form, the uppermost windows of the towers point in the cardinal directions, suggesting that the sound of bell-ringing was symbolically directed to all corners of the world. If the bells were the simple hand-bells of classic early medieval type[46] their sound would not carry far, except on a still day, although the ringing may have been intended primarily for those already within the enclosure below. Despite the absence of structural evidence for suspended frames inside the tops of the towers,[47] or tell-tale fragments of large bells or bell-casts, Roger Stalley has suggested that heavy bells were actually suspended inside the tops of the towers, and that long ropes hung from these to the levels of the doorways.[48]

The use of the towers as bell-houses – with bell-ringers either racing up ladders several times a day or simply pulling dangling ropes – does not preclude multi-functionality. On the contrary, there is strong evidence that the towers served other purposes. The circumstances of destruction at Slane in the mid-tenth century, combined with some annalistic evidence that other towers were similarly attacked or that individuals perished inside them,[49] has created the popular interpretation of these monuments as refuges at times of attack. The raised doorways and narrow windows which are characteristic have reinforced that interpretation.[50] We must surely dismiss, however, the idea that these were primarily places of retreat, or that they doubled-up as such in circumstances other than the most exceptional; their very conspicuousness alone made them singularly ill-suited destinations for terrified populations fleeing attack, and if those populations had any inkling of approaching danger they surely ran for their lives rather than huddle in the claustrophobic darkness of what were effectively enormous chimneys-in-waiting.

If the evidence of individual and collective mortalities makes clear that there were indeed violent confrontations inside towers, or that they were occupied during violent episodes, the likelihood is that the towers were identified as places of sanctuary, places wherein frightened people could hope to be spared in the event of attack.[51] The protection of the saints might have been especially expected in towers containing relics, as many towers may have done: we note, for example, the loss of the crozier of the saint and a bell when the Slane tower was destroyed in the mid-tenth century and of 'books and many treasures' when the tower at Monasterboice was burned almost century and a half later. Of course, sanctuary was not always respected, even by Gaelic-Irish aggressors: the killing of a royal heir

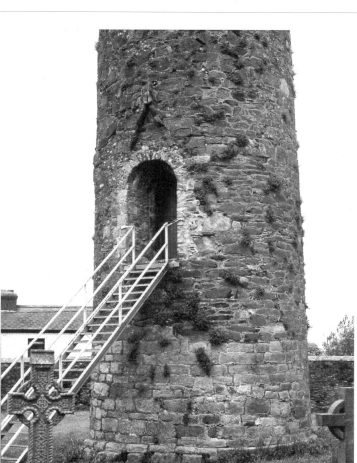

24 Kildare Round Tower and its Romanesque doorway.

of the Déisi in a stone church at Lismore in 1051 is one explicit instance of the violation of the sanctuary claimed by a member of the élite.[52] That such violence could be perpetrated in sanctified places must have horrified the pro-reform party in the early 1100s.

The idea of sanctuary suggests that Round Towers were consecrated spaces, that they were, or that they contained, chapels.[53] This is a suggestion which does not sit comfortably in our minds with the interpretation of the towers as fundamentally bell-houses. But there is other evidence to support the idea that the towers contained sacred space. First, the death of high-ranking individuals inside towers, including Murchad Ó Maeleachlainn, the newly-crowned king of Tara

who was killed by a rival in the tower at Kells, suggests that a Round Tower was not an inappropriate place for people of such rank to enter. In fact, the clear evidence that the Round Tower at Clonmacnoise had a royal patron[54] may suggest that Round Towers were often erected under royal patronage. Secondly, the doorways are often elaborated, especially in the twelfth-century (**Fig. 24**), and this must reflect the sanctity of the tower interiors and the symbolic significance of the act of entering. Using these observations, and the observation that the windows in towers often ascend clockwise in imitation of the pattern of procession, I have suggested elsewhere[55] that the towers may have had less to do with monasticism *per se* than with kingship: the processional rituals associated with them presumably involved the carrying of relics in and out, as well as the display of those relics by members of the processional parties – especially kings, for whom relics could legitimize authority – as they stood in the raised doorways in full view of spectators gathered below.

This vision of a king standing in the doorway of a Round Tower looking outwards and being looked at draws us to Anglo-Saxon England and such square tower-churches as Earls Barton (**Fig. 25**).[56] This was an estate-church of a pre-Conquest English magnate, and it has an upper 'doorway' opening out into the landscape, allowing the lord to view and to be viewed. In tenth and early eleventh-century England a church was regarded as an essential element of the ideal thegnly (or lordly) residence, and one of the critical historical sources pertaining to this indicates that such private estate-churches could sometimes be described as bell-houses; there is even a reference to a wooden belfry 140 feet high as part of a thegn's residence at Cockfield.[57] The idea of a turriform church associated with secular power and its display casts the Irish Round Tower in a new light, allowing us to imagine that there was much more to royal patronage of a Round Tower than the provision of a bell-house for a kinsman abbot or bishop.

The first appearance of the Round Tower in the early tenth century must mark a critical moment in the archaeologies of Christian practise and secular kingship in medieval Ireland. Whether the Round Tower 'arrived' as a fully-fledged monument type, or evolved briskly in the ninth or tenth century into its present 'classic' configuration from some early model of similar plan but considerably lower height,[58] it is certainly the case that its appearance, along with its prescribed rituals of use, precipitated, or was facilitated by, some radical changes in the conceptualization and physical organization of the host church sites. We know little about this, but future archaeological work may someday reveal that monasteries of eastern Ireland like Kells and Glendalough did not grow slowly from very early medieval cores by gradually accruing extra buildings like Round Towers as the centuries passed, but that they were re-organized spatially during the Viking Age – contemporaneously with the Carolingian age in north-

25 The tower at Earls Barton from the south.

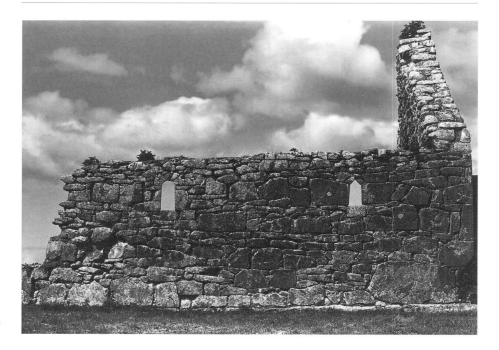

26 South wall, St John's church, Kilmacduagh.

western Europe – and were provided with an array of new buildings, including Round Towers. Given the likelihood that the first towers appear around 900, is it significant that the building of the 'great church' at Clonmacnoise and the erection of the Cross of Scriptures outside its west door, both under the patronage of King Flann Sinna (with Abbot Colmán Conaillech), also took place in the early 900s?

The eleventh century

The Round Towers clearly straddle any pre-Romanesque/Romanesque divide which we might impose on Ireland, and the subtle changes in the design of their doorways, and to a lesser degree of their windows, allow us to isolate and monitor the progress of architectural transformations during the three centuries in which they were being built.

The appearance of round-arched, and sometimes architraved, doorways in Round Towers is a feature of the 1000s,[59] which was the century during which the monument-type seems to have begun its real spread across Ireland. This dating is not just stylistic: Rattoo, one of the most elegant of the Round Towers and a possessor of a doorway of this type, has been dated by radiocarbon to the later 1000s.[60] Such doorways may have been a characteristic of the towers from the very beginning: if the monument type itself is derived from overseas architectural traditions of the 800s we would expect the round-arched doorway to be a feature

27 Clonmacnoise Round Tower.

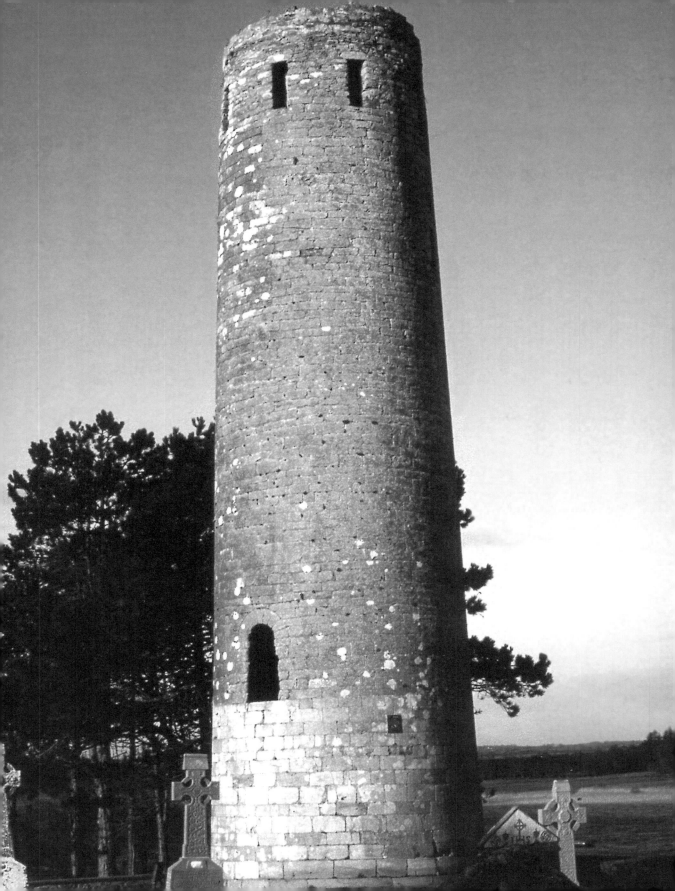

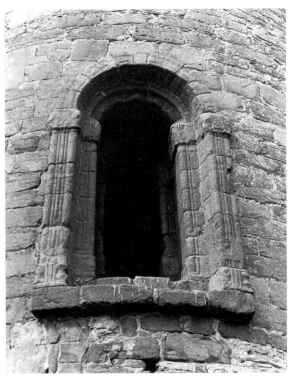

from the outset. Towers with lintelled doorways, such as Clondalkin, might not therefore be the earliest of all, easy though it is to make such an assumption, but may represent the sort of design choice which is often evident within traditions once they are well established.

The architraves of some of the doorways, however, must have been made with specific cognizance of those found on the lintelled doorways of contemporary Irish churches. This is because they are quite particular in form and not at all Continental in style. While the architrave seems to have migrated from the church to the Round Tower, the round-arched doorway generally did not migrate back.[61] The only feature of churches which might have transferred from the Round Tower is the triangular-headed window; this window appears in a small number of churches (such as Trinity church at Glendalough, St John's church at Kilmacduagh (**Fig. 26**), and the smaller of two churches at Coole).

One key monument in mapping the evolution of the towers' doorways up to and including the twelfth century is the tower at Clonmacnoise (**Fig. 27**). It is recorded in 1124 that Abbot Gilla Chríst Ó Máeleoin, supported by Toirrdelbach Ó Conchobhair, completed its renovation,[62] so its construction was presumably begun by his predecessor but one, Cormac, who died in 1103. We observe today that the character of the masonry from ground level to the threshold of the doorway is slightly different from that which rises from that level: the lower masonry is comprised of slightly larger individual blocks which seem more perfectly rendered as ashlar,[63] while the plumb-line of the batter on the west side of the tower visibly changes at this point. Clearly this is a building of two phases – but not periods – at least; we are not counting here the later medieval work at the top of the tower, nor the modern conservation work which also qualifies as a phase in the building's history. The Clonmacnoise tower's doorway is part of the masonry which forms the tower's superstructure, so a date immediately preceding

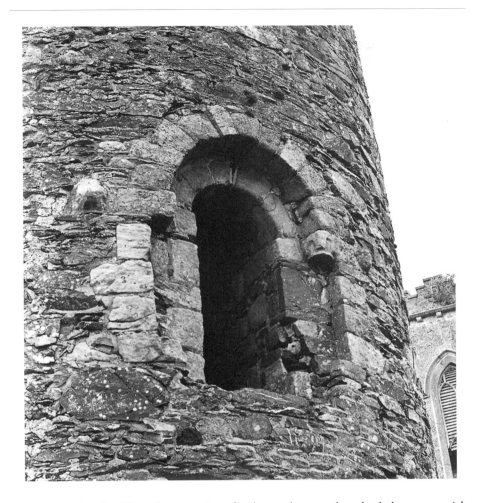

29 The portal of
Dromiskin Round Tower

1124 seems likely. That doorway is a finely made round-arched doorway with chamfered imposts, features which would not be inconsistent with a date in the early 1100s. Although that date of *c.*1120 is quite a long way into the twelfth century, by then the highly embellished forms which characterize classic Gaelic-Irish Romanesque architecture as exemplified by Killeshin (see pp. 39–42 above) had barely appeared if at all; the foundations of Cormac's Chapel were not yet laid. But when those embellished forms did begin to appear during the 1120s and 1130s onwards, Ireland's Round Tower builders happily adopted them: the *c.*1150 doorway of the tower at Timahoe (**Fig. 28**) bears spectacular witness to this, while the doorway of the tower at Dromiskin, with its typical English Romanesque engaged angle-shafts (**Fig. 29**), *could* conceivably date from as early as the 1120s. It is apparent, then, that the Clonmacnoise Round Tower builders were working out of a tradition which looked back to the eleventh- or early twelfth-century period, not forward to the embellished Romanesque work of the mid-1100s.

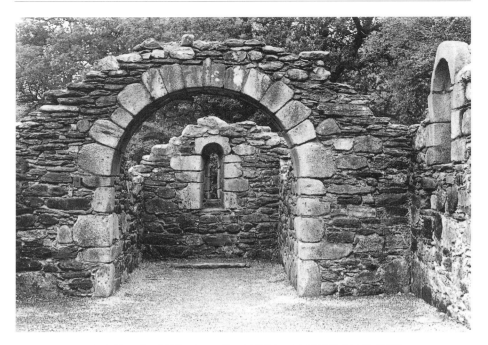

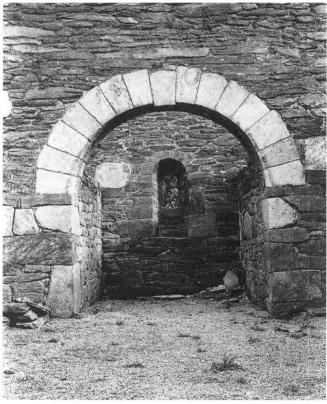

30 Chancel arches, Reefert (*top*) and Trinity (*bottom*) churches, Glendalough.

The contrast between round-arched Round Tower doorways such as those of Clonmacnoise and the lintelled doorways on the churches that stand beside the towers is instructive. It surely reflects an awareness or perception among contemporary patrons, masons and spectators that, despite the fact that these very doorways invariably faced each other across an open space, they belonged to fundamentally separate buildings. Here the idea that the Round Towers were products of royal patronage, designed to accommodate and communicate kingship, comes into play again.

The contrast also indicates that the builders of the actual churches were generally resistant to architectural change *at the doorway* during the 1000s. The same claim can be made by revealing that, while the traditional lintelled doorway form was doggedly adhered to, the actual architectural repertoire appears to have expanded in the latter part of the eleventh century with the first such expansion being the creation for the first time of nave-and-chancel churches, either by building to this plan type *ab initio* or by the adding an extra section to older, single-cell, churches, and the second being the building of vaulted churches. We will now look at these in turn, as well as at the evidence for dating them to the later 1000s.

Nave-and-chancel churches

Churches with contemporary naves and chancels are not that common in the twelfth century, and are virtually unknown in the early part of that century and earlier. Glendalough has two early examples, Reefert and Trinity (**Plate 2**), both located at the edges of the main church cluster.[64] These are buildings of enormous importance because juxtaposed contemporaneously within them are *round* chancel arches (**Fig. 30**) and *lintelled* western doorways. The chancel arch responds in each case are flush with the side walls of the chancels, which is quite rare.[65] Clearly the technology existed for the doorways to be round-arched also, and we have seen that such doorways were often to be found in Round Towers, but the traditional lintelled form was retained, perhaps because it was regarded as sacrosanct. In fact, the contrast between the two major openings in these churches is underscored by the fact that the incorrectly reconstructed lintelled Reefert doorway has shallow embellishing features which can be paralleled closely on the round-arched doorway of Monasterboice Round Tower.[66]

Contemporary, perhaps, with Reefert and Trinity is the famous monastic gateway, since its inner and outer arches are of the same form as the two chancel arches (**Fig. 31**). Although it is not east-west in orientation, the structural evidence of an upper chamber, combined crucially with the presence of antae, suggest that this was a gateway-chapel. A very good parallel, dated to the tenth century, is the 'church' of St John the Baptist at Glastonbury. Associated with Dunstan, the great

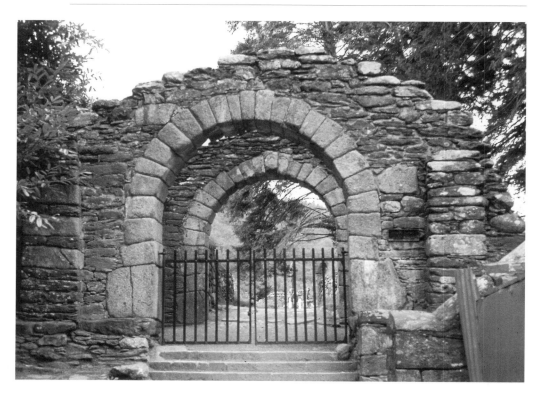

31 The gateway-chapel at Glendalough.

tenth-century reformer of the Anglo-Saxon Church, and described in his *Vita* as having 'four equal angles', this rectangular building with antae has been identified by Philip Rahtz as a gatehouse with an upper-storey chapel.[67] Influence from Irish ecclesiastical architecture may explain the antae here; they were certainly unusual enough for Dunstan's biographer to draw attention to them. It is not inconceivable that the Glendalough gateway reflects a return influence from Glastonbury to Ireland. Also contemporary with Reefert and Trinity may be the eastern extension of the originally single-celled great church, later-styled the cathedral, at Glendalough; its chancel arch was also formed of large blocks of white-coloured granite, the responds of which were left in place when a new arch was erected late in the twelfth century (**Fig. 32**) and the chancel was largely rebuilt.

What dates can we assign to these various Glendalough structures? The Monasterboice parallel suggests a date prior to the mid-1090s, when that Round Tower was destroyed. Had they been in existence long before this date we might imagine Reefert and Trinity to have inspired imitators, particularly as they were located at an important church-site with considerable pilgrim traffic. By the same token, their potential for inspiration in the twelfth century may have been scuppered by the arrival of classic Romanesque repertoire devices in the Glendalough area about the middle of the 1100s. A date in the later eleventh

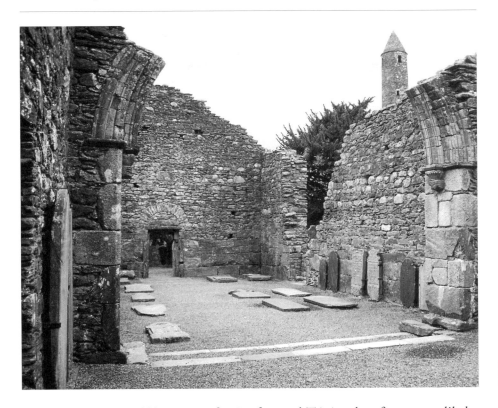

32 The chancel arch of Glendalough Cathedral viewed from the chancel.

century or early twelfth century for Reefert and Trinity therefore seems likely. Moreover, the altars in each of these churches appear to have been at the east wall – at Trinity church a piscina in the east wall of the chancel is an indication of its altar's position – and this may also indicate a date no earlier than the eleventh century: in major early Anglo-Saxon churches the principal altar was set forward from the chancel opening, as at Reculver, the Old Minster of Winchester and elsewhere, but in the eleventh and twelfth centuries the altar position was gradually moved back towards the east wall of the chancel, with the altar position comparable to that in Ireland becoming the universal position in the 1100s.[68]

Some corroboration for this chronology, and more particularly for there being a phase around 1100 when round arches began to appear in churches for the first time, is provided by a number of other churches in the Dublin-Kildare-Wicklow region, such as Palmerstown (**Fig. 33**), Confey[69] (**Fig. 34**), and St Kevin's church at Glendalough (**Fig. 35**). In these instances eastern arms were added to older, single-cell, churches to create new nave-and-chancel buildings. The chancel arches which accompanied these works of extension were again round, although at Palmerstown and Confey they were embellished with simple imposts, whereas at the Glendalough church they were continuous or uninterrupted. St Kevin's and Confey also have in common D-shaped stones above openings: there is one above

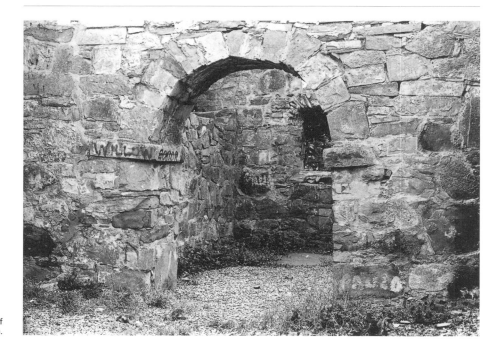

33 The chancel arch of Palmerstown church.

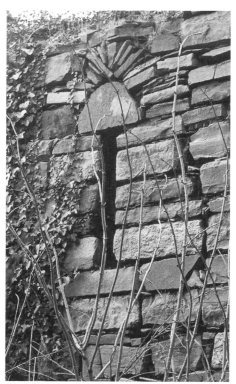

34 Confey church, south wall of nave.

the west portal at the former site, and there are two at the latter, one over a south-wall window and the other over the original east window.[70] The lin-telled doorways of the original build-ings were again retained, thus creating the same contrast between the points of entry into the nave and chancel as we saw at Reefert and Trinity.[71]

The evidence of the superstructure of St Kevin's church suggests that it belongs to the eleventh century, as we will see below, and this in turn suggests that the chancel arch, no later than the mid-1100s, is also no earlier than the late 1000s or early 1100s. Such a chronology ties in nicely with our suggested dates for Reefert and Trinity. The exact chronological relationships between these Glendalough sites cannot be established; St Kevin's nave, which

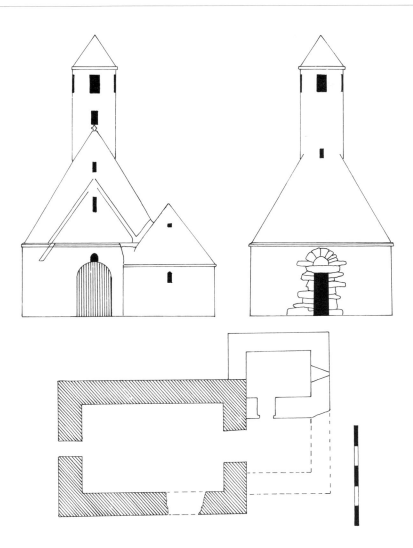

35 St Kevin's church, Glendalough, plan, west façade, and east elevation. Scale bar = 5m.

was originally a church in its own right, is presumably the earliest of the three Glendalough churches discussed here, but its chancel could well have been constructed in response to precedent at the other two sites.

Stone-roofed, barrel-vaulted churches

St Kevin's at Glendalough is distinguished by two features: the small, chimney-like Round Tower which rises above its west gable (and which gives it its popular appellation of 'kitchen'), and its external stone roofs. The former, clearly designed for a bell, is a curious and idiosyncratic feature. The stone roofs are more interesting.

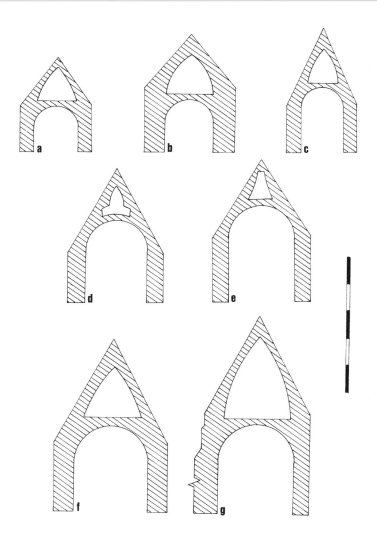

36 Cross-sections through naves with barrel vaults and external stone roofs: (a) Louth; (b) Rahan I; (c) St Doulough's; (d) Glendalough, St Kevin's; (e) Kells, St Columba's; (f) Killaloe, St Flannan's; (g) Cashel, Cormac's Chapel. Scale bar = 10m approx.

The interior of the church is barrel-vaulted rather than open to a timber roof as most churches were. Between that barrel vault and the stone roof is a narrow, triangular-sectioned, void, wide enough to crawl comfortably along. That void is accessible only through a trap-door in the underside of the barrel vault. St Kevin's is one of a number of stone-roofed churches with a chamber or chambers (sometimes pointed barrel-vaulted) above a vaulted main space or spaces; cross-sections of seven of these are given in **Figure 36**. Of these, Cormac's Chapel indisputably dates from the twelfth century; we might note that the chancels of Donaghmore [Tipperary], not illustrated here, and probably the largest of the churches at Rahan (hereafter Rahan I) had twelfth-century chancels of similar character. The other examples are less easily dated. However, given that the group

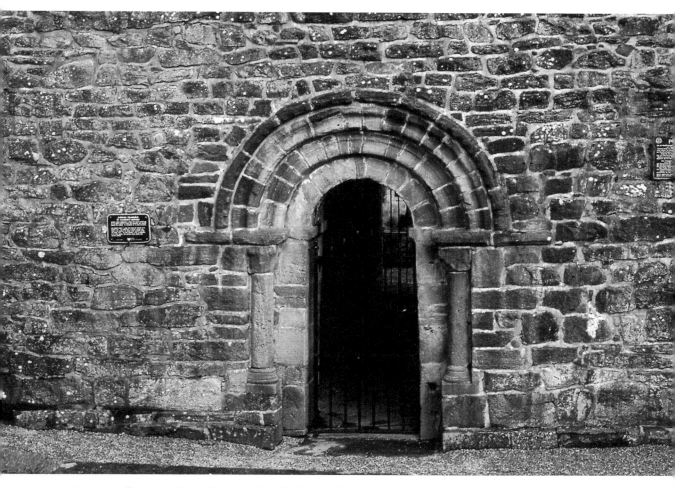

is so small in number, they can hardly be much younger or older than the fixed date of 1127 – 1134 for the use of the stone-roof/barrel-vault configuration at Cashel, and they are likely to have been inspired by some (so far unidentified) Romanesque building tradition outside Ireland.[72]

One of the examples, the nave of St Flannan's oratory at Killaloe (**Plate 3**), internally 8.90m by 5.30m, is entered through a Romanesque portal (**Fig. 37**). There is a round-arched window above this portal, and triangular-headed windows in the side walls. The chancel, which appears to have been contemporary with the nave, no longer exists, but its plain chancel arch survives, its chamfered imposts confined to the inner faces suggesting a date in the early 1100s (on the basis of the Clonmacnoise Round Tower parallel) or earlier. In a very important study Richard Gem identified the Romanesque portal as English Romanesque in type, and argued convincingly for a late eleventh-century date and a context at the very beginning of the stylistic tradition to which it belongs in Ireland.[73] The fact

37 The west portal of St Flannan's oratory, Killaloe.

that its inner order is as plain as the chancel arch, sharing with it simple chamfered imposts on the responds, does indeed suggest that it is contemporary, and so a date in the closing years of the eleventh century for the entire church seems secure.

St Flannan's and St Kevin's compare well with a further two examples, St Mochta's 'House' at Louth and St Columba's 'House' at Kells, and they are probably of about the same eleventh-century date. In fact, the Glendalough and Kells examples are especially closely connected structurally, and Henry suggested that they might be the very earliest in the entire sequence.[74] We note here that the eaves of the stone roofs in these two cases are roughly horizontal with the springing lines of the vaults inside, so the stone roofs are effectively the exteriors of the vaults. They might therefore be interpreted in both cases as by-products of a shared desire to have an internal vault, while the small, cavity-like, chambers which fill the spaces between the interior vaults and the exterior stone-finishes could certainly be interpreted as obvious solutions to the problem of reducing the weight of stone bearing down on the vaults. While such an interpretation seems to support Henry's contention that St Columba's and St Kevin's are primary within the sequence, one can raise two objections. First, there is a presupposition that those buildings with large, habitable, chambers between their vaults and roofs – St Flannan's and St Mochta's, and later Cormac's Chapel and Rahan I – evolved out of St Columba's and St Kevin's, and consequently there is an assumption that the builders of those other churches provided them with spacious upper rooms not because they wanted those upper storeys but because of the impluse from the architectural blueprints provided by St Columba's and St Kevin's. In reality, the builders of, say, St Flannan's and St Mochta's may have decided that they wished to have two-storeyed forms, with the upper storeys used as sacristies, and they may have designed the architecture accordingly. Indeed, it is not entirely inconceivable that the builders of St Columba's and St Kevin's took their cues from buildings like St Flannan's and St Mochta's. Secondly, the interpretation of the stone roof as a by-product of an interior vault plays down the aesthetic and symbolic importance of such a roof in the first instance; here Michael Herity's thesis that these stone-roofed buildings belonged within the tradition of tomb-shrines[75] has particular value. The upshot of this is that we can go no further than to recognize that neither St Flannan's nor St Mochta's is demonstrably older than St Columba's or St Kevin's, but equally that neither is demonstrably younger either.

Before we move on, it must be pointed out that Leask (who nonsensically saw this type as evolving out of the Gallarus tradition) suggested that the Kells building is the church which was constructed in 814 according to the annalists,[76] and that radiocarbon dating of mortar from it supports this view.[77] But, thinking of comparative evidence outside Ireland, it is difficult to imagine a building of

such character existing in the early ninth century; in any case, the eleventh- and twelfth-century dates that are indicated for the scheme in other churches should persuade us against an exceptionally early date for any one of the series.

The seventh example of the type is St Doulagh's, where the vault of the nave becomes groined where it runs under the tower (a fifteenth-century replacement of an earlier tower?) at the junction of the nave and chancel. The date of this is uncertain; Harbison suggests that the eastern part of the church is twelfth century,[78] but the area under the tower could be later. We might add, finally, that the churches of Kilcoole, Kilmacnessan (on Ireland's Eye island), and Devenish also appear to have had stone roofs with internal barrel vaults, but these are very ruined. There are also examples of churches with stone roofs but not barrel vaults: St MacDara's, later medieval 'Teach Molaise' on Inishmurray, and St Molua's on Friar's Island; the latter is the only two-celled church of the three, and examination of the church in the 1930s, when it was dismantled and rebuilt in Killaloe, revealed that the stone-roofed chancel was an addition to a single-cell church with a timber roof.[79]

LINTELLED ROMANESQUE PORTALS IN NORTH-EASTERN IRELAND

The focus of this chapter has been the architecture of the period up to *c.*1100. Before turning in the next chapter to the spectacular Romanesque work which sprung up in the Munster landscape after 1100, there is one more group of churches, or rather church-parts, to consider. This body of material may date from well into the 1100s, so strictly speaking it falls outside the range of this chapter, but so strong is its theme of structural (and even motific) continuity, allied with its particular distribution, that it belongs in the spirit of what we might call the 'pre-chevron' world.

Lintelled west doorways with marked batters are recurring features of pre-Romanesque Irish church architecture, as we have noted. The lintels and the jambs sometimes bear simple architraves formed by cutting away the outer surfaces of the stones to leave a shallow raised band around the opening, and there may very occasionally be a cross on the lintel, either inscribed within a circle, as at Fore and Gallen, or 'standing' on the lintel's architrave, as at Clonamery (see **Fig. 22**). Similar affects may have been achieved very widely by painting on the stone. An unusual variation is found at Killinaboy.[80] Here the upper part of the west wall of the church has a double-armed cross with unusual terminals, and this projects as stripwork above but a little to the south of the position of the former west entrance. The bottom of the cross is not of stripwork but is incised as two lines on a single, large, D-shaped stone, which may have been the lintel above the original west door (**Fig. 38**). A small number of plain round-arched openings of the twelfth century also make use of the cross: the doorway at Killeenemer, the

38 The double-armed cross on the west gable of Killinaboy church.

39 The west portal of Aghowle church.

east window at Killodiernan, the doorway at Britway (where it is highly stylized), the doorway of Donaghmore [Meath] Round Tower (where there is a carving of the crucified Christ on it), and possibly the doorway at Rattoo Round Tower (where it is particularly highly stylized).[81]

The plain architraves around the west doors of some pre-Romanesque stone churches and the occasional crosses on their lintels are more than mere decorations. They served to emphasize the iconographic role of the portal as the entrance to a sacred *locus*, and thus they relate in their iconographic function to similar crosses in comparable positions across early medieval Christendom. In the twelfth century the multi-ordered round-arched frame of the door emphasized the same inherent symbolism of the point of entry into the church, albeit in an alternative visual idiom. The earlier tradition of using crosses and other decoration on the portals prepared the way for the adoption among native patrons of the elaborate portal of 'classic' Romanesque type, and the traditional lintelled portal virtually died in the process. Only in rare instances was it retained in the twelfth century. The best-known example is at Aghowle (**Fig. 39**). Here the portal has a thick half-roll as its outer casing – a feature paralleled on the later twelfth-century portals of Clonfert and Monaincha – as well as a discreetly placed pellet moulding. It is located at the west end of an unusually long rectangular church,

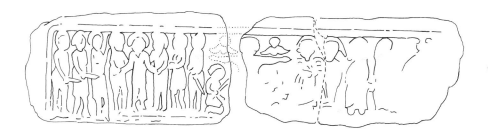

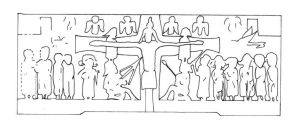

40 Figure-carved lintels at Raphoe (*top*) and Maghera (*bottom*). Scale bar = 1m.

and there is no reason to doubt that it is contemporary with two very attractive, chevron-decorated, east windows. There is a comparable though slightly plainer if rather more classical lintelled doorway at Banagher, with a narrow, square-sectioned but slightly flanged, projecting frame and a small roll all around on the inside return.[82]

Six lintels with actual figure sculpture survive. Three of the lintels – Dunshaughlin, Raphoe (**Fig. 40**, *top*) and Maghera (**Fig. 40**, *bottom*) – feature Crucifixions; Dunshaughlin has a simply-rendered crucified Christ flanked by Stephanton and Longinus, Maghera has twenty participants in the crucifixion scene, including the Virgin, the two thieves, and four angels, and Raphoe has the crucifixion scene flanked by the Arrest of Christ on one side, and by a defaced and unidentified scene on the other.[83] An *ex situ* lintel at Carndonagh has a small standing ringed cross in the centre, flanked by processional figures on one side and by an interlace pattern on the other. Its iconography is unclear. The fifth lintel, at Clonca, is too worn for an identification; according to Henry its image may be of the Last Supper, but Harbison prefers to see a *Majestas*.[84] Finally, a gabled lintel discovered at some unrecorded location on the Glendalough site was inserted in the nineteenth century over the south doorway of the 'Priests' House', a reconstructed building of twelfth-century origin. Now broken and with its detail worn, it featured a crowned and enthroned figure flanked by two kneeling figures, that on the left holding a crozier and that on the right a bell (**Fig. 41**).[85] Henry identified this – bizarrely, it must be said – as a *traditio legis*.[86] It is not clear that the central figure is even Christ, even if the enthronement suggests as much. Nor

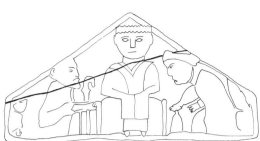

41 Reconstruction, based on the antiquarian record, of the gabled lintel of the 'Priests' House', Glendalough. Not to scale.

does it appear to be a king, since its lacks the appropriate insignia of royal office. Is it possible that it is a bishop (or, given that it is mitre-less, a bishop-elect), with a pallium draped over his forearms, and that the two flanking figures represent the submission of the ancient monastic site to episcopal authority?

We cannot be sure that these six lintels belonged together contextually or chronologically. The geographical concentration of four of the examples is in the far northern parts of Ireland, far from the main distribution area of chevron-decorated Romanesque work on the island.[87] This suggests that they constitute a distinct group of one chronological horizon. Maghera and Raphoe are both twelfth-century works,[88] and they may date the group, but it must be conceded that Carndonagh is very different in carving-style and iconography, and a twelfth-century date would probably not be suggested for it were it an isolated artefact. Of the other two lintels, the Glendalough sculpture is probably twelfth century in date, as McNab as argued on the basis of its sculptural style[89] and as its possible episcopal iconography would also suggest. The Dunshaughlin lintel is of less certain date. Henry assigned it to the ninth/tenth-century period on the strength of comparanda in the sculpture on the High Crosses,[90] but its sculptural style could simply be archaic; perhaps the geographical proximity of *twelfth-century* Donaghmore Round Tower with its crucifixion above the portal[91] points to a later date than Henry allowed.

The most impressive of the lintels is that at Raphoe, now in two *ex situ* fragments. The identification of those fragments as parts of a lintel requires some explanation at the outset. Henry had no doubt that they were originally part of a door lintel, as she identified on each 'the ends of the uprights of the door'.[92] A decade ago Harbison supported this interpretation.[93] In the interim, however, McNab expressed the view that the stones could not have been part of a lintel because that lintel would have been too wide without a trumeau to support it, and that such architectural members are unknown in Ireland. She suggested instead that the two fragments 'must have formed a frieze displaying a narrative composition, perhaps designed to decorate the façade of a church', adding that 'such Romanesque schemes exist in areas of the Continent which are rich in Roman remains, such as Provence in the south of France or where Italian prototypes are emulated as at Lincoln in England, which has been linked to Modena'.[94] The Raphoe sculpture could be described as frieze-like because its length is considerably greater than its height, but McNab used the term not to

describe the sculpture but the stone itself, and its placement on the building as a non-structural feature.

At 2.55m the Raphoe slab is indeed unusually long for a lintel by Irish standards – the massive example at Dulane is some 30cm shorter[95] – but McNab's claim that it would need a trumeau to support it was based on her calculation that the doorway would have been about 160cm wide at the top.[96] However, as a lintel is by necessity longer than the space it spans, a trumeau is only needed when the door span of a lintel is too great for the lintel to support the weight above, so the actual length of the lintel itself is immaterial. In fact, in the case of the famous early eleventh-century sculpted lintels of Saint-Genis-des-Fontaines and Saint-André-de-Sorède in Rousillon only half of each sculpted lintel spans the door space and no intermediate supports are needed. Thus we could easily envisage a long lintel stone, possibly with a relieving arch over it, having existed at Raphoe.

A second point is that, unlike Raphoe, the frieze-like sculptures at Modena and Lincoln, and at the major Provençal churches such as St-Gilles-du-Gard, are extensive, multi-panelled works fitted (fairly awkwardly in the case of Modena) into the shapes, lines and spaces of the architecture they adorn. Were it possible to substantiate McNab's reconstruction of the Raphoe slab as independent of the doorway but adorning the western wall, the comparison would not be with these complex friezes but with those numerous examples of single slabs which are positioned above, though structurally independent of, west doorways and which bear figure sculpture (as at St-Porchaire in Poitiers, for example).

McNab did not mention the Lincoln and Modena type of frieze in the context of her identification of Raphoe because of any quality – figural style, composition or iconography – of their sculpture, but if such friezes are relevant to Ireland it may be in this regard. We note, for example, that the formula for the Arrest of Christ scene at Raphoe – three soldiers on each side with St Paul in the middle of the soldiers on one side cutting off the ear of Malchus – has no parallel in Ireland, but that there is a striking compositional-thematic parallel in south-west France on the famous exterior apsidal frieze at St-Paul-lès-Dax. Here, on two adjacent panels, are (reading from left to right), the betrayal by Judas, the Arrest of Christ, St Peter cutting off Malchus's ear, Longinus and the Virgin, Christ crucified, and Stephanton and St John. The Dax sculptures also include a Last Supper, which may be relevant in the context of Clonca.[97]

CHAPTER 3

Hiberno-Scandinavian and Cistercian Romanesques

Before picking up the twelfth-century threads of this story of architectural development there are two particular traditions of the 1000s and 1100s which need to be discussed, and this can be done briefly and in relative isolation from our main narrative. The first is that associated with the Hiberno-Scandinavians, the descendants of the Scandinavians whose settlement of parts of Ireland began in the early 900s and whose ethnicity was shaped by their interaction with the indigenous population. Two buildings – or rather parts of buildings – remain, and both are well known. I will review the evidence here and make suggestions about chronology as appropriate. The second tradition is that associated with the Cistercians, whom we have already met and whose architecture has already been scrutinized by Roger Stalley. So well known is that body of material, and the corpus of related material of the so-called 'School of the West', that I am restricting the discussion here to enumerating the key sites and to addressing a small number of issues.

TWO HIBERNO-SCANDINAVIAN ROMANESQUE CHURCHES

The principal contribution of the Hiberno-Scandinavians to the Romanesque tradition of the twelfth century seems to have been a repertoire of motifs and compositional concepts which found its way into the illuminated manuscripts, onto various items of metalwork and free-standing sculpture, and into the architectural sculpture of up to two dozen churches. The Hiberno-Scandinavian 'style' which is represented in most cases is called Urnes, a style characterized by 'fluency of ornament lines and outlines, juxtaposition of one broad and one thin

ornament line, elongated proportions, interpenetrating compositions of wide loops, absence of axiality, and finally, interplay between the network of loops and the undecorated open background.'[1] Usually the 'broad and thin' lines are formed of animal bodies. The earliest appearances of Urnes in Ireland seem to be around 1100 on the Lismore crozier and on the almost contemporary Shrine of St Patrick's Bell. There is another 'style' identified by students of Scandinavian art – Ringerike – but it appears relatively rarely in twelfth-century Irish art and only as isolated motifs in the eleventh century.[2]

What of the ecclesiastical architecture of the Hiberno-Scandinavians? Among the many transformations effected by the reform movement, that which stands out in our retrospective view is the new diocesan structure, particularly since this survived through the middle ages and into the modern era. We saw in Chapter 1 that before the network was created the Hiberno-Scandinavian towns had established their own bishoprics. Unfortunately, we know very little about the cathedral churches – or indeed any of the churches – in their towns, but Dublin's medieval cathedral may preserve very important eleventh-century fabric while Waterford possesses key evidence in the form of the foundations of St Peter's church, excavated in the 1980s.

Christ Church Cathedral, Dublin

Turning first to Dublin, the cathedral church of Christ Church (formerly Holy Trinity) which we see today is an Anglo-Norman – a post-1169 – building comprised of both Romanesque and Gothic elements, but with more than a garnish of Victoriana.[3] The late medieval and early modern centuries were not kind to this venerable old building. For example, its high vaults collapsed in 1562, taking with them the south wall of the nave. Also, careless or unsympathetically plain rebuilding to make the church useable, combined with general neglect, relegated the appearance of the cathedral to a lower architectural division. George Edmund Street undertook a programme of massive restoration between 1871 and 1878, reconstructing the south aisle and the vaults, and erecting a battery of flying buttresses to ensure the stability of the latter. Although his approach to conservation at Christ Church was the subject of colourful and sometimes caustic contemporary criticism,[4] Street was not insensitive to the building's character and history, showing greater restraint than many another Victorian architect might have done, and allowing us to still read its medieval building history.

The cathedral has three different medieval elements: a crypt which is self-evidently the earliest part, a pair of Romanesque transepts, and a Gothic nave. The crypt runs for almost the entire length of the building (**Fig. 42**, *top*), effectively mirroring the plan of the church above; only the west bay of the nave of the church, added in the early thirteenth century, does not have a crypt beneath

42 Plans of crypts: Christ Church Cathedral, Dublin (*top*), St Maria im Kapitol (*bottom*). Note how in each case the transepts are square within the outer walls of the crypts, and how the apses (polygonal internally in the case of the latter, and internally and externally in the case of the former) begin immediately west of the transepts. Scale bars = 20m for top, 10m for bottom.

it. Even though its area has been reduced by some blocking of its aisles, it remains a veritable forest of stumpy piers supporting a canopy of rather crude but effective groin vaults. The piers are all square or rectangular in shape, and projecting ledges or imposts mark the points from which the arches and groin vaults rise; imported English stone was used in responds in the eastern chapels and for the quoins of the piers under the nave.[5] The crypt served a pragmatic structural function, propping up the church on what was originally a sloping site; crypts in the churches of Mellifont Cistercian abbey, Buttevant Franciscan friary, and Killone Augustinian nunnery did the same thing. The crypt was presumably also a place in which the cathedral's relics might be viewed and venerated, and by being subterranean or semi-subterranean pilgrims were able to perambulate without interrupting activity within the main body of the church above. Before we try to

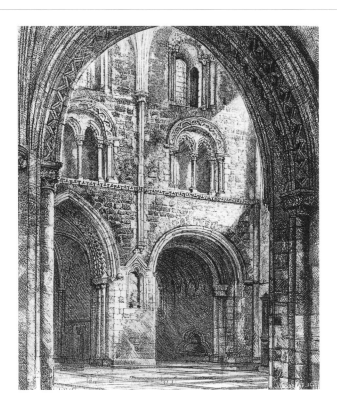

43 View, from George Edward Street's monograph, into the Romanesque south transept, Christ Church Cathedral.

establish its age – there is no record of it being built, and no dressed stonework of particular help to us instead – we need to go into the main body of the church.

The Romanesque transepts (along with the westernmost bay of the choir, which retains some original stonework amidst the Victorian restored surfaces) bears the strong imprint of twelfth-century English Romanesque workmanship: we see this in the shallow corner pilasters (which metamorphose into Victorian turrets as they rise), the great doorway which was moved from the north transept to the south transept in 1831, the chevron–decorated triforia and clerestorey windows (**Fig. 43**), and the anthropomorphic and zoomorphic motifs on the capitals. Despite a record that a new choir, a tower, and chapels were built at Christ Church under Strongbow's patronage in the 1170s,[6] it is more likely that the work which we see today was carried out under John Cumin, the former custodian of the revenues of Glastonbury Abbey who was appointed Dublin's first Anglo-Norman archbishop in 1181 but who was only permanently resident in the diocese between 1190 and 1196.[7]

Did Cumin build the crypt, or was it built in the era before Cumin arrived in town? Given that its plan transferred to the main church in both its Romanesque and Gothic stages,[8] it seems inherently likely that it was not a

particularly ancient feature by, say, 1200. Cumin, rather than his predecessor Lorcán Ó Tuathail, would seem to be a good candidate for its builder, suggesting to us that the Christ Church Cathedral we see today is simply a semi-Victorianised Anglo-Norman building from bottom to top. However, as we will see here, the crypt's plan suggests it pre-dates Cumin and Strongbow.

The actual site we are looking at was first consecrated for Christian worship almost a millennium ago. Any such consecration would doubtless have been at the behest of Sitruic, the king of Dublin from 989 to 1042, whose father Amláib (or Óláfr) Cúarán had been baptized as a Christian, ostensibly for reasons of politics, only two years before his ascension to the kingship of Dublin in 945.[9] According to the testimony of later sources,[10] the first cathedral church was founded c.1030 by Sitruic for one Donatus (Dúnán), an Irishman consecrated (in Canterbury perhaps) as the first bishop of the Hiberno-Scandinavian see. Those sources also tell us that Sitruic also built chapels dedicated to St Michael and St Nicholas. The latter was beside, and possibly even connected physically to, the cathedral church, but St Michael's chapel was evidently part of what is tantalizingly described as a 'palace', which might have been an episcopal residence or, not inconceivably, Sitruic's own royal residence.[11] While we might imagine Donatus's cathedral church being a modestly-sized but well-built timber structure on high ground overlooking the contemporary town houses on the Wood Quay site, Stalley suggests that it would have been of stone, in part because stone was used for major churches among the Gaelic-Irish and in part because Sitruic would have seen stone churches when in Rome on pilgrimage about 1028.[12]

Donatus remained bishop until his death in 1074, and was buried to the right of the high altar of the cathedral church.[13] This record of the high altar as a place near which a high-status burial might be located strengthens the likelihood that whatever later alterations were made to the church by Donatus's pre-colonial-era replacements (Patrick, 1074–84; Donngus, 1085–95; Samuel, 1095–1121; Gregory, 1121–61; Lorcán Ó Tuathail, 1161–79), the position or site of the original altar was respected. It raises the question of who, if anybody, was buried on the other side. Seán Duffy has suggested it was Murchad mac Diarmait mac Máel na mBó, the underking of Dublin from 1054 whose funeral in 1070 was held in the cathedral.[14] More significantly for us, it also raises the issue of the architectural arrangement. Should we just envisage an altar tightly flanked by two tombs on a platform, or does the description allude to a side-chapel on the south side of the high altar? Any self-respecting mid- to late-eleventh-century urban cathedral church would have aspired to an east-end plan of greater complexity than a simple rectangle, so we might look afresh at the plan of the east end of the crypt we see today.

The *échelon* (stepped) plan of the crypt's ambulatory chapels has, as Stalley observed, its closest parallel – actually, it is the only obvious parallel – in the

Norman world at Winchester, begun in 1079.[15] On foot of this, Stalley wonders if 'the late Romanesque work at Christ Church [was] determined by an earlier building' and if 'sections of the crypt [could] go back to before 1100', but he does not pursue this, drawing attention in the process to the lack of archaeological evidence.[16] But there are three items of circumstantial evidence which could point to a more affirmative if unlikely-sounding conclusion.

1 *Échelon* planning allows a central bay for a high altar and two flanking bays for subsidiary altars; this might accord with what little we know of Donatus's burial location.

2 Polygonal apses and *échelon* plans (with or without polygonal- or round-apsed chapels) were common in northern Lotharingia, specifically the Rhine-Meuse region, from which England acquired both clergy and architectural ideas in the 1000s.[17] In eleventh-century Lotharingian churches their appearance was often in association with square or near-square transepts on either side of the crossings, thus giving a 1:1:1 ratio along the transept axis from north to south; the square transepts do not start, in other words, at the outer walls of the side aisles but at the crossings. The Christ Church crypt plan is not entirely dissimilar. A connected point of comparison to be considered is that in eleventh-century Lotharingian *Langchorkrypten* such as the Cologne churches of Saints Andreas and Gereon, and Bonn Münster, and *Querschiffkrypten* such as St Maria im Kapitol in Cologne (**Fig. 42**, *bottom*), or Brautweiler, there are transepts or transept-towers immediately to the west of the straight bays of three-sided apses, or separated by an interval of only one bay. These apses, in other words, are very short, unlike in Norman and English Romanesque crypts, but this is compensated for by the length of the western arms of the crypts. This is precisely what we see in Dublin, except that the western arm here actually runs beneath the cathedral nave. If one were to slip an unmarked and un-notated plan of the Christ Church crypt into a folder of eleventh-century Lotharingian crypt plans it might not leap out immediately as an Irish interloper!

3 The rather crude imposts used on the piers which support the groin vaults in Christ Church compare so well with the imposts on two chancel arches of apparent *c.*1100 date in the Dublin area – Killiney and Palmerstown – that they may be of a similar date. Had the east end of the crypt been built in the second half of the twelfth century it would surely have been provided extensively with dressed details, particularly given that this was surely a processional space (as crypts generally were), and that some premier-league relics were on display there.[18]

Stalley remarked that the layout of the Christ Church crypt would sooner be assigned to the 1090s than the 1190s were it to be found in England but does not pursue its implications. Perhaps we should allow the Dublin Vikings their precocity. And when we consider the importance of crypts in Imperial Germany, and recognize that the Winchester–Dublin type of crypt *en échelon* may have begun at Corvey-on-the-Weser in the early ninth century, we might wonder instead exactly which route Sitruic took on his way home from Rome. The argument constructed here points to the eleventh century as the date of the Christ Church Romanesque crypt, and not necessarily as late as its last decade, and to it being the product of contact with the Continent which by-passed England.

St Peter's, Waterford

This church is located less than 200 metres to the east of Waterford's cathedral.[19] Excavations revealed a very complex structural history, with five main twelfth-century phases.[20] The earliest remains, dated by the excavators to the early 1100s, were of a rectangular chancel, an altar close to its east wall, and some adjoining fabric from the east end of the – originally timber-built? – nave. A published photograph[21] shows a large posthole in the centre of the chancel to which no specific reference is made in the text, although it might be one of those postholes assigned by the excavators to the early phases of the site's history, either as part of an earlier timber church or as supports for scaffolding associated with the earliest stone construction. Given its size and position, however, this might be the only known Irish example of a sacrarium, a drain to take the water after the priest has washed his hands and the vessels after Mass.[22]

A number of alterations were made to St Peter's in the twelfth century: an apse with thick walls and slightly elongated sides was built to the east of the chancel, a stone-built nave with opposed west-end entrances was constructed to the west, and a stone-built structure, probably a sacristy, was added to the south side of the apse and chancel (**Fig. 44**). The excavators interpreted the apse as an addition on the grounds that it was pinned onto, rather than bonded into, the external wall of the chancel, but the interval may have been very short indeed: certain metrological consistencies in the building's layout[23] suggest that all three elements of the church plan were conceived from the outset to appear together. St Peter's was designed, then, as a tripartite plan, rather like, for example, twelfth-century Kilpeck.[24] Indeed, this may have implications for the church's absolute chronology: if comparative English Romanesque evidence[25] indicates that the apse is not likely to pre-date 1100, and stratigraphic evidence indicates that the stone-built nave was built before 1125,[26] a date in the first quarter of the twelfth century emerges for the entire church.

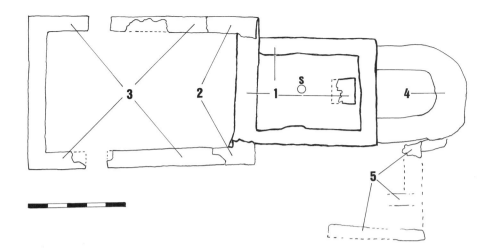

44 Plan of the foundations of St Peter's church, Waterford, in the twelfth century, showing the principal phases (numbered here 1–5) as identified by the excavators. S = ?sacrarium. Scale bar = 5m.

The tripartite plan-type with an English Romanesque-style apse, then, connects St Peter's very firmly to an early twelfth-century English Romanesque tradition, and implies that the Christian Hiberno-Scandinavian communities looked eastwards for more than simply the training and consecration of their bishops-elect. The suggested sacrarium is also important here: St Mary's church, Tanner Street, Winchester,[27] the city where Bishop Malchus of Waterford received his training, is a morphological parallel for St Peter's and has a sacrarium in its chancel. Given the English dimension, the apparent absence of sculptural embellishment on St Peter's openings is a little surprising. By 1100 there was certainly a full repertoire of sculptural forms in England and they must have been familiar to travelling Irishmen of the period, but there is little hint that any of them were used anywhere in Ireland before the second quarter of the century, so St Peter's is at least consistent with a national pattern.

A fragment of a small free-standing work of sculpture from the site, bearing a human head on one side and a stylized animal of Ringerike-style character on the other, can probably be described as a High Cross by any conventional definition. Its find-spot, insofar as it can be established from the report, is extremely interesting: it came from a post-hole, apparently under the bench on the north side of the chancel. Stalley, who dated the fragment to the second quarter of the twelfth century on the basis of a broad early twelfth- to early thirteenth-century date for the chancel, has suggested that it might have been used as a pad for a scaffolding post.[28] The more refined dating of the chancel presented here would suggest, however, that the fragment belongs to the eleventh century. Moreover, its general condition suggests that it was exposed to the elements, and maybe some degree of abuse, for quite some time in its previous life, so it may be some decades earlier than those late eleventh-century parallels to

which Stalley makes reference. One wonders if the reason for its deposition below ground was less conventionally pragmatic than the scaffolding pad suggestion: could it have been a foundation deposit by a Christian community still engaging in certain of its pre-Christian cultural practices?

CISTERCIAN ROMANESQUE

There had been more than thirty Cistercian foundations in Ireland by 1200, some of them short-lived and others quickly downgraded to 'cell' status.[29] Many have disappeared completely above ground, and others have no significant, or at least substantial, remains from the twelfth century. Those that do are Mellifont (founded 1142), its daughter-houses of Baltinglass (1148), Monasteranenagh (1148), Inislounaght[30] (1148), and Boyle (1161), and Baltinglass's daughter-house of Jerpoint (c.1160), Monasteranenagh's daughter-house of Holycross (1180), Inislounaght's daughter-house of Corcomroe (1195), and Boyle's daughter-house of Abbeyknockmoy (1190); Jerpoint's daughter-house of Kilcooley (1184) might be added to this list, although the fragmentary period remains there are of fabric rather than of architectural features.

The Cistercian Order had developed its own set of architectural ideas in the early decades of the 1100s and these were imported ready-made into Ireland from France and England. The plan-template was claustral, which dated back to at least the mid-eighth century.[31] In claustral planning there was a central cloister or courtyard with the church on the north side, the refectory on the south, the Chapter House and brethren's first-floor dormitory on the east, and the lay brethren's dormitory on the west (**Fig. 45**, *left*). All the sites listed above had this scheme in common.

Before we look at the architecture that survives, it is worth noting briefly how different is the record of twelfth-century Cistercianism in Ireland from that of the communities following the Rule of St Augustine. It is unfortunate that virtually nothing remains of the very earliest Augustinian establishments, including the church of SS Peter and Paul in Armagh, possibly the very first such establishment.[32] The earliest Augustinian buildings which do survive reveal the lack of a fixed architectural identity. We do know that when Irish monastic churches of the pre-reform era embraced the Rule of St Augustine in the twelfth century new buildings were invariably constructed, either replacing older structures, as seems to be the case at Cong and Monaincha, for example, or built *ab initio* on new plots of ground alongside older churches, as at Kilmacduagh and Glendalough, for example, but we know also that they followed no particular model. It is therefore virtually impossible to identify on the field evidence alone a pre-colonial-

45 Abbeyknockmoy (*left*) with TC for transeptal chapels, P for presbytery, CH for chapter house, R for refectory, and C for cloister: Mellifont I abbey (*top right*), and Baltinglass abbey church (*bottom right*). Scale bars = 10m.

era church in Ireland which had been served at that time by Augustinian clergy. Some Augustinian houses of Gaelic-Irish patronage were claustrally planned, but this does not seem to be the case with any of the pre-1150 foundations or refoundations. At Ferns, for example, the building which is identified in Chapter 6 as a royal chapel of Diarmait Mac Murchada seems to have been served by Augustinian canons regular – priests living in community – from about 1160 but it was apparently not altered structurally to accommodate the change, although a cloister was added to its south side.[33] Some Augustinian houses which were claustrally planned from the outset, such as Ballintober and Cong, had a layout which was transparently emulative of contemporary Cistercian monasteries.

Returning to the Cistercians in Ireland, to understand the architecture which remains we must turn first to Burgundy, where the order's first house, Cîteaux, was founded in 1098 by disaffected members of the Cluniac Molesme community seeking an ascetic ideal amidst the increasing worldliness of contemporary monasticism. Peter the Venerable mocked the breakaway community's vigorous

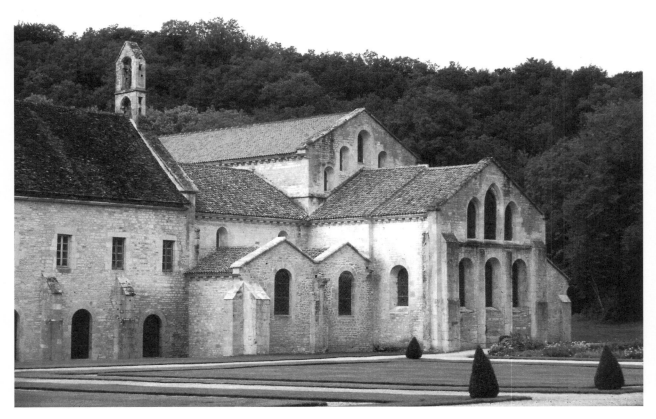

46 Fontenay abbey church from the south-east.

rejection of the trappings of contemporary Christianity, writing 'O new race of Pharisees, who to distinguish yourselves from the other monks of almost the entire world, lay claim to a habit of unwonted colour to show that you are white while the rest are black'.[34] This reference to the Cistercians' choice of garment – white habits of undyed sheep wool – is an apt metaphor for their architecture. Whereas the Cluniacs were tending towards opulence in their church architecture, as witness the great edifice at Cluny itself, the early generations of Cistercians rejected any architectural and decorative extravagance, developing out of their 'penchant for analyzing a thing in order to discover its true nature'[35] an architecture of explicitly minimalist character.

The earliest Cistercian buildings were of timber, as at Cîteaux itself. The order's first forays into masonry construction yielded unsophisticated results, as at Clairvaux, begun after its foundation in 1115 by a young ascetic, (St) Bernard,[36] or at Waverly, the first church of the order in England, which was built after 1128 with a long, unpartitioned, nave and one short transept.[37] Increasing numbers of new recruits in the second and third decades of the twelfth century created a need

for larger, stone-built, churches and domestic buildings, and Cistercian church-builders in the order's place of birth, Burgundy, responded by drawing stylistic inspiration and deriving technological expertise from the region's great Romanesque churches (such as St Philibert at Tournus) while being careful not to produce the sort of architecture the Cluniacs had produced using some of the same sources. The architectural scheme which the Burgundian Cistercians devised and used for their churches between 1135 and 1160, and which the order then used in other parts of Europe, including Ireland, adhered to a pan-European plan-standard in having aisled naves and transepts, but it was distinctive at its eastern end where the apsidal curves which terminated many contemporary great churches, such as Cluny in its different incarnations, were eschewed in favour of pairs of flat-ended chapels on each transept arm, and flat-ended presbyteries. Also, apart from articulation on large structural arches, the wall surfaces of these Cistercian churches were relatively unadorned, and their façades were not treated as especially important surfaces. Karl Heinz Esser christened this plan-type 'Bernardine' after St Bernard of Clairvaux himself.[38] Clairvaux itself was clearly the progenitor of the series, but it no longer exists; nearby Fontenay does survive and is regarded as a kind of type-site (**Fig. 46**).

The coincidence of Bernard's tenure as non-titular head of the order with the development and first diffusion of this plan-type across Europe suggests he had a role in its formulation. This is reinforced by considering the austerity of his order's churches alongside the content of one of the most quoted – and still worth quoting – passages of text from the twelfth century, the *Apologia* he addressed to William of St Thierry around 1125:[39]

In the cloister, under the eyes of the brethren who read there, what profit is there in those ridiculous monsters, in that marvellous and deformed beauty, in that beautiful deformity? To what purpose are those unclean apes, those fierce lions, those monstrous centaurs, those half-men, those striped tigers, those fighting knights, those hunters winding their horns? Many bodies are seen there under one head, or again, many heads to a single body. Here is a four-footed beast with a serpent's tail; there, a fish with a beast's head. Here again the forepart of a horse trails half a goat behind it, or a horned beast bears the hind-quarters of a horse. In short, so many and so marvellous are the varieties of shapes on every hand, that we are more tempted to read in the marble than in our books, and to spend the whole day wondering at these things rather than in meditating the law of God. For God's sake, if men are not ashamed of these follies, why at least do they not shrink from the expense?

But Bernard made no claim to have invented or to have participated in the invention of a particular plan-type or architectural style. According to William of St Thierry, he did not even know the form of the roof over the novice's chamber at Citeaux, or the number of lancets – there would have been three, as per Cistercian custom – in the east end of the church.[40] On the contrary, Bernard was something of a pragmatist when it came to architecture. He was concerned that architectural endeavours of any extravagance would be regarded as wasteful of valuable resources: just as he had criticized in the *Apologia* the 'expense' involved in creating the 'follies' of the cloister, in 1135, when Clairvaux's community was rapidly enlarging, he initially resisted any rebuilding, claiming that there was not the necessary store of money and pointing out that 'it is written in the gospel that he who would built a tower must lay up what he needs to pay for it'.[41] Bernard's reference to the expense incurred in the building of a tower is especially interesting because in 1157 the General Chapter, the body which was charged with the running of the order from the mid-1120s, issued a prohibition on the building of church towers. It was the order's first specific statute concerning architecture; earlier *capitula* from the General Chapter banned crosses of precious metal, opulent liturgical garments and vessels, coloured or figurative glass, the illumination of manuscripts, and expensive book-bindings.[42] The rapidity with which the so-called 'Bernardine' plan spread after 1135 suggests it became, *de facto*, manditory in the family of Cistercian monasteries, even if the General Chapter made no specific ruling on the matter.

Even if the evidence for the 'Bernardine' plan being Bernard's personal invention is weak, can one argue that its dissemination from Clairvaux reflects Bernard's influence? The answer is surely no. If Bernard envisaged churches with flat east ends as a fundamental part of the Cistercian package we might expect to find corroborating evidence in places like Ireland which the Cistercians colonized during his lifetime and with his eager approval. But neither Mellifont, the first Cistercian house, nor Baltinglass, the first daughter house, conforms to a 'Bernardine' ideal,[43] thus indicating that Bernard did not insist on the Clairvaux design being copied in all new foundations after 1135. Moreover, the classic 'Bernardine' plan-type only appeared in Ireland – Jerpoint and Boyle seem to be the first – *after* Bernard's death in 1153.

The first generation churches: Mellifont I and Baltinglass

We can identify one major difference between Cistercians and Augustinians in the early 1100s. Whereas the latter were invariably native churchmen who had simply adopted a new set of rules for their monastic lives, the former came to Ireland originally in a colonial capacity, even if we do not think of their colonialism as being comparable with that of the Anglo-Normans some decades later. To label

Cistercianism, or Cistercian Romanesque architecture, as colonial might be contested on the grounds that most of the order's twelfth-century Irish houses were native foundations with – famously, as it transpired in the early thirteenth century[44] – native abbots and brethren. But in this case such a distinction between 'native' and 'colonial' Romanesques would not be about the politico-ethnic identities of patrons or builders but about stylistic pedigree, and there is no doubt that Cistercianism was, quite literally, a 'colonizing' monasticism in which the principal lines of architectural expression were resolutely external to Ireland, however infiltrated they eventually were by 'native' Romanesque ideas. Indeed, if the basic conception of Cistercian architectural planning, in terms of both horizontal space and superstructure, was a response to aesthetic and liturgical considerations, its very universality across the Cistercian world made it a powerful visual metaphor for the coherence of the order's mission. The Irish Cistercian foundations are, to that extent, fundamentally part of a greater, pan-European, Cistercianism.

Comparatively little survives from twelfth-century Mellifont. The lavabo of *c.*1200 is the only substantial piece of masonry still standing from this era;[45] the rest is at foundation level only. But enough survives for us to see that the architecture of this abbey in the early twelfth century – we can call it Mellifont I, to distinguish it from the later alterations at the site – deviated from the Cistercian norm. This is fairly extraordinary, given Bernard's role in the series of events leading to its foundation. Erected under the guidance of a Clairvaux monk, Robert, and populated by French monks, Mellifont I had a church which was very different from Clairvaux and other contemporary Burgundian churches in having three transeptal chapels on each side of the presbytery, with two apsidal chapels flanking a single flat-ended chapel in each of the transepts (see **Fig. 45**, top right). Another departure from the norm was the timber-ceilinged crypt at the west end of Mellifont I's church, presumably to prop up that end on what was a sloping site.

We do not know if Mellifont I had any main-space vaulting. It is tempting to argue that it had, given that pointed barrel vaults were a feature of Burgundian Cistercian Romanesque churches, especially of their presbyteries, and that similar vaults are found in churches of the Mellifont affiliation. Stalley suggests that Mellifont I is an obvious candidate for the 'common prototype' which best explains the diffusion of such Burgundian features across Ireland.[46] But Mellifont I's curious and unparalleled eastern end surely suggests that whatever Burgundian characteristics are possessed by those other churches are not products of a direct connection with Mellifont I, despite the affiliation.

Baltinglass was founded in 1148; St Bernard knew of it and applauded its foundation. The church alone survives above ground here, and despite considerable

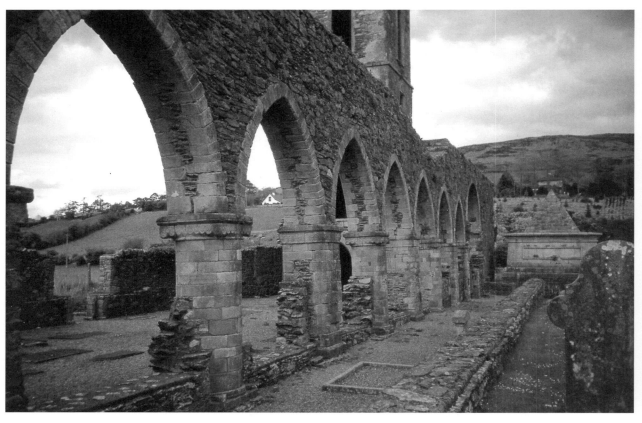

47 Baltinglass abbey church from the south-west.

change in its fabric – the northern nave arcade is destroyed, a nineteenth-century tower stands in the second bay to the west of the crossing, and the east wall has been substantially rebuilt – it remains an attractive and revealing building (**Fig. 45**, *bottom right*; **Fig. 47**). Two principal phases of construction are clearly in evidence. The eastern end, which includes the walls of the transepts as well as the presbytery, was raised in the late 1140s and 1150s, and it might reflect some influence from Burgundy, as we will see presently, and is early enough for this influence to be fairly direct. By virtue of it being so early and so unique a survival it merits close attention here. The nave, with its alternating square and round piers carrying an arcade of pointed arches, is work of the 1160s.[47] The architectural differences between the two parts are such that it is tempting to suggest an interval of some years between them; perhaps a wooden nave served the church's presbytery and transepts during the later 1150s.

The presbytery, transepts and chapels at the east end of Baltinglass were planned in one stage, as the presbytery is square in plan, and each transept is twice its length. This arrangement was laid-out around 1150. However, its superstructure has changed so much in seven and a half centuries that we must approach its

interpretation with caution. The presbytery was probably vaulted originally; this was normal in the order's churches of this period, and there are hints of vault springers within the much-disturbed fabric of the side walls. But one certain departure from normal Cistercian practice is the arrangement of the chapels in the transepts: these projected independently of each other rather than share a common east wall as is the system elsewhere, and only two were built on each transept; it might be noted that there are similarly-disposed transeptal chapels in the Augustinian friary at Buttevant, in the parish church at New Ross, and in Cashel Cathedral, all thirteenth-century Gothic structures. There was exactly enough space for three chapels on each arm at Baltinglass, which indicates that the metrical relationships between the chapels and the transept arms were carefully worked out and a decision was taken to build only four chapels and to position them symmetrically. Might we be wit-

48 The north-east corner of the crossing at Baltinglass abbey church.

nessing here an actual compromise between the Mellifont scheme on the one hand and the classic 'Bernardine' plan (two chapels on each transept) on the other? Baltinglass has the requisite number of chapels to fall within the latter category, but their separate roofing connects them to the arrangement at Mellifont.

The entrances into the transeptal chapels at Baltinglass survive at foundation level only, and even at that level they are largely restored. In a further departure from normal Cistercian practice, the quoins at these entrances were embellished with roll mouldings flanked by pairs of narrow quirks. This treatment of the quoins is reminiscent of the 'classic' Gaelic-Irish Romanesque work, and so is clearly the work of a craftsman who had worked within that other tradition. The

same is true of the significantly larger rolls, executed in warm, yellow-coloured granite, which mark the junctions of the transept arms and the presbytery and terminate in bulbous bases of a fairly standard Gaelic-Irish Romanesque type (**Fig. 48**).

Are there vestiges of Burgundian Romanesque ideas at Baltinglass? It should be said that, unlike in the case of Mellifont I, there is no record of actual Burgundians at Baltinglass, and by the time of its foundation Robert and his compatriots had left for their homeland. We can draw attention again to traces of a possible stone vault over Baltinglass's presbytery, and suggest that such a vault was Burgundian via Mellifont I. Roger Stalley identified the transepts and presbytery at Baltinglass as 'low', meaning that they were roofed at a lower level than the nave, and he cited this as evidence of Burgundian influence.[48] The indicators of their relative height are the wide, round arches which survive on the south and north sides of the crossing, connecting the roll-moulded quoins at the west end of the presbytery with the rectangular piers to the west of the crossing, and spanning the entrances into the transept arms. The arches are, however, problematic. The bases and the lower parts of the roll mouldings are unques-tionably original features of the east end of Baltinglass, but they create the expectation that capitals, and not the imposts which we see today, will mark the termination of the roll mouldings. This indicates that the transept arches are not contemporary with the roll-moulded returns at the entrance to the presbytery. Moreover, an examination of the fabric of the transept arches, as well as of their exact positions relative to those architectural members from which they spring, suggests that the arches are somewhat later than that *c.*1150 phase of building in which Burgundian influence might be expected at the abbey.[49]

When ideas travel, as did ideas of Cistercian church-planning, they undergo some formal transformation in whole or in part, or they are ring-fenced ideologically, in whole or in part, to prevent any such transformation. Certain principles of Cistercian architecture were ring-fenced for the duration of the twelfth century, such as vaulting, flat-ended transeptal chapels in alignment rather than *en échelon*, and three-window east walls to the presbyteries. Mellifont I and Baltinglass are, on the whole, easily understood within the context of early Cistercian design, but they are also idiosyncratic. Those idiosyncrasies were knowingly executed, and for us to emphasize the Burgundian parallels for these two churches might be to subvert their own subversion of Burgundian Cistercian architecture.

New foundations after 1160: a brief overview

Baltinglass's daughter house of Jerpoint, founded around 1160 (presumably under the patronage of Donnchad Mac Gilla Pádraig, *leth-rí* of Ossory), ironically

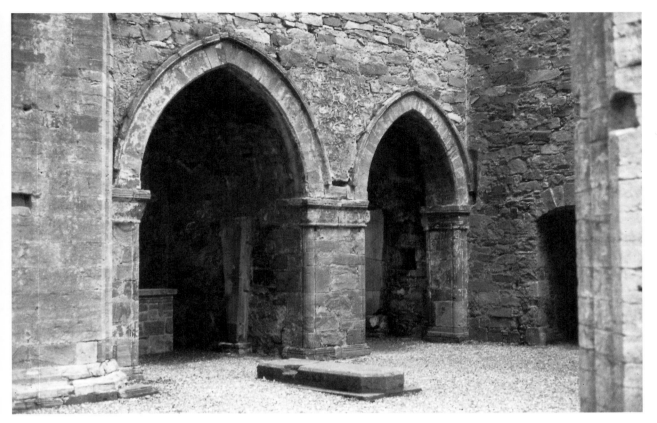

49 The south transept chapels, Jerpoint abbey church.

possesses the classic 'Bernardine' church plan (**Fig. 49**) so conspicuously missing from Mellifont I and Baltinglass.[50] The embellishment of the east end with roll mouldings and capitals is sufficiently reminiscent of work at the latter site for us to suggest a movement of masons. The influence of the Wicklow church is even more apparent in Jerpoint's nave (**Fig. 50**), especially at its east end where there are piers of alternating shape carrying pointed arches and the clerestorey windows are above the piers rather than the arches.[51] By the time building work at Jerpoint had reached the middle of the nave there was a change of mind and the piers were given octagonal shapes.

Moving to the west, we come to Boyle, with its almost complete church and large cloister (**Fig. 51**).[52] The records of the circumstances of its foundation are a little confused: an annalistic source complied in the abbey itself gives dates of 1148 and 1161, with the former seeming to refer to the date at which a group of Mellifont monks led by Peter Ó Mordha set out to establish a new foundation and the latter the date at which the present site, granted by the Mac Diarmata kings of Moylurg, was actually occupied. The church at Boyle is another classic 'Bernardine' structure, with a high, barrel-vaulted, presbytery and pairs of

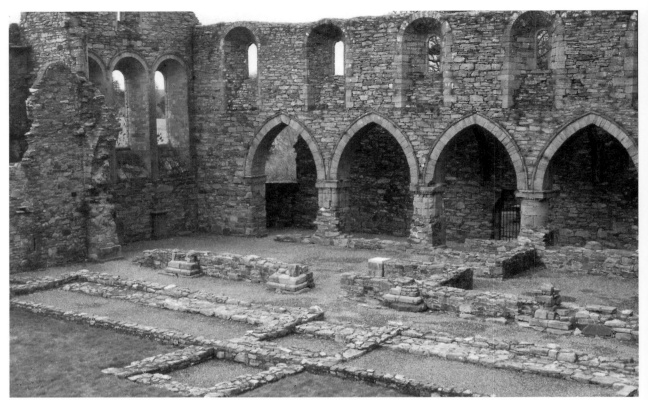

50 The nave of Jerpoint abbey church from the south.

transeptal chapels on each side. Some of the decoration here – 'fluted scallop ornament', as Kalkreuter describes it[53] – can be paralleled on Mellifont's now fragmentary twelfth-century cloister. The nave was built over several decades and, as at Jerpoint, we see formal changes as its construction progressed from east to west: the first (or easternmost) four bays on the south side were built between 1175 and 1180, the corresponding piers on the north side were built between 1185 and 1200, and the four western bays on both sides were built in the first two decades of the thirteenth century, and belong to – indeed, are the example *par excellence* of – the so-called 'School of the West' tradition of late Romanesque work.[54]

This term – 'School of the West' – was coined by Harold Leask to represent what he described as a 'body of tradition' in church architecture and architectural sculpture of the early 1200s which was associated particularly with the Ó Conchobhair and Ó Briain kings and their subordinates in Connacht and Thomond respectively.[55] It was an odd choice of phrase since he did not intend it to mean that there was a single guild of masons. The term has survived, and in doing so has probably caused as much confusion as it has provided clarity. It is at least better than 'Transitional', a word used by Champneys[56] to describe some of the same churches as represented by 'School of the West' but which also has a

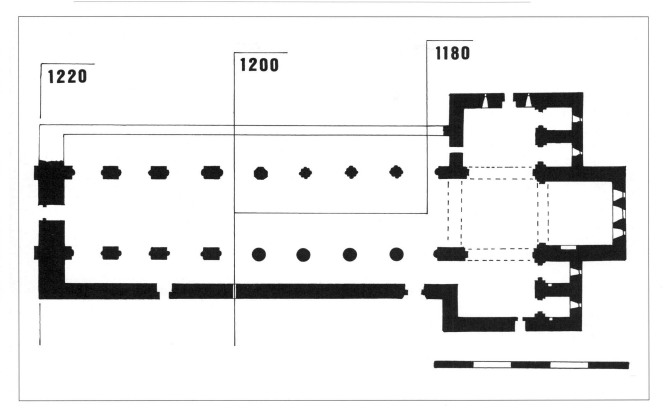

51 Plan of Boyle abbey church. Scale bar = 20m.

wider geographic usage. The problem with Transitional as a style-name (as with 'transitional' when used adjectivally in the context of styles) is that it conveys the impression that these are sites at which Romanesque is demonstrably 'transitioning' or metamorphosing into Gothic, which of course did not happen.[57]

The study of the 'School of the West' belongs within the context of a study of Cistercianism in western Ireland, as Stalley and Kalkreuter have both demonstrated, although the non-Cistercian buildings which Kalkreuter has analyzed – alphabetically, Ballintober (Ballintubber) priory church, Clonfert Cathedral, Temple Rí at Clonmacnoise, Cong abbey church, Drumacoo church, Inishmaine priory church; Killone nunnery church, Killaloe Cathedral, O'Heyne's church at Kilmacduagh, and Kilfenora Cathedral – almost outnumber the Cistercian examples.[58] This is a mixed bunch of buildings, all of them dating to *c*.1200 or a little later. We will skip through them briskly here.

Ballintober, first of all, was a foundation of Cathal Crovderg Ó Conchobhair and was built between 1216 and 1225. It was designed using the principles of Cistercian planning: the presbytery is flat-ended, with flanking pairs of transeptal chapels. Its presbytery, lit by three windows in the classic Cistercian manner, is a

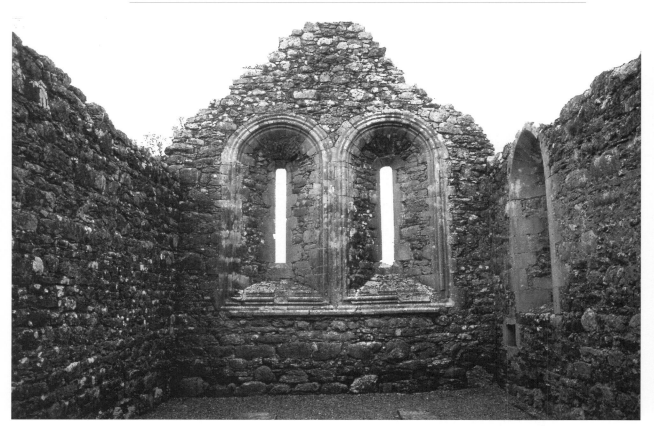

52 A 'School of the West' church: the east end of Temple Rí, Clonmacnoise.

sophisticated work of architecture: it has quadripartite rib-vaults in three bays, with the ribs supported by semi-engaged wall-shafts, the capitals of which are carved with animals, terminating just short of a string-course which marked the height of the choir stalls; the square crossing may also have been vaulted, or was intended to be vaulted: there are springers for crossing ribs. The work in question at Clonfert is an inserted chancel, dominated by a very attractive twin-light, round-arched window – a 'classic' feature of the 'School of the West' – with expanses of finely-jointed limestone ashlar between the mouldings. Temple Rí, a simple rectangular church which is also known as Melaghlin's church, also has a very fine twin-light, round-arched, east window, again executed confidently in the hard limestone of the midlands (**Fig. 52**). Cong has suffered rather badly, with only parts of the east end of the church, most of the east range, and some very fine portals (**Fig. 53**) to indicate how exceptional was its architecture. Drumacoo is a relatively little-known and insufficiently studied church with quite a complex history. It possesses a remarkable south portal of the early 1200s, which is pointed-arched with chevron, and has bands (horizontal rings at halfway points) on the jamb-shafts, and a remarkable array of capitals, including small biting animal

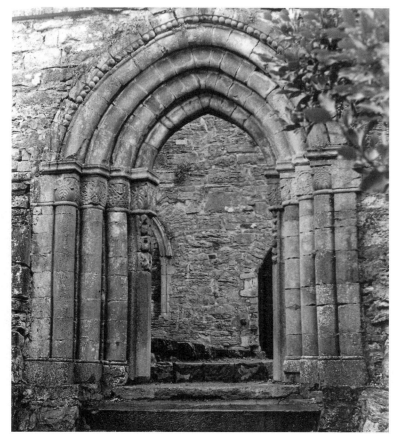

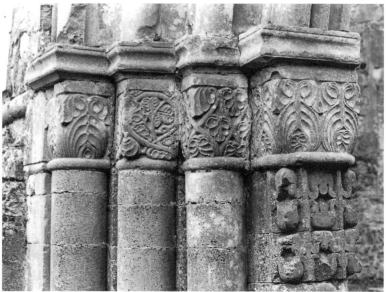

53 The south portal into the east end of Cong abbey church (*top*) and a detail of its east side (*bottom*).

heads. Its east window is a twin-light of the basic Temple Rí type, but with shafts and capitals demarcating the vertical lines, and, crucially, pointed arches. A window closer in form to that at Temple Rí turns up in the east wall of Inishmaine, a nave-and-chancel church noted for its very attractive chancel arch responds and capitals. Next, Killone nunnery church, a fairly undistinguished building, albeit with a crypt, again repeats the pattern of a twin-light east window. Here, the arches have tubular chevrons which are quite common west of the Shannon, and may even qualify a church for inclusion within the 'School of the West' category, but a passage running through the conjoined window splays has trefoil-headed openings which are firmly indicative of a date well into the thirteenth century. Killaloe Cathedral is a more sophisticated work of architecture than any of the preceding buildings: it is an aisleless cruciform church with its nave and choir being of equal length, and its south transept – the north transept has been rebuilt – half the length of these vessels. Its principal feature is its towering east window, a triple-light opening within one embrasure, its central light being round-arched and its side-lights being pointed-arched.[59] O'Heyne's church at Kilmacduagh – another nave-and-chancel building with a beautiful chancel arch – returns us to the motif of the twin-light east window rendered in perfect ashlar. The chancel of Kilfenora Cathedral, finally, has another triple-light window. Its three openings and its rear-arch are rounded, and its capitals have decorated motifs familiar to visitors to any of these churches.

As with so many of the 'School of the West' churches, one can identify forms and motifs at any of these which have parallels in the west half of Ireland, and one can postulate the movement of sculptors. The sculptor[60] or sculptors of the capitals at Ballintober, for example, had previously worked at Boyle and subsequently worked at Cong, which is another Augustinian house designed as if it were Cistercian, and possibly also at Inishmaine and at O'Heyne's church at Kilmacduagh. These sculptors had some knowledge of English sculpture as well as of Gaelic-Irish Romanesque work in Thomond and elsewhere in Connacht.[61]

The key works of the School are, arguably, the west end of the Boyle nave, and the east ends of two Cistercian abbey churches of the early 1200s, Corcomroe and Abbeyknockmoy, and of one Augustinian priory church, Ballintober, built between 1216 and 1225. The latter we have discussed already, so we can now turn to the Cistercian buildings in this list. Corcomroe was founded by Domnall Mór Ó Briain or his son Donnchad Cairprech in the mid-1190s and colonized from Inislounaght.[62] The church here was begun in the early 1200s and was designed with a two-bay rib-vaulted presbytery and a single transeptal chapel on each side, all executed in beautifully-coursed stone, as one would expect given its location in the Burren (**Fig. 54**). The quality of carved stonework here is exceptionally high, with a selection of local Burren flora to add to the sense of place.[63] Pointed arches

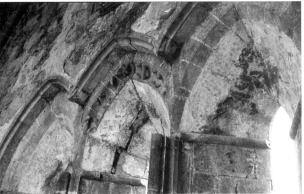

54 The blocked north transept chapel, Corcomroe abbey church.

55 The interior of the presbytery windows, Corcomroe abbey church.

throughout do not mean that this is a Gothic building, but one need only look at the three lancets in the east wall of the presbytery (**Fig. 55**) or the still-open south transept chapel (**Fig. 56**) to realize that the masons working here had some familiarity with early Gothic work elsewhere on the island. Resources and ambition took a nose dive when the nave came to be built, and the church's high architectural quality quickly peters out after the crossing. Abbeyknockmoy, another foundation of Cathal Crovderg Ó Conchobhair in 1190, and colonized from Boyle,[64] is much the same, albeit with its rib-vaulted presbytery set in a classic 'Bernardine' east end. Here we find an even more pronounced diminution in quality as the builders moved lazily on to the nave.

Returning to Cistercian monasteries of the post-1160 period, we can look finally at the other Cistercian abbeys which, like Corcomroe, are associated with Domnall Mór Ó Briain (1168–1194), the last Gaelic-Irish king of Munster. The earliest and most impressive is Monasteranenagh, founded as a daughter house of Mellifont by his father Toirrdelbach in 1148.[65] The least-studied of all the great Irish Cistercian monasteries, this is an almost forbidding ruin (**Fig. 57**), still evoking memories of 1228 when it was fortified by its community against Stephen of Lexington's visiting party, its dormitory filled with salt-preserved dead bullocks, its cloister garden filled with live cows, and its cloister-walkways filled with water receptacles, all in anticipation of a long siege. Its church's east end, with a barrel-vaulted presbytery and three transeptal chapels on each side, is not much later than the Boyle east end and must have been similarly

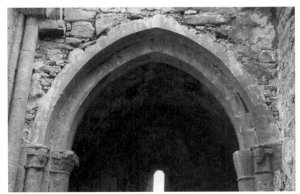

56 The south transept chapel, Corcomroe abbey church.

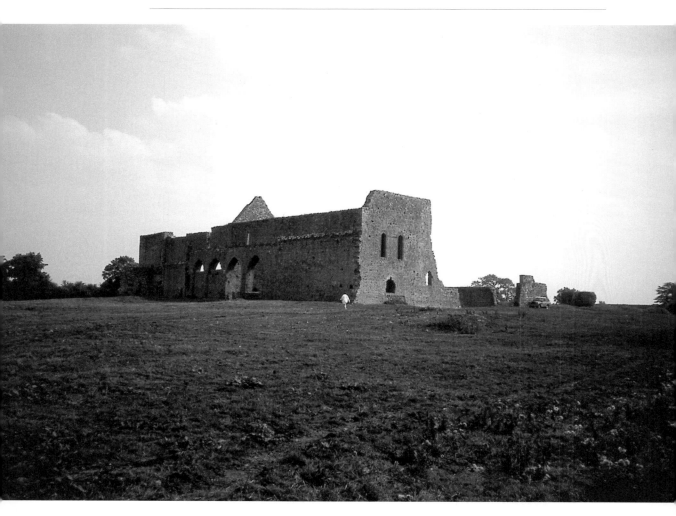

57 Monasteranenagh from the north-west.

impressive. The south chapel of the north transept was groin-vaulted; presumably the other chapels were similarly vaulted. Sculpture is sparingly used but is of high quality, with a number of capitals bearing scallops of 'melting plastic' appearance. Relatively slender piers marked the west sides of the crossing and seem to have been intended as the beginning of a westward-extending nave arcade of comparable quality, but very shortly after building work started a decision was made – presumably on foot on an anticipated structural problem – to widen these piers (**Fig. 58**). The nave was then completed to a very uninspiring scheme, with four eastern arcuated bays with no sculptural embellishment other than chamfers, and blank walls for the western – the lay brethren's – end.

Holycross, founded in 1180 and colonized from Monasteranenagh, was substantially rebuilt in the 1400s, but there remains from the twelfth century much of the west end of the nave, including four arcades on each side, and a late

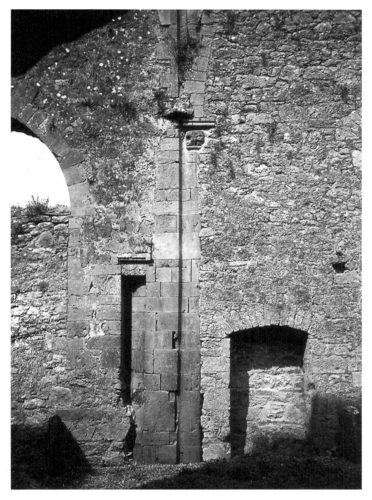

58 The north-west crossing pier, Monasteranenagh abbey church.

twelfth-century processional Romanesque doorway leading into the church from the east side of the cloister. Domnall Mór also founded Kilcooley four years later, and it was colonized from Jerpoint. Some fabric of twelfth-century date survived its substantial and spectacular fifteenth-century reconstruction, so that the dimensions of the original nave and chancel, and of most of the monastery's other buildings, can still be established in the present ruins. The vaulted fifteenth-century presbytery was clearly built inside the shell-walls of its twelfth-century predecessor, and there are six now-blocked arcades, three on each side, to be seen in the nave walls. The later alterations to the east end of the church include paired transeptal chapels of high quality, and this plan, coupled with fragmentary evidence on the eastern outside wall of the south transept, strongly suggests that Domnall Mór's foundation followed the 'Bernardine' scheme. Inislounaght was originally founded in 1148 and colonized from Mellifont, but was re-endowed by

Domnall Mór and only a late twelfth-century Romanesque portal, now preserved at Marlfield, near Clonmel, survives from it. It is not inconceivable that this long-lost monastery has left a record of itself in the architecture of two other buildings. Stalley notes that the use of the 'Bernardine' plan in the newly founded abbey of Hore, near Cashel, in 1272 is surprisingly late, and that it might be explained in terms of an earlier 'Bernardine' model, for which the neighbouring Inislounaght is a candidate.[66] We might also look at the large parish church of Fethard, an Anglo-Norman building of the early 1200s[67] which is located less than ten miles away from the Inishlounaght site. It possesses a series of lateral arches spanning the nave aisles and sub-dividing them into bays; this feature, derived ultimately perhaps from the lateral arcades in the extraordinary narthex of Tournus in Burgundy, was not uncommon in Cistercian houses in England (Fountains, for example) and France (Cernay-en-Laonnais, for example).

CHAPTER 4

Building authority in southern Ireland: Cashel in the early twelfth century

The cluster of buildings on the summit of St Patrick's Rock at Cashel – more popularly, The Rock of Cashel – constitutes the most famous architectural assemblage to survive from medieval Ireland (**Fig. 59; Plate 4**). The jewel in its crown is undoubtedly that small church founded in 1127 and consecrated in 1134 which has borne the name Cormac's Chapel since the twelfth century. This is the one building of that era in Ireland which must surely belong in the European canon of great Romanesque architectural essays; with a floor area less than the size of a tennis court it is also one of the smallest.

The significance of the chapel to any narrative about twelfth-century Ireland is well established. Historians frequently make reference to it when discussing Ireland's international perspectives in the early 1100s.[1] Archaeologists and architectural historians have long held the chapel's special architectural character in sharp focus, devoting much of their energy to locating its formal/conceptual sources and more particularly to establishing as firmly as possible its place within the historical evolution of architecture and sculpture in Ireland. All agree that it is a profoundly important building. This chapter is constructed around the sustainable claim that understanding Cormac's Chapel is fundamental to constructing an architectural (and sculptural) history for at least a century *before* its 1127–34 bracket, as well as for the century which followed. It, more than any other building, suggests itself as a tool for prizing open the Gaelic-Irish Romanesque world. It is not just its fixed dates which give it this importance, although they are certainly a contributing factor, but the fact that ideas of form and design demonstrably travelled to it (principally from England but also from Germany), were transformed stylistically and intellectually at it and by it, and travelled on again. This interpretation involves more than just the chapel itself;

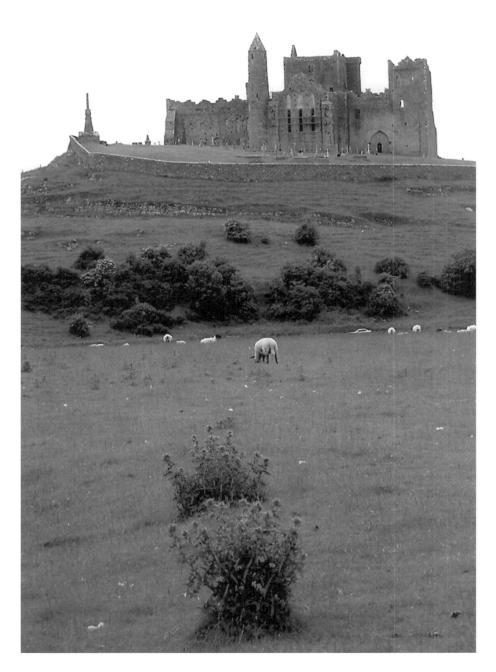

59 The Rock of Cashel
viewed from the north.

the entire summit of the Rock is implicated with it in a very complex chore-ography of ideas about structure, space, and meaning.

In brief, I will disagree with that line taken by Arthur Champneys and Liam de Paor in which Cormac's Chapel is seen as a new departure in architecture and which demands to be contextualized principally in terms of its future, of its influence on buildings which come after it. And while I will agree with Roger Stalley's emphasis on the importance to the chapel's architecture of the English Romanesque tradition, I will disagree fundamentally with his 'easy' imagining of the chapel 'in the shadow of the Mendips or close to the waters of the Severn'[2] since I see nowhere but the Ireland of the early 1100s as the place in which its specific design could have been conceived.

CASHEL, 1101–34

One of the purposes of the great pan-European medieval reform movement was to diminish the capacity of secular agency to influence the workings of the Christian mission, but we should not be fooled into thinking that this amounted to some modern-type separation of Church and State. On the contrary, throughout the middle ages the relationship between secular and spiritual powers was one of fundamental, immutable, interdependence, with one requiring the guarantees – ranging from military protection to salvation in death – on offer from the other. That relationship was purposefully strengthened rather than undermined by medieval ecclesiastical reform, the *raison d'être* of which was essentially the mutually beneficial redefinition of the sacred and secular spheres. An archaeology of the twelfth-century reform in Ireland, then, is *a priori* as much about secular power as it is about ecclesiastical power, and nowhere is this more apparent than at Cashel, where the interconnectedness of these secular and spiritual spheres was given a striking material expression.

Named from the Latin *castellum*, Cashel had been a place of political and spiritual potency long before the twelfth-century reform. Known since at least the ninth century as 'Cashel of the Kings', it was one of the principal seats of kingship – places at which rituals of kingship were enacted rather than regular residences – of early historic Ireland.[3] Its pseudo-history did not suggest, however, the same depth of antiquity as is archaeologically demonstrable at Tara, Crúachain (Rathcroghan), Dún Ailinne (Knockaulin), or Emain Macha (Navan Fort), the other key centres of kingship; rather, Cashel had an origin tale, set no earlier than the late fourth century but codified at the end of the first millennium AD.[4]

As we have seen, Muirchertach Ó Briain had granted the Rock of Cashel in perpetuity to the Church on the occasion of the synod held at Cashel in 1101, thus underscoring his reforming credentials and ensuring that the Rock could not be

easily occupied by rival dynasties, not least the Eóganachta, in the event of Muirchertach's dynasty retreating. The grant suggests that the ramparted summit[5] of the Rock was fully abandoned to the Church in 1101, which implies that there was a settlement which had to relocate, presumably to the base of the Rock. Whether 'settlement' captures the nature of whatever stood on the Rock prior to the twelfth century is debatable. As a bounded site of limited area with a sacred history, even pseudo-history, it is easier to imagine it being occupied by palatial and ritual/ceremonial structures designed for the containment and display of kingship than by conventional houses belonging to lower social groups.[6] It is also debatable whether the Rock summit was cleared after 1101 of any structure associated directly with secular power: just as a sequence of churches, four phases of burial, and a fragment of a ninth or tenth-century High Cross[7] reveal the presence of the church on the summit in pre-1101 times, a 'palace' of some description, either newly-built or retained from an earlier period, may have remained on the summit after 1101, as we will see below.

We are not yet in a position to speak with any confidence or authority about palatial buildings of immediate pre-reform date at the great centres of regional or national kingship. One possible reason why we know so little archaeologically about contemporary prestigious architecture in general is because it was largely of timber. Houses of this material are certainly well-attested archaeologically and historically in Ireland long before the twelfth-century reform.[8] As late as the thirteenth century Stephen of Lexington was writing that Irish kings lived in small huts made of wattle, but this cannot be trusted as a reliable testimony to the size of high-status secular architecture of the period given that large houses or halls, often of named individuals, were occasionally recorded as the scenes of conflagrations with very high fatalities between the ninth and twelfth centuries.[9] Incidentally, the significance in medieval Ireland of the (presumably rectangular) timber hall as specifically a place of feasting is made clear in Roger of Howden's account of the Irish kings building – as part of the ceremony of submission? – a temporary wattle palace *ad mos illius patriae* for Henry II's Christmas feast when he was in Dublin in 1171;[10] feasting halls, which often seem to have been temporary structures, may have had special material requirements for reasons of tradition, as their erection in timber continued into the high middle ages.[11]

Returning to Cashel, one of the very first tasks of the Church following its acquisition of the Rock in 1101 was the construction of a new cathedral church or the redesignation of an existing church as the cathedral, and it is very likely that whatever resources were required for this were made available by Muirchertach. Its site is presumed to be occupied by the presbytery of the thirteenth-century cathedral which now dominates the Rock's summit.[12] This is not unreasonable given the universal tendency in Christian tradition to perpetuate worship on

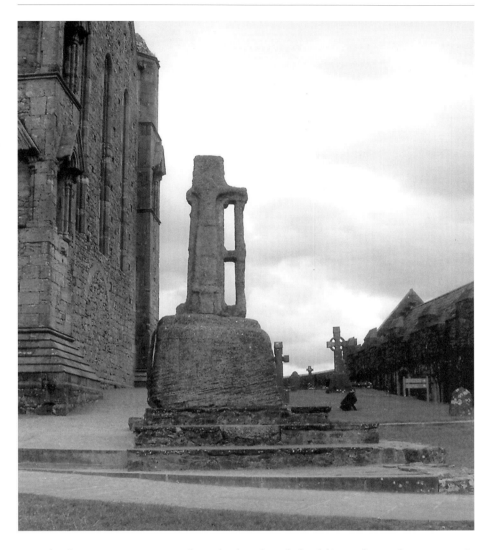

60 The High Cross at Cashel.

exactly the same spot, even though the church buildings themselves are periodically altered or even replaced.

The Round Tower and Cormac's Chapel are the only buildings of the twelfth century which are actually still present on the Rock's summit, but there are also two contemporary works of sculpture. One is the extraordinary Urnes-decorated sarcophagus chest preserved inside Cormac's Chapel but not from there originally; John Bradley has suggested that it was the tomb of Tadhg Mac Cárrthaig, king of Munster (and elder brother of his famous successor, Cormac), who died 'after penance at Cashel' in 1124.[13] The other is the High Cross dedicated to St Patrick (**Fig. 60**). Long *ex situ* and now preserved in the fifteenth-century Vicar's Choral, but with a good replica of it outside in the open air,[14] metrological analysis of the

entire site (discussed below) suggests that this cross was originally positioned about 10m away from Cormac's Chapel but directly in front of its great north portal, and that it may even have been commissioned by Cormac Mac Cárrthaig himself. The cross has a bishop carved on one side and Christ on the other. One side of the base bears a very curious image, identified by Peter Harbison as a labyrinth, with a minotaur in its centre.[15] He suggests that this motif symbolized the sinfulness of traditional, pre-reform, practices to Irish churchmen who needed to be so informed. The figure of Christ wears a long colobium with a belt. The representation is sufficiently reminiscent of the enrobed Christ on the famous and widely imitated *Volto Santo* wooden crucifix from Lucca, a stop-over for pilgrims en route to Rome between the eleventh and thirteenth centuries, for us to suggest a connection.[16] That connection might have been direct, given what we know of Irish pilgrimage to Rome, but it could also have been via England, France or, most suggestively, Germany, in which case the Cashel sculptor might not have been aware that the *Volto Santo* was the original model. The Cashel cross's most remarkable feature is the stone upright supporting its sole surviving arm, and this might suggest either a wooden exemplar, like Lucca, which the sculptor was determined to copy, even if it required unorthodox bracing. It certainly suggests that the Cashel sculptor wanted a proper cross with properly proportioned arms, and was not willing to compromise with the short stocky arms which satisfied other cross-makers.

What was Cormac's Chapel?

The Round Tower is almost certainly the earlier of the two twelfth-century buildings to survive on the Rock. Its construction date is not known, but the consensus is that it was built after the Rock passed into Church hands in 1101, and possibly under Muirchertach's patronage.[17] Its architraved round-arched doorway and semi-ashlar masonry accord well with a date around 1100, and the suggestion that a king rather than a cleric had it constructed is consistent with what we know about these towers and what we suggested above of their function.

The second twelfth-century building is Cormac's Chapel (**Fig. 61**). Its architecture and sculpture are assessed in detail later in this chapter, but some general discussion is necessary here. By contrast with the Round Tower, it has firm dates: 1127 for its foundation, and 1134 for its consecration. The chapel bears the name of Cormac Mac Cárrthaig, the king of Munster from 1123 until 1127 when 'he was deposed by the Munstermen themselves, and [he] entered Les Mór, and much destruction was wrought [in Cashel] in his absence'.[18] While at Lismore Cormac took the tonsure and settled down to monastic life under the guidance of Malachy of Armagh, but was restored to his kingdom within the year.[19] The source which attributes his foundation of the eponymous chapel to that same year is the so-called Dublin Annals of Innisfallen, an eighteenth-century compilation of various

61 Cormac's Chapel: south elevation. Scale bar = 5m.

annalistic materials, while the Book of McCarthy twice gives an incorrect date of 1126.[20] The sources are then silent until 1134 when its consecration in the presence of assorted lay and clerical nobles of Ireland is widely recorded.[21]

Roger Stalley has recently argued that only the 1134 date can be accepted as accurate.[22] His scepticism about the 1127 date has several foundations. First, he points out that the annalistic source, which entered common currency with Petrie, is not reliable. Secondly, he argues that Cormac's exile in Lismore and his return to Cashel later in the same year effectively rule out 1127 as a time in which he could have begun a project of this nature. Third, he draws attention to unusual or idiosyncratic features and aspects of the building – mistakes, even – which suggest

that it was erected far more rapidly than the seven-year duration of the 1127 and 1134 dates. Finally, he suggests that a starting date in the early 1130s is more consistent with the chapel's architecture and sculpture.

Yet we cannot abandon the 1127 date so easily. Cormac did indeed regain the kingship that very year, and it is entirely likely that, reinforced in his claim to the kingship on the one hand and conscious on the other hand that the rival dynasty had made a gift of the Rock to the Church in 1101 (and were patrons of at least one building – the Round Tower), he marked the occasion by immediately commissioning the chapel. For this act of ecclesiastical patronage to have any reality in the minds of contemporary spectators there needed to be some construction work, so 1127 is very likely to mark the start of the building activity. Periods of inactivity might explain the seven-year gap between foundation and consecration, and might even explain some of the curious features; equally, the chapel might have been completed some time before 1134 and its consecration date delayed until all appropriate guests at the ceremony were informed and given time to attend.

The written sources do not tell us explicitly for whom or for what purpose the chapel was built. We can probably dismiss the possibility that it was *specifically* for a community of Benedictine monks from the *Schottenkirche* of St James at Ratisbon (Regensburg) in Bavaria,[23] even in the face of extremely strong circumstantial evidence. Although Benedictines were quite rare in medieval Ireland, we do know that there was a community at Cashel because their expulsion by Archbishop David MacCarville around 1270 is recorded.[24] Details of the particular connection between Ratisbon and Cashel which explains their presence at Cashel are preserved in the Libellus de fundacione ecclesiae Consecrati Petri compiled in the thirteenth century, and further evidence is provided in the necrologies.[25] Three separate visits to Ireland by Ratisbon monks are recorded, the first in 1127 by Isaac and Gervasius, accompanied by Conrad the carpenter and one other, and the second and third by abbot Christian Mac Cárrthaig (who was related to Cormac) in the company of abbot Gregory, shortly before 1150. It is very

likely that it was Cormac, not
Diarmait, his rival brother who was
briefly king in 1127, who invited the
Ratisbon community to Cashel in that
very year, and it is therefore interesting
that the visit, made to secure funds for
the Bavarian monastery, would have
coincided quite closely with the
foundation of Cormac's Chapel itself.
Moreover, the evidence that kings of
Munster were chosen in the same
manner as German emperors, that the
inauguration ceremonies were also
based on the German model,[26] and that
the building's twin towers have near-
contemporary parallels in southern
Germany, not least in the church of St

63 North portal,
Cormac's Chapel.
Scale bar = 3m.

James itself in Regensburg (**Fig. 62**), together underscore the importance of
Cashel's German connection.

Why, then, should we reject the suggestion that this church was built for Irish
Benedictines from Germany? Combining the presence of a tomb recess beside the
great north portal (**Fig. 63**) with the fact that this building has been known as
'Cormac's Chapel' since the time of its foundation suggests that it was not
primarily a monastic church but was a church intended for its patron's
glorification in life and in death, and by extension the glorification of his dynasty.
As a royal chapel it was not abnormally small; Fernie might as easily be talking
about it when he says of various palace (and episcopal) chapels of Norman
England that 'they are among the most ambitious buildings erected during the
Norman century, not for their size but for their ingenuity'.[27] We can imagine
Cormac's presence in and around this chapel during its construction and after its
completion, the building acting both as a metaphor for and as a part of the
apparatus of his kingship. It is very likely that as a royal chapel it had a monastic
– in this case Benedictine – clergy, but it was not a monastic church in the
conventional sense.

When we discuss its architecture below we will see that its form was two-
storeyed, with vaulted roofs over its two storeys and an external stone roof. We do
not know why such a form was selected as an appropriate type of superstructure
for it, principally because we do not know what function the upper storey had.
The possibility was raised elsewhere that the form was inspired, at least in its
verticality, by imperial German *doppelkapellen*.[28] Although these two-storeyed

chapels are unlike Cormac's Chapel in being centrally-planned internally and in having central open wells allowing visual and aural communication between their floors, they were located in comparable contexts of intersecting secular and ecclesiastical power, and were sometimes used for burial, as in the case of the chapel of St Gothard, which Archbishop Arnold I built in the early 1100s at Mainz to be his place for his burial. The nearest example to Cashel geographically is the late eleventh-century Bishop's Chapel in Hereford, erected (possibly by Anglo-Norman masons) under the patronage of that see's Lorraine-born bishop in alleged imitation of Charlemagne's Aachen.[29] If the comparison I made in 1994 between Cashel and these buildings was a little contrived, Eric Fernie's recent drawing-together of the evidence for English royal and episcopal chapels other than Hereford suggests that this was at least the right context in which to look: the episcopal chapel of North Elmham and the chancel of the royal chapel of Melbourne, both early twelfth century, were two-storeyed.[30] The implications for, say, St Columb's in Kells and St Kevin's in Glendalough of a connection between Cormac's Chapel and the corpus of high-status, special-function churches and chapels which we have just discussed, should be noted for future research.

It is important to note here that a fine spiral stairs in the south tower in Cormac's Chapel connects the lower and upper levels (**Fig. 64**), suggesting ceremonial processions rather than simple movements from downstairs up, or indeed from upstairs down. The association of the north tower with a most spectacular (and, for such a small interior, absurdly-scaled) doorway (see **Fig. 71**), tempts us to imagine the enactment inside Cormac's Chapel of some ritual of procession involving relics, not unlike what we suggested for the Round Towers. The discovery of a late eleventh- or early twelfth-century bronze bell-crest in spoil on the floor of the room over the nave is very suggestive.[31] Is it possible that part of Cormac's strategy in building a two-storeyed chapel was to relocate by stealth those rituals previously associated with the Round Tower which Muirchertach had built twenty-five years previously? Is it possible that the pyramidal stone roof of the north tower which rises over the elaborate internal doorway is a translation into a new shape of the conical stone roof of the site's Round Tower, itself located to the north?

Cormac's Chapel and St Flannan's oratory

The stronghold or *cathir* of Kincora was established by Brían Bórama (Boru) in 1012. It was located in the vicinity of the present town of Killaloe, overlooking the adjacent ecclesiastical site of Cell-da-Lua (as well as the river Shannon beyond) from the position which is now occupied by town's Roman Catholic church.[32] During the eleventh century the Killaloe/Kincora centre – its seems wise to refer to them together and even to regard them as essentially one place – was the centre

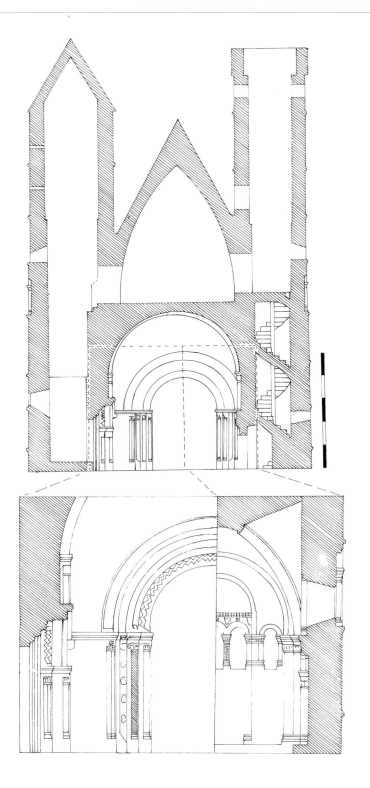

64 Cross-section of nave and towers of Cormac's Chapel, looking east (*top*), with half-elevations of the east wall of the nave and the back wall of the chancel. Scale bar for top section = 5m.

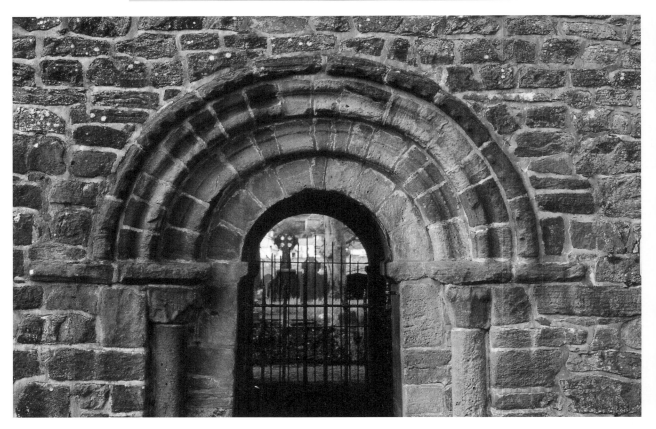

65 The arch-rings of the west portal of St Flannan's oratory, Killaloe.

of Ó Briain power. Its location made it preferable to nearby Iniscealtra, an older ecclesiastical foundation which enjoyed royal patronage.[33] In 1050 a council was held at Killaloe/Kincora in response to a famine and to the social disorder which that famine precipitated,[34] and Kathleen Hughes has described the council as significant 'as an attempt at civil government in which Church and secular power combine'.[35] Thus Killaloe/Kincora prefigures the Cashel of 1101 as an arena in which the spiritual-secular dualism is played out in the gathering of a council.

In 1061 Kincora – now described as a *dún* – was demolished and Killaloe was burned.[36] More attacks are recorded during Muirchertach Ó Briain's reign between 1086 and 1119, in 1088, 1101, and finally in 1118 when Toirrdelbach Ó Conchobhair dismantled the fortress, described significantly but tantalizingly as being of 'both stone and wood'.[37] But whatever the fate of the palace of Kincora, the church site of Killaloe remained in commission. Muirchertach himself may have been the patron responsible for the building there of the stone-roofed, barrel-vaulted, St Flannan's oratory; as we discussed above, its dating certainly fits well with the years of his reign. Its invoking of the saint, whether by simple dedication or by housing some crucial relic, would certainly have suited Muirchertach's

66 Details from the façade of Lincoln Cathedral.

67 Details from the façade of Tewkesbury abbey church.

political project. Moreover, the portal may, if we accept Gem's argument, reflect or articulate Muirchertach's well-documented connections with Norman England.

That portal requires closer scrutiny at this juncture (see **Fig. 65**). The inner of its two orders is plain, apart from simple chamfered imposts; taken on its own we would describe it as one with the chancel arch in the same building. But it is the outer order which *enframes* that inner order – I italicize that word to draw attention to the possible metaphor – which is strongly Norman Romanesque in character, with its three-quarter columns in the returns, its voluted north capital, its south capital bearing two animals which share a single head, and perhaps especially its arches with bowtell mouldings flanked by hollow rolls on the archivolt; for the latter feature see, for example, the arches of the side-niches of the west front of Lincoln Cathedral, finished by 1100 (**Fig. 66**), or the arches on the west front of Tewkesbury abbey church, built around 1100 (**Fig. 67**). There is a striking absence of chevron here; chevron is the most frequently occurring ornamental device in English Romanesque work, but was barely registered by the start of the twelfth century.[38] Anglo-Norman hands worked on the Killaloe portal, but were not allowed free rein: their imprint is kept back from the actual entrance into the building. The pattern created here which is of a simple inner order framed by a highly embellished outer order, is repeated on other doorways.

This Killaloe building, with such subtleties of image and meaning as we have tried to tease out here, must surely have been known to Cormac mac Cárrthaig. Was it his cognizance of this which persuaded him that Anglo-Norman stone masons should be set the task of assisting in the building of the Cashel chapel, and that this new chapel should follow the same architectural principle – two storeys, a barrel vault and stone roof – as St Flannan's but at a significantly greater scale?

The metrology of early twelfth-century Cashel

The thirteenth-century cathedral at Cashel might well retain the alignments or positions of earlier walls, even if the evidence has been destroyed with the making

of its foundations; it is especially likely that the east end of the later cathedral marks the site of the original, pre-Gothic, cathedral (**Fig. 68**). Metrical observations on the site's plan provide some confirmation of this, as well as crucial evidence that the entire summit at Cashel had a very complex spatial geography in the early twelfth century (**Fig. 69**):

- the Round Tower and the north-west corner of Cormac's Chapel are in a north-south alignment (*Line A*);
- the halfway point between the south edge of the tower and the southernmost point of the chapel is half the width of the (thirteenth-century) cathedral's long axis (*Line B*);
- the two doorways of Cormac's Chapel are aligned (*Line C*) on the intersection of *Line A* and *Line B*;
- the distance from *Line A* to the inside wall at the east end of the cathedral (*Distance 1*) is within one metre of the distance to the inside wall at the east end of the fifteenth-century tower at the west end of the cathedral (*Distance 2*);
- *Distance 1* is also equal to the height of the Round Tower (22.1m);
- the distance from the east wall of the cathedral to a north-south line which touches the eastern edge of Cormac's Chapel (*Distance 3*) forms a square at the east end of the cathedral; that square can be converted into a rectangle by multiplying its width (which is *Distance 3*) by 1.414 (or √2, which is 1.414 multiplied by itself). The rectangle, then, has proportions of 1:√2. Its internal length (*Distance 4*) is equal to the full north-south width of the chapel (*Distance 5*); there are also other metrical relationships (*Distances 6, 7*).

68 View of the roofless thirteenth-century east end of Cashel Cathedral from the crossing tower; there is an *a priori* case for the side walls and the end wall of this preserving the outline of the twelfth-century cathedral, with the steps which mark the thirteenth-century division between choir and presbytery possibly marking the approximate west wall of that older cathedral.

Thus it is possible to reconstruct on paper the following: (a) the original ground area of the post-1101 cathedral (noting that the doorway of the Round Tower would have faced its west doorway directly); (b) the open area or *platea*[39] in front of

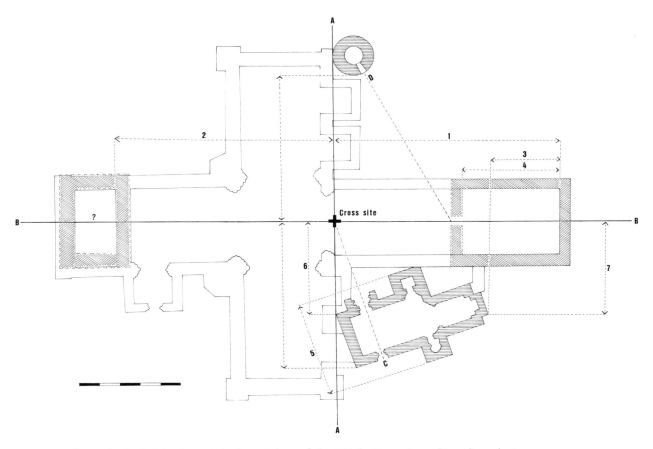

the cathedral; (c), the original position of the High Cross (standing directly in line with the two doorways of Cormac's Chapel and located at the junctions of *Lines 1* and *2* in Figure 69);[40] and, most speculatively, (d) a royal building or palace of some description (replaced in its approximate location by that residential tower – note the continuity of function – which is at the west end of the present cathedral and which is so clearly locked into the same metrology). I therefore envisage early twelfth-century Cashel having four structures which were paired in very particular spatio-political relationships. The Round Tower and Cormac's Chapel were positioned opposite each other along a north-south axis but were not engaged in any kind of dialogue: the former looked to its contemporary cathedral while the chapel faced the (presumably contemporary?) High Cross about 10m away.[41] The cathedral and the suggested 'palace', built on the same east-west axis and facing each other across an open space, rather like the late eleventh-century arrangement of cathedral and castle at Durham in England, might be interpreted as explicitly homologous of the relationship between Church and State at this crucial stage of history.

69 Plan of the summit of the Rock of Cashel showing significant alignments and the suggested reconstruction of the layout of the early twelfth-century structures.

While the present remains at Cashel militate against envisioning a Carolingian type church-palace complex with a connecting covered or arcuated passage,[42] it is conceivable that some of those problems of understanding the design of Cormac's Chapel which we will encounter next – the towers, or the transverse arches of the barrel-vaulted nave, even its small size – would seem a little less intractable if we had a high-status palatial structure surviving here at Cashel or indeed elsewhere in Ireland.

THE ARCHITECTURE OF CORMAC'S CHAPEL DESCRIBED

This is a two-storeyed, stone-roofed nave-and-chancel church with square towers projecting north and south from the east end of the nave. The pitched stone roof over the nave rises to a height of 15m above ground-level, while the roof over the chancel rises to 6m. Internally, the nave is 9m by 5.1m, and the chancel is a little over 4m by 3m. There is a small, rectangular, projection for the internal altar to the east of the chancel.

The exterior

The two external walls of the nave differ in arrangement and detail. On the north side the lower stages are taken up with a large, deeply recessed portal, a tomb recess and a colonnaded corbel table. The west end of this wall, including part of the portal, is masked by the masonry of the thirteenth-century cathedral transept. The south wall of the nave has not been obstructed by later features. It has four stages, the lowest of which incorporates a portal, but whereas the north wall of the nave has not been altered, two windows were inserted into the south wall, probably in the late middle ages; they have been removed in recent years and an attempt made at a restoration of the wall's original appearance.

The north portal arch-rings are intact but the jambs have suffered some damage and most of the angle-shafts are lost. There were three external orders and two internal orders of jambs; the two outer and two inner orders had single angle-shafts while the remaining central order (the inner of the three external orders) had engaged twin-shafts. All but one of the arch-ring orders are decorated with saw-tooth chevron, while there is bar-and-lozenge ornament and arris chevron on the soffit of the central arch-ring. The capitals are either versions of the scalloped type, or are of an undifferentiated type decorated with human faces, animals or tendrils. The bases have multiple tori and stand on high respond pedestals. Above the doorway is a tympanum decorated principally with a centaur and with a lion in profile facing outwards, beneath which are two reclining animals or serpents. This portal is pedimented; within the pediment are vertical and horizontal strips

decorated with chevron. They appear to be skeuomorphs of timber support beams. Enclosed within the pediment are rosettes (see **Fig. 63**).

Immediately east of the north portal is a tomb recess 2.15m wide. The original mensa has been replaced by a plain slab. Fragments remain of a moulded cornice under the mensa, while the moulded base survives intact. The vault over the recess springs from a chamfered course and is undecorated. Above the recess is a string-course with chevron which is continuous with the border of the pediment, and associated with this horizontal string are five human and animal heads. The recess is partially roofed-over by the pediment but it also has an independent roof which slopes back to the vertical wall-surface of the nave. Beneath the wall-head and above both the portal and tomb recess is a colonnaded corbel table with alternating heads. The engaged shafts have cushion capitals.

The south wall has three stages of arcading and a colonnaded corbel table, the latter exactly comparable to that on the north wall. The lowest stage has three arched recesses, two of them paired. The arch-rings are decorated with incised chevron. There is a continuous billet-moulded impost which is interrupted only by the tympaned portal (**Fig. 70**). The outer order of this portal has angle-shafts surmounted by a head-capital on the west side and by a capital decorated with lozenges on the east side. The middle order has a chamfer while the inner order is a plain respond. Of the three pairs of imposts associated with this portal the two outer are billet-moulded while the inner is plain. The arch-rings are decorated with archivolt saw-tooth chevron (see Glossary) while the hood-moulding has billet ornament. An animal of unknown type (probably a lion), with its tail characteristically curled between its hind legs and across its back, decorates the tympanum.

The stage above has one original blind arch with angle-shafts and an unmoulded arch-ring. An impost runs for most of the length of the wall, interrupted by the arch and, until recent repair work, by two later window openings taking the place of two other arches. The stage above that again (which is the stage beneath the colonnaded corbel table) has an arcade of eight blind arches with unmoulded arch-rings. The end-responds and the seven dividing piers of the arcade have single and twin engaged shafts respectively.

The east wall of the nave is visible above the east gable of the chancel. It has a colonnaded corbel table at the same height as those on the north and south walls, and continuous with them via a register of arcading on the two towers. Both sides of the nave gable are irregular, particularly the north side where the side of the gable rises in two stages to accommodate the extra width of the nave on this side caused by the different axis of the chancel. There are three windows in the gable: two are small and round-arched, and the third is rectangular and apparently a replacement of an earlier window, possibly an oculus. Two now-incomplete string-courses cross the gable.

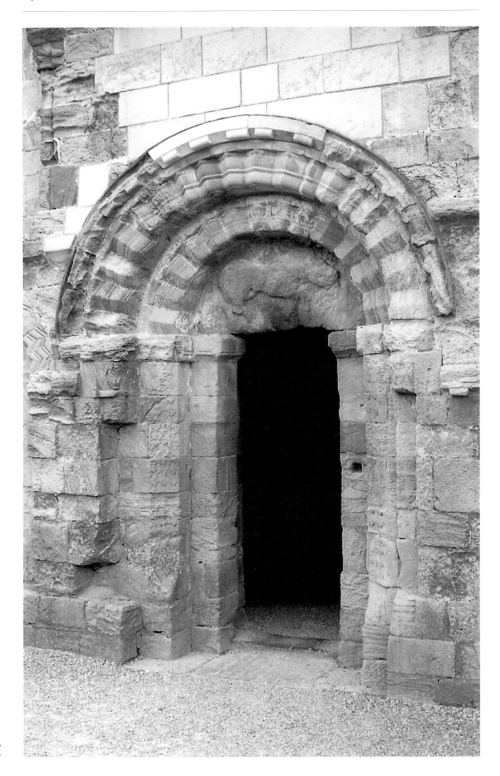

70 South portal,
Cormac's Chapel.

The west wall of the nave originally had three windows, only one of which is visible in the back wall of one of the thirteenth-century transept chapels of the cathedral. There are three string-courses above this window and within the gable, with a small animal head tucked in beneath the apex of the roof.

The exterior north and south walls of the chancel are identical: an arcade of six arches with three-quarter engaged shafts, roll-moulded arch-rings and a continuous impost. These arcades stand on and are framed above by string-courses. Low on the south wall there is another string-course. There is no equivalent feature on the north wall. In the east wall of the chancel, on either side of the altar projection, are single arches identical to those on the side walls. Within the gable of the chancel are two small oculi decorated with beads and, high up, a small round-arched light.

The east wall of the altar projection has been rebuilt with an arcade of four arches. The reconstruction is modelled on the chancel arcade and is probably faithful to the original, though the original number of arches is uncertain. On the narrow north and south walls of the projection are similar arches, but in these cases they contain windows lighting its interior.

Externally the towers have string-courses but not all these match the string-courses, imposts or other horizontal levels on the nave and chancel walls. Arcades with single and twinned arches, and enclosing some small round-arched windows, are at the same level as the nave's colonnaded corbel table, and are joined to it. The north tower, which is the larger of the two, has a pyramidal roof while the south tower has a parapet. Lintelled doorways, gave access into, or exit from, the east sides of both towers.

The interior

The north and south walls of the nave are divided into two stages, the lower containing wall arcading, the principal access and exit doorways, and the portals leading into the towers, while the upper stage has rows of engaged shafts supporting the transverse arches of the vault (**Fig. 71**).

The nave was lit by three windows high in its west wall at a level equivalent to the upper stage on the side walls. Only the central window remains open, albeit having been widened at some later date, while the two side windows are blocked by cathedral masonry outside. The embrasures of all three windows were flanked by small angle-shafts, two of which apparently extended down to ground level. The masonry beneath the central window has been replaced.

Internally the two doorways opening from the north and south have single recesses and are unelaborated. The backs of their tympana are undecorated. On the north side the portal is flanked by a single blind arch on its west side and by

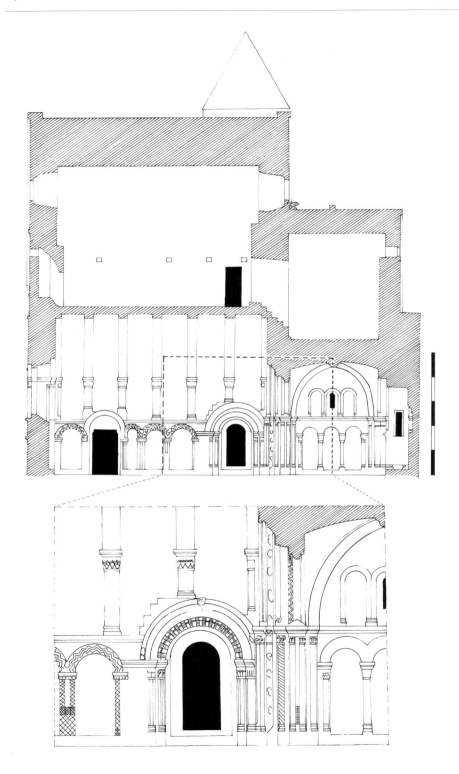

71 Cross-section through Cormac's Chapel looking north, with close-up of part of the elevation. Scale bar for top section = 5m.

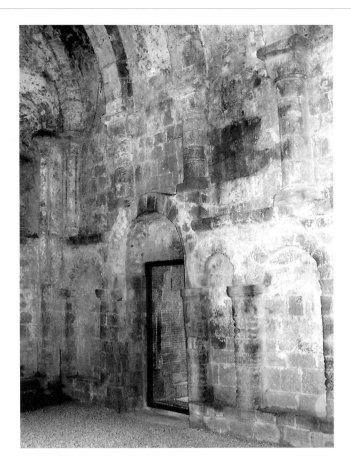

72 Interior north-west corner of nave, Cormac's Chapel

an arcade of three blind arches on its east. All are recessed two courses above floor level. The piers and responds of the latter are decorated with irregular diaper patterns of chevron, lozenge, billet and four-leafed petal, and their abaci are billet-moulded. All four arches have arch-rings decorated with chevron. An identical scheme is found on the south wall, except that there are four arches in the arcade on one side of the portal.

At the east end of the nave are a doorway leading into the south tower and a portal leading into the north tower. The latter is highly elaborate. Two original orders remain: the two inner orders are late medieval replacements. Of the two original arch-ring orders, the outer has a roll-moulded arris, and the inner has saw-tooth chevron. The crown of the arch has a carved human head. The eastern and western label stops are respectively an animal head and an animal head biting a human head. The two west-side angle-shafts of the portal are polygonal. The bases have two tori separated by a shallow hollow roll. The doorway leading into the south tower has a highly moulded tympanum-lintel atop plain responds.

The nave vault is a rubble-built barrel supported by seven transverse ribs of square section, two of which are engaged to the end walls of the nave. These transverse arches are carried on short, thick, engaged half-shafts with capitals decorated with scallops or with heads. The bases have torus mouldings with spurs. The half-columns stand on a string-course. The skewback at the springing of the vault is clearly visible.

The chancel arch has four jamb and arch-ring orders, of which the second is a hollow chamfer. The inner order – the respond of the arch – has twin engaged shafts with a wide fillet on its jambs, and a thick roll on the soffit of its arch-ring. The capitals vary between scalloped forms and an undifferentiated form with tendrils or human heads.

The interior chancel elevation, like that of the nave, is in two stages. The lower stage has an arcade of three blind arches on each side. On the north side the arch-rings are unmoulded but on the south side they have thick rolls with hollow rolls above, on the archivolt, and beneath, on the soffit. The capitals are scalloped forms, with one capital on the south side having volute spirals carved on its face. The bases are all combinations of torus and hollow roll. The corners of the chancel have engaged three-quarter shafts, and their capitals and bases conform to the pattern above. Above these arcades is a string-course marking the start of the upper, rib-vaulted, stage. There is a smaller arcade of three arches on each of the side walls at this stage. Each arch has a continuous roll border without capitals or abaci, and the central arch on each side contains a window.

The four ribs, square in section with thick soffit rolls, spring diagonally from the imposts of the four engaged shafts in the corners of the lower stage of the chancel. At their junction each rib has a downward-facing head carved on it. Heads are displayed on all sides under the vault.

The soffit of the vault also preserves some very fine paintings which have been conserved by David and Mark Perry and Richard Lithgow; there are other painted surfaces on the chancel walls, and one can see in places that more than one episode of painting was involved. The vault paintings have been analysed recently by Roger Stalley, who draws two conclusions: first, that they were painted in the second half of the twelfth century, not in the 1130s as was previously assumed, and second, that their iconography is an Infancy cycle comprising the Magi before Herod, the Adoration of the Magi, and a scene involving the Shepherds.[43] He further wonders if the visit of Henry II to Cashel in 1171 might be the context in which to view their painting. The case is strongly argued, and the presence of fragments of painting at Lismore, another place visited by Henry II, provides some corroboration.[44]

It is difficult to know why Cashel would have been provided with an Infancy cycle at *any* stage in the twelfth century, especially one which gives such prominence to the Magi before Herod. Stalley's suggested late date might find some correspondence in the late dating of an Adoration of the Magi in sculpture at Ardmore (see below, pp. 223–4), but the presence at Ardmore of Solomon, juxtaposed compositionally and iconographically with the Magi scene, makes me wonder if Solomon is not somewhere on the vault,[45] as well as Cormac himself perhaps, and if kingship is a more explicitly-stated theme.

The east wall of the chancel is perforated by an arch which in turn frames the altar projection. The responds of this arch have twinned shafts with scalloped capitals and torus and hollow-roll bases. The altar projection itself has a shallow arched roof of cut stone rather than rubble. It is lit by two long rectangular openings, one in each of the side walls. The west wall of the altar projection is comprised of the responds on either side of the altar recess, an arch, and the curving space above the arch. On the responds there are two small blind arches, one on each side, each flanked by a combination of single-and twin-engaged shafts. The arch-rings are roll-moulded and the capitals and bases conform to the type above. The east wall, or interior rear wall, of the projection has itself an arcade of three blind arches similar to those above but different in having more complicated roll-mouldings and single engaged shafts, two of which are decorated, one with spiral and the other with zig-zag. Above this arcade is a billet-moulded string-course on four head-corbels. Beneath was the altar: this was table-like, standing on four columns of which three bases – torus and hollow-roll combinations, with spurs – survive.

The towers, entered indirectly through the nave or direct from the outside through doors in their east walls, give access to the upper storeys. The south tower contains the access stair which spirals clockwise. The upper half of the south tower has no stair so access to its parapet must have been by wooden ladder. Similarly, a ladder must have provided access up or down the north tower.

The chamber above the nave was roofed by a pointed barrel vault. Lighting was supplied by three round-arched windows, two in the east gable and one in the west gable, and by three rectangular windows, two cut through the slope of the stone-roof on the south side, and one high up in the east gable. Descending steps in the east wall gave access to the similarly-vaulted chamber above the chancel, itself lit by two small oculi and one round-arched window, all in the east gable.

CORMAC'S CHAPEL: ARCHITECTURAL CONTEXTS AND INTERPRETATIONS

The chapel is unusual by the standards of contemporary and later twelfth-century Irish churches. In terms of very basic plan structure (**Fig. 73**) it does conform to

73 Plans of the church (*top*) and upper storey (*bottom*) of Cormac's Chapel. Scale bar = 5m.

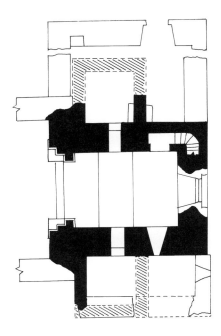
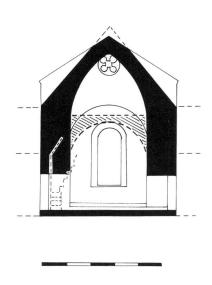

74 Plan and cross-section looking east of Rahan I. Scale bar = 5m.

the nave-and-chancel type which was so widely used outside Ireland in the eleventh and twelfth centuries and was first used (but sparingly so) in Ireland around 1100. But three features of its plan are unique, or virtually so, for pre-1150 Ireland.

The first and most obvious is the pair of towers, each a different size, projecting north and south from the east end of the nave. Small square structures were attached to the sides of the barrel-vaulted chancel at the largest of three churches at Rahan and may suggest a parallel of sorts (**Fig. 74**), but their positioning is not the same as at Cashel, they are entered through plain if archaic-looking round-arched doorways (**Fig. 75**), and they did not rise above one storey (**Plate 5a**). Indeed, whereas at Cashel one of the towers contained stairs ascending to spaces above the vaults, at Rahan the over-vault space was accessed by a narrow mural stair in the chancel itself. Temple Finghin, Clonmacnoise (**Fig. 76**), which has a single Round Tower located at the junction of its nave and chancel, might also be pertinent here. Formally, it is very far from an exact parallel – apart from the self-evident difference of shape and number, it possesses no string-courses or any other articulating device – but it might well have been designed by a mason familiar with Cormac's Chapel and its conceit of integrating the Round Tower function into the church.

The second feature is the arrangement of entrance doorways in the side walls. The earlier convention in Ireland was to have a single doorway in the west wall, with side-wall doorways (in single or in opposed pairs) only becoming common

75 Exterior (*right*) and interior (*left*) of the doorway leading into the south-side chamber at Rahan I.

in the thirteenth century. The only known exception to this is the long-destroyed seventh-century church dedicated to St Brigid at Kildare, described by a contemporary hagiographer, Cogitosus, as having opposed doorways at the west ends of its side walls, that to the north being for female members of the double monastery to process through, and that to the south being for males.[46] If the date of 1100–25 assigned to it above (page 102) is correct, St Peter's in Waterford is the only other church of pre-Cormac's Chapel vintage in Ireland to have had opposed doorways in the lateral walls. Like Kildare, Cormac's Chapel's opposed doorways were presumably designed to accommodate different types of procession, sometimes simultaneously: royal and episcopal parties certainly entered through the large portal on the north side, while clerical concelebrates and choristers presumably entered through the smaller portal in the south wall. Ardmore Cathedral has opposed Romanesque doorways dating from the late twelfth century, as we will see below, and one of them (that to the north) is larger and more elaborately decorated than the other. The larger of the two churches at Liathmore, thirteen miles to the north-east of Cashel, also has opposed doorways

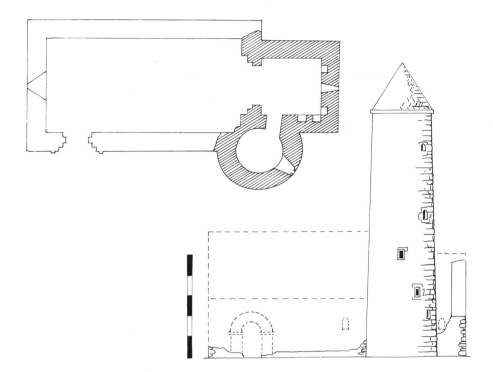

76 Plan and elevation of Temple Finghin, Clonmacnoise. Scale bar = 5m.

with Romanesque details, but since both have been rebuilt it is not clear whether they reflect a twelfth-century scheme.[47] In fact, low foundations wrapped around the present nave (**Fig. 77**) are very likely to represent a twelfth-century phase, and the thickening of the foundation at the west end of the south wall suggests the site of an elaborate portal. Some Romanesque churches, meanwhile, have their doorways in their south walls. Those at Temple Finghin in Clonmacnoise and Ballysadare are certainly original, while that at Kilcash was possibly moved to its present position in a late twelfth-century nave from the west wall of a pre-twelfth-century church, and that at nearby Kilsheelin might have been moved to its

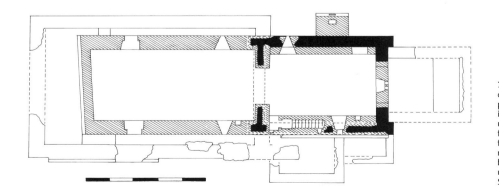

77 Plan of Liathmore church. The original pre-Romanesque church is indicated in black; upstanding masonry from various twelfth-fifteenth-century rebuilds are shaded, but foundations are unshaded. Scale bar = 10m.

present north-wall position in the 1400s, by which date side-wall entrances were fairly common.

Finally, we come to the shallow altar projection, lit by lateral windows, at the east end of the chancel. This is an original feature, as is revealed by the metrological analysis of the entire site and by fabric analysis of the building itself. One curiosity worth mentioning, however, is that its lowest external string-course is chamfered on the top and bottom while the string-course adjoining it on the east wall of the chancel is chamfered on the top only; there is no evidence of an alteration, and yet one hesitates to suggest that the wrong string-course segments were taken from the work-area and nobody noticed or bothered to rectify that. The altar projection gives the entire building the sort of tripartite arrangement along its long axis which is common in contemporary English Romanesque churches, as we noted in the discussion of St Peter's, Waterford, but the eastern element at Cashel is nothing more than a container for the altar, allowing no movement around its side or to its back; the altar was pushed into the interior back wall of the chancel so the exterior back wall was pushed out *repoussé*-like. There was a second example of this scheme in Ireland: Kilmalkedar, an important church of the early 1100s which is discussed in the next chapter, was originally a single-cell church with a laterally-lit altar projection.[48] At an early date in its history – but certainly still in the 1100s – its altar projection was replaced as the church's eastern limb by a fairly standard chancel, but jagged vestiges of it still remain.[49]

The most curious feature of the plan of Cormac's Chapel is the alignment of the chancel on an axis parallel to but 0.5m south of the axis of the nave. This discord is most clearly manifest on the inside of the chapel with the chancel arch: its axis is to the right of centre as one faces eastwards from the nave towards the altar, with the result that above the crown of the arch and to its left (north) side there is a crescent of blank walling. It is actually the nave rather than the chancel which is problematic. The chancel is a compact and regular structure internally, a rectangle with its open west side defined precisely by the jambs of the arch. The normal procedure for raising a church building in the middle ages was to begin at the east end and progress westwards so that the liturgical activity could begin as soon as possible. That area of blank walling in the nave on the north side of the chancel arch which creates the visual impression of imbalance is a feature of the nave, not of the chancel. Thus it is the western not the eastern arm which violates the chapel's internal balance.

Leask interpreted the 'eccentricity' of the chancel axis as suggestive of a change in favour of a wider nave made shortly after building work began.[50] There are some conflicting threads of evidence here. A change of plan would help explain, circumstantially of course, the seven years between 1127 and 1134. It might also explain some irregularities and inconsistencies in the masonry on the south

side of the church, otherwise attributable to different work gangs and long intervals.[51] Against this is the metrological evidence: the $1:\sqrt{2}$ proportion is used throughout the chapel's plan, albeit in rather unusual ways, and the whole chapel is, as we saw above, incorporated in the metrology of the Rock's summit. In the final analysis we must be realistic in our thinking about this church, and resist any temptation to see it as ham-fisted in either its conceptualization or execution. A change of plan suggests caprice or indecision, or perhaps a suddenly-realized miscalculation for the vaulting; whichever one we opt for, Cormac Mac Cárrthaig or his builders are cast in unflattering light, and such a judgement would surely be very unfair. If we suppose that a change *was* made, whatever the reason, the window of opportunity for that change closed once vault construction began, so the building could not have been far advanced. I find it inconceivable that in such circumstances masons would opt to leave a single wall and a few other foundations in place rather than dismantle and rebuild them using exactly the same stones, especially in the case of a building of such small size and especially given the projected size of the superstructure. It makes a lot more sense to interpret Cormac's Chapel as built to plan, and to suggest that the nave widens on the north side to reflect and accommodate the visual spectacles of procession involving both north-side doorways.

In many respects Cormac's Chapel is just as unusual from ground level upwards as it is in plan. While the chapel covers a relatively small area of less than 60 square metres internally, with a maximum internal length of less than 15m, and a maximum internal width of a little more than 5m, its superstructure is of comparatively immense volume. Externally the height of the western arm is about 15m, almost half of which is comprised of the pitched stone roof, the height of the eastern arm of the chapel is 6.5m to the wall-head, and a little over 11m to the top of the external stone roof, and the north and south towers each rise to about 18m. Just one aspect or feature of this superstructure can be paralleled fairly widely in Ireland: its two-storeyed, stone-roofed, character. The corpus of buildings of such character – and Cormac's Chapel is a key item within that corpus because we know so much about it – is problematic in terms of style-designation, context and date, and the quantity and geographical spread of examples justify the importance which Leask and others have attached to it. As we have seen, though, the basic blueprint for a two-storeyed church, barrel-vaulted internally and stone-roofed externally, already existed by the time Cormac's Chapel was begun, and it is clear, therefore, that in this regard the building's unnamed master mason was drawing on an indigenously-developed tradition. We speculated above that St Flannan's oratory at Killaloe might have been the building which inspired Cormac's Chapel, though not to flatter by imitation but to outdo in grandiosity.

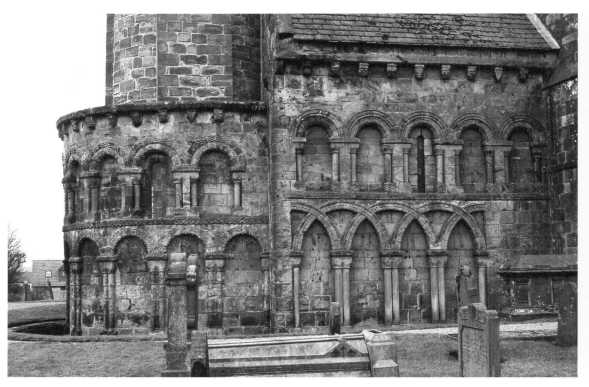

78 North wall of Leuchars church.

The particular balance between forms and concepts of overseas and indigenous origin which characterizes Gaelic-Irish churches of the period is not found in Cormac's Chapel: rather than having a simple spatial conception and bare walls interrupted only by one or two elaborated details, the chapel has more highly articulated wall surfaces internally and externally and a wider spectrum of individual architectural and sculptural components than is found in contemporary or earlier churches. While de Paor's evaluation of the chapel as 'a piece of architecture, as hardly any other [Irish Romanesque] church is'[52] must be rejected on the grounds of the narrowness of his definition of architecture, it is true that this is the one building in Ireland in which the visitor may experience Romanesque architecture in the way it may be experienced in one of the great overseas twelfth-century churches: the interior of the church has a sculpted quality, with the nave and chancel sealed by vaults and framed by walls with quite complex schemes of vertical and horizontal articulation.

The search for the overseas sources

Walking around Cormac's Chapel, outside and inside, one instantly recognizes that it has affinities in Britain. The arcading and the chevrons can be paralleled effortlessly in literally hundreds of English Romanesque contexts, from south

Wales to East Anglia, and from Exeter to Dundee (**Fig. 78**). Moreover, their execution speaks not of Gaelic-Irish craftsmen who have learned these forms and how to carve them but of actual English Romanesque craftsmen in Cashel in the late 1120s and early 1130s. We cannot prove this, of course, but later Romanesque work in Ireland looks sufficiently different for us to be very confident that Anglo-Norman hands recreating an English Romanesque repertoire shaped large parts of Cormac's Chapel. In this section we will explore the claims of England, as well as of France and Germany, to be source areas for the chapel's architecture. It is useful, first, to put these claims in historiographical context.

Back in 1910 Champneys acknowledged the Englishness of Gaelic-Irish Romanesque architecture in general, pointing out that 'very clear evidence indeed would be required to prove the independence of this Irish ornamented architecture'. England, or rather the culture area of English Romanesque (which includes South Wales and southern Scotland), must indeed be identified as the principal source area for Cormac's Chapel. Champneys was also aware that the chapel was no mere copy of an English Romanesque work: while he attributed the towers, the vault ribs, the north portal, and innumerable details at Cashel to what he described as a Norman origin, he also emphasized the chapel's pedigree in that Irish architectural tradition which produced stone roofs, commenting that it is 'essentially an Irish building'.[53]

Leask, as we noted, was struck, as was McNeill before him, by the German character of the towers, and so he reiterated the Ratisbon connection.[54] It is not clear, however, that he had any personal experience of the relevant German buildings. By contrast, Françoise Henry was a little less sympathetic to the Norman/English and German Romanesque ingredients of the Gaelic-Irish Romanesque style in general than she was to the French (and especially western French) material with which she had considerable familiarity. So, while she acknowledged the origin within the Normandy-England area of the chapel's arcuated elevations and its chevron decoration, her analysis of the interior of the chapel drew equal attention to features not obviously of English Romanesque origin: apropos of the barrel vault over the nave she mentioned Saint-Eutrope at Saintes, where the vault has ribs supported by short, twinned, engaged shafts, and apropos of the chancel arch she cited Bellegarde-du-Loiret where heads are arranged in a configuration similar to those at Cashel.[55] Whatever the merits of these parallels, however, the articulation of the external and internal walls of the chapel, and the use of scalloped capitals and chevron, point incontrovertibly to a significant English Romanesque contribution to the chapel's aesthetic, and Henry's down-playing of this is a flaw in her analysis.

Liam de Paor went back to Champneys, reintroducing that English Romanesque dimension which had slipped slightly from view with Henry's

leanings towards France and Leask's leanings towards Germany, and he restated Champneys view on the position of Cormac's Chapel within Irish architectural history. De Paor articulated the view that the chapel belonged 'at or near the beginning of the Irish Romanesque series: it has an alien character, since it marks the importation of a new style'.[56] He went on to explore the role of Cashel by reference to a number of sculptural motifs which appear elsewhere, and by reference to the pedimented portal. In terms of its conceptualization, de Paor's hypothesis had an in-built flaw: a building which is ostensibly the common denominator in a selective catalogue of architectural and sculptural forms is not necessarily the source of those forms. Suffice it to add in this context that de Paor's analysis of Cashel did not account for the upper storeys and their vaults: one has a very strong impression that de Paor separated in his mind the upper and lower parts of the chapel, analysing the latter but never reconciling that analysis with the *a priori* implications of an upper part.

The most systematic analysis of the building was by Stalley two decades ago.[57] He brought together the points made in earlier work, supplementing them with further comparative data, and presented an interpretation which did not stray significantly from those of Champneys and de Paor. The aim of his study of Cashel was not to demonstrate any further what he and those earlier writers saw as the chapel's primacy within the Irish Romanesque sequence, but to trace its place of origin or conception, which he identified as the English West Country.[58] His observation that architectural motifs within the chapel have parallels in this area was not entirely new,[59] but he supported it by deploying a knowledge of comparative material in England unmatched among earlier writers. In addition to the obvious features of English Romanesque origin – the arcuated elevations combined with extensive use of chevron – he drew attention to the importance of the stone rosettes which are found on a small number of early twelfth-century sites in Ireland and England.

Stalley's command of English Romanesque material lends greater authority to his concessions that the towers are Germanic in appearance and that there are other elements of the chapel which are ultimately of French origin. But his remarks that Cormac's Chapel could be imagined in England and that 'despite its German and French connections, [it] remains overwhelmingly English in style and ought to be considered an integral part of Romanesque art in the West Country',[60] are unsettling, and not for reasons of national pride. These judgements disregard the significance of the chapel's *actual* geographical location – not just in Cashel, or in Munster, but in Ireland – in its particular formal and intellectual synthesis of disparate elements. Moreover, though perhaps less obviously, there is an implication here that any problems which are posed by the chapel's Romanesque elements, such as its synthesis of forms of apparent or alleged

English, German and French origin, can be abandoned to students of the English Romanesque to resolve.

The origin of the east-end altar projection

We can start our search for origins with one feature of the chapel about which little has been said but which illustrates very well the problem of identifying its architectural kin: the altar recess/projection on its east side. This cannot be interpreted as a mere practicality, conceived indigenously or imported from outside, to prevent the altar from taking up too space in the chancel. In fact, the ideal place for Cormac's Chapel's altar would have been directly beneath the apex of the rib vault, allowing the vault to serve the obvious function of ciborium or baldachin.

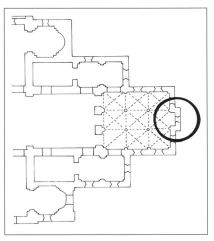

79 Plan of the east end of Lüttich, showing the eastern projection. Not to scale.

The point is well made by the early eleventh-century crypt-chapel in the Belgian church of Hastière, south-west of Liège: this was a square crypt with nine groin-vaulted bays, and its altar was placed not in the square recess of equal width in the thickness of the back wall but in the easternmost vaulted bay of the central axis. Hastière is in the region of Lotharingia where more obvious parallels for the Cashel projections than it can be found, such as Lüttich (**Fig. 79**) and Essen Münster, but if a Lotharingia-Tipperary connection is a little unlikely one might posit instead a connection via England: Rochester in Kent had a projection of very similar size to that at Cashel in its later eleventh-century east end, while the early twelfth-century phase of Old Sarum (Old Salisbury) Cathedral in Wiltshire had a fairly shallow, flat-ended, eastern projection, larger than that at Cormac's Chapel but probably somewhat similar in external appearance when it was standing.[61]

The origin of Cormac's Chapel's towers

Of the two areas other than England which have been suggested as source areas for Cormac's Chapel Germany has a greater *a priori* plausibility than France, thanks to the documented Cashel–Regensburg connection. Paired towers are the quintessence of German Romanesque. Parallels for the Cashel pair are easily found in the Rhineland: one might think of Bonn Münster and the Cologne churches of St Gereon and St Severin, where square towers project north and south from the junction of the choir and apse, or Boppard, where the towers are in transeptal positions, or Speyer Cathedral, where towers are tucked in between the transepts and the apse, flanking the barrel-vaulted straight bays of the choir.

Southern Germany provides better and more historically pertinent comparanda. Appropriately, the church of St James at Regensburg, the Irish Benedictine monastery with which Cashel was associated, has a pair of square towers at its eastern end (see **Fig. 62**). These towers, which are connected to side aisles, have small apsidal chapels projecting from their eastern walls at ground level, and they flank a square chancel from which another apse projects. Unfortunately the towers and chancel are all that remain of St James's earliest, pre-1120, phase; the apse is a mid- to late twelfth-century replacement of an original, and the church's nave, which is famous for a spectacular north portal, is also post-1150 in date.[62] The towers of St James's are slightly atypical in their southern German context in that they lack those distinctive 'Lombardic arcades' – rows of small arches which spring one to another but have no supporting jambs or responds – which are found widely within the region and which probably reflect the influence of such northern Italian buildings as late eleventh-century Sant' Abbondio in Como. But, that absence aside, the *Jakobskirche* towers are fairly standard. Within the diocese of Regensburg itself we can parallel their shape, their flanking of a chancel, and their apsidal chapels, in the early twelfth-century (and still fairly intact) churches of Prüfening, located on the west side of Regensburg, and Biburg; in these two churches the paired towers stand proud of transept arms on their western sides. There is another, slightly later but still early twelfth-century, example of the same thing at Windberg, east of Regensburg; it is probably a co-incidence that the north portal at Windberg has a man attacking a lion, which is comparable with the man attacking the centaur on the north portal at Cashel.

The manner in which the towers in these southern German churches are visibly on the same plane or, to put it a different way, are visibly connected to each other by a wall behind (on the west side of, in other words) the projecting apses, is a feature which we can parallel at Cormac's Chapel. This, combined with their chronology, strengthens the case for identifying the Cashel towers as an element of southern German origin, accommodated within the chapel's architecture because they suited the building's ritual needs and evoked the homeland of the Ratisbon Benedictines. It is surely not too far-fetched to imagine Cormac, some masons, and the Germans, actually engaged in discussion at the site about suitable architectural strategies, and coming up with the building we see today. If such discussions of this nature took place, somebody in the group must have argued successfully against giving apsidal terminations to the towers and chancel as are found in southern Germany.

The identification of a German origin for the Cashel towers by-passes England. Champneys had actually suggested an English Romanesque origin for the Cashel towers, citing as parallels the massive twelfth-century transeptal towers of Exeter Cathedral (**Fig. 80**), as well as the towers which he understood to have

flanked the nave of the Anglo-Saxon cathedral of Canterbury.[63] In early twelfth-century Hereford Cathedral there may have been a pair of towers rising, German Romanesque-like, above the easternmost bays of its choir aisles; significantly, the bishop of Hereford from 1079 to 1095 was Robert de Losinga, a Lotharingian, who erected the *doppelkappel* known as the Bishop's Chapel.[64] Also from Lotharingia was the first bishop of Salisbury, Herman, under whom the eleventh-century cathedral at Old Sarum was started.[65] Clapham suggested that towers stood above its transepts but his argument seems to be based on a misunderstanding of the evidence.[66] These English Romanesque examples notwithstanding, the connections between Cashel

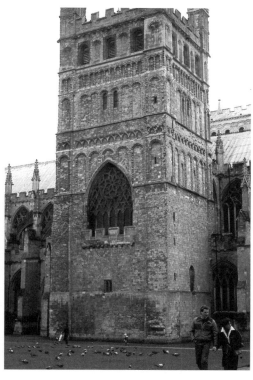

80 The south tower at Exeter Cathedral.

and Regensburg leave us little reason to posit England as the direct source of the Cashel towers or even as a staging post in their transmission between Germany and Ireland. This interpretation does not deny the possibility that English masons, under instruction, actually participated in building the towers.

The vaulted church

We have already noted that two vault types were used in the lower parts of Cormac's Chapel: a barrel vault spanned by plain-section transverse arches in the nave, and a simple four-celled rib-vault in the chancel. The latter is easily contextualized: the rib vault appeared in English Romanesque architecture at the end of the eleventh century, quickly achieving popularity for its aesthetic and technical virtues, and eventually facilitating (in combination with other aesthetic elements and technical advances) the creation of Gothic architecture.[67] In addition to Durham, which was vaulted throughout (**Fig. 81**), major pre-1130 examples in England include Lindisfarne, Peterborough, Gloucester, Romsey and Winchester.[68] Cormac's Chapel's rib-vault was conceived and begun in the later stage of this generation. It keeps impressive company (**Fig. 82**). Anglo-Norman hands must have erected it.

Given the unmistakably English Romanesque character of the chancel vault it is something of a surprise that one enters that chancel having walked under a

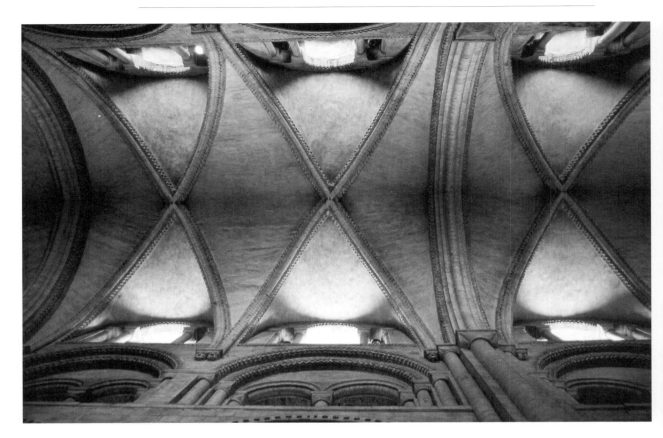

81 The vaulted roof of Durham Cathedral.

nave vault of different pedigree and character. Such barrel-vault/rib-vault combinations were used only occasionally in Norman and English Romanesque contexts. Françoise Henry had no difficulty ignoring England and Wales, then, and scurrying to France for suitable parallels. She might even have looked to eleventh-century Rhineland Germany: Speyer Cathedral has, at the west end of its eastern arm, two barrel-vaulted bays which are marked off with square-sectioned pilasters and transverse arches, and which have a wide cornice around the wall at the point where the vault springs; St Maria im Kapitol, Cologne, to cite another example, has barrel vaults over the intermediate bays of its apse. But these parallels notwithstanding, the very fact that barrel-form high vaults were used in English Romanesque contexts, even if sparingly, should make it the first suspect in the search for origins.

Before turning to Normandy and England, a word about the Continent. The idea of a barrel vault supported by transverse arches found an early and most elegant expression in the ninth-century architecture of the kingdom of Asturias in northern Spain.[69] At Santa Maria de Naranco near Oviedo, a royal hall of c.850 which is one of the glories of Asturian architecture, the springing of the vault is

marked by a string-course, as happens in eleventh and twelfth-century churches, but the transverse arches which spring from the same string-course are not otherwise supported. By contrast, in the great majority of Romanesque barrel-vaulted churches with transverse arches the arch supports extended down to ground level, thus uniting the vault and elevation in a single articulating scheme and, at the same time, creating bay-divisions. The architectonic link between

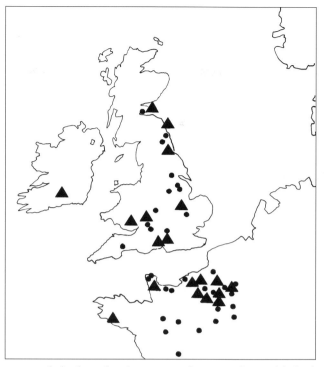

82 Distribution map of twelfth-century rib-vaulted buildings in north-west Europe. Large triangles are examples pre-1140.

the vaults, its arched supports and the bay-dividing verticals was only established at the end of the eleventh century but continued as a rule thereafter. There are several ways in which this architectonic link is executed, though it should be noted that these ways are not exclusive to barrel-vaulted churches but are also found in groin-vaulted and rib-vaulted churches where there are transverse arches. In aisled churches, where the walls of the central vessel are perforated by arcades, two schemes are employed. The commoner of the two has the vertical support grafted onto the arcade piers and continuing straight down to ground level, thus giving the main arcade support itself a form which we describe as composite, as for example in the great galleried churches of the pilgrimage roads, such as Saint-Sernin, Toulouse. In the second scheme, the pilaster or engaged column or shaft support is carried down onto the impost between the arches of the main arcade, and while it is discontinued, its line is continued by the arcade verticals: a good example is the choir of Saint-Eutrope, Saintes, where both short engaged columns or shafts between the impost of the large arcade and a string-course marking the springing of the vault support the transverse arches. Henry actually compared Cormac's Chapel's articulation to that at Saint-Eutrope,[70] but because the Irish building is not aisled its transverse arch supports sit on a string-course about half-way up the wall, their line not continued down to ground level by ribs or shafts.

We can return now to the Norman and English Romanesque worlds. While

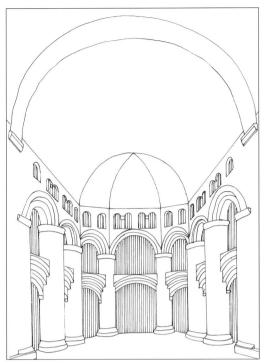

83 Philip McAleer's suggested reconstruction of the east end of Tewkesbury abbey church.

barrel vaulting is found there, it is by no means a typical feature of their traditions.[71] Small barrel vaults were sometimes used over small spans in large churches, as in the south porch of Southwell Minster or in the entrance bay of the south transept chapel of Tewkesbury Abbey, or covering main spaces in relatively small churches, such as the parish church of Kempley. But it is the use of barrel vaults over main spaces within the churches – as high vaults, in other words – which concerns us most.

In Normandy a transeptal barrel vault in Mont-St-Michel is clearly original to that later eleventh-century church, and it might be assumed safely that the eastern end of that church, rebuilt in the later middle ages, had a barrel vault as well; no other barrel vault in the broadly-defined Norman realm is earlier. It has been suggested that originally there were barrel vaults over the nave of St Pierre in Jumièges and over the choirs of Notre-Dame in Jumièges, Bernay, and St Vigor in Bayeux,[72] but the evidence is very slender indeed. Moving to England, the entire length of the late eleventh-century St John's chapel in the Tower of London, erected by William I, is covered by a barrel vault (although, curiously, a groin vault was used instead in the near-contemporary chapel in the great tower of Colchester Castle, also built by William), and parts of the fully-vaulted Bishop's Chapel at Hereford may also have been barrel-form.[73] Most importantly, there were evidently barrel vaults over much wider spans in the eastern arms of Gloucester Abbey (later Cathedral), Tewkesbury Abbey, and Pershore Abbey.[74] The barrel vaults here might best be understood in terms of their builders' familiarity with French – France outside Normandy, that is – architecture; their appearance in England at Gloucester and Tewkesbury (**Fig. 83**) might be related to the use in both buildings of the giant order, a tall columnar pier rising through two storeys of an internal elevation.[75]

There is no reason to think that the builders of Cormac's Chapel's vaults were French or were drawing on French exemplars when they worked on its nave, or even that they were Norman and were looking to Normandy. Rather, those

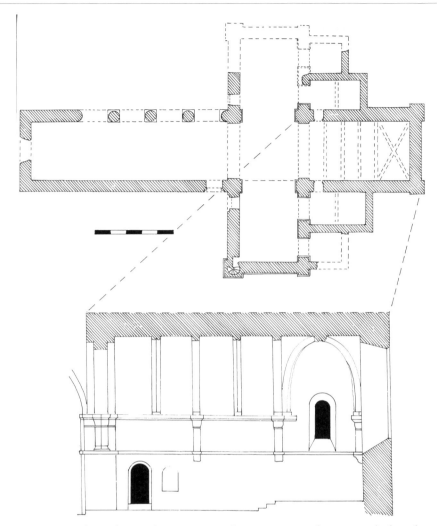

84 Plan of Ewenny priory church, and cross-section of the chancel looking east. Scale bar for plan = 5m.

builders must have been the same Anglo-Normans who erected the chancel vault and who probably also helped to build the towers. Where in the English Romanesque world did these masons come from? Where had they worked previously? What English Romanesque buildings did they know? It is in the nature of this type of enquiry that we cannot answer the first two questions, but we can suggest an answer for the third. They either knew the Benedictine priory church of Ewenny in South Wales, or they knew the building on which it was based.

Cashel, Ewenny, Old Sarum

Ewenny, probably built between 1116 and 1126,[76] is located close to Bridgend on the north shore of the estuary of the Severn river, so it had a geographical connection with the two great Romanesque centres of Gloucester and Tewkesbury,

a point which is worth memorizing at this juncture. The church has a Cistercian plan of that so-called Bernardine form which we discussed earlier, with a square-ended chancel flanked on each side by two square-ended chapels (**Fig. 84**, *top*). The nave and transepts were roofed in wood but the chancel or presbytery was vaulted in a pattern comparable with that at Cashel:[77] barrel vaulting covers the two western bays of the choir and rib vaulting covers the eastern bay, and the barrel vault is supported by ribs of alternating square and moulded profile, springing from short engaged twin shafts which stand on a string-course but do not continue down any lower as articulating members (**Fig. 84**, *bottom*).

A close study of the proportions of Ewenny's church reveals that while it is largely of one period,[78] actual building campaigns can be isolated. The entire church was laid out using 1:√2 rectangles, with the chancel laid out as one unit, but an alteration to the west sides of the north and south crossing arches[79] suggests that the nave and chancel were started simultaneously, and that the transepts were slightly too narrow to carry the crossing arches without some alteration slightly higher up. On this evidence it appears that the Ewenny church was more or less as it is today – minus some fifteenth-century and later additions – when it was dedicated by Bishop Urban. The Ewenny vaults were therefore extant, and the liturgical spaces beneath them in use, by the time Cormac had returned to Cashel from Lismore.

Although the evidence indicates that Ewenny is the earlier building, we cannot identify Cormac's Chapel as being in any way its copy or, to use Leask's preferred word in such instances, its 'derivative'. Yes, there are positive comparisons, but they are middle range. The differences between the two churches are at macro- and micro-scale, and these matter hugely in determining the relationship. At macro-scale, we have seen that the two churches are very unlike: one has Cistercian-like regularity, the other is irregular in many regards and seems almost wilfully idiosyncratic. At micro-scale, the Cashel chancel vault-ribs have thick roll-mouldings on their soffits, which is quite widespread within Norman and English Romanesque work, but at Ewenny the comparable rib soffits have twin rolls separated by narrow fillets, which seems to be a less common type (**Fig. 85**). Another significant difference at micro-scale is the orientation of the supports for the ribs. At Cashel they are aligned along the walls of the chancel: in other words, the abaci of the capitals immediately under the ribs are parallel and at right angles to the side walls. In Ewenny, by contrast, the ribs are supported at the east wall of the chancel by short engaged shafts, with the abaci of its capitals at 45° to the side walls; in other words, the rib supports face diagonally across the chancel.[80]

These differences mean that we should probably consider Cormac's Chapel and Ewenny priory church as parallel developments from some core idea of vaulted space which was executed elsewhere, possibly in more than one building,

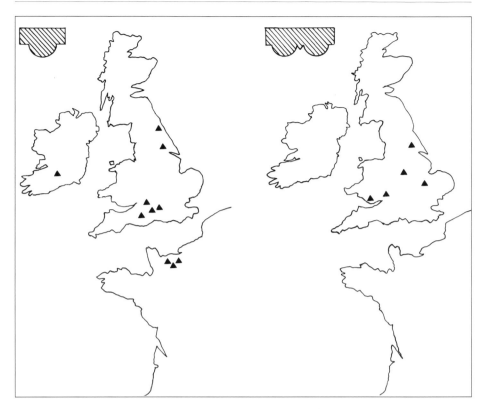

85 Distributions (provisional) of soffit-rib profiles of Cashel type (*left*) and Ewenny type (*right*).

and probably at a larger scale. We do not know which English Romanesque building or buildings may have been the source or sources, but we can probe the issue a little deeper by going back to some first principles in English Romanesque architecture.

Churches in this tradition are distinctive above all else in having elevations comprised of main arcades, triforia and clerestoreys. The earliest churches of the tradition had well-articulated elevations though apparently no vaulting. The evidence of Durham, where no provision was made at the outset for vaulting the nave and transepts but where they were vaulted very shortly afterwards, would suggest that technical difficulties inhibited the earliest architects. Even in the second and third generations of English Romanesque churches few attempts were ever made to vault nave spans; the mighty cathedrals of Peterborough and Ely, for example, were left with timber roofs. Vaulting seems not to have been a prime objective of most English Romanesque architects, except when they were building choirs. Now, of all three basic vault types – barrel, rib and groin – which were obviously available to English Romanesque builders who chose to vault main spans, the barrel vault seems to have been the least compatible with the tripartite arrangement of the side walls. First, a barrel vault exerts continuous and regular

pressure along the lateral walls into which it is grouted. If built above a clerestorey such a vault would be too high to support and would be in constant danger of collapse. Secondly, there is frequently a wall passage running through the clerestorey embrasures. This is facilitated by making the wall very thick; this is what Jean Bony described as the *mur épais* or 'thick wall' technique.[81] A barrel vault might be secure if built on a 'thick wall' which has no passage, but the *raison d'être* of the 'thick wall' is the passage. The only practical means of combining a clerestorey with a barrel vault is to remove the middle (triforium) stage of the elevation, or to cut the clerestorey windows through the vault, as at Payerne in Switzerland. Given these conditions, it is hardly surprising that barrel vaults are most frequently found in so-called 'hall churches,' churches without clerestoreys in which the principal lighting is supplied from the side aisles or the end walls.

Neither the Cashel nave nor the Ewenny choir possesses clerestoreys, but the walls supporting the vaults in each are divided into two zones, the upper zone containing in each case the engaged shafts from which the transverse ribs spring, while the lower wall is blank at Ewenny and arcaded at Cashel. In possessing both transverse arches across the vault surface and zones of engaged shafts to which the arches are attached halfway up the walls, the Cashel nave and the Ewenny choir possess a monumental character suggestive of a derivation from actual multi-storeyed elevations. Thus, in both structures the lower zone might be equivalent in its location and relative dimensions to the area of open arcading in a larger church, while the zones of engaged shafts might be considered equivalent to a triforium.

The destruction of the barrel-vaulted (or putatively so) sections of the great churches of Gloucester, Pershore and Tewkesbury, all located within the same Bristol Channel/lower Severn valley region, means that we will never identify the sources for Cashel or Ewenny, and will never know how these two remarkable buildings relate to each other. The best candidate among these for Ewenny's sources is certainly Gloucester, of which it was a priory: for example, the ambulatory of Gloucester has stumpy columns and square-sectioned soffit arches very similar to those in Ewenny's nave. If Ewenny's east end helps in the reconstruction on paper of Gloucester's original choir and presbytery high vaults, Cashel's vaulting may be a clue to the original form of vaulting in one of the *other* churches.[82]

Perhaps the most important building in understanding the myriad connections between the Welsh and south-western English Romanesque churches themselves, between Cormac's Chapel and the English Romanesque, and indeed between the whole Irish Sea area itself and both Normandy and Germany, is the one about which we know the least: Old Sarum (**Plate 5b**).[83] The fragmentary ribs which survive from early twelfth-century Old Sarum Cathedral are of the same

type as those at Cashel, and it shared with Cormac's Chapel the use of decorative stone rosettes, trefoil-shaped shafts, and a shallow east-end altar projection.[84] Is it possible, then, that Cormac Mac Cárrthaig, seeking an appropriately foreign-looking architecture for his chapel, called on Roger, bishop of Salisbury from 1102 to 1139, for masons to assist his project? Roger was a man of considerable wealth and enormous political power, and his buildings, which included castles as well as churches, were praised for their high quality in contemporary commentaries.[85] The evidence of Roscrea, discussed in the next chapter, lends modest support to this idea.

CHAPTER 5

From Ardfert to Ardmore: the Romanesque century in Munster

We noted in Chapter 1 that Canterbury was excluded from the Synod of Cashel in 1101. It is impossible to know what would have been the stylistic consequences had that not been the case. Even if Anselm himself had attended the synod Cashel would never have possessed a church comparable in scale and style with, say, Canterbury's St Augustine's Abbey, but it is tempting to conclude that in following its own independent path at that critical moment the Gaelic-Irish Church nipped in the bud any drift towards an explicitly English Romanesque architecture for its reform-era churches. Cormac's Chapel is perhaps as near as any Irish church of the period comes to 'being English', but its English Romanesque points of reference are in the West Country rather than eastern England where Canterbury is located.

The building of Cormac's Chapel must have involved some input from masons from the Anglo-Norman world, but uncertainty surrounds them; we know nothing of their number (although they were probably no more than a few in number), their communication with Cashel prior to the commission, the conditions of their contract, the hierarchy of responsibility among them, or the duration of their stay in Ireland. Nor do we know how and from where Cormac knew their work or the work of other English Romanesque-trained masons. We raised the possibility that he actually sought such men from Roger of Salisbury, but it is not inconceivable that he had simply seen work by Anglo-Norman masons somewhere in Desmond in the mid-1120s, or maybe further afield within Munster, and that this alerted him to what they could offer his project and to the kudos which could accrue from having their type of work on display at Cashel. Suffice it to say here that we will see below that Ardfert's Romanesque Cathedral might well pre-date Cormac's Chapel and may also be the work of Anglo-Norman hands. But whether the masons Cormac employed were already working on the

166

island or came here especially for his job, we do at least know that they would have travelled to and from Cashel over land – there is no river there – thereby passing through other Christian communities in Munster. One wonders what they saw on their travels and what they made of it, and how that experience armed them for their commission at Cashel.

After 1134 these masons no longer register with any clarity on our radar screen. One possibility is that they had returned to England by 1134: the parts of Cormac's Chapel which required their expertise would surely have been completed by 1131 or 1132. Another is that they, or some of them, headed north to Roscrea. Alternatively, they (or, again, some of them) stayed within Cormac's commission and headed down to Cork to work on Gill Abbey, a house of Augustinian canons which he established after the consecration of his eponymous chapel in Cashel. Six finely carved heads comparable with those in Cashel have been identified from this site.[1] That a small cache of high-quality stone heads should be the main survivals of a twelfth-century church is fairly remarkable, and suggests perhaps that they were carved in Cashel rather than Cork, and then transported south.

If Anglo-Norman masons from the Cashel job worked at Cork or Roscrea after 1134 they may well have simply stayed in Ireland, drifting into the slowly-developing world of Romanesque church-building elsewhere on the island by locating themselves in masons' yards, familiarizing local craftsmen with forms and techniques, and taking commissions wherever they could. This could explain the carved details at other churches in Munster, notably Kilmalkedar, which are broadly comparable with those at Cashel. Whatever their fate, we should recognize that work opportunities for such masons with their particular stone-carving skills were relatively few and far between in the Ireland of the 1130s and 1140s. There were burgeoning Romanesque traditions in west Kerry, in the lower Shannon region, in the Lismore district, and in south Leinster,[2] but nothing compared with England, where new parish churches and established abbeys and cathedrals provided steady employment. Moreover, to our knowledge there was no single medium-term or long-term project in Ireland which offered the type of challenge which Cormac's Chapel offered.

ROMANESQUE LISMORE AND ITS AMBIT

Founded by Mo-Chutu/Carthach after he had been expelled in 636 from Rahan, Lismore was one of the most powerful of the early monasteries in the south, with a scriptorium and an ascetic tradition which contributed to the Céli Dé reform.[3] Its history as a diocesan centre after Ráith Bresail is entwined with that of Waterford, the old Hiberno-Scandinavian see, but its status as a premier league

centre for the reform of the Gaelic-Irish Church was not diminished by that. On the contrary, it had very strong connections with key people and key places of the reform era.[4] After he died at Ardpatrick in 1129, Cellach, archbishop of Armagh, was buried by his own request in Lismore, and Malachy, Cellach's chosen successor in Armagh, had two sojourns in Lismore, during the second of which (1127) he had the temporarily-exiled and now-tonsured Cormac Mac Cárrthaig under his wing. It is fairly certain that Cormac built a church or churches at Lismore, but the sources are confusing about the date and the number: 1126 or 1127 seems to be the date, but the number given in the Book of McCarthy is twelve, and this must be an error. The uncertainty over the date means that we cannot say whether Cormac provided for a church (or churches) before his exile in Lismore, or when he arrived there, or as a gift to the monastery immediately after he returned to Cashel. But whatever the case, it is certainly apparent that acts of church-foundation in places other than Cashel were on Cormac's mind in the mid-1120s.

If the historical material draws Lismore into the discussion of reform-era Cashel under Cormac's rule, other historical material highlights Lismore's connections with Kerry. Lismore's founder was a Kerryman, as were its pre-reform abbots. Gille Críost Ó Conairche, its bishop and a papal legate from 1152 to 1179, was also from Kerry, retiring to Abbeydorney, a Cistercian house near Tralee, where he later died; Domnall Ó Connairche, a kinsman, died as bishop of Ardfert in 1193. Furthermore, the entries in the Annals of Innisfallen concerning the period 1092–1130 suggest Lismore as its place of compilation.

Lismore is the unknown quantity in assessing architectural and sculptural developments in early twelfth-century Munster. Very little remains there from the early twelfth century, which is hugely unfortunate given those links with Kerry where there is Romanesque work from the first half – if not the first quarter – of that century. The present Lismore Cathedral is largely a work of the seventeenth century (and, appropriately, is of great importance for the archaeology of that particular period), but the crossing preserves thirteenth-century responds and arches, and the chancel may preserve twelfth-century fabric, to judge by the two fragments of twelfth-century painted plaster recovered from the north side when a doorway was being inserted in 1989.[5] The painted plaster might be late twelfth-century in date: in 1171 Henry II stayed in Lismore before travelling to Cashel, and Stalley's attribution of the painted plaster at Cormac's Chapel to the king's visit might equally apply to Lismore.[6]

A number of *ex situ* items of architectural sculpture are preserved in Lismore Cathedral, and they are interesting enough to merit description and discussion here. One is a fragment of an engaged shaft, which is undateable except to within the twelfth century. There are two fragments of capitals. One of these is a

scalloped form with a voluted angle, its scallops outlined with incised arcs like those scalloped capitals in Cormac's Chapel, while the other is a quarter-sphere with very fine foliage decoration which was carved as one piece with its half-column; this latter capital form is similar to those used in the lavabo in Mellifont around 1200, but the south window of the nave of Templenahoe in Ardfert provides a better (and more obviously relevant, given what was noted about Kerry) parallel. Finally, there is an impost with two rows of chequer-board billet and six bosses connected by scrolls. This is a particularly important piece: billet is not a common device in Ireland, but it turns up elsewhere in Lismore in an early twelfth-century context (see below) so that might be the correct date for this feature. The scrolled bosses are better paralleled about the 1150s; they were a feature of the west portal of Aghadoe church and of the cornices of Templenahoe at Ardfert.

86 Lismore Cathedral, *ex situ* figure. Scale bar = 20cm.

The most impressive Lismore sculpture is of a seated figure holding open a book on its lap, with a badly-defaced inscription facing outwards to the viewer (**Fig. 86**). Christ is the obvious identification, not least because he is so frequently represented as carrying a book in eleventh- and twelfth-century art, but the absence of a halo on the Lismore figure as it appears today – it could have broken off – raises doubts. The inscription on the open book was identified by Macalister as having mixed capitals and half-uncials arranged in four horizontal lines and reading as follows: IN ME(N)SAM DOMINI IERUSALEM DET ARMA ET CORONOS AUR(I) [UPON THE TABLE OF THE LORD LET JERUSALEM LAY (HER) ARMS AND CROWNS OF GOLD].[7] The inscription is now so illegible, with no more than a few letters from any of the lines still visible,[8] that we are left to trust Macalister's reading, even though it is scarcely believable that he saw all the letters he claimed. The date of this remarkable sculpture is uncertain, but the treatment of the hair points very tentatively to the twelfth century. Another factor which might point to this period is the curvature of the top of the sculpture: if this is an actual feature of the sculpture rather than later damage it suggests that the figure was originally displayed under an arch, which would probably rule out a date before the eleventh century. Where might it have been displayed? The likelihood is that it was associated with an entrance, either on a façade or as part of a portal. The curvature of an arch, combined with its

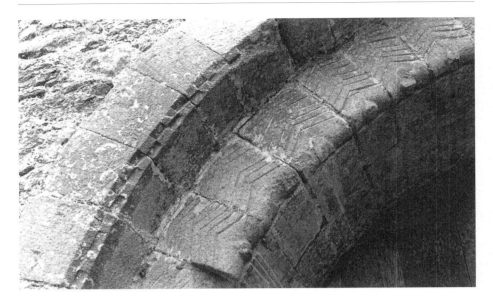

87 Detail of the gateway arch, Lismore Castle.

height of 58cm, suggests that it was enframed. It could conceivably have been the central part of composite tympanum.[9]

The principal twelfth-century architectural relic at Lismore is a wide, two-ordered archway at the entrance to the castle. Its original provenance is unknown, though it has been suggested that it came from a building in a cemetery area close to where it is now located.[10] Whatever its original context – and this is assuming that the two orders were originally together on the one feature – it was quite substantial: the inner order is 2.6m wide, suggesting a chancel arch inside a church, or maybe a gateway arch into an enclosure. In fact, its use today as a gateway arch, albeit in a seventeenth-century setting, might not be a coincidence.[11] The features of the arch (**Fig. 87**) allow us suggest a probable date for it before 1150. Its inner order has moulded chevron winding along the arris; comparable chevron can be found in many English Romanesque churches of the early 1100s.[12] In a departure from the most frequent English Romanesque practice, tiny zoomorphic or anthropomorphic figures occupy the small spandrels, and incised lines form chevron shapes on the archivolt. The arch responds have roll-moulded corners. The outer arch has a narrow chamfer filled with two rows of chequer-pattern billet ornament made by cutting into the chamfer at angles, a technique also used in Cormac's Chapel. The two rows of billet on an outer order of an arch is not uncommon in England in the early twelfth century.[13] This archway seems a good candidate for a work of Cormac Mac Cárrthaig patronage.

These scattered fragments at Lismore are all that remain of a monastic site and diocesan centre which allegedly had 'at least twenty' churches,[14] among

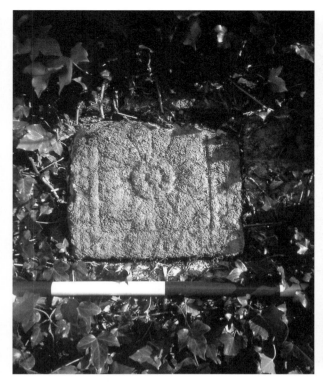

88 The Kilmolash rosette.

89 The Coole rosette.

which numbered one or two Cormac Mac Cárrthaig churches and a cathedral. One observation worth making about whatever stood here in the twelfth century is that it was different in at least some respects from Cormac's Chapel: none of these items looks like it came from a building which was similar to the Cashel masterpiece, and that is particularly the case with the castle gateway.

Important hints at what might be missing from Lismore are provided by the fortuitous survivals of stone-carved rosettes at Kilmolash (**Fig. 88**) and Coole (**Fig. 89**), two important rural church sites.[15] Kilmolash, several miles east of Lismore, is an ancient site, with an ogham stone incorporated in the fabric of its church. Now ruined and somewhat neglected, this church has a nave which is largely late medieval in date, and a chancel which may be twelfth century in date apart from its east wall. That this site falls within Lismore's sphere of influence is indicated by its abbacy being possessed in the tenth century by an erstwhile bishop and vice-abbot of Lismore. Coole is also an ancient site, honoured (allegedly) with possession of one of St Patrick's teeth. There are two churches here, a couple of hundred metres apart. The larger, 'Coole Abbey', has a nave, internally 10.65 by 7.46m and with antae, which may have been a single-cell church in the pre-Romanesque period. There are basal stones of a simple doorway with roll-moulded jambs in the west wall. The chancel dates from the

thirteenth century but with later alterations; the very fine stonework of its chancel arch is consistent with the possibility that there was a relic here.

We noted in the previous chapter that rosettes are found in English Romanesque contexts, especially in the West Country where their chronological horizon is the early twelfth century. In Ireland they are features of the north portal at Cormac's Chapel and of the early twelfth-century portal and rebuilt upper parts of the contemporary façade of Roscrea, discussed below. Unfortunately, neither the Kilmolash nor Coole rosette is *in situ*.

The latter was used as a part of the fabric of the external east wall of the chancel, and luckily for us it was used facing outwards. Carved naturalistically and in strong relief, it invites comparison with the rosettes at Cormac's Chapel and Roscrea and is probably of the same general, *c.*1130, date; moreover, it is carved on a rectangular block of stone without a frame, suggesting that it was originally displayed as an isolated item of sculpture on a blank area of ashlar walling, which is the case with the rosettes at Cormac's Chapel.

The Kilmolash rosette is a more difficult proposition. Rendered in low relief, the flower was carved onto a square block of stone and was highly stylized within a frame of beads. Clearly this stone was part of a larger sculptured composition, and there would probably have been at least one more stone bearing the same design. A date contemporary with the other rosettes is not so obvious here, as beading seems to be a feature of work of the middle of the century – it is found on the portal at Aghadoe, for example, dating from the 1150s – rather than the period around 1130. The nearest, though rather inexact, comparison in Ireland for the Kilmolash rosette is, perhaps significantly, in Kerry, on the interior of the south window at Templenahoe, Ardfert, a building which is closer to 1150 than 1130 in date.

While we cannot attribute the Coole and Kilmolash carvings to the one workshop, their location close to Lismore must be significant. Their very existence is surely consequent on Lismore's prominence as a site of patronage, and they suggest that rosettes were used on some church at Lismore. Here, then, was stone-carving activity as early as that in Cashel. How can we contextualize it within early medieval Munster? The evidence which survives constitutes too shaky a foundation on which to construct a model, but with some archaeological and historical evidence directing us northwards towards Cashel, and other evidence directing us to Ardfert, another place with work of the early 1100s, Lismore and district emerge as a sort of common denominator, the axle in a two-spoked wheel. Whatever the actual historical development of twelfth-century architecture and sculpture in southern Ireland, it is apparent that Lismore had a huge role in it.

ARDFERT AND ROSCREA CATHEDRAL FAÇADES

Two churches which Leask described as 'derivatives' of Cormac's Chapel are Ardfert Cathedral and St Cronan's in Roscrea.[16] Neither is intact, but, happily, their façades – their western or *front* walls – remain. Ardfert's is contained in the west wall of a thirteenth-century cathedral, while Roscrea's stands as an isolated wall at the side of a road close to the centre of the modern town. These are remarkable survivals, every bit as important in architectural history as Cormac's Chapel.

Before considering these two façades we should first reflect on the notion and function of the façade itself. The east end of a medieval church was, as a general rule, the main focus of liturgical activity. It was normally the end at which building construction began, so that Mass could be celebrated as early as possible, and often it alone was affected by 'modernization' in the succeeding Gothic style, as for example at Le Mans and Durham Cathedrals, to select but two. But the opposite end, the west end, was no less the subject of functional requirements and aesthetic desires. The pattern of placing the principal altar at the east end was established as early as the fifth century, but from Carolingian times onwards it was common for the builders of the largest churches to incorporate liturgical space within the west ends of their churches by the provision of chapels in towers and transepts. Moreover, of the external elevations of churches the most important aesthetically and iconographically, certainly by the Romanesque age, was the west façade. It was the face the church presented to the on-coming worshipper and thus to the outside world, and this role as the 'front' of the church is reflected in architectural and sculptural embellishment which is often richer than on any of the other church walls.

Fundamental to the inherent symbolism of the west façade as the front of the church is the fact that the church is usually entered through it, and it seems a fair judgement that portals and other elements of façade composition were conceived and arranged to be in harmony with each other and with the façades according to aesthetic and philosophical principles.[17] When the portal dominates the west wall, as it does in Ireland, it is because that wall is not embellished in a way that might draw the visitor's eye away from the entrance; in its turn, the visual impact of such a wall is enhanced by its starkness and particularly by its contrast with the portal. This pattern of a decorated portal in a plain façade is so ubiquitous in Ireland that each exception to it – the cathedrals of Ardfert, Roscrea, and Ardmore – represents the conscious decision of a patron to break with fashion. Yet, in stressing the relative importance of the portal in Gaelic-Irish Romanesque, few writers on the Irish material have commented on façades either as settings for those portals or as intrinsic elements of church design.[18] So, while the façades of Ardfert and Roscrea have long been

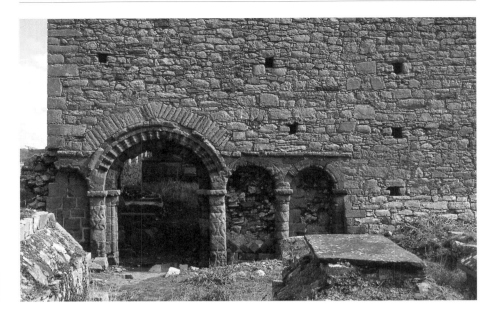

90 Ardfert Cathedral Romanesque façade, prior to conservation.

identified as crucial to any narrative on Romanesque Ireland, published commentaries on them have treated the west wall placement of their articulating, non-structural, decoration almost as if it were incidental.

The Ardfert façade (**Fig. 90**), originally a little over 9m wide, had five bays, with two bays of blind arcading flanking the portal on each side. The portal and the two bays on the south side remained in good condition into the modern era, although there was some breakage of parts of the ashlar facing within the two bays; only the inner arcade survived on the north side. The upper parts of the west wall of the cathedral may incorporate fragments of twelfth-century fabric, including one blocked window.

The portal, with the central door opening measuring 1.55m in width and 2.0m in height to the top of the impost, has two orders, of which the outer (which could be described as a 'pilaster respond' because it projects outward, pilaster-like) also frames the two innermost blind arcades of the façade. The inner responds have clusters of three shafts on their inner faces, and the associated arch-ring has archivolt saw-tooth chevrons with lozenge-and-bar on its soffit. Separating the uprights from the inner arch-ring are scalloped capitals with astragals, and chamfered imposts with quirks on the fasciae and billet ornament in the chamfers. The outer order has no capitals but has imposts which continue the line and the form of the imposts of the inner order, and archivolt saw-tooth chevron on the arch-ring. The outer faces of the pilaster responds are decorated with two rows of incised chevron, and these define lozenge shapes on the central faces of the two pilasters. Some of the stones here have clearly been moved around

at some stage; one of the stones (on the south side) even appears to be decorated on its outer face not with lozenges but with closely-set concentric circles; could this have been a sculpture similar to the tightly-circled maze enclosing a small unidentified animal on the north side of the base of the High Cross at Cashel? The bases of the inner order of the portal have multiple tori and spurs.

The portal has a hood moulding above it: this has the same profile as the imposts of the capitals below, except that it lacks billet. Above the arcades on either side is a horizontal string-course with a similar profile. The two arcades immediately flanking the portal contain ashlar blocks above diaper work (courses of small square stones in a diamond formation). The bay to the north of the portal preserves much of its fabric: there were six horizontal courses of ashlar above two full and two half courses of diaper, and that in turn was laid above an interlace-decorated pre-Romanesque cross shaft. The bay on the south side had blocks of cut stone at its base, with fragments of original diaper preserved above them. The outer bay on the south side contains nine courses of ashlar; the equivalent bay on the south side was destroyed during the middle ages. The arches over the two inner bays are chevron-decorated, while the outer bay arches simply had roll mouldings flanked on both intrados and archivolt by double quirks.

A half-column decorated with chevron separates the two southern bays. The half-column rises from a base with scotia-and-torus mouldings. At the top of it is a scalloped capital with an astragal and with a chamfered impost which has a quirk on its fascia and billet in its chamfer. The original equivalent vertical member on the north side is destroyed but a base survives: this was of the same type as on the south side of the inner order of the portal, but was designed for a respond or pier with a cluster of four shafts rather than three. The outer bay on the south side has a simple respond with a roll moulding at its southern end. The moulding terminated at the top in a small capital of cushion form, and terminated at the bottom in a small base with a scotia. Above the small capital is a chamfered impost with a quirk on the fascia and a chamfered lower edge.

The overall affect at Ardfert Cathedral is of a façade design which becomes less elaborate as it moves away from the portal towards the edges, and which might – but this may be a consequence of later alteration – make some distinction between the left (north) and right (south) sides.

The five-bay west façade at Roscrea (**Fig. 91**) is all that remains of a church 10m wide and of unknown length. It is preserved much as it was in the twelfth-century, with the gable alone being of later date. At its edges are antae with roll moulded corners; these are twelfth-century antae rather than survivals from an earlier church. Between the antae and the central portal on each side are two blind arcades under pediments. The arcades are grouped in pairs, as at Ardfert, but, in a reversal of the Kerry church's scheme, the innermost bay on each side has the

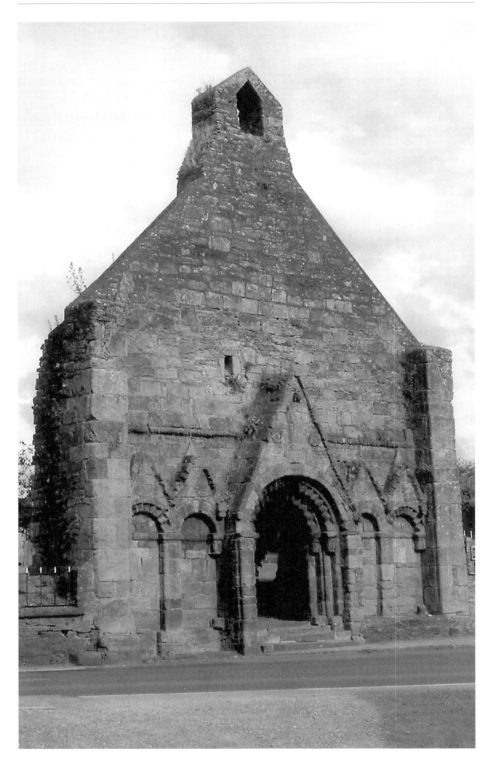

91 Roscrea Cathedral Romanesque façade.

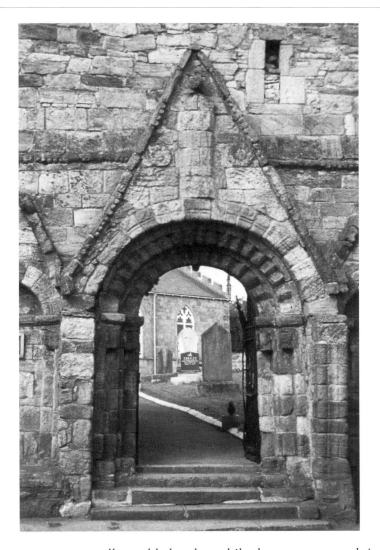

92 The portal and pediment figure, Roscrea Cathedral.

simpler treatment – a roll-moulded arch – while the outermost arch is embel-lished with archivolt chevron. Each pair of arcades is divided by an upright member with roll mouldings defined by double quirks. There are no capitals, but imposts run right across the bays at arch-springing level. The outermost responds of each pair of arcades (the responds at the antae or at the portal, in other words) have head-capitals identical to those of the inner order of the portal. Above each arcade bay is a pediment defined by a single projecting moulding of projecting stone with intrados chevron. At the termination of each pediment is a stylized animal head.

The portal itself has only two orders proper, unless one counts the outer pilaster-responds which support its pediment. The portal's central opening is 1.9m

high to the impost and 1.5m wide. Between the two jamb orders were angle-shafts of which only the capitals survive: these are head-capitals, and the heads are clean-shaven. The two arches have archivolt saw-tooth chevron. The portal's pediment, which projects about 80cm forward of the wall, is outlined by a narrow moulding with bosses. Within the pediment is a standing figure, fully robed and possibly holding something at chest level (a book?); the details, alas, are very worn (**Fig. 92**). Flanking this figure are rosettes, one on each side.

Above the level of the portal and arcading, and separated from them by a string-course with bosses, the façade has clear signs of later medieval alterations. A small blocked rectangular window to the north of the portal pediment is set in masonry that may be late medieval. Directly above the pediment is a group of five rosettes arranged in a cross-shape, and higher up again are two isolated rosettes; given the apparently extensive rebuilding above the façade arcading these rosettes might not have been arranged in this manner originally. The façade is now crowned by a late medieval bell-cote.

How should we interpret these two façades? Let us address, first of all, the possibility that these are 'derived' from Cormac's Chapel. The principal reason for thinking that this is the relationship is the multiple arcading, not found anywhere else in Ireland other than on these three buildings. In the case of Ardfert, the lack of a pediment and the manner in which the arch of the portal interrupts the string-course above the flanking arcades are other similarities between it and Cormac's Chapel's arcuated exterior south wall. Also, the chevron types and triple-shafts at Ardfert were paralleled on Cashel's north portal, and the billet and its deployment on the impost is paralleled on Cashel's south portal. In the case of Roscrea, the three-quarter detached jamb columns, the archivolt chevron, the pedimented portal, and the rosettes can all be paralleled at Cashel. Moreover, the figure within the Roscrea pediment compares in style, if not also in iconography, with the figures on the twelfth-century High Crosses at both Cashel and Roscrea.

But if, in reconstructing connections, we regard overall composition as more significant than detail, Cashel is nudged out of the equation: in possessing five-bay façades Ardfert and Roscrea have more in common with each other than either has with Cormac's Chapel. So, if there is a pattern of derivation here, it is more likely from one of these to the other. Ardfert would seem to be earlier than Roscrea. The judgement is based on two factors, both circumstantial but together constituting quite a strong argument. First, the Lismore-Kerry corridor in the twelfth century suggests that Kerry was no backwater, far removed from the epicentres of reform thinking and architectural innovation. Second, Ardfert's Romanesque architecture, in contrast to Roscrea's, makes no obvious explicit reference to earlier Gaelic-Irish tradition.[19]

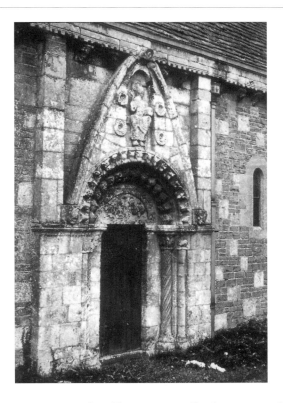

93 The south portal, Lullington church (photo: The Françoise Henry archive, Department of Archaeology, UCD).

Roscrea is no mere copy of Ardfert. Its overall scheme must have been built with some cognisance of Ardfert, possibly at the level of patronage, or possibly at the level of masons, but its proportions and details are sufficiently different for us to suspect other stylistic impulses at play. Aspects of the design of Cormac's Chapel, like its pedimented portal and rosettes, may have had an influence, a suggestion which presupposes that Roscrea post-dates the Cashel church. Alternatively we might look directly to England, and specifically to that same south-western province from which Cashel derived stylistic forms. The presence of a pediment figure flanked by rosettes connects Roscrea unequivocally to the south portal of the parish church at Lullington in Somerset, where there is an enthroned Christ-in-Majesty of French type accompanied by two rosettes on each side (**Fig. 93**). Leask knew of Lullington, and, with characteristically insular myopia, described its portal as 'almost Irish', while Stalley suggested that an Irish ecclesiastic might have seen it while travelling through England and used its doorway as a model for his own.[20] Stalley is certainly nearer the truth, but the relationship between Roscrea and Lullington is surely not the result of an accidental encounter. Lullington was one of the churches of Roger, Bishop of Salisbury. The possibility that Cormac Mac Cárrthaig introduced masons from Roger's jurisdiction for his eponymous Cashel chapel was raised at the end of

Chapter 4; the Roscrea-Lullington comparison adds to the possibility that the English Romanesque connection which Cormac forged was not with the West Country in general but was specifically with Roger of Salisbury's diocese.

Historical evidence supports the stylistic evidence of a link between Ardfert and Roscrea.[21] Neither had been chosen as a diocesan centre in 1111. Ardfert had been passed over in favour of Ratass as the diocesan centre for Kerry. At some unknown date Ratass's existing church, a single-cell building with antae and a lintelled and architraved west portal, was extended to the east and was either given a new east window or had its original east window moved to the new east wall location; its original entrance remained unmodified. The immediate post-1111 period would seem a good candidate for the date of the alteration to Ratass, thus illuminating ideas of architectural form at the dawn of the twelfth century. The death of a bishop of Ardfert in 1117, however, suggests that the larger site claimed episcopal status shortly after 1111, and we know that this status was confirmed at the synod of Kells/Mellifont in 1152. Roscrea, an old monastery, was passed over at Ráith Bresail when its traditional territory was split between the new dioceses of Killaloe and Cashel, but following the death of Muirchertach Ó Briain in 1119 it was able to assert its claim to being a bishopric, and it had this status confirmed in 1152 (only to lose it again a few years later). It is surely significant that both Ardfert and Roscrea, the only two churches in Ireland with five-bay façades, were denied diocesan status in 1111 but still claimed that status very shortly afterwards. It seems likely that both churches were built to stake the diocesan claims of their respective communities. A suggested construction date in the 1120s for Ardfert would not be inconsistent with its architecture, while a date in the late 1130s for Roscrea would accommodate the possibility of a Cashel connection for its rosettes and a Lullington connection for its pediment figure.

We began this account of Ardfert and Roscrea with a comment on the idea of the façade. These two buildings stand out because they breach a tradition in Ireland of simple west walls which originated in pre-Romanesque work and which outlasted the twelfth century. Why were Irish church-builders, especially of the 1100s, so averse to complex façade architecture such as that which their contemporaries were creating elsewhere? Adherence to a long-established tradition is the answer, even if that further begs the question of why such a tradition should have started in the first instance. Perhaps the geography of the earliest church-sites helps us understand why a complex façade architecture was not developed at an early stage: the *platea* or open space in front of a church was an area across which the worshipper walked towards a church, so its affect was to emphasize that church, no matter how small. As 'modern travellers' to medieval churches we have lost some of the sense of church-sites being places of procession; we often approach these buildings from the side or from an angle, not for any reason of

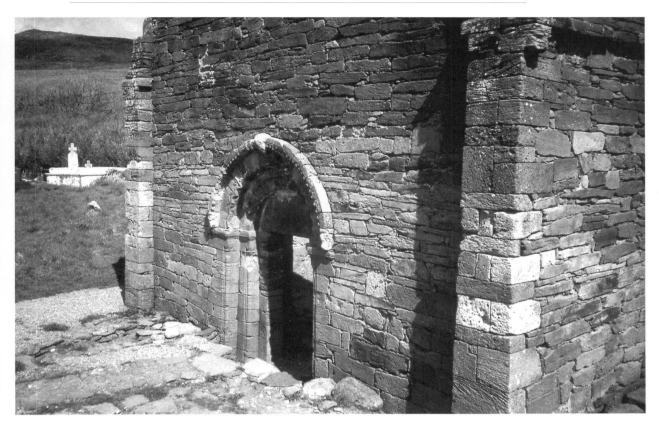

94 The west wall of Kilmalkedar church.

ritual but simply because many of the nineteenth-century walls which enclose medieval church-sites as rectangular spaces happen to have gates and stiles in their long walls. The affect of walking towards Ardfert or Roscrea in the early twelfth century must have been quite startling.

A KERRY ROMANESQUE TRADITION?

Ardfert Cathedral did not precipitate the development of a Kerry Romanesque tradition comprised of comparable forms. Rather, it remained a one-off. Interestingly, the next church to it in chronological sequence is probably Kilmalkedar, located near the west end of the Dingle peninsula at the most distant extremity from Cashel of the kingdom of Desmond, and it has Cormac's Chapel, rather than Ardfert Cathedral, is its closest relation.

Kilmalkedar

This is a complete nave-and-chancel church, 8.3m by 5.25m, and 4.9m by 3.5m internally (**Figs 94**, **95**). The nave walls stand to their full height with a chamfered

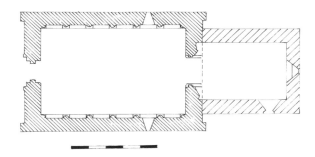

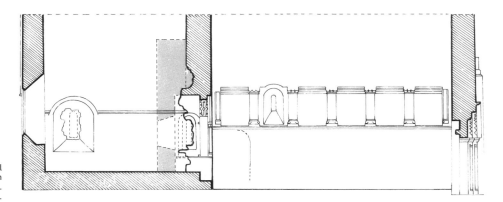

95 Plan and internal south-facing elevation of Kilmalkedar church. Scale bar for plan = 5m.

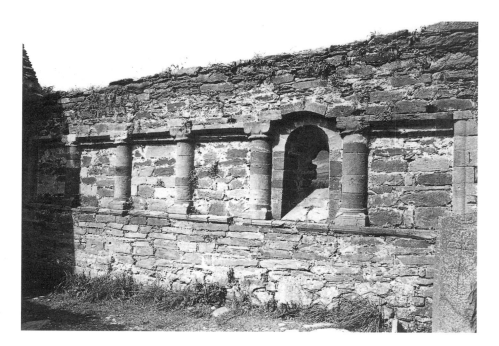

96 The interior north side of the nave of Kilmalkedar church.

eaves-course marking the wall-head on the north and south sides. Under the
eaves-course and facing north and south from each of the four corners is a grotesque
animal head carved on a corbel-like projecting stone. Ashlar antae, 50cm in width
and projecting a mere 25cm, flank both east and west ends of the nave. The antae
continue up the sides of the gables for several courses; their line continues up to the
apex of the gable, changing from projecting ashlar to horizontally laid rubble more
flush with the walls, and narrowing gradually all the way up to the finials.[22] The west
gable has a finial of the simple X-type with a moulded edge, while the east gable has
an equal-armed stone cross with slightly expanded terminals.

The nave was partially if not entirely covered by a barrel vault and external
stone roof, with the lower corbelled courses of each surviving on both sides; the
lack of any scarring on the internal end walls of the nave suggests that the upper
two-thirds of the internal space might have been roofed over in timber rather than
in stone, but the thin bands of horizontally-laid stones on the outer edges of the
gables are commensurate with there being a complete stone roof originally. Joist
sockets in the interior of the gables may belong to such a timber construction, or
alternatively were used for constructional scaffolding.

The external walls of the nave have well-coursed sandstone masonry with a
horizontal band of yellow-coloured stone about 1m thick running around the
mid-height of all the walls (including what little of the east wall can be seen beside
the chancel) but not found on the antae. Internally, the side walls are each
embellished with rows of blind bays of almost-square shape, about 1m high and
recessed 20cm into the wall (**Fig. 96**). The bays are at least 2m above the original
floor level to judge by the level of the threshold of the west door. These bays are
divided by half-shafts engaged to the wall. They stand on bases with collar
mouldings and spurs which in turn stand on a grooved and chamfered string-
course. The columns carry triple-scalloped capitals, and these support two
chamfered string-courses, one directly above the other. There are six bays on each
side, and on each side the second-last of these to the east contains a round-arched
window with a sloping sill. The string-course above the bays rises in a gentle arc
above each window before returning to its horizontal course. At the east end of
the south wall a 1m wide opening in the wall below the last bay, of uncertain date
and function, has been filled in.

The west portal (**Fig. 97**) is three-ordered. Its jambs are boldly battered with
the doorway narrowing from 97cm to 90cm from bottom to top. The outer and
middle orders have roll-moulded jambs with double quirks on each side. The
capitals are simple half-cushion types. The imposts are grooved and chamfered.
The equivalent arch-ring orders have chevron decoration: the outer order has
chevron rolls on the archivolt alternating with triangular spurs on the soffit, while
the inner order has archivolt saw-tooth chevron. The inner order has plain

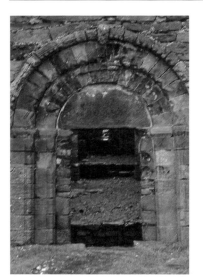

responds, now partially replaced by modern masonry. There are no capitals here but the impost of the two outer orders continues across the top of the responds to support a tympanum. This tympanum is plain on the exterior, suggesting it may have been painted originally, but in the centre of its interior face there is a projecting animal head. The whole portal is covered by a grooved and chamfered hood-moulding – the chamfer contains bosses – which is crowned by an elongated human head and terminates in two carved animal heads.

The nave originally had a small altar projection to the east, internally less than 2m wide and probably no more than 2m deep, which was replaced in the twelfth century by the present chancel. Ruined parts of this structure survive (**Fig. 98**). It was clearly entered through the same arch as now opens into the chancel, and was lit from each side by a round-arched window set in a splaying embrasure with a sloping sill. The arch is two-ordered. Its outer jamb order contains a three-quarter engaged shaft with collared and torus-moulded bases and double-scalloped capitals, while the inner is a simple respond. There is no abacus or impost. The outer arch-ring order is roll-moulded with a band of pellets running concentric to the roll on the archivolt, while the inner is decorated with chevron on the archivolt and has a lozenge-and-bar motif on the soffit. The two-ordered jambs of the arch do not rise to the arch from the ground level but from a height above the ground level; that height may be interpolated as about 1m off ground level using the level of the threshold of the west portal as an indication of the original ground. Beneath the two arch-orders are plain responds, chamfered on the west side, returning to form what were probably the lower side walls of the original altar projection. The upper parts of the side walls of this feature, from the bases of the two windows upwards, was recessed 20cm inside the vertical plane of the lower parts of the walls, and rose above the window embrasures to form what appears to have been a barrel vault. Externally this projecting structure had a triangular pitched roof, probably of stone. The scars of this roof are visible in the west wall of the chancel.

The chancel is an early addition which seems to have necessitated the removal of the east wall of this altar projection. Its metrology was closely connected to that of the nave: the internal length of the nave is equal to the sum of the internal width and length of the chancel, the external width of the chancel is equal to half the external length of the nave, and the internal width of the

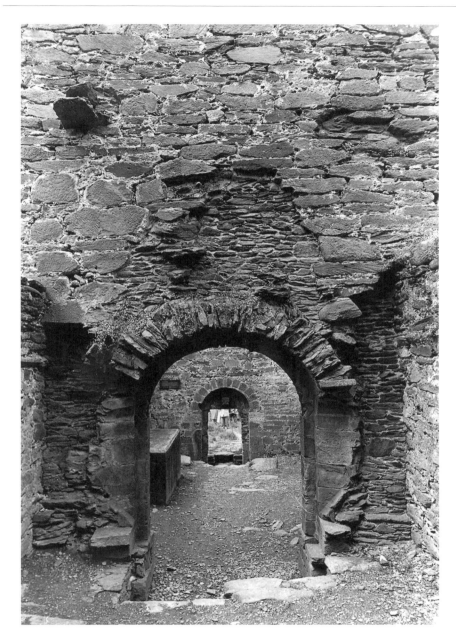

98 The Kilmalkedar altar projection viewed from the chancel.

chancel is equal to half the external width of the nave. These relationships suggest that the nave and chancel, although separated in time by the construction and subsequent alteration to the altar projection, are actually linked very closely by a basic planning conception.

This new chancel was inserted between the antae of the east end of the nave. It had a stone roof, parts of which survive projecting westwards from the east

gable. This roof rose from a chamfered eaves-course which returned at the gable to support a still-extant stone barge-course. The east wall of the chancel has a finial of X–type, similar to that on the west gable of the nave except slightly longer. Internally the chancel had a barrel vault which sprang from a chamfered string-course. Only the lower courses survive. The vault was not tied into the end walls of the chancel suggesting that here, as in the nave perhaps, the upper part of the roofing was of timber rather than stone. The chancel's round-arched east window is externally recessed and chamfered, and is set in a wide splaying embrasure flanked internally by two grotesque animal heads projecting just above the springing of the rear-arch. The window in the south wall is now largely destroyed.

The date of Kilmalkedar's construction is not recorded. Similarities with Cashel in its plan (especially the internal bays and the altar projection), superstructure (barrel vaults and stone roofs) and detail (especially the chevron ornament and the typanum) suggest it is an early building within the Irish context. It is also of very similar size to Cormac's Chapel: the Kilmalkedar nave is only slightly smaller than the Cashel nave, and its chancel slightly larger. The elevation on low pedestals of its altar recess/chancel arch may invite comparison with St Flannan's at Killaloe, another possible indicator of an early date. There is an entirely reasonable consensus in all the literature that Cormac's Chapel was Kilmalkedar's source, and that it post-dates the Cashel church by no more than a few years. This would make it roughly contemporary – the late 1130s, even the start of the 1140s – with Roscrea; it would also mean that while Ardfert was influencing Roscrea, about one hundred miles to its north-east, Cashel was influencing Kilmalkedar which is the same distance to its south-west. But given the case for a pre-1127 date for Ardfert, how absolutely certain can we be that Kilmalkedar is not a work of the 1120s and was not a source for Cormac's Chapel?

The west portal is perhaps the most important feature of Kilmalkedar from our perspective of reconstructing the history of stylistic development in Gaelic-Irish Romanesque architecture. Several of its features – the tympanum, the small cushion capitals on the jam – rarely appear again, but the roll-moulded jambs themselves, and the hood moulding with its quirk and embossed chamfer and its zoomorphic label stops, become very common indeed. This is certainly not to say that Kilmalkedar started the fashion; indeed, the fact that other churches in the Kerry-Limerick-Clare region use the angle-shaft rather than the roll-moulded jamb is proof enough of that. But Kilmalkedar shows that some of the formal ideas which were to inform many later portals in Ireland had certainly crystallized by about 1140 in the earliest known generation of decorated Romanesque work in Ireland.

Other Kerry churches

There is one dated church in Kerry: Aghadoe's incorrectly named 'Cathedral'. Its completion as a 'great church', built in honour of the Trinity and Mary by Amhlaoibh Ó Donnachadha, is recorded in 1158, as is Amhlaoibh's burial on the right-hand side of the altar.[23] It is unfortunate that it has suffered much alteration, with comparatively little untouched twelfth-century fabric.

This is a long rectangular church measuring a little more than 25m by 7m internally. A cross wall, 1.1m thick and clearly later than the side walls of the church, divides the interior into two parts of almost equal length, with that to the east being 2m longer. Extant architectural features are the west portal, two twelfth-century round-arched windows in the western part, one in each of the side walls, a rubble-constructed round-arched window and a segmental-arched niche in the partition wall, both opening from the west side and possibly late medieval in date, and two long lancet windows of the thirteenth century set in pointed embrasures in the east end wall. Substantial parts of the side walls of the church are late medieval or post-medieval re-buildings (particularly on the south side where much of the fabric has been destroyed above the level of the lower courses), as is the entire west wall apart from the portal. The eastern part of the church appears to be a thirteenth-century addition to an earlier structure, but preserved in this part of this building is an isolated, *ex situ*, twelfth-century capital of oval-leaf type identical to those on the west portal; its original location in the building is unknown but it might have come from a chancel arch.

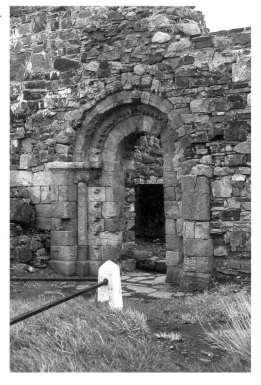

The portal (**Fig. 99**) appears to have remained largely intact from the twelfth century except for its outer arch-ring and hood moulding of which only fragments survive. It has three orders. The width of the central door opening is 88cm at the bottom and 82cm at the top, and it is 1.70m high to the top of the impost. The depth of the portal from the inner face of the west wall side to the outer surface of the pilaster-responds is 1m. The inner respond and arch are entirely

99 The west portal, Aghadoe 'Cathedral'.

without surface decoration or imposts. The soffit of the arch has a central recess all around to accommodate a tympanum; Etienne Rynne has suggested that it was a wooden tympanum originally on the grounds that the recess on the soffit is too narrow at 5cm, and the shelf on the top of the arch springer on each side too shallow at 3cm deep, to have supported a stone tympanum.[24] The second jamb order has a key-pattern ornament, defined on the outer face by flat, angular, mouldings and by indented or battlemented on the intrados face. The equivalent arch has intrados saw-tooth chevron. Tucked between the jamb and the outer pilaster respond are angle-shafts of polygonal shape; that on the north side is decorated with beaded chevron, while that on the south side has bands of beads twisting around it. The equivalent arch is square-sectioned with a keel moulding on the arris; its archivolt and intrados are each decorated with a central, concentric band with small beads, the centres of which are perforated, separated by horizontal rows of three small pellets. The outer order of the portal is a pilaster-respond 33cm wide and projecting only 4cm from the west façade of the church. The arch associated with this order is largely destroyed, but there are various chevron-decorated fragments in its place. The hood moulding, which rested on the impost of the pilaster responds order below, is also fragmentary. Four stones survive, indicating that it was chamfered with bosses in the chamfer: of the seven bosses which survive four are or appear to have been semi-spheroid, two are facetted and one is a spiral-boss. The label-stop on north side is defaced but appears to have been decorated with an animal head. The only capitals in the portal are associated the angle-shafts. These capitals are of oval-leaf type. Their abaci are grooved and chamfered. All the orders, except the inner, which is entirely plain, rise from square or rectangular pedestals, the top edges of which are chamfered.

Aghadoe's portal of c.1158 helps us date a number of other churches, among them Templenahoe (**Fig. 100; Plate 6a**), the second Romanesque church at Ardfert. The twelfth-century ecclesiastical complex at this important site of Ardfert had a geography not unlike the summit of the Rock of Cashel, but was its reverse. Here the Round Tower, of which there are only foundations, was close to the cathedral on its south-west side while the 'non-cathedral' church of Templenahoe stood further away from the cathedral on its north-west side. Moreover, Templenahoe, like Cormac's Chapel, was built at an angle, thus preserving the sense of an open funnel area in front of the cathedral. There the comparisons stop: only the partly-rebuilt nave of Templenahoe survives above ground so we must be cautious in our judgement, but it seems to have been a much less sophisticated building, entered from the west through a surprisingly low-key doorway and with only a nicely-decorated south window facing onto the *platea* to suggest any cognizance of setting relative to the cathedral.

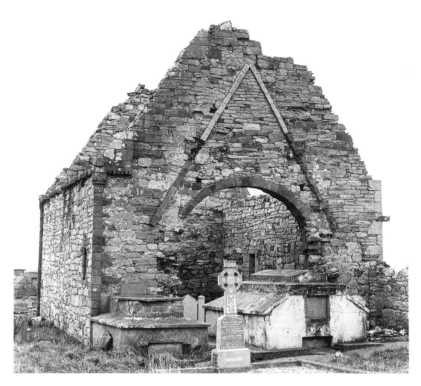

100 Templenahoe, Ardfert, from the south-east.

Templenahoe's nave measures 6.4m by 11m internally (**Fig. 101**). Only the abutment of the sloping roof of the chancel survives on the exterior east wall of the nave. The nave has a west portal, a chancel arch, quoin-columns, a decorated cornice, and five or six windows, two in the north wall (one of them destroyed), one or two (though probably only one) in the south wall, and one in each of the other walls.

The portal in the west wall is two-ordered. The entire portal is 2.2m wide and 2.8m high to the crown of the hood moulding, while the central opening is 82cm wide and is 2.1m high to the crown of the arch. Neither the inner nor outer order is decorated and there are no capitals or imposts. The partly destroyed hood moulding over the portal has a narrow fascia decorated with a row of small beads, and the hollow chamfer of the lower edge contains faceted bosses. The hood terminates in an animal head on the south side: that on the north is destroyed. Above the portal is a wide rectangular window with rubble sides, presumably belonging to the late medieval building activity.

There is one window in the south wall of the nave, but an area in the centre of the wall contains masonry which is later than the rest of the wall and may indicate that there was another window here. There were two windows on the north side of the church, that on the west side is fifteenth century; that at the east

end is destroyed but may have been of the same date. The extant window in the south wall is decorated both inside and outside. The rear-arch has a keel moulding flanked by quirks, and is decorated on its outer face with a continuous band of ornament. The ornament is comprised of square flowers or plants, each with four or eight petals or leaves, within square frames which are separated from each other by rows of beads running at right angles; these are very similar to the rows of beads on the Aghadoe portal. On the exterior this window is decorated on its uprights with interlace and on its arch with a (almost anthropomorphic-looking) vegetal motif which is repeated at least five times.

Quoin-columns are extant at three of the four external corners of the nave, the exception being the north-east corner where a single stone of a column survives. The extant columns are three-quarter detached and terminate with decorated capitals with astragals. The capital on the south-east corner is a form of cushion capital, the D-shaped field outlined by a band with small beads, but it also has heads at the corner as in a volute capital; the heads are worn but appear not to have been bearded. The capital at the south-west corner is also a cushion form with an astragal, but the cushion is outlined in this instance by a horseshoe-like device. The capital at the north-west corner is scalloped and also has an

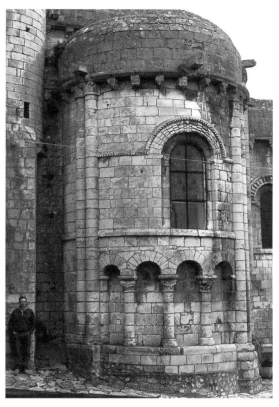

102 Exterior of apse at St-Pierre, Chauvigny.

astragal. These quoin-columns are attached to a cornice which originally ran the full length of the building but only crossed a part of the east and west end walls. That cornice is identical to the impost of the chancel arch in profile, but its fascia was not decorated, and its chamfered lower edge contained spiral bosses in addition to faceted bosses.

The chancel was entered through a three-ordered arch, of which the inner order is destroyed. The width across the present inner order is 3.75m. Less than 50cm above present ground level the vertical rise of the orders of the arch is interrupted on each side by a horizontal slab of unknown function set across the jambs. There is no decoration on the uprights, but the chamfered imposts were decorated with leaf ornament on the vertical faces and with faceted bosses in the chamfers. The outer arch has archivolt saw-tooth chevron, and this is further embellished with small beads. The inner of the two arches has archivolt and intrados chevron.

Above the chancel arch was a rectangular window similar to that above the portal but it is blocked. It suggests that this structure had a more complicated building history than its simple plan would otherwise suggest; it may originally have been a single-cell church onto which a chancel was added. In this regard it

resembles the small single-cell church on another Kerry site, Innisfallen; a mere 4.9m by 3.35m internally, this also had a two-ordered doorway, its inner order plain except for archivolt chevron and its outer order bearing an unusual archivolt and intrados saw-tooth chevron on the arch-ring.

What date is Templenahoe? The quoin-columns can be paralleled at the east ends of Tuamgraney and Monaincha, the former near Killaloe and the latter near Roscrea, and both unlikely to pre-date 1150, as we will see. Such features might reflect influence from the sort of semi-engaged columns or shafts which articulate the return angles of parts of major Romanesque churches overseas, not least in France (**Fig. 102**). The plain inner respond of the west portal can be paralleled at Aghadoe, dated to the 1150s, and the manner in which the central plants in Aghadoe's oval-leaf capitals are bent at the top can be paralleled on the plants which decorate the interior and exterior of the south window at Templenahoe. These parallels suggest a date for Templenahoe around the middle of the twelfth century, probably the 1150s.[25]

Before leaving Templenahoe we must note again that substantial parts of the building were reconstructed after the twelfth century, possibly in the late middle ages: the nature of the masonry – roughly coursed rubble masonry – is typical of late medieval work in Ireland. Within the later fabric are various fragments of carved stone, one of which bears a snippet of an inscription.[26] But the most interesting and important fragment is high up in the west gable: it is a voussoir with an animal head biting a roll moulding (**Fig. 103**). This motif turns up elsewhere in Ireland: there are nearly complete arch-rings made up of it at Clonfert and in the Nuns' Church at Clonmacnoise, a more fragmentary collection at Dysert O'Dea, and more fragmentary still at Dromineer, while animal heads biting rolls on jambstones are found on the chancel arch at Temple Finghin in Clonmacnoise, on a now-lost major opening at Donaghmore (Tipperary), and on the rebuilt window in the west wall at Dysert O'Dea. Françoise Henry identified this motif as having a French origin,[27] and it seems appropriate to discuss that possible French connection at this point since this is our first proper encounter with it.

There is no doubt that western French carved animal heads – they seem to be mainly horses – on arches such as at St-Fort-sur-Gironde are similar to those in Ireland, even though they lack the abstract, vegetal or zoomorphic tattoo-patterns which Irish sculptors liked to carve on their animals' foreheads. Such an origin for a motif found in Ireland does seem rather far-fetched, for, as Garton has noted,[28] one might imagine a greater, more explicit, display of 'Frenchness' in other features of these sites. Moreover, it is tempting to suggest an origin in the English Romanesque beak-head tradition, as classically represented at Iffley in Oxfordshire, for example, for the Irish examples of the motif of an animal-head

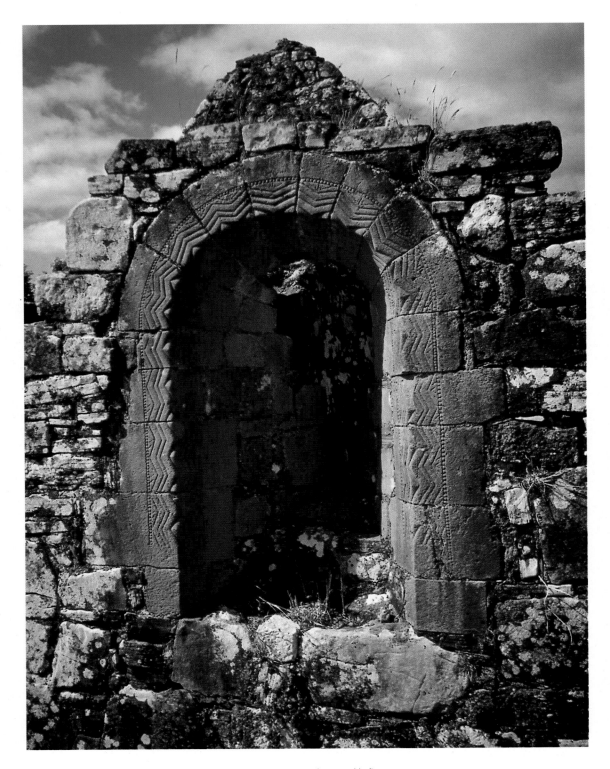

1 Romanesque window at Inchbofin

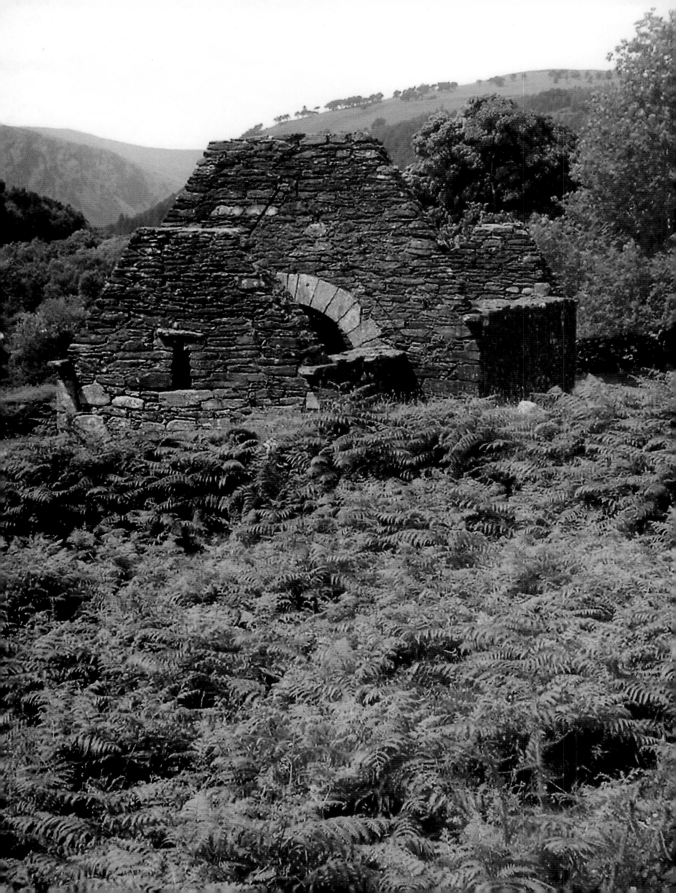

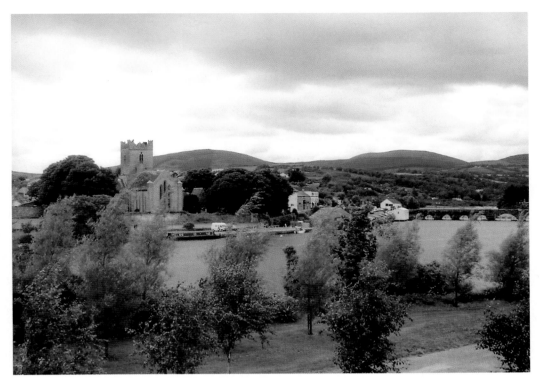

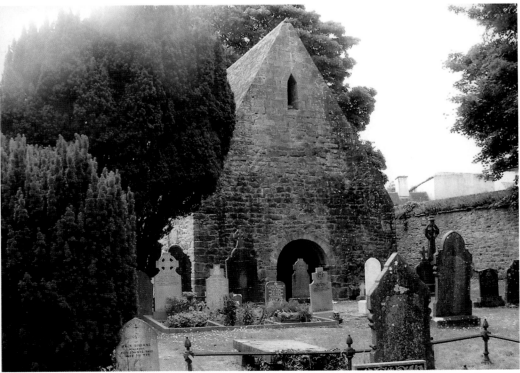

2 Trinity church, Glendalough, from
the north-east.

3 a Killaloe from the south-east;
b St Flannan's oratory, Killaloe, from the south-east

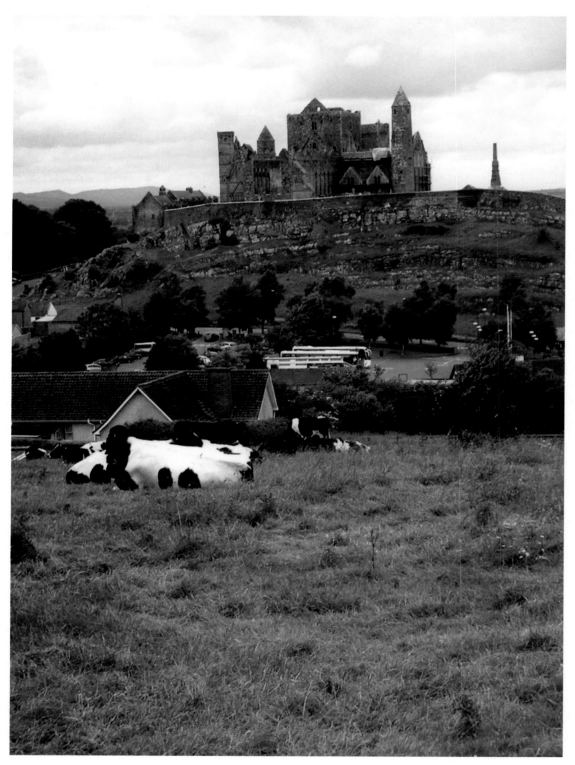
4 St Patrick's Rock, Cashel, from the north-east.

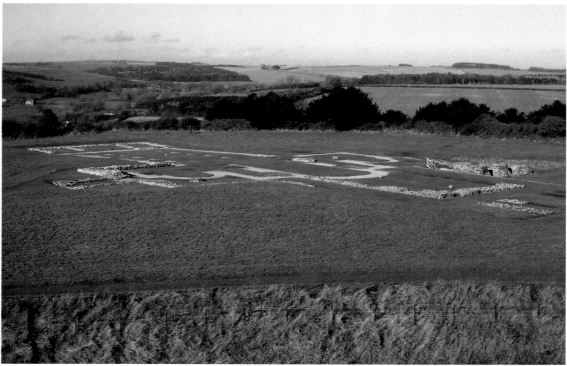

5 a Rahan I from the north-east; **b** Old Sarum from the south-east

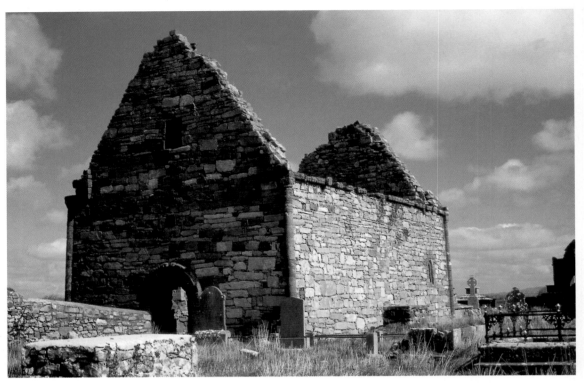

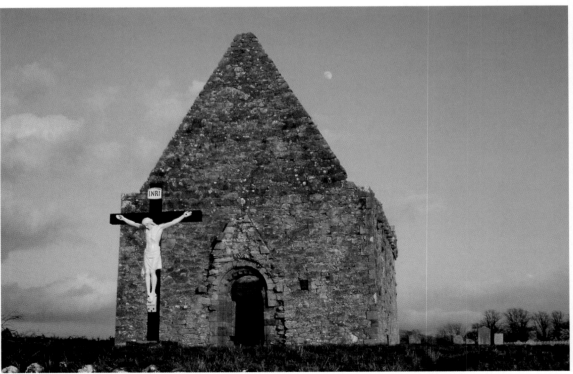

6 a Templenahoe, Ardfert, from the south-west; **b** Donaghmore [Tipperary] from the west

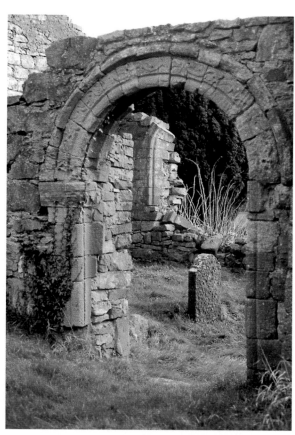

7 a North portal,
Kilsheelin;
b Chancel arch detail, the
Nuns' Church
Clonmacnoise

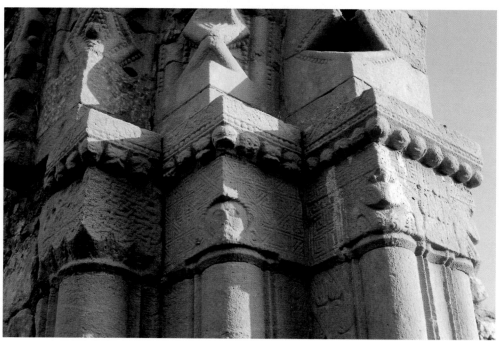

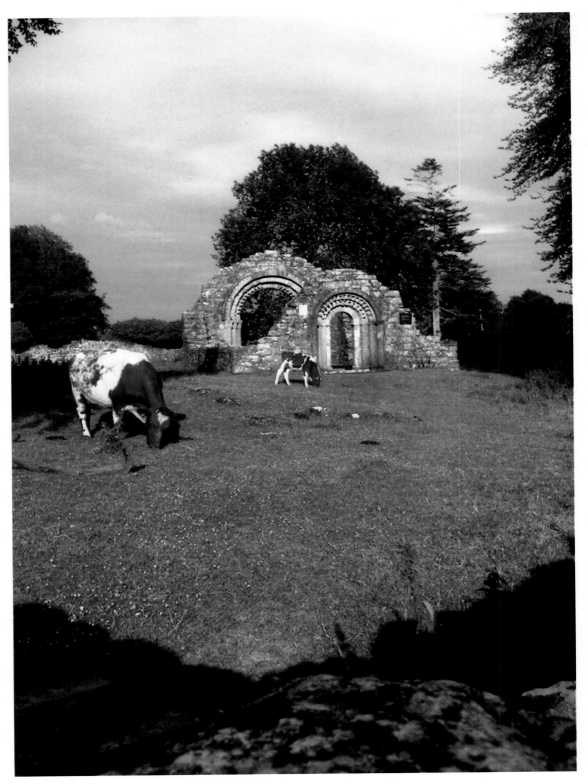

8 The Nun's Church, Clonmacnoise, from north-west

103 *Ex situ* animal-head voussoir at Templenahoe, Ardfert.

biting a roll at 90° to it on a jambstone. However, the distribution of these Irish sculptures is, with the exception of Donaghmore, essentially a Shannon valley distribution. It is more likely that the idea travelled up the Shannon *from* the Atlantic than travelled down the Shannon *towards* the Atlantic; if the idea reached, say, Clonmacnoise or Clonfert by an overland route from England one might expect to see it at some inland sites between the Shannon and the Irish Sea. Moreover, there are two other motifs in the Shannon region which seem to point to France. The first is the scalloped arch, represented at Dysert O'Dea and Clonfert. This can certainly be paralleled in France, although it also turns up in England.[29] The second is the small animal head in a chamfer, whether of an impost, an abacus, or a hood moulding; a typical western French example is St-Hérie, Matha, while in Ireland such animals occur on the Clonfert doorway, the chancel arch in the Nuns' Church at Clonmacnoise, the hood moulding of the west portal on Innisfallen, and the early thirteenth-century doorway at Drumacoo. Add to this the evidence of Freshford's portal and Ardmore Cathedral's west wall, two churches to be considered later in which possible French influence of a different nature might be detected, and we have a small but significant amount of French sculptural influence in twelfth-century Ireland.

Back to Kerry. Church Island, Waterville, is a nave-and-chancel church (**Fig. 104**) with fragmentary remains of a chancel arch and a reconstructed west portal.[30] Although built *ab initio* to the plan which both Kilmalkedar and Templenahoe possessed, it is probably of about the same date as the latter. The nave measures a little more than 7m by 4m internally, and was lit by a round-

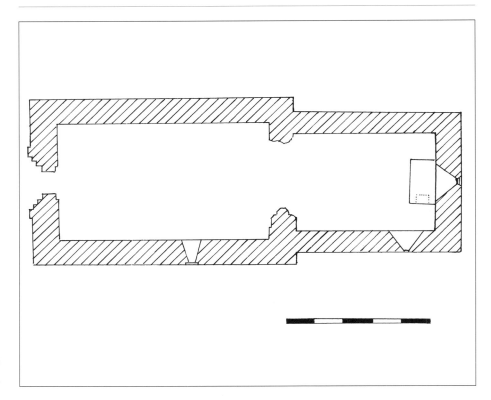

104 Plan of Church Island (Waterville) church. Scale bar = 5m.

arched window in the south wall. The reconstructed portal has a plain inner order, 80cm wide and 2m high to the crown. This was flanked by two orders with angle-shafts, the inner of which on the north side was decorated with spiral bands. The third order, which is a pilaster-respond, has roll-moulded corners. Capitals survive on all these angle-shafts and roll mouldings except for on the inner angle-shaft on the north side; the inner order capital on the south side has features which have been identified as 'ornithomorphs'.[31] The arch-rings are largely destroyed, but sufficient remains to identify archivolt chevron on the inner order and archivolt saw-tooth chevron on the second arch-ring; no carved stonework survives from the third arch-ring. Parts of the outer hood moulding survive: this had nail-head ornament. The label-stop on the south side was carved with a human head. An arch opening into the 3.5m wide chancel is now destroyed apart from fragments of the semi-cylindrical inner responds and chamfered outer responds, one on the nave side and the other on the chancel side of the semi-cylindrical respond. The present capitals – round with narrow, convex, surfaces – may not be original. The round-arched east window has three animal heads flanking it, one above it and one on each side. Preserved within the church are several figure sculptures, one of which is a square panel with a carving of a man playing a viol.

KILLALOE AND THE LOWER SHANNON BASIN

Just as Ardfert Cathedral stands relatively isolated in the development of Romanesque architecture in Kerry, so too does St Flannan's oratory at Killaloe in Munster. We might expect Killaloe to have been a place from which stylistic influences emanated, especially in the early 1100s, but we cannot monitor any such process. In fact, Tessa Garton's dating of the spectacular doorway re-erected in Killaloe Cathedral (**Fig. 105**) to the very start of the thirteenth century[32] leaves virtually a century of building activity unaccounted for at that key site. When we consider that, excluding Roscrea (which is not in Thomond but was affected directly by Muirchertach's politics in the early 1100s), there are no churches which are obviously of the 1110s, 1120s or 1130s in Killaloe's political-economic hinterland,[33] we are tempted to conclude that between the death in 1119 of Muirchertach Ó Briain, likely patron of the oratory, and the accession to the kingship in 1168 of Domnall Mór Ó Briain, probable patron of the Killaloe Cathedral doorway, there was simply little interest among the Ó Briain either for the development of a truly monumental architecture for Killaloe itself or for the promotion of Romanesque work in Thomond in general. Indeed, a general disinterest in matters architectural among twelfth-century Ó Briain kings may actually explain the dualism of Thomond Romanesque in the second half of the twelfth century: on the one hand there are churches which reveal a connection with the Kerry buildings just described, and on the other there are churches – and High Crosses – which combine decorative devices of Hiberno-Scandinavian origin which may have originated in metalworking traditions further up the Shannon (see p.36 above) with some sculptural motifs which can be paralleled in the midlands.

Clonkeen, south of Limerick, might be the oldest building in an explicitly Gaelic-Irish Romanesque tradition within a broadly defined Killaloe region. The church is a single-cell structure, 14.6m by 5.5m internally, with antae, a west portal and four extant windows. The eastern two-thirds of the building has well-coursed flat stones while the western end has large stones somewhat irregularly coursed; this suggests two phases of construction, with the eastern part probably the later part of the building. Moreover, the only twelfth-century windows are in the western part of the building, one each on the north and south wall, with that on the north wall having a rear-arch decorated with shallow rolls and double quirks and a band of beaded incised chevron; the windows at the east end of the side walls date from the fifteenth century.

The west portal (**Fig. 106**) has a plain inner order without imposts, capitals, bases or plinths. It is slightly battered, 95cm across the top and 1.05m across the bottom. The height to the springing of the arch is 1.95m. There is an

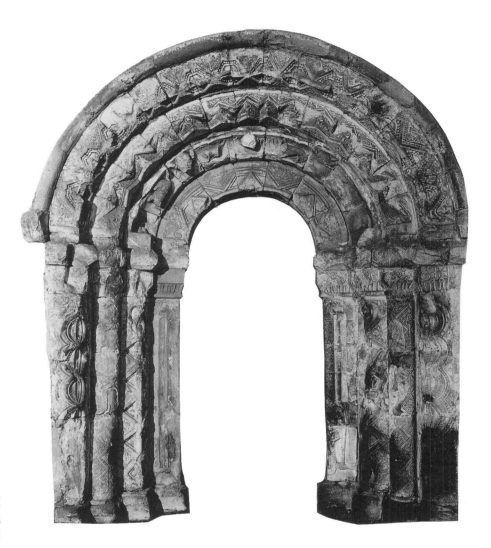

unembellished pilaster flanking the portal on each side, giving it an overall width
of 2.50m. Tucked between the inner order and pilasters are two polygonal angle-
shafts – that on the north side is now largely destroyed – decorated with beaded
chevron. The two capitals, with astragals, survive and they have oval leafs at the
corners. The base and plinth of the column on the south side survives: each base
has a torus moulding with horizontal bands of beading and chevron below, and
spurs, all above a chamfered plinth. The arch-rings do not correspond exactly to

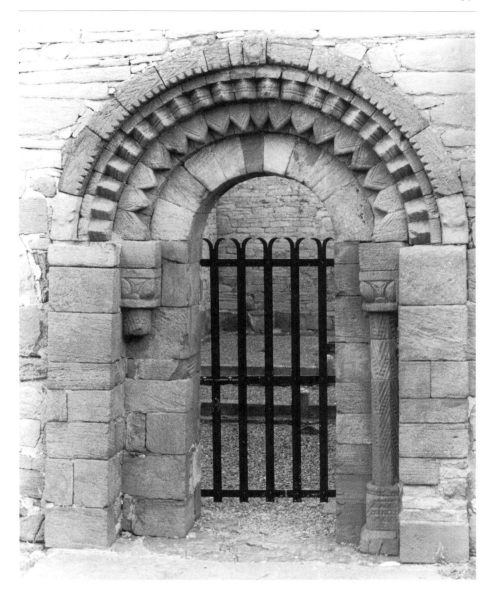

106 The west portal, Clonkeen.

the jamb orders below except in the case of the inner order which, like the responds, has no embellishment. The voussoirs of the second arch-ring are partly shaped with intrados saw-tooth chevron. The next arch-ring has archivolt saw-tooth chevron. The hood moulding stands on the edges of the outer pilaster respond. It is chamfered, with a form of dog-tooth ornament in the chamfer, and has beaded chevron on the face. There is a human head on the keystone and the terminations are stylized animal heads.

107 Plan of St Caimin's
church, Inis Cealtra.
Scale bar = 5m.

Clonkeen's general morphological form and some of its specific sculptural
details, especially its capitals, suggest a relationship with Aghadoe, which points
to a date for it in the 1150s. Clonkeen also looks to Inis Cealtra, the island
monastery at the heart of Ó Briain territory, and specifically to the chancel arch
of its focal church of St Caimin's. This is a nave-and-chancel building of which
the antae-bearing nave, 9.3m by 6.15m, is pre-Romanesque, possibly tenth
century, in date (**Fig. 107**). Its now-reconstructed west portal was a twelfth-
century insertion. Liam de Paor's reconstruction of that portal in its original
twelfth-century incarnation gives it an inner order with archivolt saw-tooth
chevron, a central order with incised chevron, and an outer order with head-
carved voussoirs.[34] It has three orders without capitals or imposts: the jambs have
roll mouldings with double quirks, while the inner arch has archivolt saw-tooth
chevron, the middle has rolls only, and the outer has incised archivolt chevron
with alternating spurs.

St Caimins' chancel, 4.45m by 3.8m, was added in the twelfth century, and
was entered through a three-ordered arch with plain arch-rings (**Fig. 108**). The
capitals, crowning responds and jambs with wide roll mouldings, are of the same
oval-leaf type as we saw at Clonkeen and Aghadoe. The inner respond has a pair
of rolls on each side. The bases have tori and spurs, as well as horizontal zones of

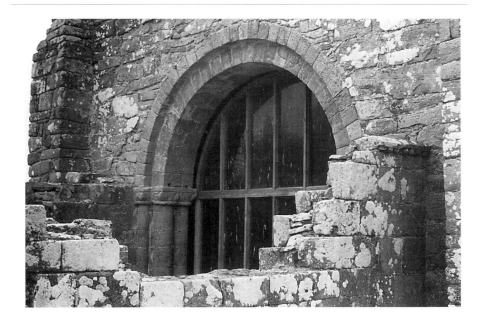

108 Chancel arch, St Caimin's church, Inis Cealtra.

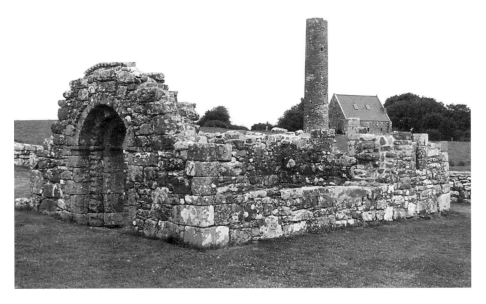

109 St Brigit's church, Inis Cealtra.

decoration. The altar is Romanesque, with corner rolls and small leaf-capitals. There was a cornice around the chancel, and this had bosses.

Another Inis Cealtra church, St Brigit's (**Fig. 109**), also suggests a Kerry connection. This is a small single-cell church, 6m by 3.6m, with a reconstructed Romanesque west portal of three orders. The inner respond has chevron on the outer face, the middle jamb has both archivolt and intrados chevron, and the

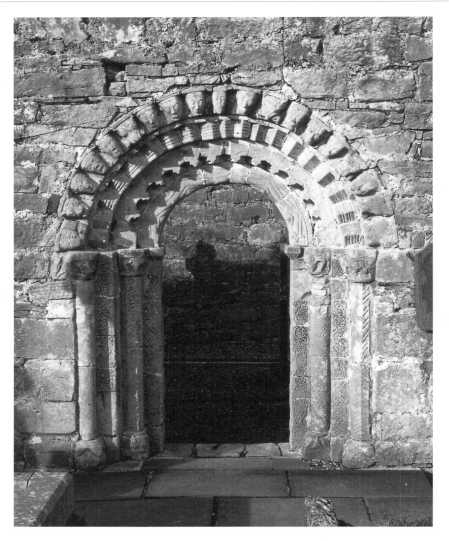

110 South portal,
Dysert O'Dea.

outer jamb order has a roll moulding. There are no capitals but an impost runs
under all the arch-rings. The inner ring has incised archivolt chevron with
lozenges on the arris, the middle ring has archivolt and intrados saw-tooth
chevron, and the outer ring is plain. There is a hood moulding with square bosses.
The only other Irish portal with archivolt and intrados saw-tooth chevron used
on the same order is at Innisfallen.

Dysert O'Dea church, or rather its famous portal, represents the other
element of Thomond Romanesque as described above. This is a nave-and-chancel
church, much rebuilt in the seventeenth century:[35] its Romanesque south portal
was probably a west-wall portal originally, and its present west window was
probably a south-wall or east-wall window originally. In its present reconstructed

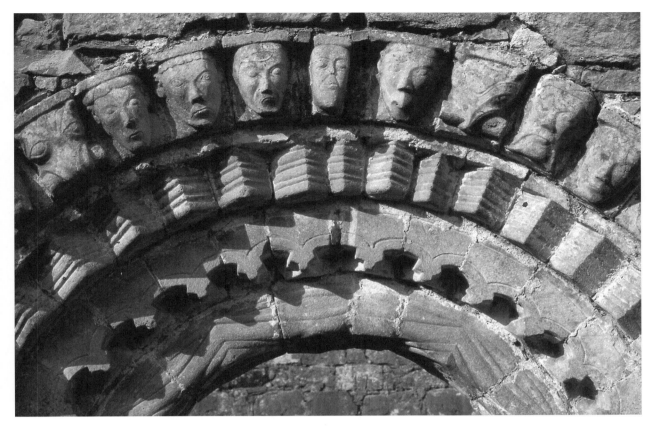

form (**Fig. 110**) the portal's central opening is 1m wide by 1.80m high, with a maximum width of 2.30m. It has four orders. The inner responds have chamfered imposts. The second jamb order (counting from the inside out) is comprised of angle-shafts, polygonal on the west and cylindrical on the east. Outside this again is a plain respond without capital or impost. The outer order, finally, has angle-shafts, polygonal in each case. All four of the angle-shafts have bulbous bases with spurs, and capitals decorated with head motifs, and their decoration is comprised of both beaded chevron and Scandinavian-derived ornament. Of the arch-rings (**Fig. 111**), the inner has incised archivolt chevron, the second order is polylobate or scalloped, the third has archivolt saw-tooth chevron, and the fourth (the outer) has human and animal head voussoirs; the animals bite on parts of a roll moulding and may originally have belonged in yet another arch-ring. The external decoration of the church's west window also features animal heads biting a moulding which metamorphoses into an animal: here the heads are a little more elongated, but are not quite beak-head.

The Dysert O'Dea chevron bears comparatively little resemblance in its style and the context of its use with chevron in Kerry, suggesting that its source lies

111 Detail of the arch, Dysert O'Dea south portal.

elsewhere, probably in the midlands Romanesque tradition which is reviewed in the following chapter. Western French input is indicated, as noted earlier, by the portal's scalloped arch and animal-head voussoirs, both paralleled at Clonfert, which is late twelfth century in date. But Dysert O'Dea need not be quite so late: unlike at Clonfert, its carvers had a use for chevron ornament, and this probably draws it nearer to the ambit of the 1160s-period Nuns' Church at Clonmacnoise, which also has animal-head voussoirs.

There are other churches in south Clare which belong to the same horizon as Dysert O'Dea.[36] One is at Temple Cronan, an early site with two slab-tombs flanking a single-cell rectangular church, only 6.4m by 3.9m internally, with a lintelled west doorway and small roll-moulded quoins. Three human heads, modelled in the round and quite naturalistic, and five animal heads, all of them carved on corbels, suggest a connection with Dysert O'Dea. The pellet decoration on the interior of the reconstructed east window has more regional parallels: it is found on the doorway of the Round Tower at Dysert Oenghusa, south of Clonkeen, on the reconstructed north window at Liathmore, near Cashel, and on the west door of Killodiernan, located on the east side of Lough Derg.[37]

Slightly later in date than Dysert O'Dea, perhaps, are Rath Blathmaic and the east end of Tuamgraney; both have zoomorphs which invite comparison with the late twelfth-century doorway at Killaloe (discussed below). At the latter sites the principal features are the chevron-decorated rear-arches of the windows and the quoin columns (see Fig. 20). Rath Blathmaic probably rivalled Dysert O'Dea for opulence, judging by the very few twelfth-century fragments which survived a substantial later medieval rebuilding. Preserved in the south wall is a base of a window decorated with foliage and zoomorphs, and a sheela-na-gig flanked by animals (**Fig. 112**). There are other fragments of Romanesque carved stone (including a square stone with Scandinavian-derived interlace, and a squatting human figure) but their original contexts are unknown. The animals on the window base compare with those on the portal of Clonfert; the sheela-na-gig itself, unique in Ireland in being flanked by animals, is one of a group of twelfth-century examples, the others being in the Nuns' Church at Clonmacnoise, the church at Liathmore, and the Round Tower at Rattoo. There is also an extraordinary male exhibitionist figure from a window of Tomregan Round Tower.[38]

The final monument to consider in this discussion of the Killaloe area is the re-erected doorway in Killaloe Cathedral itself. This is a most extraordinary piece of work, and is quite the most elaborate item of Romanesque architectural sculpture to survive in Ireland, surpassing even the Clonfert portal. It was the subject of detailed analysis two decades ago.[39] It is a four-ordered portal, the central opening of which is 1.1m wide and 2m high to the impost. Each order has a scalloped capital, with the face above the scallops decorated with plant motifs, and an

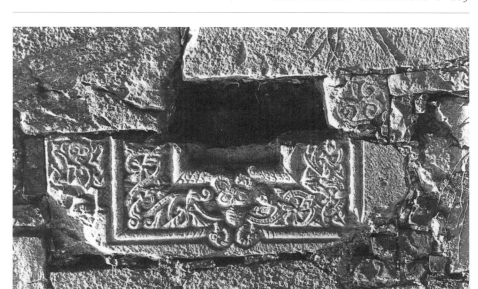

112 *Ex situ* window in south wall of Rath Blathmaic church.

impost which is chamfered on both the top and bottom edges. The bases have torus mouldings above plinths, the upper, chamfered, surfaces of which are decorated with plant motifs. The inner respond order on each side has a roll moulding on the arris of the jamb and this roll represents the body of a long serpent the head of which is at the bottom of the jamb. The associated arch-ring has gapped chevron on the archivolt, intrados, and arris. The second order has archivolt and intrados chevron with a roll on the arris, and that roll terminates in an animal head immediately below the capital. The associated arch has a hollow roll in which well-moulded animals and human heads alternate; parts of two of the heads survive. The third order has three-quarter columns decorated with lightly incised lozenges. The associated arch has archivolt saw-tooth chevron alternating with shallower intrados saw-tooth chevron. The fourth order has cusped jambs, with each pair of cusps defining a pointed oval-shaped field. The associated arch has gapped chevron on the archivolt and intrados, with a roll moulding on the arris. The whole portal has a semi-cylindrical hood moulding, and this terminates in rectangular blocks at least one of which – that on the west – is scalloped. Virtually all the chevrons are beaded, and all the spandrels filled with plant motifs. Throughout are interlaced animals, a number of them emerging out of roll-mouldings and biting on other rolls.

The Killaloe doorway's composition is not wholly satisfying to twenty-first-century eyes: the sculpture impresses with its detail and expansiveness, but it conceals the doorway's structural lines with an almost baroque enthusiasm. Nonetheless, the sheer elaboration of this work leads us to imagine it being

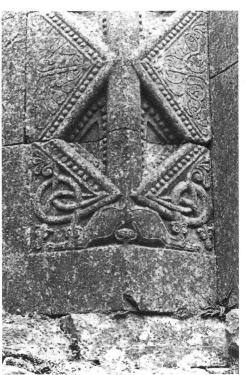

113 Details of the east window of Annaghdown Cathedral.

worked on in the mason's yard for a lengthy period of time and being brought to the site of its use with considerable fanfare. Its original context was probably the cathedral church immediately preceding the early thirteenth-century one which we know today, and it probably stood out against comparatively unadorned masonry the way the Clonfert portal does. The workshop may have been the same as that which provided carved stone to Rath Blathmaic and Tuamgraney, and it was certainly connected at some level to that which provided Annaghdown Cathedral, located on the eastern shores of Lough Corrib, with its east window (**Fig. 113**). The Killaloe portal, therefore, sits within the Thomond Romanesque as described above, but it also sits at the edge, stylistically and geographically, of that late Romanesque 'School of the West' in Connacht which was discussed in Chapter 3.

Leask and Henry both regarded this portal as a work of *c*.1170,[40] a clear measure of how they adjudged the Anglo-Norman arrival to be a sort of cultural fire blanket, extinguishing native creative capacity even beyond the colonial frontier. Garton's date of '*c*.1200 or shortly afterwards'[41] must be nearer the mark. But I would favour a date before rather than after 1200. She rightly drew attention to the closeness of parallels with sculptured details at *c*.1170–1180 Monaincha church (pp 252–5 below), but Garton also stressed the portal's abundant stylistic comparisons with 'School of the West' work at Corcomroe and Ballintober over those with Monaincha for the purpose of dating. I would argue that the Monaincha parallels, combined with those of other late twelfth-century Gaelic-Irish Romanesque work in the midlands and Thomond, are the more significant for the purposes of dating, and that they point to a date in the late 1100s rather than an early 1200s. On that basis I would suggest that this portal was made late in the career of Domnall Mór Ó Briain, king of Munster from 1168 to 1194. Indeed, this portal may be a key monument in understanding the *early* development of the 'School of the West'.

Domnall Mór was a fairly prolific patron. We have already encountered some of his Cistercian foundations. St Mary's Cathedral in Limerick has also been

attributed to him.[42] This is a much-altered structure of the later 1100s, maybe as late as 1200.[43] Its ground plan is simple: the nave is aisled (with slightly pointed arcades and lateral arches spanning the aisles at each bay division), and the transepts and crossing are square, while the now-truncated eastern arm was probably rectangular and flat-ended. Even in the absence of transeptal chapels, the only comparable plans of an appropriate date in Ireland are Cistercian. It is also reputed that Domnall Mór built cathedrals at Killaloe and Cashel. The present medieval cathedral at Killaloe is, as we noted earlier (p. 118), of early thirteenth-century date, so is probably the work of his son, Donat, who might have been the founder of Corcomroe abbey. Thirteenth-century programmes of work in Cashel Cathedral mean that nothing remains which can be attributed to Domnall, so it is harder to assess the claim that he built something there. However, his sheer industry as a founder or builder of churches suggests that Cashel would have been an irresistible object for his attention, even if it was only to make some changes to an extant superstructure, and the presence of a kinsman, one Marianus Ó Briain, as archbishop at Cashel in the thirteenth century is surely no co-incidence.

ROMANESQUE ORMOND

There are two small, rather heterogeneous, and often-overlooked, groups of churches to consider in east Munster, one located in the lower Suir valley, mainly within the diocese of Lismore, and the other in the Nore valley, much of it within the diocese of Ossory (which is actually in Leinster, which is treated in the following chapter).[43a] Their interconnections are not especially strong, but together they constitute a large group separating Cashel from the heartlands of Diarmait Mac Murchada's Leinster. They are both located within river valleys which drain into Waterford harbour, the busiest harbour in Ireland throughout the middle ages with both English and Continental connections.

Lismore's diocesan area extended eastwards from its focal monastery/cathedral towards Waterford, the old diocesan centre with which it had an erstwhile bonding. A low-lying countryside hemmed in between the Knockmealdown and Comeragh mountain ranges to the north and the sea to the south, it was as natural an economic, even cultural, hinterland for Lismore as the Blackwater valley itself. Not only did Lismore episcopal authority reach as far as the border of Ossory, but it possessed a long coastline running between Cork and Waterford, and Cashel's most convenient corridors to the channel between Ireland and France or to the Irish sea – the river Suir or the Rian Bó Phádraig[44] respectively – ran through it.

One of the churches here, Donaghmore, probably built about 1150, could almost be an outlier of the Kerry-Limerick-Clare churches discussed above (**Plate 6b**). This is a nave-and-chancel church: the nave is 12.2m by 7.5m internally, close

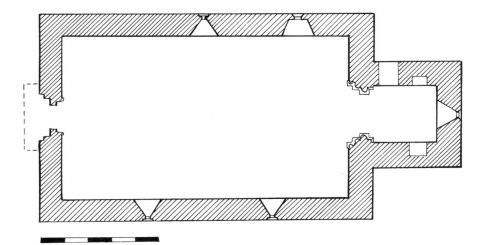

114 Plan of Donaghmore church (Tipperary). Scale bar = 5m.

to the Golden Section ratio of 1:618, while the chancel is almost square, internally a mere 2.5m or so each way (**Fig. 114**). There is a pedimented west portal, two windows on each of the nave's side walls, a vaulted chancel with a single east window, and an upper storey with part of an external stone roof.[45]

The pedimented portal (**Fig. 115**) projected 35cm forward of the west wall. Its outer parts are largely destroyed,[46] but it is possible to see in the rubble how it was built on the thick skewbacks of the outer arch and on its short span of 'true arch'; it might be noted that there is some chevron carved on a surface within the rubble: this may have been abandoned work which was simply recycled as rubble. The sides of the pediment carried bosses. There was no figure sculpture in the centre. Below the pediment, the central door opening is 90cm wide and 2m high to the impost. There were three orders, the surviving inner two having roll-moulded corners. The polygonal profiles and beaded chevron decorations on these roll mouldings can be paralleled very well on the jambs of the Aghadoe and Clonkeen portals, but with one very significant difference: at the latter two sites the features in question are angle-shafts, set into returns in the jambs, whereas Donaghmore repeats the pattern first seen at Kilmalkedar of the angle-roll in place of the angle-shaft. There was a tympanum associated with Donaghmore's inner arch-ring order – its rebate is still visible – and this too points us back to Cashel, Aghadoe and Kilmalkedar. The arch-ring of the central order remains and this repeats the type of archivolt saw-tooth chevron found at Clonkeen and (as an intrados saw-tooth chevron) at Aghadoe.

The chancel arch is destroyed but its upright supports remain. There were three orders, each with a large angle roll of which the central one was cut to a polygonal shape. The bases are slightly bulbous but with narrow bands running horizontally across their centres and with small flowers in place of spurs. The

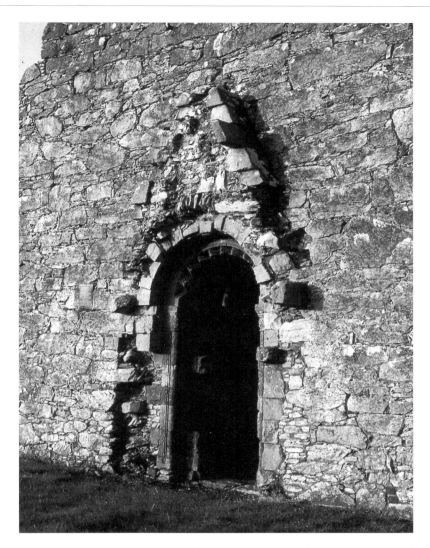

115 The pedimented west portal of Donaghmore church (Tipperary).

capitals that survive bear an oval-leaf decoration somewhat reminiscent of what we noted at Clonkeen, Aghadoe, and St Caimin's, Inis Cealtra.

Donaghmore's particular location – it is in hilly country several miles north of the Suir – may explain its points of reference to Cormac's Chapel: the barrel-vaulted and stone-roofed chancel, the almost altar-recess scale of that chancel, and the tympanum. Its relationship with the work underway in the mid-1100s at the far side of the island is more interesting. It certainly indicates that there was a movement of stylistic ideas around the south-west corner of Ireland about 1150, and that the particular architectural and sculptural motifs which constitute the 'classic' Gaelic-Irish Romanesque architecture as defined by Leask, de Paor and others were becoming common currency. The continued importance of Lismore

and Cashel, not necessarily as workshops but as centres to and from which there was regular travel, may explain why Donaghmore relates so well to work which is relatively far away within other political and ecclesiastical jurisdictions.

Another church of particular interest in this small region, very different from Donaghmore and possibly later than by a decade or two, is at Kilsheelin. This is a nave-and-chancel building with extensive fifteenth-century alterations. Of the nave only the east wall with its chancel arch and a couple of metres of the adjacent side walls on each side survive intact; the present north portal is Romanesque (**Plate 7a**) but is incomplete and is not on its original present position. Only part of the south wall of the twelfth-century chancel survives.

The single order which survives of the portal has keel mouldings on the arris of the jambs and the arch. The jambs had capitals, that surviving on the east side having a plant motif. The inner face of the jamb order has a hollow roll, and the archivolt of the arch has a continuous plant scroll. Close to the east end of the south wall of the nave is part of a window with a pointed bowtell moulding. The keel and bowtell mouldings on these openings suggest a date for them in the second half of the twelfth century. The chancel arch, however, is plain except for a chamfered impost confined to the responds, which we would probably assign to a pre-1150 date, and this may suggest that the door and fragmentary window belong to a secondary phase.

The main interest of Kilsheelin are the two three-quarter columns which are evidenced in the two interior eastern corners of the nave (**Fig. 116**). Both columns are destroyed, but that on the north has its plain plinth, a much defaced base and its capital – decorated with a plant motif identical to that on the east capital of the portal – intact, indicating that the column was at least 3m high and extended almost to the height of the original wall-head. Of the south column only the base – it has an ogee profile – and plinth survive. The later alterations make it impossible to know if these two features were replicated at the west end of the nave, which is unfortunate. If we had evidence that there were more columns than just these two we would envisage them either carrying up to the wall-head to support wall-plates, or supporting some form of rib-vault, as in Cashel's chancel, or maybe supporting the transverse arches of a barrel vault, as in Cashel's nave. Two columns alone would probably have supported an arch against the east wall of the nave and concentric with the chancel arch.

Kilcash, nearby, is another nave-and-chancel church and is different again.[47] The nave is a little smaller than at Donaghmore – 11.35m by 6.15m internally – but has quite similar proportions. It is largely twelfth century in date, with a Romanesque south portal and three windows, two of which are certainly of that period. There has been an indeterminate amount of rebuilding here: the west wall may be thirteenth-century, and the south portal might not be in its original

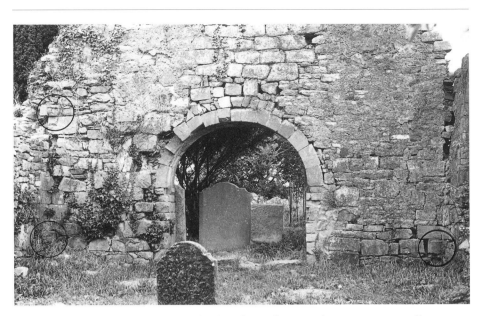

116 The chancel arch and east wall of the nave of Kilsheelin church, showing the single surviving capital and the two surviving bases from the angle columns.

position. The present, much-rebuilt, chancel, 6.8m by 4.5m internally, was a single-celled church of the pre-Romanesque period. Indeed, the original west gable of that early church survives intact within the east wall of the Romanesque nave; the chancel arch built when the conversion was made no longer exists. On the south side of the west face of that wall, facing into the Romanesque part of the church and presumably a Romanesque addition associated with the chancel arch, is part of a string-course with chamfered top and bottom edges and a double quirk on its face.

The portal (**Fig. 117**) has three orders. It is in rather poor condition; decoration survives but is quite worn, with only the bases (of an inverted-cushion type) well-preserved. The width of the central door opening is 1.05cm; its height to the impost is 1.80m. The maximum width of the portal is 2.30m. The inner and middle orders have roll mouldings, possibly keeled, on their arches and jambs, and these rolls are flanked by double quirks. The outer order of the portal has pilaster responds with rolls, flanked by quirks at both sides. The arch over these responds has archivolt saw-tooth chevron. There is no hood moulding but there may have been one originally. Sufficient survives of the imposts to show that they were chamfered with bosses in the chamfers. There are no capitals but the top stones of the jambs on both sides of the middle order have heads carved on them: although defaced, these heads appear to be pear-shaped, and are clean-shaven with ears high up on each side. A similar head in a similar context – at the top of a roll-moulded jamb in place of a capital – appears on one side of the single-order west doorway of the small church of Kilbunny; the latter is in the same region as Kilcash and its arch also has archivolt saw-tooth chevron.

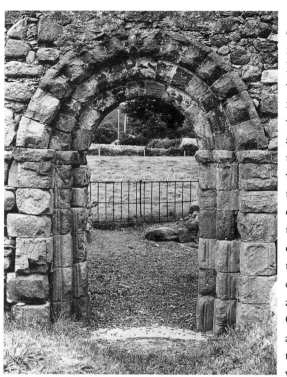

117 South portal, Kilcash church.

A partly rebuilt single-cell church only 7.1 by 4.3m internally, Kilbunny is a curious little building. A stone, carved with an animal head, projects from the wall beside the doorway but is known to have been above the doorway, at least in the phase before the small ruin was conserved. The motif on the south-side of the portal opposite the head just mentioned is a 'ram's head', the only parallel for which seems to be on the south side of the chancel arch at Aghaviller, about fifteen miles north in Ossory.[48] There was a window above the portal and it seems to have been of the same width, and if this was a feature of the church in its Romanesque incarnation it would surely have been arched like the doorway.

It is appropriate to mention Sheepstown in this context, not least because it is a short distance from Aghaviller. This small church with roll-moulded quoins has an even more modest portal than Kilbunny: its arch is unadorned, it has simple chamfered imposts, and roll-mouldings on the jambs (**Fig. 118**). The date of Sheepstown is not known. It is tempting – though dangerous – to assign it to an early twelfth century date on account of its similarity with, say, the Round Tower doorways such as that at Clonmacnoise; the doorway into Myshall church in Carlow is very similar to Sheepstown's but even simpler, with its chamfered impost restricted to the responds, and is similarly undated. It is certainly easy to envisage the mason at Kilbunny having a basic template similar to what we see at Sheepstown and simply adding chevron, 'fake' capitals and impost bosses.

The key church in twelfth-century Ossory was probably at Kilkenny, but only a number of carved stones remain.[49] While they bespeak a building with grand details, including scalloped capitals and Hiberno-Scandinavian motifs, insufficient remains to speculate on its plan or superstructure. There was also a residence of the Mac Gilla Pátraic kings at Kilkenny in the 1100s,[50] which suggests that here too was the same co-incidence of cathedral and palace as Cashel and

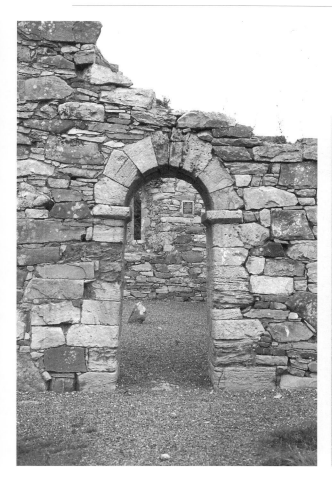 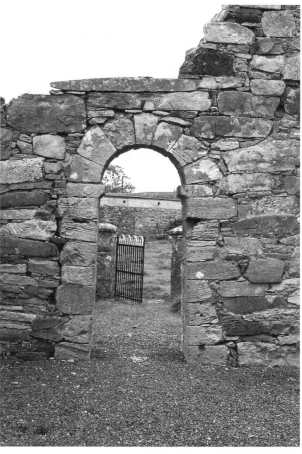

118 West portal of Sheepstown church: exterior (*left*), interior (*right*).

Killaloe. In the absence of Kilkenny, the church at Freshford, on the old church site of Achadh-Ur, is the key (non-Cistercian) monument of Romanesque Ossory.

Much of this church may be only a couple of centuries old, but its west façade, 9m wide, is medieval, complete with antae and a great pedimented portal, and an oculus of Romanesque form which seems to be much more recent (**Fig. 119**). The portal, 3.1m in maximum width, projects 70cm from the side walls but is sufficiently deep to form a sort of porch. The door opening itself is 95cm wide and 1.95m high to the springing; it has plain responds with a long inscription on its outer face to greet the visitor, and another inscription on the south jamb: these are, respectively, OR DO GILLA MO-CHOLMOC U CE … CUAIN DO RIGNE translated as A PRAYER FOR GILLA MOCHOLMOC O CENNCUCAIN, WHO MADE [THIS], and OR DO NEIM INGIN CUIRC ACUS DO MATHGAMAIN U CHIARMEIC LASDERNAD IN TEMPUL SA, translated as A PRAYER FOR NIAM, DAUGHTER OF CORC, AND FOR MATHGAMAIN O CIARMEIC, UNDER WHOSE AUSPICES THIS CHURCH WAS BUILT.[51]

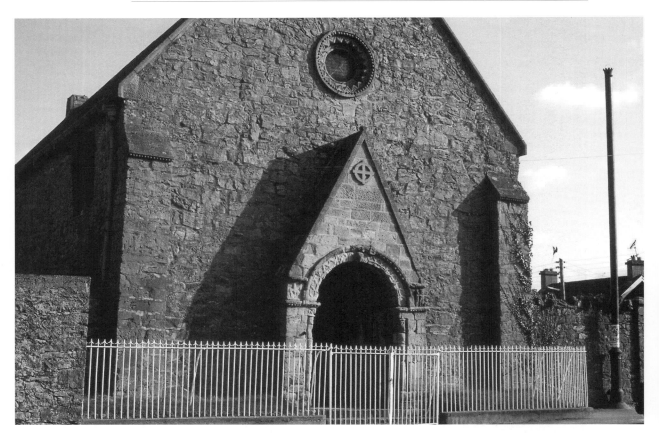

119 West façade of Freshford church.

Facing each other across the opening are small rectangular frames designed for sculpture, one of them preserving two figures (**Fig. 122**). Such enframing gave emphasis to whatever sculptured forms were contained within. The sculptures themselves were made as separate components and slotted into place. There are two middle orders, each with an angle-shaft topped with scalloped capitals, and with arches decorated with archivolt saw-tooth chevron (inner) and alternating archivolt and intrados chevron (outer). The outermost order has pilaster-responds holding up the pediment and small twin-columns facing across the opening. The capitals on these twin-columns are quite short from impost to astragal, and they bear human heads gripped by animals. The arch of the outer order has stepped or embattled ornament on both soffit and archivolt faces, and the keystone is decorated with a human head; there is a hood moulding with an embossed hollow chamfer and decayed terminals. Above the imposts and flanking the arch immediately below the rising of the pediment are two sculptured panels, that on the north having an image of an equestrian figure (**Fig. 121**), and that on the right having an image of a pair of figures, at least one of whom is an ecclesiastic (**Fig. 120**).

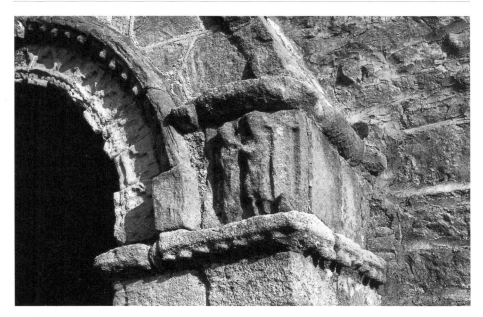

120 Relief of figures, south side of Freshford church portal.

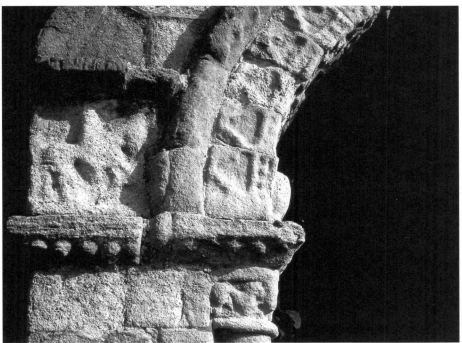

121 Relief of equestrian figure, north side of Freshford church portal.

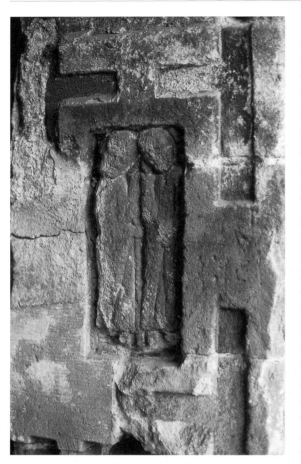

122 Figure sculpture in the doorway respond (south side) of Freshford church.

Leask, in one of his few references to overseas Romanesque work, remarked that the manner in which the two sculptured panels on the exterior of the Freshford portal recall '(in a very humble way) the splendid figure friezes of the Romanesque of southern France'.[52] The comparison with France is not as tenuous as one might first imagine (**Fig. 123**), and in making the comparison Leask certainly touched upon what might be the essential nature of the Freshford portal: its bold projection gives it the quality of a small façade, and both the positioning and the iconography of the sculpture suggests that it was inspired to some extent by a façade conception, a point revisited below.

There is a wide network of comparanda for Freshford's individual elements – the twin-columns of the outer order, for example, compare with the chancel arch of St Caimin's, Inis Cealtra, which is actually only forty miles to the west – but no other portal compares exactly with it. The north portal at Cormac's Chapel and the west portal at Donaghmore compare in the sense that all are porch-like beneath their pediments, while the use of angle-shafts connects Freshford more closely with the former than with the latter. Killeshin, a work associated with Diarmait Mac Murchada, is the pedimented portal which is closest to Freshford geographically, and while they share quite a few features – head-keystones, head-capitals, step patterns on arch-rings, and inscriptions, as well as the pediments themselves and the façade antae – they are certainly not products of the same workshop. One hesitates, then, to use stylistic evidence for their dating relative to each other, but Freshford's closer proximity stylistically to Cashel would suggest it is the earlier of the two, which would probably mean a date in the decade 1140–50, maybe even the half-decade 1145–50. Perhaps Diarmait Mac Murchada

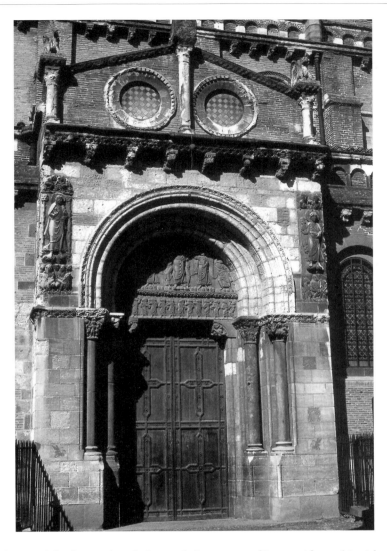

123 South portal,
St Sernin, Toulouse.

knew the Freshford portal and directed that some of its motifs, and its idea of an
inscription, be used at Killeshin?

Before leaving Ossory there is one more doorway worth discussing, and it is
the most enigmatic of all. The old churchyard at Kilkeasy, abandoned and eerie
on a little-travelled road, has a much overgrown ruin of a Romanesque church, at
the west end of which are the remains of a three-ordered Romanesque portal
(**Fig. 124**).[53] The arch is destroyed apart from a single, plain, voussoir. The three
jambs each had a large corner roll, bulbous immediately below the capitals; those
capitals have curving lines in the manner of a fern leaf meeting on the edge. The
imposts have chamfered lower edges, and their vertical faces are decorated with
chevron. The type of capital represented here is without parallel in Ireland. The

124 The west portal of Kilkeasy church: general view and details.

bulbous device between the top of the roll and the capital is paralleled at Temple Finghin (Clonmacnoise) and Timahoe, although in each case it is found at the bottom of the jambs; these might indicate a date *about* the 1150s for Kilkeasy.

ARDMORE: A LATE ROMANESQUE ARCHITECTURAL CONUNDRUM

Munster's Romanesque century is book-ended by two cathedral churches, both of which needed to argue their diocesan rank and both of which are distinguished by having enormously interesting west façades. The earlier was Ardfert, and the later is Ardmore Cathedral, one of the best-known buildings of the period in Ireland.[54] The site itself is an early one, associated with Declan, one of Munster's alleged pre-

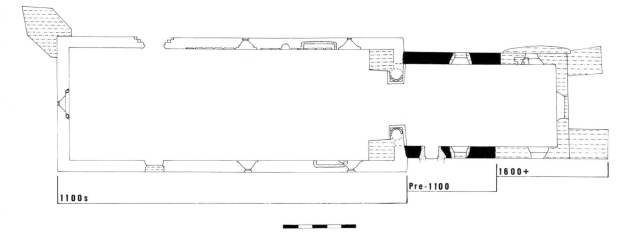

1100s

Pre-1100

1600+

125 Plan of Ardmore Cathedral showing principal growth phases. Scale bar = 5m.

Patrician saints.[55] Diocesan status was claimed in 1152, and a *vita* of Declan was written at that time to support that claim by highlighting Declan's place within the history of the Déisi, but the claim did not survive the thirteenth century.[56] The building identified as the erstwhile cathedral is the ruined church associated with Moel-ettrim Ó Duibherathra, a 'noble priest of Ardmore' who died in 1203 after 'finishing' its building.[57] There is also a particularly magnificent Romanesque Round Tower, distinguished by string courses at intervals as it tapers upwards, and a small, early medieval, tomb-church with antae known as St Declan's 'House'.

The cathedral is a nave-and-chancel building (**Fig. 125**). Internally, the nave is 22.10m by 7.95m, and the chancel is 10.60m by 5.80m. There are seventeenth-century alterations: much of the east end of the chancel, including the windows and two external buttresses, are from this period, as are the external north-west corner buttress of the nave and the two buttresses against the west side of the chancel arch wall. Otherwise the church is almost entirely medieval, but there is clear evidence that this is a multi-phase building within that period. First, the western half of the chancel is built with large, irregularly coursed stones, and is clearly retained from an earlier building. Second, the chancel arch is of two periods: the capitals of the present arch cuts through the earlier capitals of a Romanesque arch. Third, the western 7.90m of the length of the nave on the exterior is of a different build than the eastern parts of the nave, and the string-course which runs along the eastern part of the nave at the level of the window arches discontinues, indicating the present fabric at the western end of the nave is later than the remainder of the nave (**Fig. 126**).

The interior of the building is now entered through a portal at the west end of the north wall of the nave; there was another portal – externally a simple round-arched form with a chamfered edge – in the opposite wall but this is

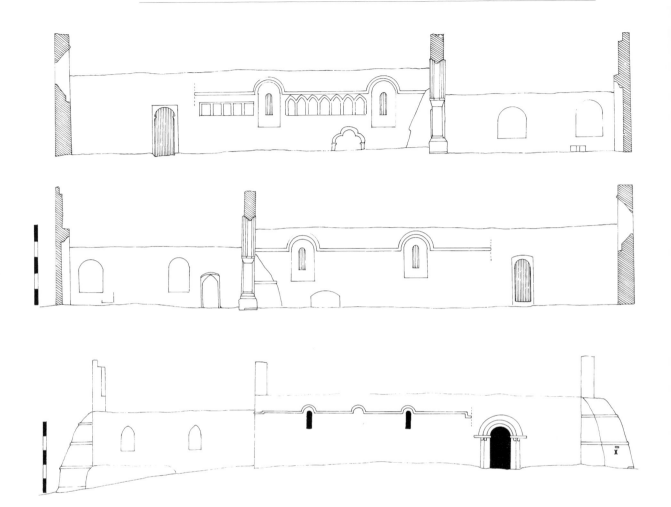

126 Schematic drawings of the elevations of Ardmore Cathedral nave: interior side (*top*), interior south side (*middle*), exterior south side (*bottom*). *x* marks the date-stone. Scale bars = 5m.

blocked and on the exterior much of it is embedded in a pile-up debris and burials. The portal in the north wall of the nave has three orders (**Fig. 127**). The overall width of the portal is 2.30m, measured from the edges of the outer responds, or 3.05 measured from the edges of the impost, and the estimated height is 3.70m. The doorway itself is 1.10m wide and 2.40m high to the top of the impost. The inner order has a hollow-chamfered impost which is continuous with the abaci of the capitals of the outer orders. The middle order had an angle-shaft on each side (both now destroyed) with a scalloped capital on the east side and a form of scalloped leaf capital (the lower part of the capital has palmette-like plant leaves) on the west side. The equivalent arch-ring order has a pointed-bowtell moulding flanked by hollow rolls. The base of the column on the east side is a square pedestal the top edges of which are convex, while the base on the other side

is merely a square pedestal. The outer order has angle-shafts within rebates in the responds. The shafts are destroyed on both sides, but the capitals and bases are preserved: both capitals are scalloped, and the bases are square pedestals the top edges of which are concave. The arch associated with this order is identical to that associated with the middle order. The abaci of the four capitals of the portal continue a little to the east and west as imposts and support a hood moulding of the same profile. Internally the portal is rebated with an arch over the rebate. The portal is of late twelfth-century date and of the same basic tradition as the surviving portal from Inislounaght Cistercian abbey (now in Marlfield church near Clonmel)

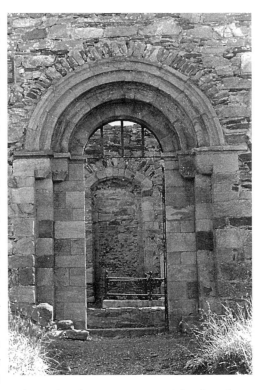

127 North portal, Ardmore Cathedral.

and the Romanesque portal preserved in the fragmentary parish church at Knocktopher.

The nave itself is of great interest. Inside, its north wall (see Fig. 126) is embellished with a row of five square frames on the west side of the westernmost window, and with a row of eight arched frames on the east side. Towards the east end is a late twelfth-century tomb recess in the south wall of the nave, opposite a trefoil-arched thirteenth-century recess in the north wall. The pointed-arched twelfth-century chancel arch remains, complete with its semi-cylindrical responds and scalloped capitals. However, it is possible that the arch is a (late medieval or early modern period?) re-erection and that the mangle of different sculptural elements which we see on either side of it are the consequence of later rebuilding.[58]

It is the exterior west wall of the nave that is most interesting. Here are two registers of figure sculpture within architectural frames, a window in the gable, and a buttress on the north side (**Figs 128, 129**). The lower register is comprised of two lunettes,[59] each about 2.5m wide. There was originally a third lunette: it shares a springer with the central lunette. The two extant lunettes are filled with ashlar and with sculptured panels of different colour and texture. The arches and uprights which define the fields of sculpture have chamfered edges. Above the lunettes is a register of thirteen arcades, of which nine contain figure sculpture.

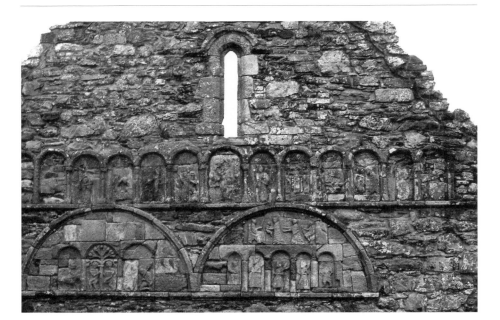

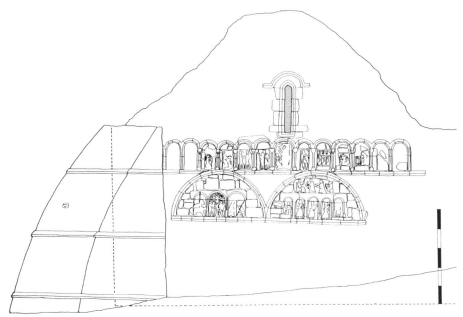

128 West wall, Ardmore Cathedral.

129 Elevation drawing, west wall, Ardmore Cathedral. Scale bar = 5m.

The arched frames are of different types, with different types of capitals used on the small uprights. As in the lunettes, stones of different sizes and colours are used, and they are in different states of disrepair.

This west wall has been the subject of considerable debate. Champneys had this to say: 'The details of this church are mainly of Transitional architecture, but

there is a probability that these carvings belonged to a somewhat older church which has been more or less rebuilt – the arches do not seem made for the west wall, as it stands at present', and elsewhere, he says that 'the church, as we have seen, has a west front probably of the XII century, and appears to contain masonry belonging to a still earlier building in the chancel, which has also undergone alterations at some date later than the "finishing" [of 1203] above mentioned'.[60] De Paor had little to say about Ardmore, and Henry, remarkably (and regrettably in view of the complexities of the iconography), gave no assessment of it at all in her volume on the Irish Romanesque. But since then two lengthy analyses, fifteen years apart, restored the wall to its proper place as a key Romanesque work which is simultaneously a tricky archaeological problem.[61]

In 1972 J.T. Smith interpreted the building's twelfth-century history, producing the following sequence. The nave dates from the later 1100s, but the seven or eight metres at its west end were added before 1203, the recorded date of completion; the original west wall of the nave had an entrance and a window, and in the immediate pre-1203 alteration the former was moved to become the present north portal and the latter became the window in the gable of the present west wall; the sculptures and their frames were on the west wall of the original, shorter, nave, and the lunettes 'must' have flanked the doorway. Peter Harbison, in the most recent examination of the wall, sides with Smith's reconstruction but suggests that the nave on which the sculpture was originally displayed was not built in the late twelfth century, as Smith maintained, but in the period 1150–75.[62]

McNab's analysis in 1987 led her to suggest a different and more complicated (and more difficult to follow) sequence of events. Her original west wall had, as Smith had claimed, a high west window and a central portal, but, *contra* Smith, that portal was enclosed by one lunette and flanked by two others. Somewhere 'in the vicinity' of the cathedral was another building which featured a 'small-scale, blind arcade' possibly containing some sculpted panels. When the church was extended this arcade was built into the new west wall of the nave, and inserted into it was an array of sculpture, some of it evidently made to be displayed there and some of it relocated from another context. The west portal was moved to the north wall about the same time. Also, the lunettes, originally 'purely architectural features' (not containing sculpture, in other words), were built into the new west wall albeit a little off-centre, and were filled-in with ashlar and with sculpted panels; those panels were re-used from a context, possibly in the original twelfth-century church, in which they may have been arranged in the form of a 'frieze decoration as at Modena'.

But an alternative structural history is suggested by the remains.[63] The string-courses along the internal and external side walls do indeed terminate between 7.50m and 8m short of the west wall, as is shown on **Figure 99**, but it is not

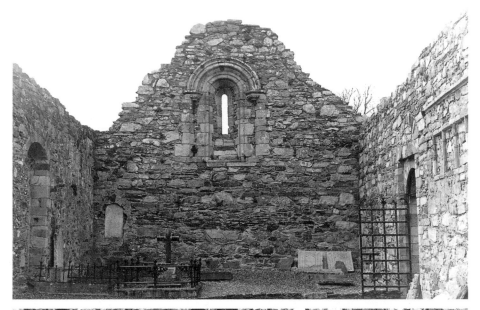

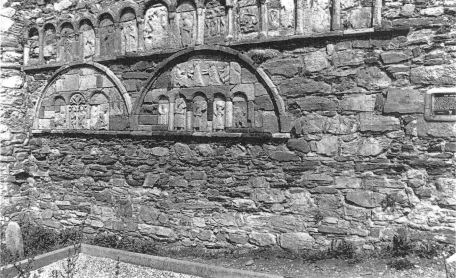

130 Interior (*top*) and exterior (*bottom*) of west wall, Ardmore Cathedral.

unequivocally the case that the whole west end of the nave was an extension to an older nave. One can see on both the outside and inside of the west wall (**Fig. 130**) that its whole middle part – the part that contains the sculpture – is secondary masonry; there are older foundation courses *in situ* below. How old are those foundations? A simple metrological analysis of the entire nave as we see it today reveals that it was laid out as two 1:√2 rectangles end-to-end, which suggests that

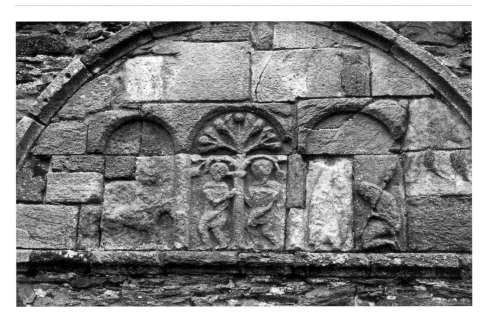

131 Northern lunette,
Ardmore Cathedral

they belong with the rest of the nave. The west end of the church, then, would seem to be a *rebuilding* above foundation level, not an extension.

As we have noted, the arcade and lunettes are contained within the rebuilt wall; one could deduce this anyway because there is no scarred masonry where the third lunette should be. When did this rebuilding take place? Here the buttress comes into play. If we measure the width of the wall, starting at the point at which the buttress connects with the west face, we find that three lunettes would fit almost exactly, leaving a gap of the order of 15–20cm at either end. Whoever rebuilt this wall must have seen, or must have known, that there were three lunettes, and carefully positioned the two 'reconstructable' lunettes to leave space for where the third had been. And whoever rebuilt this wall built the buttress. There is a date stone on the buttress, not identified by Smith or McNab, which gives us 16 [?30]. This, therefore, is a seventeenth-century reconstruction.

What we have, then, is evidence of a portal-free west wall with three lunettes. These must have carried sculpture from the very outset. The idea that a portal slotted under one of the lunette arches is nonsensical, given the horizontal string-course on which they stand; the idea that they were originally empty of sculpture is also nonsensical. In fact, compositionally, the surviving sculpture makes it clear that we are seeing the panels that were originally contained within two of the lunettes. In the northernmost lunette (**Fig. 131**) there is a central Fall of Man (Adam and Eve) flanked by an equestrian figure on the left and two figures – an ecclesiastic blessing a soldier? – on the right. In the central (now the southern) lunette (**Fig. 132**) there is a Judgement of Solomon above and a Virgin and

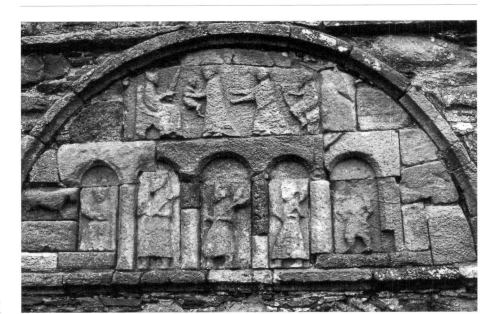

132 Central lunette,
Ardmore Cathedral

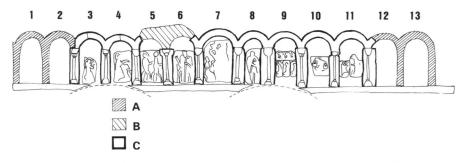

133 The upper arcade,
Ardmore Cathedral,
showing types of
supports and arch-rings.

Child/Adoration of the Magi below, and the juxtaposition is quite deliberate: one has a king in judgement over a disputed child, its 'mothers' reaching out to stake their claims, while the other has a child who is king being held by his mother and being visited by three kings.[64]

What about the arcade? The first observation to be made is that it is made up of different types of supports and arch-rings (**Fig. 133**). Type A is comprised of rib-like moulded arches and springers, Type B of arch-rings which are recessed on slabs, and Type C of verticals or supports which are tiny engaged shafts with capitals and bases. The capitals also differ. Types A, B and C are not contemporary but represent at least two actual phases of work. The best clue to chronology is the fact the sculpted panels are set in frames bounded by Type C verticals only. Thus, the parts of the arcade which are made up of stones of Types A and B may have been constructed over an original, though defaced, arrangement of sculptured panels within Type C frames. Those associated capitals that are best preserved have

134 Chancel arch responds, Ardmore Cathedral, viewed from the nave.

small scallops comparable with the scallops on capitals on the chancel arch (**Fig. 134**), suggesting that the arcade is of the same general date as the nave.

The arcade in its original form stood on some architectural or architectonic feature. It is likely that the present string-course was that original arcade support. This string-course is cut away to accommodate the crowns of the lunette arches below, indicating that the lunettes were extant when it was created. There seems no reason to doubt that the arcade was installed immediately after the horizontal course was put in place, but the time interval between the construction of the string-course and that of the lunettes below is rather more uncertain. We have already seen that the lunettes are not in their original exact positions but have been re-set, and that by the time they were re-set in the rebuilt wall they had suffered damage. Since the arcade is itself incomplete it is possible that it and its string-course were also re-used, and from the same original context as the lunettes. It is suggested, then, that the lunettes, the string-course and the arcade of Type C frames are all contemporary and originally co-existed on the one wall, and that they all belong to the church finished by 1203.

The way in which the sculpted panels under Arches 6 and 8 (**Fig. 135**) are fitted between the verticals indicates that this original arcade was made to contain them. The other panels are likely to have been displayed there also. Their present untidy appearance within the arcade can hardly be what was intended by the twelfth-century craftsmen. There is a simple explanation for this within the

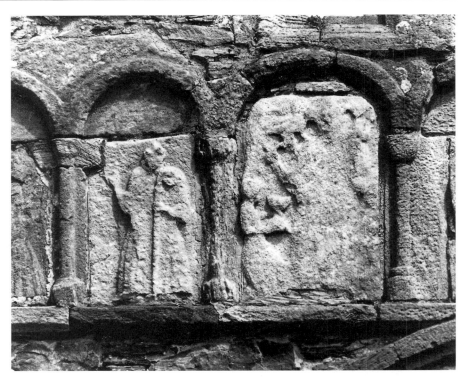

135 Detail of upper arcade, Ardmore Cathedral: Arches 6 and 7 (*bottom*), and 8, 9, 10, 11 (*top*).

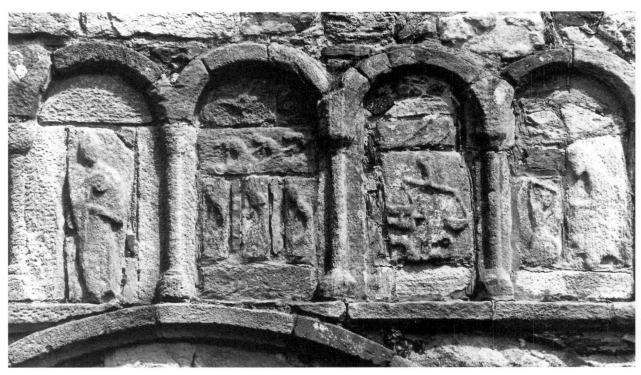

136 West façade, Notre-Dame-la-Grande, Poitiers.

context of the architectural history elucidated here: if the original arcade was contemporary with the lunettes on the original wall, it too would have suffered damage when it was moved; the panels which had survived the move could have been inserted as we see them today and the arcade repaired with Type A stonework. It is possible that some of the panels we see today were originally in the destroyed third lunette: the fragmentary Weighing of the Souls (God's final judgement) in Arch 10 (**Fig. 135**) would certainly fit nicely at the end a simple

137 West façade, Civray.

iconographic scheme which starts the Fall of Man (God's first judgement) and has both the birth of Christ and the Judgement of Solomon in the middle.

What are the possible parallels for a west wall with three lunettes and a row of small arches above? Smith cited as parallels for his reconstruction of Ardmore the façades of the churches of St-Nicolas in Civray, Notre-Dame-la-Grande in Poitiers and the Cathédrale de St-Pierre in Angoulême, all in western France. These façades are arcuated and feature extensive figure sculpture, arranged thematically, as was *de rigeuer* for that region.[65] None of these façades is exactly comparable with Ardmore but the general comparison is valid, certainly with respect to the figures under arches (**Fig. 136**).[66] In fact, mention of Civray is apposite, since high up on the north side of its west façade is a much-broken equestrian figure, facing southwards (**Fig. 137**). This is quite a common motif in western French Romanesque. His identity – one presumes it is a man since the horse is often depicted trampling on a woman – has been the subject of much debate. Equestrian figures are usually identified as St George in England, as St James in Spain, and as Constantine in France, but Linda Seidel has concluded with respect to twelfth-century western France that the ancient image of the equestrian figure

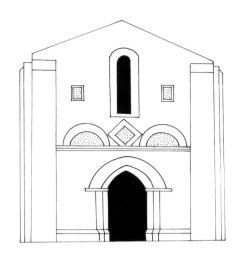

138 West façades:
St Saturnin (*left*),
Olerat (*right*).

had 'in the eyes of contemporaries, become identified with the struggle against Islam' and therefore 'represents no single individual but stands instead for a class of heroes, big and small, past and present, each of whom battled, metaphorically, alongside Charlemagne in the fight for Christianity and for country.'[67] Ardmore and Freshford are the only two places in Ireland in which this motif is found in a twelfth-century architectural context, and in both instances the figure is, like in so many French examples, on the north side of the architecture, facing southwards. The geographical location of these churches relative to each other – one near the river Nore and the other on the coast near its estuary – may be significant. The only English Romanesque example I know of an equestrian figure in an arched frame other than a tympanum is on south side of the chancel wall – in other words on the left-hand side facing to the right – at Barfreston in Kent, significantly one of a number of Kentish churches at which we can see French influence.[68]

The Ardmore lunettes themselves can also be paralleled in western France. At Surgéres in Charente Maritime, for example, there are two deep lunette-shaped niches on either side of an inserted Gothic window high up on a restored seven-bay façade, and each niche has an equestrian figure facing the window. St Saturnin in Charente has two lunettes squeezed in between storeys in the elevation at the expense of the façade's horizontal lines (**Fig. 138**, *left*); within the north lunette is an image of a saint offering a crown to a bishop (could this be what is represented at St Declan's old site?), and in the south is a panel featuring Christ with an orans gesture between the Virgin and St John. Also in Charente, at St-Étienne-d'Olérat, La Rochefoucauld, two lunettes were used in the middle storey of the façade, and in the space between them there is a lozenge-shaped panel (**Fig. 138**, *right*); the north lunette contains an ox and the south lunette a

lion, and the lozenge-shaped panel an *Agnus Dei*.[69] In view of the formal similarities it is possible that one of these French façades provided the inspiration for the Ardmore scheme.

If there is nothing improbable, then, in the hypothesis that the Ardmore façade was inspired by some façade in western France, there remains the problem that the Ardmore façade as reconstructed here had no west portal whereas in the formulation of western France's distinctive tradition of bay-divided, two- or three-storeyed façades, the central doorway was clearly fundamental to the explicit iconographic reference to Antique triumphal arches. Is it possible that at Ardmore opposed doorways were considered necessary, one for the secular congregation perhaps, and the other for the church personnel, thereby necessitating a digression from the model?

How might French ideas have come to Ardmore? One thinks always of pilgrim travel. Ardmore's location on the south coast is halfway between the towns of Cork and Waterford, both of which saw merchant traffic coming and going from Aquitaine and Gascony in the thirteenth and fourteenth centuries. The presence of Saintonge pottery in thirteenth-century Cork, and in southern Ireland in general, almost certainly reflects trading activity from the Bordeaux area along older trade routes.[70] A convenient means of access to the Continent for those who were going on pilgrimage to Compostella or Rome was to follow the merchant routes towards the south of France, and pilgrims coming and going this way would have seen the arcuated façades of western France at the start and end of their journeys.

The politics of patronage and the Romanesque diffusion, 1140–1200

When we move away from the Killaloe and Cashel of Muirchertach Ó Briain and Cormac Mac Carthaig respectively the story of Gaelic-Irish Romanesque architecture gets more complex. Munster south of the Killaloe–Cashel line certainly has the earliest work, as we have seen, but there is very little of it dating back to the pre-1150 period; that which we know is concentrated in Kerry and the east Cork-Waterford region, with virtually nothing located in the territories between. It seems that, despite being part of the arena in which a Romanesque idiom developed in the first instance, the area between the Blackwater and the Atlantic saw the formal development advance no further than its very first steps; fragments of one chevron-rich doorway of probable mid-century date at Aghacross in north central Cork, and one fairly complete but odd portal with little decoration at Ballyhea,[1] seems a poor return from here.

A meagre rag-bag of dates and the unreliable evidence of stylistic progression indicate that, in the most general terms, Leinster (basically, the area which became the archdiocese of Dublin in 1152) had Romanesque forms around the middle of the twelfth century, the Midlands (the dioceses of Clonfert, Elphin, with its little-studied diocesan centre, Ardagh and Meath in 1152) in the middle and later twelfth century, and Connacht (territories contained within the archdiocese of Tuam as created in 1152) in the later 1100s. We will try to map some of that pattern here using broad brushstrokes and guided by some patterns of patronage.

UNDERSTANDING PATRONAGE

Although we have enough data to reconstruct something of the evolutionary shape of Romanesque architecture in early to mid-twelfth-century Ireland, we

231

have comparatively few names of key people whom we might applaud for the corpus itself: we know Muirchertach Ó Briain moderately well, and Cormac Mac Cárrthaig and Diarmait Mac Murchada rather better, but virtually everybody else remains anonymous. Even when the century passes its mid-point and chevron-festooned arches crop up around Ireland we can utter far fewer personal names than site names. It is this relative anonymity of the secular powers who facilitated and may even have financed many of the works, and not just the apparently exclusively-ecclesiastical nature of every major *extant* project of the age which required Romanesque forms, which secures the identification of Gaelic-Irish Romanesque with the Gaelic-Irish Church.

While Romanesque architectural and sculptural devices were not exclusively the domain of the Church in any part of twelfth-century Europe, they may have been regarded as intrinsically Christian. Those patrons whose 'secular works' – castles, palaces – embraced Romanesque forms in one way or another were, after all, customarily founders of churches as well, and it is possible that the origin of various Romanesque devices in *Christian* Antiquity, via one of those 'pre-Romanesque' Christian renaissances such as the Carolingian or Ottonian, was widely known, especially in imperial or the more powerful royal contexts. But the real significance of a repertoire of architectural forms and sculptural devices being shared between castles (and palaces) and churches may have been its articulation of the contemporary view of the embeddedness of secular and sacral power: medieval ideas of kingship and government carried a scriptural imprimatur, and Christian symbolism can be 'read' in buildings and landscapes associated with secular authority.[2]

We know of course that Romanesque monuments and their elements are not animate, organic things, but we still speak sometimes of Romanesque 'developing' stylistically from one form to another, or 'spreading' geographically from one area to another. Human agency, manifest in choice-making and know-how, is easily if inadvertently written out of the equation, as if Romanesque can exists independently of it. But if Romanesque forms appear to have 'developed' and 'spread' it is precisely because their values, political and aesthetic, were recognized, and the myriad ways in which they might be altered were reflected on and acted on.

The question which follows on from this is who did the recognition, the reflection, and the alteration. Put another way, whose vision informs the finished work? For every Abbot Suger of St Denis, anxious to be identified as 'author' of a work of art or architecture, or a Cormac Mac Cárrthaig who is recorded as physically engaged in the act of building, there was a mason, or a craftsman, or a whole workshop full of them, doing the actual physical work.[3] In the absence of good documentation with respect to the question of authorship, the formula 'artists and patrons' (or 'patrons and artists') is often as far as we can go by way of

generalization, even if it seems an evasive response. It does conflate two types of individual into one, implying a sort of umbilical connection between the hands of one person and the mind of another, and crediting both (and also in a sense crediting neither), but it may be that seeking a distinction between artist and patron misses a fundamental point about the creative process in the twelfth century: we make the distinction between he who commissions and he who takes the commission, and if twelfth-century people were as concerned about these things as we are they might have left us more clues.

A second question, asked here specifically about Ireland, is just how low down the social scale was constructive or useful patronage possible, or even permissible. The involvement of royal houses, of kings and their siblings, is clear enough, and they certainly possessed both the resources and the political need for extensive patronage, particularly for churches with regional catchments, such as cathedrals. Their patronage was not limited to church-sites and the buildings thereon but could manifest itself in gifts of land, and in the requisitioning or manufacturing of gifts of liturgical appurtenances and furnishings, from altar plate and vestments to reliquaries.[4] But must we regard every church of the period as a *direct* product of the patronage of ruling élites whose rituals of consecration and systems of genealogical accession marked them out as royal? Although named patrons are invariably of royal stock, the answer is surely no. The evidence that a type of parochial network familiar to us from the later middle ages had developed in pre-colonial Ireland fits with the lack of unambiguous evidence that many Gaelic-Irish Romanesque sites were places of monastic observance at that time. It suggests that the responsibility for ensuring practical – as in tithing – support of the local Church institution within the kingdoms and dioceses simply devolved to the level of those local lords who held land of a royal house, just as it appears to have been in the post-1169 period.[5] This, combined with our difficulty of attaching names to twelfth-century churches or phases in churches, suggests that the world of most churches of the period was fundamentally local, as was their patronage.

DIARMAIT MAC MURCHADA AND LEINSTER

For Leinster the spotlight naturally falls on Diarmait Mac Murchada, who is the best documented of the small number of known patrons of the era in Ireland. A *bête noir* of traditional Irish history, Diarmait's career in Leinster spanned the four middle decades of the twelfth century and his involvement with the Church surpassed even Cormac Mac Cárrthaig.[6] He succeeded to the kingship of Uí Chennselaig and to the provincial kingship of Leinster in 1132.[7] His career was interrupted in 1166 when he was driven into foreign exile by his rivals, but it famously resumed in 1169 when he successfully engaged Anglo-Normans as

mercenaries for his cause.[8] Diarmait died in 1171 as king of Leinster, but '...
without unction, without body of Christ, without penance, without a will, in
reparation to Colmcille and Finnian and to the saints besides, whose churches he
destroyed'.[9] During his career Diarmait was actively involved in the foundation
and support of churches, and however we judge his sincerity as a patron, or his
commitment to the reform of the Church (a process still underway during his
reign), we can hardly doubt that his acts of ecclesiastical patronage stood him in
good political stead. Baltinglass Abbey, is a case in point.

He founded this Cistercian abbey in 1148 and was awarded a certificate of
confraternity from St Bernard of Clairvaux for his effort. In making this grant
Diarmait would have known of the Cistercian desire for extensive lands, and in
giving the Baltinglass community the requisite acreage in west Wicklow he
effectively separated that land which the Ó Tuathail – one of the subordinate
families in the Leinster kingdom – held in demesne in the district of Uí Muiredaig
from certain mountain lands which they had recently acquired in the district of Uí
Máil, thereby depriving them of one continuous tract. Later, between 1162 and 1165,
Diarmait confirmed by charter a grant which was made by one of his subordinate
kings to another Cistercian abbey within the kingdom, Killenny. This also had a
strategic location; it was close to the north-south pass of Belach Gabráin through
which Strongbow was later to march on his way north to Dublin. By facilitating the
settlement of a reformed monastic community at Killenny, Diarmait again ensured
that his political rivals would not gain easy control of that territory.

Lorcán Ó Tuathail, the archbishop of Dublin, was a witness to the Killenny
grant. He had been elevated to this position in 1162 following nine years as abbot
of Glendalough. Diarmait appears to have secured these high offices for Lorcán,
having married Lorcán's half-sister Mór about 1153 and having later presided over
the synod at Clane at which Lorcán was installed as archbishop. Diarmait's role in
Lorcán's foundation of the priory of St Saviour's for canons regular of St Augustine
(following the Arroasian observance) at Glendalough is unclear, but the archi-
tecture and sculpture at the site, which we will review presently, and the likelihood
that Diarmait imposed a new abbot on the community after Lorcán moved to the
metropolis in 1162, suggests his role was proactive. Moreover, he had a strong
attachment to monastic groupings following the Rule of St Augustine, not least
communities of nuns: around 1146 he founded the abbey of St Mary de Hogges
in Dublin for Arroasian canonesses, followed five years later by the convents of
Aghade and Kilculliheen. Around 1162 Diarmait installed the Rule of St Augustine
(again, following the Arroasian observance) at St Mary's Abbey in Ferns, an older,
secularized, monastic house, and at All Hallows Priory in Dublin.

Churches which were not the possessions of reformed clerics or nuns in the
twelfth century could also be the products or beneficiaries of Diarmait's largesse.

Killeshin, the principal monastery of Uí Bairrche in earlier medieval times, stands out among them. Having purged an assortment of Leinster noblemen in 1141, Diarmait apparently annexed Uí Bairrche and imposed on it the family of Úa Gairbíd who had been dispossessed of the kingdom of Uí Felmeda further to the east, and he endowed Killeshin with a new church, or at least with a new portal on its church, as part of his strategy for Uí Bairrche's annexation.[10] There are much-weathered inscriptions on the portal.[11] The earliest recorded transcription of the inscription which runs horizontally above the capitals was made in 1838, and gives us ÓR DO … ART RE LAGEN … DON AIRCHINDECH … LENA …, and [ÓR] DO … TOISECH HUA NDUACH, with the translation A PRAYER FOR … ART KING OF LEINSTER … FOR THE AIRCHINDECH … LENA …, and [A PRAYER] FOR THE CHIEF OF UI DUACH. In 1872 a second inscription running up one of the north jambs of the portal was first recorded and read as + ÓR DO CELLACAMI (A prayer for Cellachán?). There have been several readings since then, but the stonework's decay has been considerable in the past century and a half. The consensus is, however, that the '… Art' whom O'Donovan identified is Diarmait,[12] and this ties in with the date of the portal and the history of the district.

The royal chapel at Ferns and St Saviour's Priory church, Glendalough

Ferns was the capital of Diarmait's kingdom. Until their destruction in 1166, the year of his exile, Diarmait had a stone-built 'house' and *longphort* somewhere here. Its location is not known; rather than be in the vicinity of the cathedral and other ecclesiastical remains – Ferns had been chosen as the diocesan centre of Uí Chennsalaig in 1111 and retained that status in 1152 – at the north end of the village, it may have been at the south end of village, on or close to the site occupied by the Anglo-Norman castle in the thirteenth century, with the settlement stretched out in between.[13]

St Mary's, the ruined nave-and-chancel priory church of the community of Augustinian canons regular, is a building of enormous interest (**Fig. 139**). It is also a difficult building to make sense of, in part because it has seen a curious longitudinal destruction – the southern two-thirds have gone – and in part because there is repair work on the upstanding remains, some of it possibly dating to the middle ages. Entry was originally through a two-ordered portal in the west wall, of which only the north-side bases (of bulbous form) remain *in situ*. A small square turret projects westwards from the north side of the west façade of the church, flanking the portal, and once it clears the original roof level of the nave it changes shape, becoming cylindrical, like a Round Tower; restoration of the masonry here makes assessment difficult, but it is possible that this square turret/Round Tower is an addition to the original west wall of the church, just as happened at Trinity church at Glendalough, and that it is

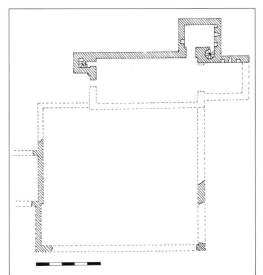

139 St Mary's church, Ferns: plan of church and claustral area. Scale bar = 10m.

therefore later than the portal. The surviving north wall of the nave stands to a considerable height, but it too may be of two phases: the lower part is comprised of thin, slate-like stones, and seems to be contemporary with the portal in the west wall, while much of the wall's fabric higher up could be contemporary with the Round Tower. A two-storeyed building, almost square in plan with a barrel-vaulted lower chamber, projects from the north side of the junction of the nave and chancel, and was accessed from the nave; a spiral stair gave access to its upper chamber as well as to a room above the chancel.

The nave was probably timber-roofed but the chancel was originally barrel-vaulted with an upper, presumably timber-roofed, floor; if the apparent height of the chancel is any guide, the nave must have risen to a height comparable with that of the nave of Cormac's Chapel (**Fig. 140**). The chancel's central axis is slightly to the north of that of the nave. Its vault was supported by three flat-sectioned transverse arches (**Fig. 141**), creating an effect similar to what we see in the nave of Cormac's Chapel. However, the arches here spring from neither horizontal nor vertical members; rather, their chamfered springers simply projected from a narrow set-back along the line of springing of the vault, and small holes perforating these springers may have accommodated structural tie-rods of metal.[14] The chancel arch and the east wall have both been destroyed, depriving us of crucial information, but a single, splaying window, now blocked, remains in the north wall of the chancel.[15] Its rear-arch is uninterrupted and has finely-wrought stones. Flanking it on its east and west, and set at the same horizontal level, are niches[16] with roll-moulded jambs, imposts, and unmoulded arches. The stones of which they are formed appear to have been reused.

The field on the south side of the church has no surface traces of other buildings, but an early twentieth-century survey drawing recorded foundations indicating very clearly a claustral area adjacent to the south wall of the church and measuring about 22m east-west and about 20m north-south (**Fig. 139**).[17] The cloister seems from this to post-date the church, and if it belongs, as it surely must, to the adoption of the Rule of St Augustine at Ferns around the year 1160, we have both confirmation of Flanagan's interpretation of St Mary's as an existing

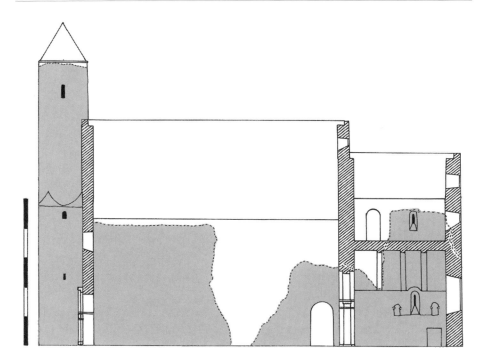

140 Reconstruction cross-section through St Mary's church, Ferns, looking north; surviving masonry marked by half-tone. Scale bar = 10m.

monastery with a new set of regulations, and an approximate *terminus ante quem* for the church.

The earliest stage of the church would appear to pre-date 1160 anyway. The most obvious point of comparison for it is Cormac's Chapel, particularly in its chancel barrel vault with transverse ribs. Eastern and south-eastern Ireland had long established contacts across the Irish Sea, not least with the Bristol Channel area, and Ferns was better placed geographically than Cashel for receiving stylistic ideas from England, but it seems unlikely that St Mary's is the product of a direct contact with English Romanesque work. Its barrel vault's transverse arches are a little too idiosyncratic. Diarmait Mac Murchada may have had the eastern limb of this church constructed in both stylistic and symbolic emulation of Cormac's Chapel, but used masons who were familiar only with short-span, self-supporting, vaults of the type found in the later eleventh century in Ireland.

St Mary's, then, might be viewed as another royal chapel. There is too little left of its west portal to help us settle on a date in the 1130s or 1140s for its construction, but given the evidence of St Saviour's at Glendalough, which we will review in a moment, we can be fairly certain that it existed by the early 1150s. The square turret carrying the Round Tower may be an early addition, if indeed it is an addition. It is tempting to connect it with such rituals of kingship as we discussed with respect to Round Towers in general and Cormac's Chapel's north tower in particular, and to draw special attention to its position at the north-west

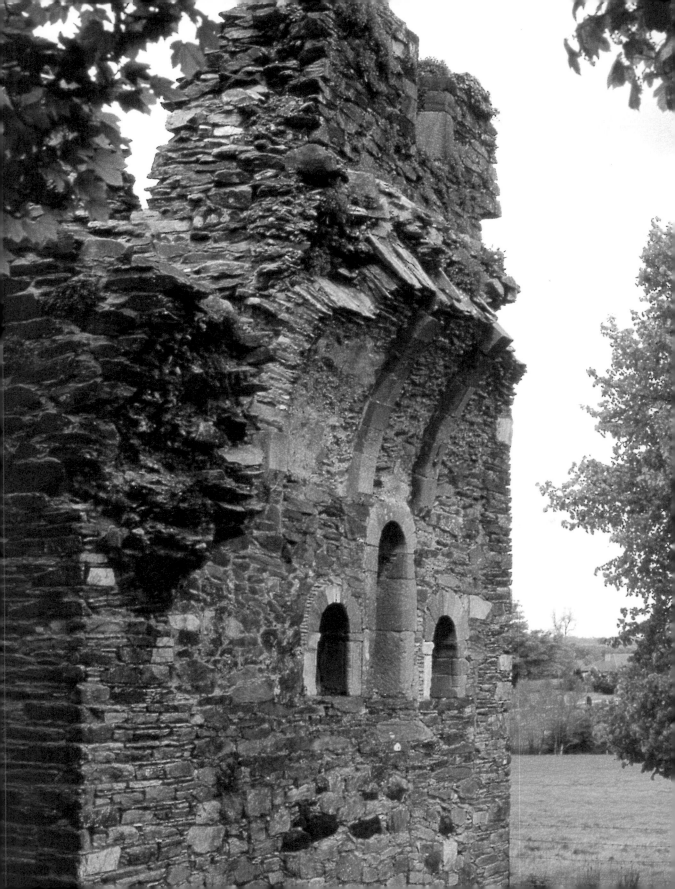

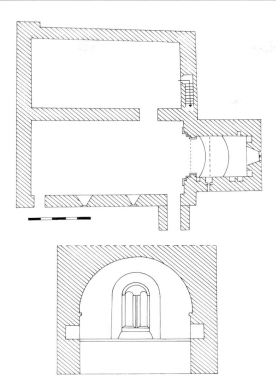

142 Plan of St Saviour's priory church, Glendalough, with cross-section of the chancel. No attempt is made to represent reconstruction phase on the plan, and the details of the reconstructed east window are omitted. Scale bar for plan = 5m.

corner of the church. It was presumably extant by *c.*1160 when the Rule of St Augustine was adopted at Ferns and a cloister added to the church. Is it possible that the embracing of the Rule at St Mary's signalled Diarmait's disengagement from this church and its environs, and his construction of a residence – that which was destroyed in 1166 – somewhere else at Ferns?

The Augustinian priory church of St Saviour's at Glendalough can be dated to the between 1153 and 1162, the years during which Lorcán Ó Tuathail was abbot; Lorcán probably held the abbacy thanks to Diarmait's influence, and the church's architectural similarities with Ferns bears out the connection. St Saviour's is heavily restored, its lovely stonework disfigured by calcite leaking from the late nineteenth-century mortar, but the restoration seems quite faithful to its original appearance. This is another nave-and-chancel church with a rectangular building attached to the north side of the nave (**Fig. 142**). The latter was originally two-storeyed, with the lower storey originally divided into two rooms. The church itself was entered through two doorways at either end of the south wall of the nave, both reconstructed with plain round arches; foundations of a projecting porch was discovered outside the easternmost doorway in the 1870s. There are two windows, each round-arched with external hood-mouldings, between the doorways. The interior of the rectangular building was accessible only through a

141 The north wall of the chancel of St Mary's church, Ferns.

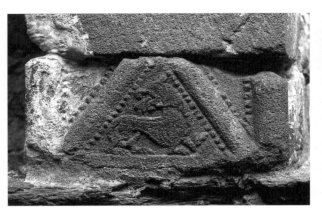 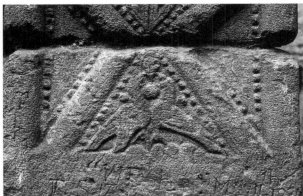

143 Details of the interior of the east window, St Saviour's priory church, Glendalough.

doorway at the east end of the church's north wall. An opening in this building's east wall led to a flight of steps which then led to the space above the chancel arch, and from there one could turn left into a room above the chancel itself.

The chancel, which is not on the same axis as the nave but slightly to the north, was barrel-vaulted originally, with the springing of the vault marked by a ledge of chamfered stone. The reconstructed chancel arch itself has three orders, the inner one broadening to form a wide arch over the western part of the chancel. The outer (nave-side) order of the arch is plain, but the central order has saw-tooth chevron, and the side of the inner order which faces the nave has voussoirs carved with a remarkable assortment of small motifs set within lozenges. The internal east wall of the chancel has a twin-light window with a monolithic mica-schist head; a similar window type was used at Temple-na-Skellig, further up the Glendalough valley. On the outside wall of the chancel this is set within an external, round-arched recess with small angle-shafts supporting a decorated arch and hood moulding; on the inside it has a highly elaborate surround featuring different types of chevron, small marigolds, interlace patterns, and small triangular panels which contains zoomorphic and anthropomorphic motifs. Some of the motifs are important for fixing the church's wider context, even if there is some uncertainty as to their original arrangement: a small lion on the interior of the east window (**Fig. 143**, *left*) can be paralleled with a small animal on one side of the crossing-arch bases at Baltinglass, while a motif of two large birds biting a tiny human head on what seem to be clouds (**Fig. 143**, *right*)[18] has a barely-visible parallel in two tiny and inverted birds biting the large human head on the key-stone of the outer arch at Killeshin.

Workmanship similar to that at St Saviour's can be seen elsewhere at Glendalough in the Romanesque details built into the so-called 'Priests' House', located south-west of the cathedral in the old monastic core. Disturbances following Lorcán's departure from Glendalough for Dublin left several structures – 'Cró Cóemgin', 'Cró Ciaráin', and 'Reccles an dá Sinchell' – in ruins,[19] and it is

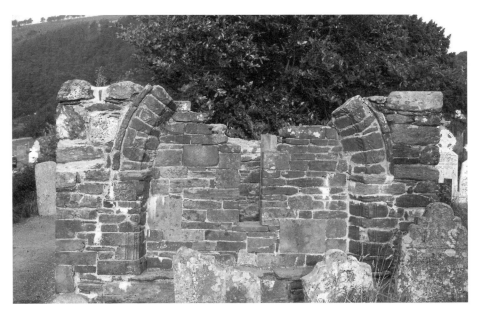

144 The 'Priests' House', Glendalough, from the east.

possible that the present 'Priests' House', distinguished by an unusual external east-end arch (**Fig. 144**) is a rebuilding (of a rebuilding?) of one of these, complete with its Romanesque detail, albeit broken and in the wrong order, if not also in the wrong relative position. It may be significant that the only other decorated Romanesque work in Glendalough's core area is the chancel of the cathedral, and this is later than St Saviour's. The rear-arch of its east window (**Fig. 145**) has a type of chevron that is comparable with that on the north door of the nave, dating

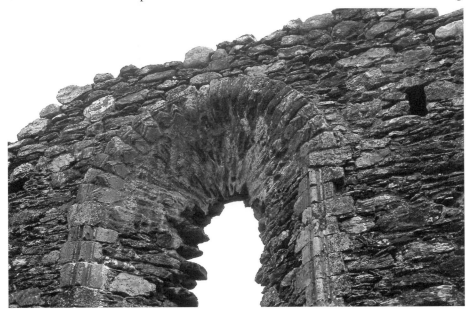

145 Detail of the east window of Glendalough Cathedral.

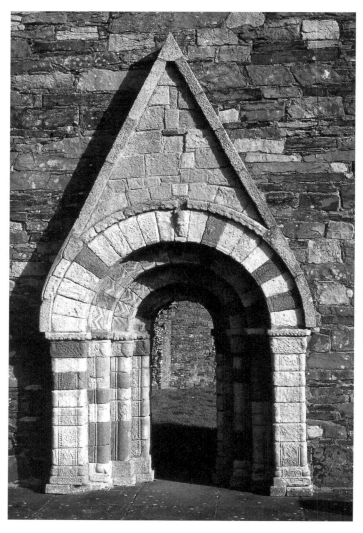

146 The west portal of Killeshin church.

from the 1160s, at Baltinglass. Also, its chancel arch and the north portal of its nave have filleted rolls of a type generally indicative of a date in the thirteenth century, so it is possible that the chancel arch and north portal were added to the cathedral towards the end of the 1100s.

St Saviour's compares with St Mary's at Ferns in several regards: both chancels were barrel-vaulted with rooms above, and both were on axes slightly north of centre, and both chancels had rooms overhead which were accessed by stairs contained within adjacent buildings on north sides of the churches and entered through the naves. There are many differences, of course, not the least of which is the decoration at the Glendalough site, but the destruction of the Ferns chancel arch and east wall has deprived us of a means of assessing this. St Saviour's dating

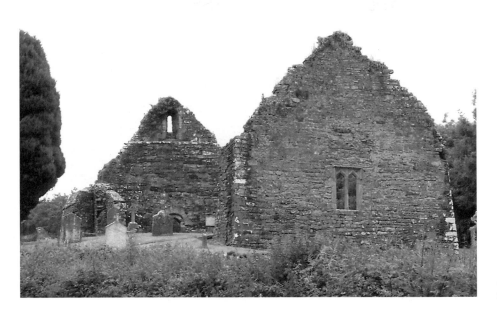

147 Killeshin church
from the south-east

to the period between 1153 and 1162 is secure. It is reasonable to suggest that Ferns, located at the heart of Diarmait's kingdom and a building which was not intended at the outset for a reformed monastic community, is older. A date in the 1140s seems likely for it, especially when one factors in the evidence of another site with which Diarmait was associated, Killeshin. And if Ferns belongs to the 1140s St Saviour's probably belongs to the early rather than the late 1150s.

Killeshin

The Killeshin portal is one of the masterpieces of twelfth-century Irish art (**Fig. 146**). The church which it adorns is a nave-and-chancel building (**Fig. 147**) dating from the twelfth century but standing on the site of a stone church 'broken' in the mid-eleventh century.[20] There are several phases. The earliest extant fabric is clearly on the north and south sides of the nave (although considerably less remains of the latter than of the former), and on the north side of the west façade. The north window, set within a gabled surround on the exterior and with a roll-moulded rear-arch, indicates a date of construction in the twelfth century for this wall. The portal is a contemporary construction but has been moved to a position a little to the south of where it was originally. Significantly, the fifteenth-century east window of the chancel is slightly off-centre

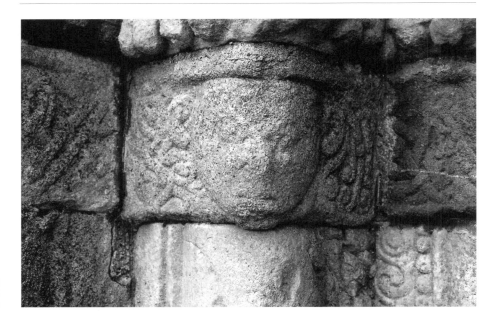

148 One of the head-capitals from Killeshin church.

in the east wall of the chancel, but it is aligned with the rebuilt west portal, and that suggests that the west portal had been rebuilt in its present position by the fifteenth century. The rebuilt portal is faithful to the original configuration, if only to judge by the geometrical regularity, specifically the ratios 1:2 and the Golden Section ratio of 1:1.618 – which the rebuilding exhibits.

Most of the portal's structural and decorative features are characteristic of the Gaelic-Irish Romanesque tradition. There are already lengthy published descriptions and analyses of it,[21] so we can be brief about it here. The pediment, first of all, is without sculpture, but this might not always have been the case: there is a missing portion of hood-moulding above the head at the crown of the outer arch-ring and it is tempting to speculate that some work of sculpture, maybe a statuesque figure such as that at Roscrea, occupied the interior of the pediment and rested on this head. The hood moulding has a type of billet work, which is an ornamental device used only rarely in twelfth-century Ireland. That head (just mentioned) at the crown of the arch is not unique – we saw it at Freshford, for example – but the Killeshin example, which is elongated, bearded and moustachioed, and has curling locks, has two inverted birds pecking at the beard. We have already mentioned its parallel at St Saviour's, Glendalough.

On the doorway itself, the jambs are roll-moulded with quirks, whereas on the arch-rings there are small rolls, with narrow fillets, marking the convergence of the flat archivolt and soffit faces. The roll mouldings on the Killeshin jambs terminate with bulbous bases. Similar bases are found widely in south-east Leinster, as at Ferns west portal, Timahoe Round Tower portal, and the west end

responds of Baltinglass presbytery, in the midlands, as on the chancel arches of the Nuns' Church at Clonmacnoise and Rahan I, and west of the Shannon among the *ex situ* stones at the Augustinian priory church at Annaghdown.

The square and rectangular capitals on the Killeshin portal form what is effectively a continuous frieze, separating visually the jambs from the arch-rings but giving no impression that they are actually required structurally. The affect is heightened by the repetitive decoration, which is comprised of an almost three-dimensional head with animal interlace in Urnes style woven into the hair (**Fig. 148**). Such 'frieze-like' capital-rows with sculpted heads also occur at Timahoe, where the depth of the portal in question breaks up the affect a little, at Kilteel, where they are now used in a reconstructed chancel arch but may originally have been displayed on a portal,[22] and at Annaghdown, where the original context of their use may have been another portal; there is a single surviving head capital from Duleek, an important early site which enjoyed diocesan status only temporarily, but its original setting – presumably a portal again – is now lost.

Most of the decoration on the Killeshin portal is lightly incised on quite well polished surfaces. This, combined with the different colours of the stones, suggests that paint was applied in the twelfth century to the carved surfaces. Abstract shapes and both zoomorphic and vegetal motifs abound, sometimes with the same motif used on both sides of the portal but in a mirror-image configuration. Chevron appears on all Killeshin arch-rings except the outermost, where an unusual strap-like device arranged in a chevron-like configuration is used instead, and even though it is interrupted by the head at the crown of the arch, the triangular shape of the head does seem somewhat integrated with it. Some of the spandrels of the second-largest arch-ring have small animals carved within them, including a dog chasing a stag; these have been identified as animals from the bestiary.[23] The influence here is from manuscript illumination, and we can easily imagine that they were painted in the same limited range of colours as is found in twelfth-century manuscripts.[24] But the influence of metalworking traditions is suggested by parallels for the step patterns on the plinths of the portal and on the soffit of the outer arch-ring on, for example, the Breac Maodhóg, the Soiscél Molaisse, the Shrine of the Stowe Missal, and St Patrick's bell-shrine.

There can be little doubt that the name recorded in the inscription on this portal is that of Diarmait Mac Murchada, and that the most likely date at which he could have involved himself in the patronage of a church (or part of a church) at Killeshin is after 1141. The presence at both St Saviour's (probably built in the early 1150s) and Killeshin of the motif of a human head flanked by biting birds, and the presence at Baltinglass in *c.*1150 of bulbous bases very similar to those at Killeshin, allow us suggest a date in the late 1140s or early 1150s for this great portal. Perhaps the embracing in 1152 of the traditional boundary between Uí

Chennselaig and Uí Bairrche by the new the diocese of Leighlin – something which might have happened under Diarmait's influence – provided a specific context for the making of the portal.

Other Leinster sites

Kilteel is not a site directly associated with Diarmait, so it does not belong in the same category as Killeshin, Ferns, St Saviour's or Baltinglass, but it was located within Uí Máel Ruba, a territory of the Fothairt Airthir Life among whom numbered Diarmait's own mother, it had an elaborate portal (and maybe also a chancel arch) which could hardly have been built here without his knowledge and acquiescence, and its sculpture has certain parallels with that at Killeshin.

The Romanesque work in the ruined church here is mainly displayed in a reconstructed chancel arch. The carved stones were recovered in the outbuildings of the nearby late medieval castle about seventy-five years ago.[25] Unfortunately, the sculpture has weathered considerably in the half-century that it has been exposed and much of the detail is no longer clear. The arch *as reconstructed* has three orders on the side of the nave, with the inner respond and outer order defined by bold roll mouldings with quirks, and the middle orders having a curved edge with chevron on both faces. On both sides of the arch the inner respond has head-capitals with interlace ornament; two capitals survive in the south side and one on the north, and these are very similar to the head-capitals at Killeshin. The inner respond on the north side has four stones with decoration. The upper stone features a man blowing a horn (**Fig. 149a**). Beneath that are two stones (**Fig. 149b**) which originally belonged together in the same manner as they are reconstructed: the upper has two embracing figures kneeling on a flat boss shaped like a flower, and the lower has an acrobat, his contorted body holding up that flower while balancing on another flower below. The bottom stone (**Fig. 149c**) has David holding the head of Goliath on his spear. On the respond opposite there are also four stones with decoration, though only the top two have images which can still be made out. That at the top, immediately under the capitals, has a robed standing figure with a staff, clearly an ecclesiastic (**Fig. 149d**). Beneath are two wrestlers standing on the top half of another flower-like boss (**Fig. 149e**). Of the two lower stones in the respond that on the bottom appears to have a figure – like the acrobat, perhaps? – standing on or balancing on another part of a flower-like boss. There are two other carvings elsewhere on the reconstructed arch, the Fall of Man, and David (or Samson) and the Lion, and now built into the low wall on the north of the church nave is a stone decorated with an unidentified ecclesiastic, probably St Luke.

The original context sequence of the sculpture at Kilteel is not known, and the iconography of what survives is no guide to an accurate reconstruction.

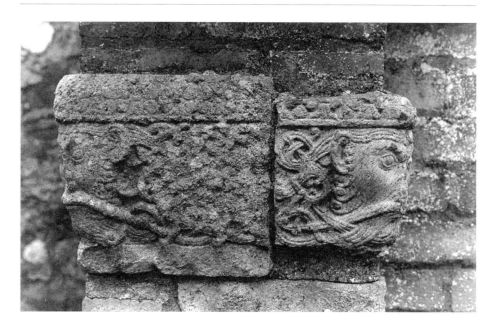

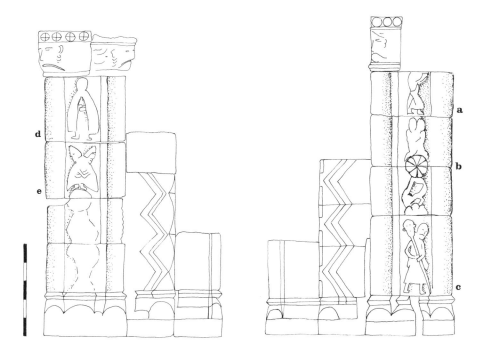

149 The sculptured stones at Kilteel. Scale bar = 50 cm

Conleth Manning, who excavated the church in the late 1970s, has recently argued very convincingly that the stones came not from the church which we see today but from another church nearby, possibly in the vicinity of the High Cross several hundred metres to the north.[26] The stones certainly originated in more than one architectural feature within the one church: the Fall of Man and David and the Lion are not from the same setting as the other sculptures. As a working hypothesis we might envisage a multi- (three-?) ordered west portal with respond-pilasters like those at Killeshin displaying the sculpture to the visitor.

The iconography is puzzling. We have biblical or scriptural references, images which are likely to be allegorical (the wrestlers, for example), and representations of individuals from earlier or contemporary church history (the ecclesiastics). It is the same mixture as is encountered in the more sophisticated iconography of the Ardmore façade, with the Fall of Man being the only certain common denominator.[27]

The manner in which the figures at Kilteel are in sunken spaces between the roll mouldings, with their top surfaces flush with the surfaces of the rolls, relates quite closely to the carvings on the earlier High Crosses. In terms of figural style, the Kilteel sculpture also belongs firmly within the tradition which twelfth-century Irish artists inherited from their earlier medieval predecessors: the Fall of Man, for example, is surely sufficiently similar in form and conception to earlier Irish versions for us to reject McNab's claim[28] that the movement implied by the shapes of the figures links it to contemporary Romanesque Italian work in Pavia. There are small compositional differences between the early Christian versions and the Kilteel versions of these images, as earlier writers observed[29] and these reflect the larger scale at which the Kilteel versions are executed, as well as perhaps a greater awareness in the Romanesque work of the manner in which a figural motif might be carved to give a three-dimensional quality within its architectural frame.

The Round Tower at Timahoe, already mentioned, shares with Killeshin a highly decorated Romanesque portal as well as an architraved triangular-headed Romanesque window. The portal is deep and porch-like, with the inner doorway 1.6m high to the crown of the arch and only 50cm wide. There are four orders of which the inner and third are responds, the second a half-respond, and the outer a pilaster-respond. All of these have roll-moulded corners defined by quirks. The arches are all plain though they have roll mouldings. The capitals have heads with interlace, recalling Killeshin and Kilteel, except on the inner order where scalloped/leaf designs are used. The bases have either human heads or baluster-like units, the latter not unlike features at Kilkeasy and Temple Finghin at Clonmacnoise. The parallels with Killeshin and their proximity to each other suggest that this is a work of the 1150s.[30]

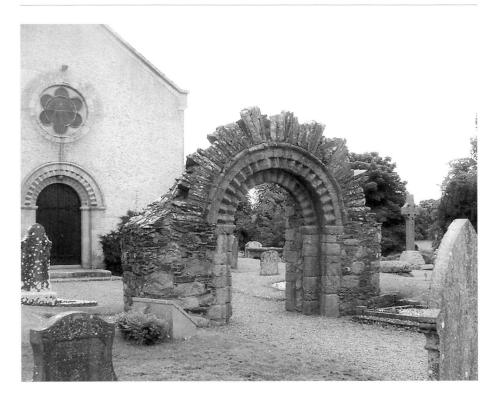

150 Castledermot: reconstructed portal.

The runner-up to Timahoe among the twelfth-century Round Tower portals is at Kildare itself (see **Fig. 24**). This undated feature is distinguished by having a triangular pediment formed of two ridges of stone and terminating with a stone dressed to a triangular shape. Unfortunately much of the opening itself has been replaced by plain stones but the inner parts are intact. The width across the central door opening is 60cm and the height to the impost is 1.65m. The inner order has rolls at the edges of the jambs defined by double quirks, and a slight convex moulding on the inner face. The capitals are flat and block-like, and are decorated with small plants with a pair of leaves flanking a central flower. There is no impost. The associated arch has lozenges, with spandrels, on the soffit. The jamb of the second order survives on the north side only but there is no decoration. The associated arch has archivolt saw-tooth chevron, with a half-roll, defined by double quirks, on the soffit. The third order jambs are missing but the arch has a three-quarter roll on the arris flanked by hollow rolls on the archivolt and soffit. Fragments of voussoirs with roll mouldings testify to the former existence of a fourth order.

There is a small amount of other Romanesque work in the Kildare area. At Old Kilcullen is a long rectangular nave-and-chancel church, the nave measuring 15.3m by 5.5m and the chancel 4m wide and at least 4m long. There was an elaborate chancel arch still standing in the early 1800s, but only a bulbous base

151 The west portal of
Clone church.

survives *in situ*; in a late eighteenth century account that arch is compared to the portal of the Round Tower at Timahoe.[31] Françoise Henry has suggested that the Romanesque portal in Wicklow was removed there from Old Kilcullen.[32] That Wicklow portal has one extant order, which has roll-moulded jambs with spirals supporting an arch with archivolt chevron and decorated spandrels; there are no other jamb orders, but there is a second arch-ring order with archivolt chevron, and outside that a hood moulding with stylized animal head label stops.[33]

South of Old Kilcullen is Castledermot, where there is only the reconstructed west portal surviving from a twelfth-century church (**Fig. 150**). It has two orders but originally it probably had a third, inner, order. The present width of the opening is 1.60m and its height to the impost is 1.64m. Both pairs of jambs have roll-moulded corners with quirks. There are no capitals but the springers of the arch were decorated, although that decoration is now very worn. There are no imposts, and no visible bases are visible. The two arches have archivolt saw-tooth chevron, and the hood moulding is chamfered.

Back in Wexford, there are fragments of a once-fine doorway lying scattered at the overgrown site of Kilmakilloge church, a possible cell of Ferns.[34] Another possible cell of Ferns was Clone. This has a Romanesque west portal that was originally round-arched, but now has a concrete lintel over the opening, and heads which decorated the arch have been rebuilt into the wall above the lintel (**Fig. 151**).[35] There were at least six of these heads; one of which appears to be an animal head, while another has a mitre and is bearded. The central opening of the portal is battered, measuring 95cm across at the bottom and 85cm across at the top. Its height to the original level of the springing of the arch is estimated at 2.2m. The maximum width of the portal is 2.2m. The doorway has plain responds. About 0.5m to each side are narrow square-sectioned projecting members, and tucked between these and the outer faces of doorway responds are small three-quarter columns decorated with chevron and pellet. There are no

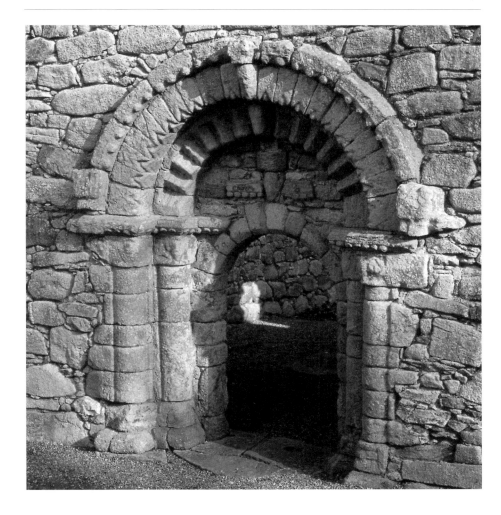

152 The west portal of Ullard church.

153 Sculptured panel above the west window at Ullard.

extant bases, capitals or imposts. However, set into the wall above the portal but barely visible under the ivy is a flat, square, stone, perhaps 25m across with a chamfered edge containing bosses on at least three sides, and this might be part of an impost. The chevron-decorated south window of the seventeenth-century church of St Peter's in Ferns is believed to have been removed there from Clone.[36]

It is not inconceivable that the west portal of the church at Ullard, downriver of Killeshin, was originally pedimented (**Fig. 152**). This is a nave-and-chancel church – the nave is 10m by 7.2m internally, and the chancel 7.3m by 5.25m – which was largely rebuilt in the late middle ages, and this includes the west wall in which the portal is set. The portal has two orders, but clearly had a third, inner, order originally, the present inner order being a late medieval replacement. The two extant orders have large roll-mouldings on their corners with head-capitals and bases (now very worn) with spurs; the inner arch ring has archivolt saw-tooth chevron and the outer has archivolt and intrados chevron alternating on the arris. The keystone of each order has a carved human head. The entire portal is framed under a hood moulding with bosses, an animal head on the keystone, and animal head label-stops. Above the west portal is a triangular-headed window, and above that, though clearly not in original position, is a panel decorated with a pair of embracing figures, possibly beard-pullers, which is quite a common Romanesque motif, but given the parallel of the sculpture at Freshford it seems more likely that they are ecclesiastics and are engaged in a more serious, benedictional, embrace (**Fig. 153**).

THE MIDLANDS

While Munster had decorated Romanesque forms as early as the 1120s and Leinster as early as the 1140s, it was not until the 1160s that the new stylistic elements were embraced in those midlands dioceses east of the Shannon in which monasticism and the carving of scriptural High Crosses had flourished in previous centuries. Clonmacnoise itself saw a range of new work from about 1160, starting outside the monastic enclosure at the Nuns' Church, or on its perimeter at Temple Finghin. Elsewhere in the diocese there was building work at the important early monastery of Lemanaghan, and at a little further east again at another old site, Rahan, in the diocese of Meath.[37]

Before we look at Clonmacnoise and churches within its ambit there is the important church at Monaincha near Roscrea to consider.[38] This is a nave-and-chancel building of the twelfth century, the two cells measuring 10.5m by 5.25m and 3.6m by 2.5m respectively, with a long vaulted sacristy of late medieval date extending to the north (**Fig. 154**). The church was considerably modified in the thirteenth century with the addition of new windows in the south wall of the nave

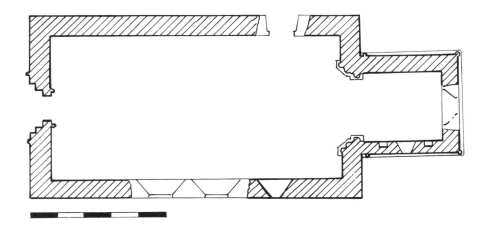

154 Plan of Monaincha church. Post-1200 alterations are unshaded, and the late medieval building attached to the north is omitted. Scale bar = 5m.

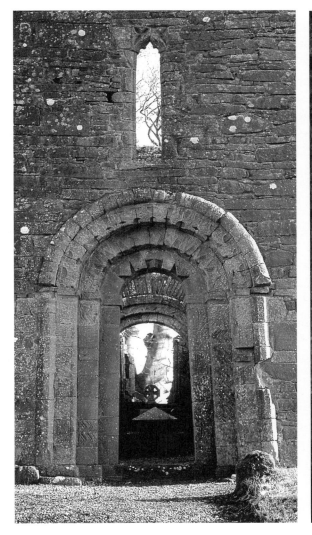

155 The west portal at Monaincha church (*left*) and a close-up of its inscription (*right*).

and in the east wall of the chancel. There also appears to have been some replacement, possibly in the late middle ages, of original twelfth-century fabric on the north side of the nave. The Romanesque features of the church are the west portal, the chancel arch, the quoin-columns and round-arched south window of the chancel, and the architraved south wall window of the nave.

The church is entered through a west portal the central opening of which is 90cm wide at the bottom and 84cm at the top, and 2m high to the impost (**Fig. 155**, *left*). The maximum width of the portal is 2.53m. It has three orders, excluding the shallow three-sided pilaster-like feature which frames it. Many of the stones of the portal, particularly of the inner order, are modern replacements. The inner respond order had roll mouldings on the edges and was decorated on the inner and outer faces. The impost on the south side survives. The upper stone of the jamb on that side is also original but it has no capital; instead, there is a stylized animal head biting on the roll moulding. The associated arch-ring had chevron. The second order has jambs decorated with chevron on the inner and outer faces with lozenges on the arris, and the arch-ring has beaded, gapped chevron on both the archivolt and intrados, meeting on a roll moulding on the arris. The third order had jambs with roll mouldings and apparently also decoration (the surfaces are now very worn), and an arch-ring with a roll moulding on the arris and with small square crosses on the archivolt and intrados. Outside these three orders, the portal is framed by thin, three-sided half-piers, and springing from the impost above them is a half-cylindrical hood moulding. There are faint traces of an inscription – OR[OIT] DO [T...] – on the top stones of the half-pier on the south side (**Fig. 155**, *right*).[39]

The elegant chancel arch, 2.10m wide and 2.35m high to the impost, has three orders, each of which has a chevron-decorated arch ring (**Fig. 156**). The inner order has a half-column on the inner face of the respond and carries an arch with intrados and archivolt chevron with a roll moulding on the arris which forms part of a zoomorph. The middle and outer orders have three-quarter columns; the middle one supports an arch-ring with beaded, gapped chevron, and the spandrels of the chevrons of both arches are filled with small plant motifs. The capitals are scalloped with chamfered imposts above, while the bases have tori and scotia mouldings. Internally, the chancel is divided into two horizontal units by a half-cylindrical string-course beneath the level of the window. Externally, the chancel is distinguished by having quoin-columns, two of which are tucked in the return angles with the nave. The columns, of which only those on the south side are well preserved, stood on a plinth that ran around the entire chancel. There is no trace of the cornice at which they would have terminated.

Some of the features of this church can be paralleled elsewhere in Ireland, especially in the midlands: two motifs of the west portal – the intrados and

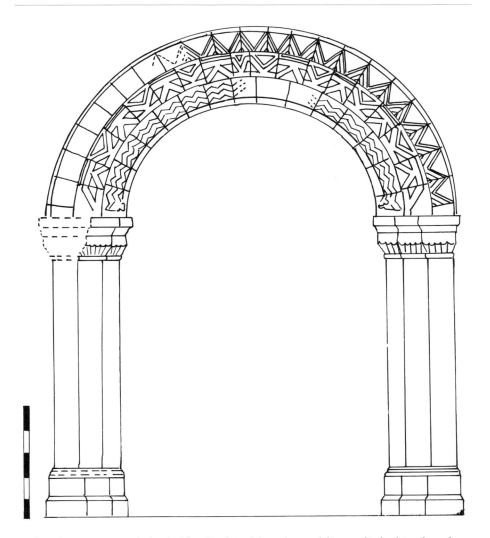

156 The chancel arch, Monaincha. Scale bar = 1m.

archivolt crosses, and the half-cylindrical hood moulding – link this church to Clonfert, the type of chevron used in the middle jamb order links it to the Nuns' Church at Clonmacnoise, and the quoin-columns can be paralleled at Tuamgraney and Templenahoe. Garton has drawn attention to many small points of comparison with the *ex situ* portal at Killaloe.[40] A date late in the third quarter of the twelfth century is indicated by its range of parallels.

Churches of Clonmacnoise and its ambit

The adoption of Romanesque forms in the Clonmacnoise region is surprisingly late, and especially so at Clonmacnoise itself. Gilla Chríst Ua Máeleoin was abbot at the time of the synod of Ráith Bresail, having been selected from outside the

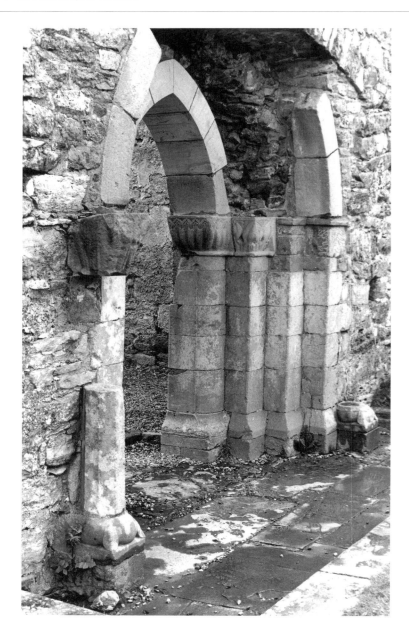

157 The west portal of Clonmacnoise Cathedral.

traditional ecclesiastical dynasties of the monastery, presumably by pro-reform interests.[41] However, Clonmacnoise was not chosen as a diocesan centre in 1111, and a synod was convened almost immediately at Uisneach which allowed Gilla and Murchad Ó Máelsechlainn to nominate Clonmacnoise as the centre of a diocese for the western part of the kingdom of Meath.[42] A certain amount of building work at the site followed this, with Gilla roofing the *erdamh Chiarain* in 1117,[43] and he

completed the Round Tower – discussed above, pp. 80–1 – with Toirrdelbach Ó Conchobair's assistance seven years later.[44]

Toirrdelbach's father, Ruaidhrí, died and was buried at Clonmacnoise in 1118[45] but this seems not to have precipitated any particular new building work. Did Toirrdelbach build anything at Clonmacnoise later in his career? The praise lavished on him in his obit in 1156 – 'Augustus of the West of Europe, the splendour and glory of Ireland and a benefactor of the churches and monasteries'[46] – leads us to imagine that he did. Moreover, his taste in art is well represented by the fine High Crosses which he had erected in his capital of Tuam, and by his donation of 'three jewels to Saint Ciarán of Clonmacnoise, to wit a drinking horn inlaid with gold, a goblet inlaid with gold and a patten of copper inlaid with gold' in 1115.[47] However, the claim that he introduced Augustinian canons regular – to whom he had a particular devotion – to Clonmacnoise has been disputed[48] and there is no archaeology to suggest that he sponsored any architectural project on the site between the completion of the Round Tower in 1124 and his death in 1156. He might simply have been indifferent to the idea of providing this old monastic site with the type of decorative-architectural work with which the other leading kings of the period had provided key sites within their jurisdictions.

Manning has suggested that the late Romanesque building work in Clonmacnoise Cathedral, comprised mainly of the west portal (**Fig. 157**) and a south-projecting sacristy, might be associated with the enshrinement on the north side of the high altar in 1208 (under the patronage of Cathal Crovderg Ó Conchobhair)[49] of Toirrdelbach's son, Ruaidhrí, who had died in Cong in 1198.[50] That portal has been repaired at least twice since c.1200 but one of its original features, an outer order comprised of a detached column set into a base with spurs, can be paralleled at Lemanaghan and Rahan II. Only part of one side remains of the portal at the former site, but there is a complete portal at Rahan, albeit in a church which was substantially rebuilt in the late middle ages (**Figs 158, 159**): this is single-ordered with roll mouldings above bases with scotia mouldings, scalloped capitals with small flowers on the scallops, and an arch with archivolt and intrados chevron and large lozenges on the arris, and there is a hood moulding with stylized animal head label stops. These two parallels suggest that Manning's early thirteenth-century date is a little too late. Nonetheless, it does appear that the cathedral itself survived Toirrdelbach's forty-year reign without any substantial alteration, although we cannot rule out the possibility that the original entrance to the cathedral had already been replaced with a portal with some decorative stonework after 1111 or 1118, and that the present portal is *its* replacement.[51]

The internal arrangement of the great church prior to the fifteenth century is not known; in this later medieval period its eastern third, or sanctuary, had

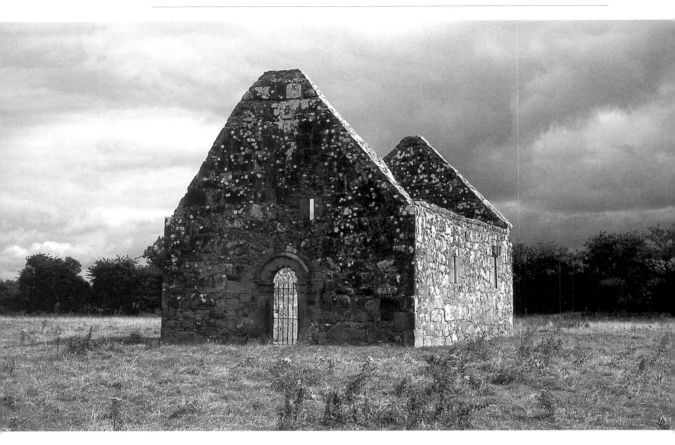

158 Rahan II from the west.

inserted into it a curious arcuated structure, comprised of twelve free-standing columns or engaged half-columns of English Perpendicular-style which were arranged in a configuration three bays wide (north-south) and two bays deep (east-west). These bays may originally have been vaulted to form a vast canopy or baldacchino over the altar; indeed, if the altar was under the central bay at the front of the structure the rest of the structure could have acted as a form of ambulatory. Alternatively, the entire structure might have been a freterum of low elevation on which the fifteenth-century altar was positioned. In 1208 Cathal Crobderg Ó Conchobair had Ruaidhrí's remains elevated and enshrined in Clonmacnoise, again presumably inside the cathedral. It is possible that the curious fifteenth-century insertion into the cathedral's east end was inspired by an older feretrum or ambulatory associated with the 'great altar' and Ruaidhrí's shrine?

The second Romanesque building in the main monastic site is the somewhat enigmatic Temple Finghin, sometimes also known as McCarthy's church (**Fig. 160**). This building stands on the lowest of the river terraces and forms part of the northern boundary of the old cemetery. It has two parts: a nave and chancel, and a Round Tower which is attached externally to the southern side of

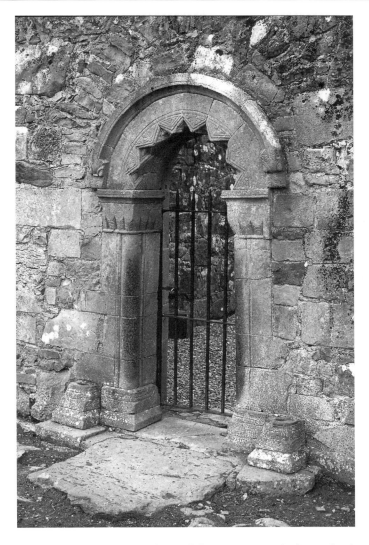

159 The Rahan II portal.

the junction of the nave and chancel but is entered through the chancel. Examination of the building's fabric suggests that the tower, nave and chancel are contemporary, and comparative analysis of the architectural form and sculptural detail suggests a date in the second half of the twelfth century, but there is no written record of the date of their construction.

The nave of the church measures 8.8m by 4.3m internally. Its walls survive to foundation level only, except at the west end where there has been reconstruction. The south portal is destroyed, although some fragments of decorated Romanesque stonework of later twelfth-century date are embedded in the reconstructed foundation. Fragments of the rear-arch of a window have been re-assembled in the rebuilt west wall: the arch was decorated with chevron and pellets on the outer

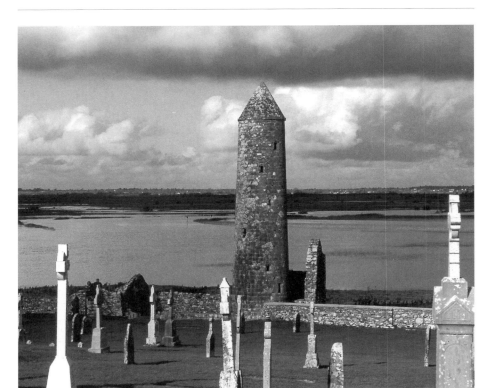

160 Temple Finghin from the south.

face and splay, and the spandrels were decorated with small plants. This window is sufficiently different in form and decoration from the chancel arch at the east end of the nave that it must have been inserted into the church in the later twelfth century; it may, alternatively, have been in some other building on the site originally and simply reconstructed as part of Temple Finghin.

The chancel arch has three orders, of which the inner order – made of limestone – is an insertion. The width of the arch, measured across the inner order, is 1.8m. Its height to the impost is 1.7m. The inner order has moulded imposts and bases; the former has an ogee moulding and the latter a quarter roll. The arch is square-sectioned. The middle order has, on each side, a wide roll-moulding with three animal heads biting it. The capitals, which are scalloped, have astragals. The bases are barrel-shaped and do not have bases but are cut into the lower part of the respond. The associated arch has chevron on the archivolt and intrados meeting on a roll on the arris. The outer order has a roll moulding. There are no capitals but the springers of the arch have heads, now defaced, with high ears and bifurcating beards. The associated arch has a keel moulding defined on both sides by a double quirk, and on both the archivolt and intrados are single shallow rolls also defined by double quirks. The impost of the middle and outer orders is chamfered.

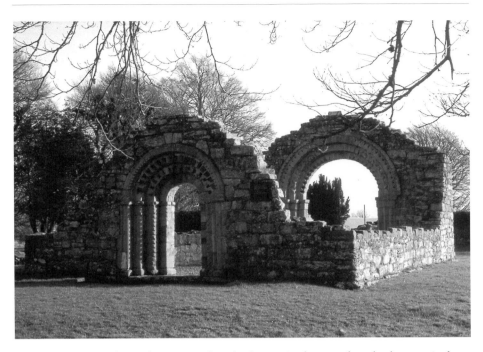

161 The Nuns' Church, Clonmacnoise, from the north-west.

The square chancel, 2.6m each side, has a single round-arched east window, two niches on either side of it and two niches in the south wall. A round-arched doorway gave access to the Round Tower from the chancel. That Round Tower has an internal diameter of 2.13m at ground level and a height of 14.5m to the top of the cap. It has four round-arched and three lintelled windows, and all but one of the former are recessed externally. At the junction of the tower and the nave is a squinch arch of three orders, of which the inner order is moulded. Beneath this inner arch is a wide roll in the return angle of the nave walls, and this terminates in a base with a hollow roll.

There is some confusion over the origin of the church's two names. The Mac Cárrthaigh, a Munster family, were among the donors to the church at Clonmacnoise according to the Registry,[52] and this was presumably their church, as one of its names suggests. But the Finghin element is more difficult to explain. Fingin Mac Caírthaigh, an ally of Cathal Crovderg during the latter's fights for the kingship of Connacht, is known to have had a place of sepulture at Clonmacnoise,[53] and so the building may take its other name from him.[54] However, it is more likely to have come from an earlier Fingen whose name is recorded in 'Regles Finghin' in 1017.[55] This particular individual is presumably the Munster anchorite of that name who died in Clonmacnoise in 900.[56] While we do not know for certain the location of 'Regles Finghin', it is very likely that this building occupies its site, and that the tradition of Mac Caírthaigh sepulture at Clonmacnoise begins with this earlier anchorite. This interpretation is based on

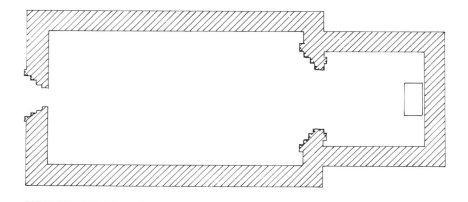

162 Plan of the Nuns' Church, Clonmacnoise. Scale bar = 5m.

two later pieces of evidence: first, the Registry of Clonmacnoise records that Fingin Mac Carthaigh had a 'choise place' of burial in 'Tempoll Finyn',[57] suggesting that the Mac Carthaigh sepulture already bore the name of Finian, and second, a memorandum of 1684[58] distinguishes between 'Temple McCarthy built by the Maccartys' and 'Temple Fynane alias Fynian' while clearly indicating that they are at the same place in Clonmacnois.

Finally, we come to the Nuns' Church (**Fig. 161; Plates 7b, 8**). This is located in a small enclosure to the east of the main monastic complex and is a replacement of an older stone church of which fragments are visible. One of the few churches of the period in Ireland with a fixed historical date, it has been mentioned many times here as possessing comparanda for features which we have already encountered. The annalists record its completion by Derbforgaill in 1167.[59] She was the daughter of Murchad Ó Máelsechlainn of Meath, whom we met above, and her sister was Agnes, the abbess of the nuns of Clonard. Murchad had granted the 'church of the nuns' at Clonmacnoise to a community of Arroasian nuns in 1144,[60] so this was a family church, or at least a church with which Derbforgaill had connections. She does not, in other words, appear out of nowhere. Her claim to fame, of course, is that in 1152 Diarmait Mac Murchada 'abducted' her from her husband Tigernán Ó Ruairc of Breifne,[61] an action of his which contributed greatly to his subsequent exile and to the eventual invasion of the Anglo-Normans.

This is a nave-and-chancel church (**Fig. 162**), the west portal and chancel arch of which were restored very well by the Kilkenny Archaeological Society almost exactly seven centuries after it was completed. Apart from the walls in which these two features are located, the entire building is represented by low walls. The nave measures 11m by 5.5m internally and is featureless apart from the west portal. As reconstructed, the portal is 85cm across and 1.65m high to the impost. It has four orders. Much of the inner order is restored, but the original chamfered plinth and parts of a jamb and of the arch survive. The jambs have chevron on the inner and

outer faces, meeting to form lozenges on the arris. Separating the jambs from the arch on both sides are imposts with spiral cones in the chamfer and small pellets on the face. These imposts continue across the entire portal. The arch has roll mouldings on the edges, defined by double quirks. There is also lightly incised decoration – plant motifs – on the interior and exterior faces of this arch. The second order has complete jambs and these are decorated with chevron in an identical manner to the inner order. The chevrons here terminate in small serpent heads, and highly stylized animal heads carved on the top stones of the jambs bite these smaller heads. The arch associated with this order has

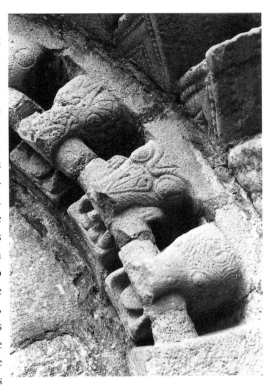

163 Detail of the west portal of the Nuns' Church, Clonmacnoise.

eleven original voussoirs with animal heads biting on a full roll moulding on the arris. The heads are somewhat stylized. In one case the front paws are also carved, and these grip the roll moulding (**Fig. 163**). The third order has jambs with false columns defined by double quirks, and these terminate without mouldings. There are block-like capitals, each with highly stylized animal heads biting small serpent heads and also the columns themselves. The associated arch has archivolt saw-tooth chevron. The outer order of the portal also has false columns on the jambs, but there are no capitals. On the north side the column terminates with a simple band, but that on the south side terminates on the plinth. The arch associated with these jambs is actually a hood moulding. It is chamfered, with small bosses in the chamfer, and has what might be described as a herring-bone pattern on its face. It terminates at both ends in stylized animal heads.

The chancel, 4.35m by 4.15m internally, has an altar standing immediately in front of the east wall. Parts of the east window survive and are mounted on the low wall behind the altar. The arch, spanning a width of 2.70m, and 2.20m high to the impost, has four orders in the nave and two in the chancel (**Fig. 164**). The inner order, or respond, and the outer order in the nave, have each a pair of roll mouldings on their two edges, and each moulding is bordered by double quirks. The remaining orders have single rolls, similarly treated with double quirks. There

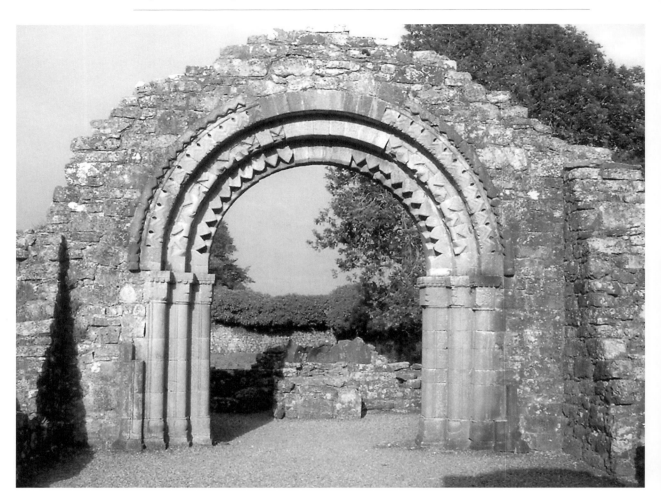

164 The chancel arch of the Nuns' Church, Clonmacnoise.

is a hollow roll in the centre of the inner order. The bases of all the orders are bulbous, except the outer orders in both the nave and chancel where the rolls terminate without any embellishment. The bulbous bases of the inner order are flattened, and are decorated with disks. The capitals of the outer order in the nave are lost; those of the outer order in the chancel are scalloped. The inner order of the arch has block-like capitals decorated with highly stylized animal heads which 'swallow' the false columns below, plant motifs and fretwork. The second order capitals in the nave are also block-like and are decorated with fretwork and have small human heads on the corners. The third order capitals in the nave are scalloped and have Urnes-style ornament. Three arch rings survive. The inner has archivolt and intrados saw-tooth chevron meeting on the arris, giving the effect of hollow lozenges. The second arch-ring has bar-and-lozenge on the arris and gapped chevron on the archivolt and intrados. The third arch-ring has archivolt

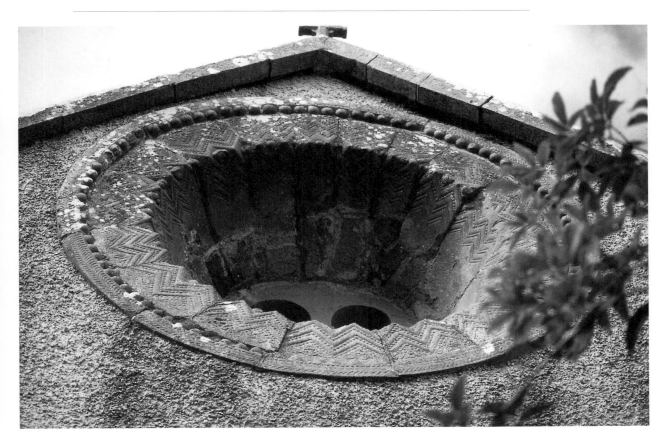

165 The oculus at Rahan I.

and intrados chevron forming a particularly elaborate form of arris lozenge; within the spandrels are small carvings of animals and one sheela-na-gig.

Derbforgaill's patronage of the Nuns' Church reminds us that while Clonmacnoise was part of the world of Connacht under the Ó Conchobhair kings, it was also part of the world of Meath to the east. It is not surprising, therefore, to find parallels for the elements of the Nuns' Church sculpture at Rahan I, within the diocese of Meath. Those parallels are especially apparent in the details of Rahan I's extraordinary oculus (**Fig. 165**), now in the church's east gable but probably over its long-disappeared west portal originally.

Only the barrel-vaulted chancel and the foundations of two adjoining 'rooms' (apparently timber-roofed originally) actually survive of this Romanesque church at Rahan (see **Fig. 75**); the original nave was replaced by the present nave in the early eighteenth century. The chancel, 8.7m by 5.2m internally, was lit by an east window, replaced in the thirteenth and eighteenth centuries, and by a round-arched window in the south wall. A three-ordered arch leads into it from the nave, and this has head capitals and bulbous bases, both with clear affinities in Leinster, while the pellets and bosses of the abaci point to Clonmacnoise. Two

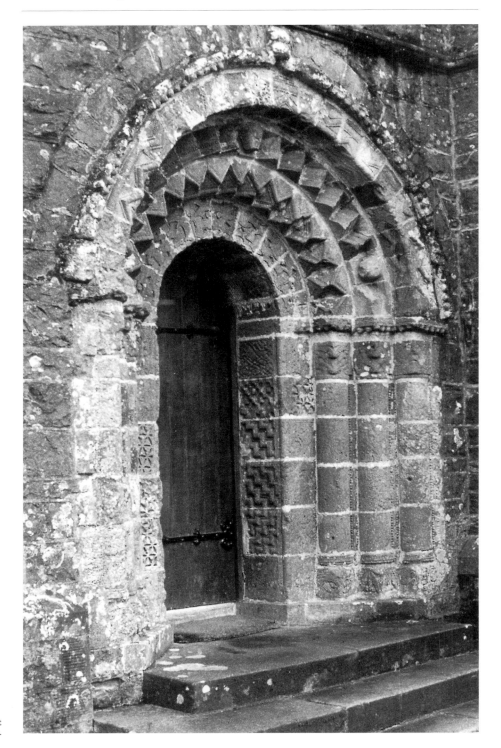

166 The portal at
Kilmore.

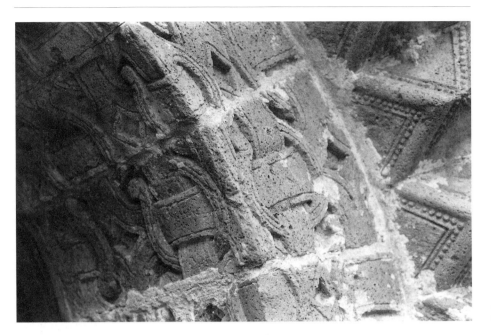

167 Detail of the ring-chain motif at Kilmore.

round-arched doorways in the centre of each wall-face led into small square structures but they are now blocked. Part of a mural stair rises in the north wall at the east end, and this originally gave access to a chamber above the chancel.

Also related to the Nuns' Church in a whole spectrum of sculptural detail is the remarkable four-ordered portal that was removed from Trinity Island, Lough Oughter, and re-erected at Kilmore Cathedral in the mid-1800s (**Fig. 166**).[62] This is the only significant work of sculpture from the medieval kingdom of Breifne, and the fact that Tigernán Ó Ruairc's wife was Derbforgaill suggests that she had a role in its creation, and possibly ensured Clonmacnoise masons were entrusted with the job.

The width across the central door opening is 83cm, and the height to the impost is 1.63m. The inner respond has no capital but there is an impost, and this continues across the entire width of the portal. The impost is chamfered, with spiral bosses in the chamfer and with a thin band of beads on the fascia. The arch has a unique Irish instance of a ring-chain motif (**Fig. 167**) of possible Scandinavian origin. The jambs of the portal are decorated with Urnes-style zoomorphs, and with embattled and peltae patterns. Each of the three outer jambs has a false column, and these are separated from each other by thin beaded fillets. The capitals are square and block-like, and all except that on the far right which caps the outer order have stylized animal heads: the exceptional capital has a human head with interlace. Each base is of inverted-cushion type with a scotia above. The bases are decorated with zoomorphic and plant motifs. The arch of the second order has archivolt and intrados saw-tooth chevron meeting on the arris

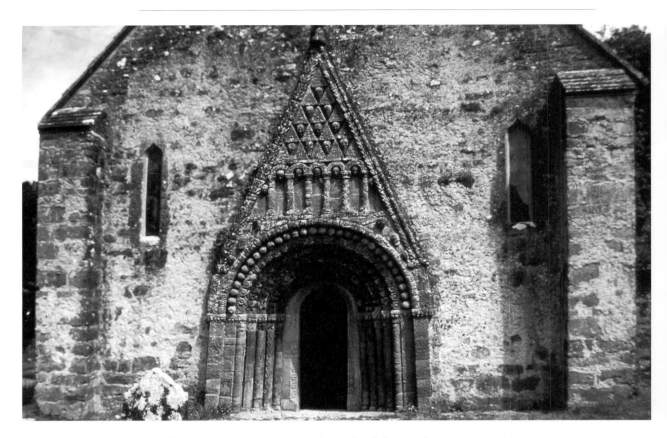

168 The façade of Clonfert Cathedral.

and forming hollow lozenges. The arch of the third order has archivolt saw-tooth chevron, with human head voussoirs at the crown and at either end of the arch. These human heads have curling fringes and interlaced beards. The outer arch ring has gapped chevron on the archivolt, intrados and arris. The hood moulding is similar in form to the impost, but the bosses are not spiral bosses. The moulding seems to emerge from the mouth of a stylized animal at the crown, and it terminates in stylized animal heads at either end.

THE CLONFERT PORTAL: A LATE ROMANESQUE MASTERPIECE

The phenomenon of the pedimented portal is widespread in Europe. The source of the pediment is in classical architecture, and not surprisingly the finest examples of its use in Romanesque contexts are in places such as Italy and Provençe where monuments from Antiquity survived in large numbers into the middle ages.[63] There are eight extant Irish examples of pediments of which three cover deep portals within porches (Cashel, Donaghmore [Tipperary], and Freshford), four

169 The east end of Clonfert Cathedral viewed from the south.

act as elaborate hood mouldings above multi-ordered portals (Clonfert, Kildare, Killeshin and Roscrea), and one (Ballyhea) acts as a form of architrave around a plain round-arched doorway. Clonfert is the most elaborate and perplexing of these. Parallels for its details within the region point to a date in the later 1100s, from the 1160s to the 1180s, and the synod convened at Clonfert in 1179, not long after the burning of the place is recorded, may have been the actual context for which it was made.[64]

The cathedral of Clonfert itself is a nave-and-chancel church with many phases of alterations. The nave, 19.8m by 8.2m, is a pre-Romanesque structure, with antae at the west and east ends. The west façade has a large Romanesque portal flanked by two fifteenth-century ogee-headed windows (**Fig. 168**). Above the façade is a large tower, also of fifteenth-century date, supported by the insertion of walls in the interior west end of the nave. The windows in the side walls are modern replacements of windows which were probably inserted in the fifteenth century, and which themselves probably replaced twelfth-century windows. Two transeptal chapels opened off the nave, that on the south, possibly dating to *c.*1200, still survives and was the larger of the two.

The chancel, 8.3 by 7.05m internally, was built onto the east end of the original church, its west end tucked between the antae (**Fig. 169**). It appears to be an early thirteenth-century work judging by its lovely east-wall window, with late medieval windows in its side walls. The present chancel arch is fifteenth century in date but replaces a thirteenth-century arch. Preserved within the chancel until recent years was a triangular-shaped stone with a moulded border and possibly

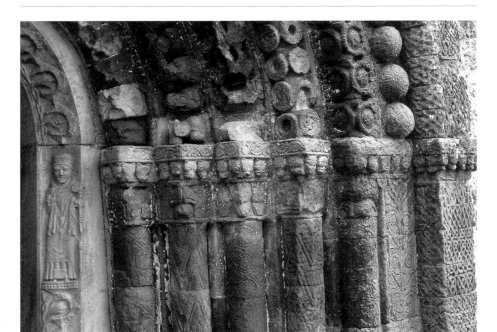

170 The south side of the west portal, Clonfert Cathedral.

bearing original paint, which was evidently part of an internal architectural fitting of some elaboration.

The west portal dominates the façade of the building; its maximum width is 4.05m while the west façade is 10.50m wide. It is surmounted by a tall triangular gable, giving the entire portal an estimated height of almost 8m. Excluding the pilaster-responds, the portal has six Romanesque orders (**Fig. 170**); there was probably a seventh, inner, order but this was replaced by the present inner order in the late middle ages. The interior of the portal is largely reconstructed but parts remain of two responds, each decorated with chevron, the spandrels of which are filled with small plants, and bordered by roll mouldings. On the exterior the width across the present inner Romanesque order is 1.5 at the bottom and 1.4 at the top. The height of the portal to the impost is 1.87m. The orders are all shallow: the depth of the portal is only 1.2m, and its projection forward of the exterior west wall of the church is only 15cm.

Tucked in the return angle of each order of the jambs are semi-engaged angle-shafts, each decorated with incised ornament, and each pair has the same motif. The bases of these columns have ogee mouldings and spurs. The columns have capitals, and their decoration also occurs in pairs: the capitals of the inner Romanesque order have full animal heads, those of the second order have addorsed dogs' heads, the third order capitals have each three elongated animal heads, the fourth order capitals have each a pair of masks, and the fifth order capitals have 'column swallowers'. The outer order has no column associated with it and has no

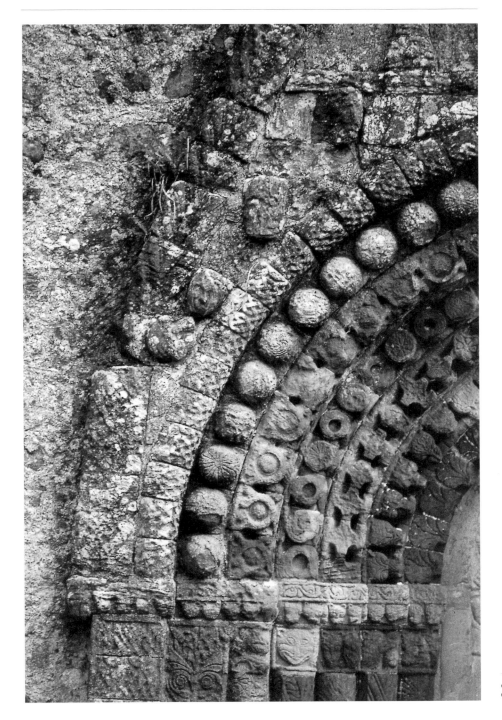

171 The north side of the west portal, Clonfert Cathedral.

capitals. The abaci of these capitals continue as imposts across the outer order and the pilaster responds. These members are chamfered on their lower edges, and within the chamfers are small animal heads; the fasciae have plant scrolls. The pilaster responds at the edges of the portal are square-sectioned and are decorated with interlace on their outer faces, and with entwined animals of Urnes type on their sides.

We can now turn to the arch-rings (**Fig. 171**). The inner arch ring is scalloped on the arris, and on the archivolt a plant motif is associated with each pair of scallops. The second arch-ring order has animal heads biting on a full roll moulding. The faces of the animals are embellished with incised lines. The third arch-ring order has square crosses on the archivolt and intrados with a full roll moulding on the arris. The next order has flat disks, alternating between full and perforated, on both the archivolt and intrados, and these touch each other tangentially on the arris; the disks are decorated with spirals, serpents and flowers. The fifth order has small bosses on both archivolt and intrados, and each of these is wrapped in a penannular cable moulding. On the arris is a full roll moulding. Finally, the outer order has thirty semi-spherical bosses, each decorated with interlace, spiral, zoomorphic or plant ornament. Springing from the imposts of the pilaster responds of the portal is a semi-cylindrical moulding decorated with interlace. Also rising from these imposts are rectangular blocks of stone, decorated with Urnes motifs, and these blocks in turn support the bottom edges of the pediment.

The pediment projects 15cm forward of the wall of the church. It is framed by a double cable moulding with a central pair of quirks. These mouldings terminate in animal heads, with that on the north twisted and facing back up the wall. The top of the pediment has a long triangular finial formed of four moulded stones. The top of the finial is flanked by two round human heads facing north-west and south-west. Within the pediment is an arcade of five bays, and above it a diaper pattern with triangles (**Fig. 172**). The arcade has human heads under the arches; the second and fourth are bearded while the others are clean-shaven. A further two heads are positioned between the outer arches and the sloping sides of the pediment, while four more heads occupy the space between the horizontal course on which the arcade stands and the outer arch-ring of the doorway below. The remaining space under each of the arches is filled by two flat slabs that may originally have been covered by painted plaster. The arcade bays are divided by half-columns, each with incised decoration except one which was baluster-turned. These half-columns stand on bases (forms of hollow roll and torus moulding), and capped by astragals, capitals (plant motifs deployed in the manner of scallops) and abaci (plain). The arch rings themselves are square-sectioned and their outer faces have plant scrolls.

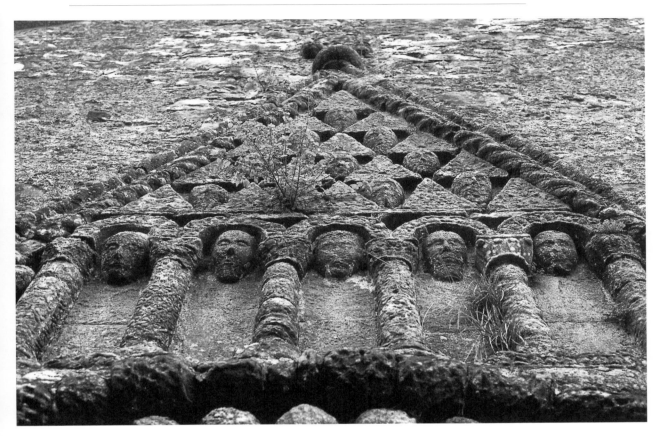

The diaper work above is comprised of 25 triangles, of which ten are hollowed out and contain human heads. Like the heads in the arcade below, bearded and clean-shaven heads are arranged with regularity, with the latter found in the top and third row of triangles. The triangles that are not hollowed out are decorated with plants, with either one large plant or three small plants in each case.

172 Pediment sculpture, Clonfert Cathedral.

Parallels and origins for the portal

There are a number of English parallels. The best is the south portal at St Margaret-at-Cliffe in Kent (**Fig. 173**). This has two jamb and arch-ring orders, on top of which is a remarkable pediment. The St Margaret and Clonfert portals share a number of features: a diaper pattern covering the inside of the apex of the pediment which is small in area compared to the expanse of the door arches, arcading between the outer arch-ring and the diaper, and displays of heads, and probably also of full figures – there must have been such figures attached to the heads in the Clonfert arcade – within frames. This Kent parallel is interesting because this is an area which, like the Shannon valley in Ireland, reveals contacts

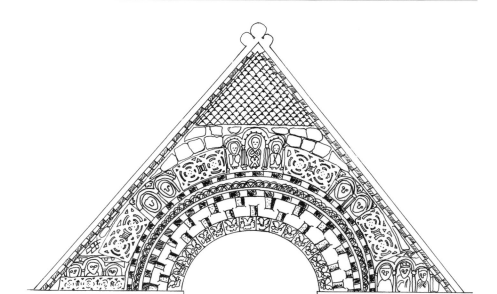

173 Sketch of the
pediment at
St Margaret-at-Cliffe.
Not to scale.

with western France. Elsewhere in Kent there is the shallow-projection portal of
Patrixbourne, features of which include a tympanum decorated with a *Majestas*,
an arch-ring order with radiating voussoirs, and above the doorway a pediment
with steep sides tangential to the outer arch-ring. Musset compared the
Patrixbourne combination of a doorway and pediment to Norman Romanesque
work, citing as examples Foulognes and Sainte-Croix de Saint-Lô, but he wrote
that the decoration of the portal 'évoque invinciblement' the regions between the
Loire and the Gironde.[65] However, while the Clonfert voussoirs with their animal
heads may have been directly inspired by work in Poitou and Saintonge, the
Patrixbourne voussoirs are derived from those at Rochester Cathedral which in
turn were inspired by work further north-east in France, perhaps in Touraine.[66]

In contrast to that on the St Margaret portal, the arcading on the Clonfert
pediment has a monumental and architectural quality, reminiscent of the large-
scale arcading which is found on five non-pedimented portals in Worcestershire:
the south portals at Knighton-on-Teme and Stoulton, the north and south
doorways at Bockleton, and the south doorway at Eastham.[67] None of these
portals features figure sculpture. However, further north at Prestbury in Cheshire
there is a portal with a row of seven now partly defaced figures, among them
Christ and St Peter, cut out of rectangular blocks and displayed above the
doorway. While there is no framing arcade, the figures are placed at intervals
much as they would be were there an arcade (**Fig. 174**). Significantly, in view of
the French dimension for Clonfert, the Prestbury figures can be paralleled fairly
widely in western France (at Fenioux, for example, where there is a register of
figures above a portal) while the *Majestas* on the Prestbury tympanum is likely to

have been inspired by that on a tympanum at Malmesbury Abbey which is known to have been influenced by work in France.[68]

None of these parallels is entirely convincing as a source for Clonfert. They are parallels in the proper sense of that word: the presumably complex lines of development that led to Clonfert from sources yet unidentified also led to these portals. Rather than look among such portals to illuminate Clonfert's genealogy and locate its meaning as a work of architecture, we might look instead at larger architectural structures, recalling how, at Freshford, a projecting portal possessed sculptural images which had more in common with façade design than portal design. One such larger structure is the projecting portal-block of the type found, for example, in the north elevation of the westwork at Kelso, a mid-twelfth century Tironensian foundation in Scotland. The tripartite arrangement of elements which is found at Clonfert – a multi-ordered doorway, a register of arcading and a pediment with diaper work – is also a feature of this, but what separates this from the portals just mentioned is that it projects as a building in its own right. Clonfert looks like a two-dimensional version of this type of feature. Alternatively, we can look at the larger scale of actual façades themselves, and see affinities for the Clonfert design in façades such as those of the twelfth-century Norman churches of Bieville, Mouen, and Meuvaines (**Fig. 175**, *left*), or of the western French (Saintongeais) churches of Marignac and Saint-Fort-sur-Gironde (**Fig. 175**, *right*). The façade at Saint-Fort is particularly relevant because of the diaper work in the pediment (now largely rebuilt) and because it has horse-head voussoirs comparable with those at Clonfert on one its doorway arch-rings.

It is difficult to be sure which of the Romanesque traditions, the Norman/ English or the western French, might have contributed the architectural form of a façade to the Clonfert portal, but I would opt for the latter. The almost complete lack of chevron on the portal, coupled with the motifs of western French origin which were discussed earlier – the animal-head voussoirs, the small impost-chamfer animals, the scalloped arch – surely indicates that the stylistic inspiration came from the Continent rather than from England, probably reaching Clonfert by the Shannon routeway.

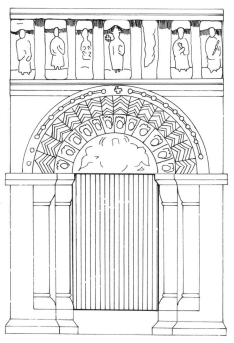

174 Sketch of the portal at Prestbury. Not to scale.

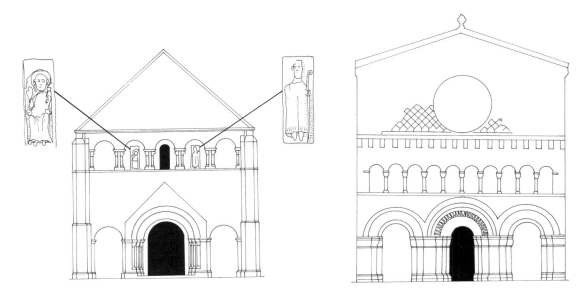

175 The façades of Meuvaines (*left*) and Saint-Fort-sur-Gironde (*right*).

Perhaps we can add to this list of French-origin features the use of the heads in the register of arcading on the portal. Henry has this to say of them: 'The heads inserted in niches like trophies are nearly reminiscent of some Gaulish monuments of the south of France, and the likeness may not be wholly fortuitous.'[69] Similarities between Clonfert and late Antique schemes are not fortuitous since late Antique forms were used in Romanesque French work, not least in Aquitaine.[70] There, the legacy finds one expression in full figures of various scales adorning façades at places such as Ruffec, Perignac, Fenioux, St-Jouin-des-Marnes and Loupiac; if we imagine the Clonfert heads with full figures painted on wood and plaster the connection becomes clearer.

Inevitably the question arises as to *why* Clonfert was furnished with what amounts to a mock façade. The first possibility is that it was for purely decorative purposes: whatever about the symbolic attributes of façades in the source area, the Clonfert master exploited the form as a means of enriching an otherwise dull and archaic church front, while at the same time sparing himself the trouble of substantial rebuilding. But the Clonfert portal is too rigorous a work of architecture and too rich a work of art to be summarily dismissed as a casual or even whimsical decorative addition to a church. Effectively the Clonfert master created on the front of his church a sort of model or representation of another church – perhaps one with which he was familiar in western France? – in much the same way as pre-Romanesque sculptors placed small oratories on the tops of High Crosses (**Fig. 176**). This may be the key to the interpretation of the portal. The suggestion has been made that the small models of buildings on the High Crosses are representations of the heavenly city of Jerusalem.[71] It is well known

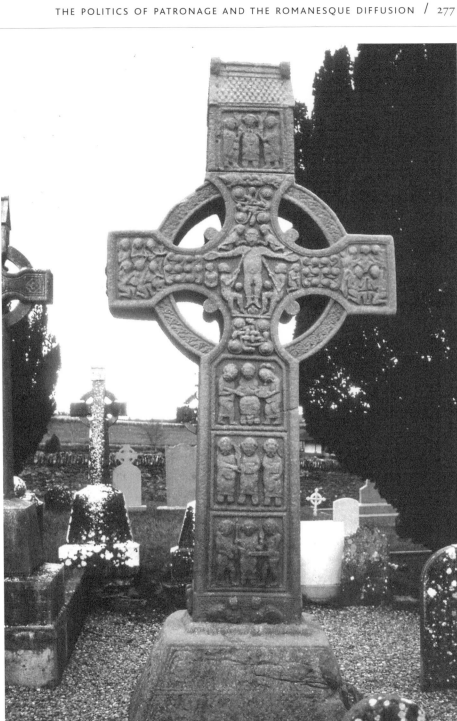

176 Muiredach's Cross at Monasterboice, showing the cap-stone in the form of a small church.

that medieval artists depicting the Celestial City drew on real architectural forms[72] and Gardelles even suggests that those Aquitanian façades on which the Clonfert portal might have been modelled were projections of the Holy Temple or of Jerusalem itself.[73] Did the Clonfert master unconsciously participate in the twelfth-century Continental penchant for imagining heaven? Or did he knowingly draw from a now-lost artistic model or a now-forgotten intellectual tradition at Clonfert in which such imagining was already in place. And, finally, in eschewing such explicitly English-origin forms as chevron on the exterior of the portal, was he making a political statement as the clatter of English armour could be heard across the Shannon?

Romanesque contexts and meanings: some reflections

Continuity and change are the two oldest chestnuts in historical writing, and a story of Gaelic-Irish Romanesque architecture can happily be written around them since churches of Ireland's twelfth century were simultaneously part of an indigenous continuum stretching back more than a century and part of an international tradition with its own very complex continuum. Such a story would be relatively easy to write if we believed that only one church could be built at a time in Ireland and that everybody saw everything that was built. But the reality was very different, and the challenge for us is all the greater for that. Twelfth-century Ireland's community of church-builders was not bound by any moral imperative to create a homogenous corpus of architecture. Even if homogenization was a *desideratum*, there were practical barriers: when senior clergy and aristocracy gathered at synods and talked about their churches they had no photographs to show around. A precocious design at one end of the country could easily go unnoticed at the other.

The eleventh-century transformation

Where, chronologically, should one begin a narrative about Gaelic-Irish Romanesque architecture? The appearance of the Round Tower in the tenth century is one possible starting point. It signals changes in landscape aesthetics and patterns of ritual activity in ecclesiastical contexts. If we knew a little more about the specific histories of the sites on which it appears we might find that the Round Tower was actually part of a package of physical and iconographic changes made in the 900s and 1000s. Leaving that problem to one side, when we look to the eleventh century we begin to observe small changes in the hitherto static architecture of churches. The bicameral or nave-and-chancel plan appears for the

first time, albeit it in only a few instances and possibly within a fairly restricted geographical range. Such plans were created either in single episodes of construction or by extending older unicameral, single-cell, plans in one direction or the other. Whatever the case, they required the use of true, voussoir-constructed, arches for their chancels, and yet the traditional lintelled doorway continued to be favoured. One has a strong impression that these are churches representing a tradition in transition, with the pull of modernism (as represented by those round arches and the first stirrings of architectonic outling) being resisted by the comfort of tradition (as represented by those lintelled doorways). We also see the stone-roofed church with the barrel-vaulted interior beginning to appear around this time, and with these we get our first clear impression that overseas building traditions are known about and that somebody somewhere in Ireland has identified a vaulted interior as desirable and capable of being built safely.

If the dates in the second half of the eleventh century which are assigned here to these buildings are correct, they belong within that run-up period to the Church reform of the early 1100s. A number of them are located at key sites – Killaloe, Kells, Louth, Glendalough – within the contemporary secular/ecclesiastical polity. Even in the absence of any explanation for their construction, they certainly merit the appellation Romanesque on contextual grounds. Elsewhere I used the term 'First Romanesque' – a term originally coined by Puig Y Cadalfalch with reference to Catalonia – to describe these eleventh-century buildings.[1] My reason in giving them their own name was largely to emphasize the point that Cormac's Chapel, Killeshin, Clonfert, and those other famous or 'classic' Gaelic-Irish Romanesque buildings about which Leask, de Paor, and others wrote did not simply evolve out of these eleventh-century works but represent a *new* departure in the era of Church reform, even if it was one which was made possible by that eleventh-century transformation in the architectural aesthetic. I would now suggest that the term 'First Romanesque' be dropped, and that the buildings which comprised it should simply be enfolded into our contextually-defined Gaelic-Irish Romanesque category, albeit into its early stages. But the view that Cormac's Chapel and other churches of the middle fifty years of the twelfth century did not simply evolve out of these eleventh-century monument-types must be retained.

In the final analysis, the significance of these eleventh-century buildings might lie not in any long-term roles that they may have had in the development of architectural structure at regional and national scales. Rather, it may be in that idea that they simultaneously embodied both a resistance to and an acceptance of tradition and modernism. Here, on the eve of Church reform, was an architecture that involved or embraced some element of contestation. This idea that architecture can even be a form of discourse of contestation – that the struggle

between ideas can be articulated in the material fabric of a building – is central to understanding the buildings erected after the process of Church reform was underway.

The twelfth-century transformation

By 1130 two changes had taken place in the indigenously developing-architectural tradition. The first of these saw new decorative devices (like chevron, most obviously) and new ways of shaping architectural members (like roll mouldings, most obviously) being imported as ideas into Ireland from England. Whatever their business, Irishmen travelling to England knew its architecture by sight, and may have stored images and impressions for when they returned. But the likelihood is that actual Anglo-Norman masons working within the English Romanesque tradition were enticed to Ireland to work on some key jobs, and that their skills nourished the classic architectural tradition of the twelfth century during its infancy. The handiwork of such masons was possibly to be seen at Killaloe before the twelfth century even began, and it was on spectacular display at Cashel in 1134. How should we assess this in terms of cultural and political history? We saw that Canterbury's political influence was nipped in the bud at Cashel in 1101, and that Henry II's papal permit to invade Ireland half a century later remained a rolled-up parchment, but here, long before the 1169 landings, was the aesthetic of *normanitas* taking root.

The date and location of the first appearance of English Romanesque devices are uncertain, with Cashel, Lismore, Ardfert and Killaloe all being pushed at some stage or other onto or towards that podium. Part of the human condition seems to be the fetishizing of the idea of a 'first' or 'earliest' or 'oldest' example of any phenomenon. But in the field of cultural studies (as distinct from natural-scientific studies) the question 'which is the first …?' often misses some important points. Chronological 'firsts' might not be the ones that matter. Great break-throughs are often products of a momentum built up in different places and with different velocities, and so they are made not in single moments and in single places but are episodic and multi-locational. So, rather than attempt to rank Cashel (Cormac's Chapel), Lismore, Ardfert (the cathedral) and Killaloe (St Flannan's oratory) in order of age as part of the mapping of the transformation which was underway by the end of the 1120s, we should simply recognize them as elements of a horizon of change.

The second change concerns the *function* of architecture, but is more difficult to assess qualitatively. Let us think back for a moment to Cashel. Fifteen years after the consecration of Cormac's Chapel St Bernard wrote of the king's 'royal munificence' in supplying gold and silver for a now-lost and unidentified monastery (*monasterium Ibracense*) which Malachy was founding, adding that the

king was at the building site itself, 'busy and ready to serve: in attire a king but in mind a disciple of Malachy'.[2] It might not be too far-fetched to imagine, then, Cormac's spin-doctors circulating among the assembled noblemen and clerics at the occasion of the Cashel consecration and telling them that the king himself designed its architecture and helped to hoist the stones. The towers, they were told, were a nod to Ratisbon, to Irish monasticism overseas, and to Cormac's family connections within it; the carved-stone surfaces, they were also told, were made by men from south-west Britain, from the employ of bishop Roger, Henry I's *de facto* deputy while in France; the stone roofs, they asserted, were 'better' than those in the 'smaller' church at Killaloe. Is this over-imaginative? In detail, yes, but in essence, surely not. We have seen that Cormac had a political motivation for building his chapel, but we must recognize that its politics did not stop at the moment of completion. The chapel's architecture was in itself a discourse on royal authority, its sources and materiality, and it was also engaged simultaneously in discourse with other structures on the site through the spatial and physical relationships which it had with them. So, for the chapel to have 'worked' in this sense there must have been some level of explanation, and that explanation, very likely to have been delivered within the consecration ritual itself, may have been quite a sophisticated one. The idea of 'building' is a powerful metaphor: Cormac was one of the principal builders of reformed Christian practice, and here at Cashel he was rebuilding a holy place which had been destroyed after his 1127 departure just as surely Constantine rebuilt the holy places of Christ in the fourth century.

All buildings are political. The act of building is a political act.[3] I suggest that the 'horizon' of new buildings in the early 1100s as represented by Cashel and Killaloe had a more specific, or at least a more immediately identifiable, political rhetoric than the corpus of the buildings preceding it, even in that erstwhile-entitled 'First Romanesque' phase. The Gaelic-Irish Romanesque tradition which emerged in that Munster rhomboid of Cashel–Lismore–Ardfert–Killaloe during the early 1100s was a direct product of the way in which two sets of relationships – an older relationship between the secular and the ecclesiastical, and a newer one between Gaelic Ireland and Norman England – were activated as one and the same relationship by the reform agenda. The story of reform, therefore, is absolutely crucial, but it is possible to show, *contra* an earlier view which I held, that Romanesque was not a *metaphor* for reform.[4]

Romanesque and reform

Let us look more closely at the relationship between Romanesque and reform. It is easy for us to speak about such architectural and sculptural forms as having been collectively 'an expression of the spirit of reform', but exactly how, and precisely to whom, might they have fulfilled such a role? This is worth thinking

about: would we, after all, ever make such an interpretation of any work of art or architecture in our age? Also, did Romanesque's spectators, to a man and a woman, think 'reform' when they stood in front of some piece of Romanesque work? Did they need to be told what Romanesque meant? What would the patrons have been able to tell them? We have seen that building a church could be as much a political act as an act of devotion among Ireland's royal dynasties, but was the fact that their new churches had round arches or certain sculptural motifs central or incidental to the political act?

Two factors directly connect Gaelic-Irish Romanesque architecture and its associated sculpture with the institution of the Church in Ireland: the *in situ* preservation of Romanesque workmanship in ecclesiastical contexts, and the politics of Church reform in which those contexts can be understood. The new conceptualization at Ráith Bresail of a diocesan Church seems to point, at an immediate if simple level, to this synod rather than that at Cashel in 1101 as the critical event in the history of Gaelic-Irish Romanesque architecture and sculpture: High Crosses with images of bishops, and new, partly European-like, churches located at diocesan centres or in monasteries in which some measure of reform was embraced look like the *acta archaeologia* of the 1111 proceedings. Thus, the former seem to symbolize explicitly the establishment of a diocesan system, while the latter seem to symbolize reform in a slightly more abstract way while simultaneously providing specific environments – roofed spaces – for reformed clerics.

However, there are several reasons why we must conclude that Romanesque was not intrinsically a metaphor for reform, even if it could be made to articulate ideas raised by or germane to the issue of reform. First, if the contextual definition of Gaelic-Irish Romanesque offered here allows us to include mid-eleventh century material within the rubric, it does not then allow us to regard Romanesque as the material expression of the historical actuality of reform, since reform was merely aspirational prior to 1101. Secondly, Cormac's Chapel, the building around which so much of our understanding of this phenomenon revolves, was not about reform but about politics. Finally, and most significantly, the fact that the principal distribution of Gaelic-Irish Romanesque architecture and sculpture is outside the north-eastern, Armagh Province, dioceses undermines any blithe conclusion that, in some essentialist way, Romanesque and the reform of the Church were correlatives. In fact, if reform in that north-eastern corner of Ireland did not require the use of those formal types of architecture and sculpture which were used in reform contexts further south, as we have discussed in this book, it follows that the use of those formal types did not necessarily 'mean' that reform had been embraced in those places in which they are found.

We can go a step further. Once we recognize Romanesque forms as expressions of political ideology or as a medium of political discourse which can

be put at the service of reform in one place, or eschewed in the politics of reform in another place, we acknowledge that Romanesque can also constitute subtle expressions of *resistance* to reform.[5] How certain can we be, for example, that bishops carved on High Crosses in early 1100s were *never* subtle statements of resistance or objection to the tightening to those rules regarding episcopal appointments which reform ushered in?

To make this point more fully we might think again about the twelfth century's built inheritance from the pre-reform era. That inheritance was a built-environment comprised of small and modest churches, most of them no more than a couple of centuries old. Those that were altered in the twelfth century usually had their floor areas enlarged, either by extending westwards with a nave, thus converting a single-cell building into a chancel, or eastwards, thus converting the original building into a nave. Another strategy was to replace original openings with new stonework carved in a contemporary fashion; one would imagine that this was quite common – it certainly sufficed at Clonfert and Clonmacnoise Cathedrals, where west portals were inserted into single-cell churches in the second half of the twelfth century – but instances of this type of alteration, while not always discernible in the rubble construction which was characteristic of Irish churches throughout the middle ages, were probably not common.

The fact that older churches were altered is interesting since the type of reform successfully prosecuted in post-1101 Ireland did not necessitate such structural changes. It was not primarily a reform of liturgy. Now, reform ideals may have been promoted through the insertion of Romanesque forms into older churches, especially if such forms were on display at places like Cashel and Lismore and were being explained to contemporary audiences in the context of reform, but the point is that there is nothing in the *acta* of the reforming synods which can be interpreted as a direct instruction or an oblique signal to church patrons and builders to either make the types of physical change which we observe in older churches, or build new churches which look different from the older, pre-reform buildings. This is crucial: by combining this observation with the conclusions drawn in Chapter 4 about St Flannan's at Killaloe and Cormac's Chapel, it is clear that the rationale for upgrading old churches as well as for building new churches with Romanesque forms lay not in the reform itself but in the politics surrounding it and in the political environment which accommodated it.[6]

This interpretation is corroborated, ironically perhaps, by the very many older churches which were still in use in the twelfth century but which were *not* given Romanesque face-lifts, even in the southern half of Ireland where Romanesque forms were most popular. In some instances such churches may have been left untouched because potential patrons chose other projects, or local communities (secular or ecclesiastical) lacked the wherewithal to effect the

changes, but it is probable that in most cases a decision was made not to alter. The retention of an original building could reflect an awareness that reform did not require it to be changed, or a sense that older fabric demanded veneration as a form of relic in its own right. But again it could also be an agent of resistance, to reform itself, to a secular polity promoting reform, or to a secular polity which was simply using Romanesque forms as part of its furniture of power. Identifying resistance to reform is more difficult than identifying acquiescence, but we must at least acknowledge it as one of the potential functions of the discourse of this twelfth-century architecture.

Romanesque and feudalism

In the course of this book we headed south from Cashel to contemporary Lismore, and from there explored the Lismore–Kerry axis of that same period, eventually following the style of church which was represented in mid-century Kerry into the lower Shannon region. We also headed south-east of Cashel to Ossory where some of the same compositional forms and motifs were identified. The first journey brought us, in terms of time, to the eve of Connacht's late twelfth-century Romanesque tradition, and, in terms of space, back to Killaloe and the south midlands; the second brought us to 1203 and the completion of Ardmore Cathedral, a date by which Anglo-Norman control of southern Ireland was well established, and to the borders of the king who brought the Anglo-Normans here, Diarmait Mac Murchada. The churches which we encountered represent a development which is to a large extent accretive: every church connects to another by some degree of stylistic or motific change as well as by some political-geographic and topographic context. We could almost be following in the footsteps of an imaginary pack of builders, travelling around Munster, and all the time making changes in the template, adding novel forms of their own creation, or adopting and adapting ideas – from France, from the Hiberno-Scandinavian tradition – as they appear. Leinster, next door to Munster, was even closer geographically to England and it had in Diarmait a king every bit as likely as the Munster kings to desire a Romanesque expression in the twelfth century.

The attitudes of the Ó Conchobhair kings of Connacht are very interesting by comparison. Tuam had the finest High Crosses produced anywhere in Ireland in the twelfth century, and a church which became the cathedral church for an archdiocese after 1152. The latter was destroyed by fire in 1182 but replaced immediately by a late Romanesque structure of which there still remains, hemmed in between high medieval and Victorian structures, a small square chancel, complete with a fine chancel arch and a three-light window. Roger Stalley has analysed its sculpture in detail[7] so it need not detain us here. In general, however, the Connacht landscape did not have the garnish of fancy churches enjoyed in

southern Irish landscapes. Even Clonmacnoise, which belonged within their world, had to wait until well into the second half of the 1100s before it had any Romanesque work. Right at the end of the twelfth century, as the Anglo-Normans were grabbing lands further east, reformed monasticism was embraced with considerable gusto in western parts, and by the Ó Briain kings as well as the Ó Conchobhair kings. There was an extraordinary flowering of architecture and sculpture, the former firmly within the tradition of Cistercianism (even when the monastic houses were Augustinian) and the latter largely within the Gaelic-Irish Romanesque tradition. It is hard not to conclude that these acts of patronage were motivated as much by the knowledge that eastern Ireland belonged within the Angevin realms than by devotion to the Church.

Connacht was, in a sense, the last bastion of that part of Gaelic Ireland in which the Anglo-Normans had settlement aspirations, and in the second quarter of the thirteenth century that settlement happened. The Ó Conchobhair kings of the late 1100s and early 1200s, the period immediately prior to Anglo-Norman settlement, draw our attention to a theme of more explicitly secular concern: feudalism. This is a complex concept of comparatively recent invention with a large and sometimes-disputatious historiography,[8] but it can be understood most simply as descriptive of a mode of social organization which was pyramidal in structure and was nourished by the provision of labour service, and then military service, as the pyramid narrowed towards the top, and by the provision and protection of certain rights and privileges as the pyramid broadened towards the bottom. Medieval European societies are invariably described as feudal from their eleventh-century incarnations at least.

The case for regarding Gaelic-Irish society of the immediate pre-colonial period as feudal now has a three-decade long history.[9] It is now being argued that Gaelic-Irish society began to develop feudal institutions and practices from as early as the tenth century, and that such institutions and practices were well established by the time of the Anglo-Norman arrival in 1169.[10] Whatever the chronology of the earliest manifestations of these structures, we do at least have a social-political (as well as an ecclesiastical-political) context in which to set Gaelic-Irish Romanesque.

Given the importance of military service in our conceptualization of feudalism, it is entirely appropriate that our particular vision of feudal Ireland prior to 1169, not least in Connacht, is one dominated by the evidence of military building projects, such as castles and bridges, as well as military campaigns. Annalistic sources contain much valuable material, albeit in frustratingly brief snippets, while two twelfth-century propagandist texts, Cogad Gaedel re Gallaib, The War of the Irish against the Foreigners, and Caithréim Cellacháin Chaisil, The Battle Career of Cellachán, King of Cashel, give us substantial accounts of

contemporary patterns and strategies of warfare.[11] That increased militarization of Irish society was apparently facilitated by, and had knock-on affects on, the organization of social and economic resources in the countryside, is evidenced by a reconceptualization of land and territory in the eleventh century for its taxation value and its capacity to service armies.[12] The settlement dimension of this is not yet fully understood and we do not need to pursue it here. Suffice it to say that an understanding of that settlement dimension has been severely hampered by those confused and confusing historical-geographical models of the mid-twentieth century that Charles Doherty has started to take apart.[13] But one process in settlement history which may be related to these developments is a general abandonment of Ireland's ringforts, evidence of which may be found in the radiocarbon dating of occupation levels in excavated examples[14] and, more anecdotally, in Giraldus Cambrensis's observation that 'you will find here [in Ireland] many ditches, very high and round and often in groups of three, one outside of the other, as well as walled forts which are still standing, although now empty and abandoned'.[15] We know little about the new configurations of settlement following the abandonment of many existing ringforts and a widespread discontinuation of the practice of erecting new forts, but a model of nucleation around high-status settlements and Romanesque churches, some of them newly-built and others newly-refurbished, has an a *priori* strength.

A whole spectrum of contemporary secular architecture is missing from the record, and missing with it are crucial clues to the development of the forms and ideas of Gaelic-Irish Romanesque. To make this point we might reflect momentarily on one category which is often excluded from consideration of Irish architecture in the pre-colonial period: the castle. Harold Leask drew attention to its existence in his small book on castles, first published sixty-odd years ago, and there has been a steady trickle of commentary on the matter in recent years.[16] Little seems to survive above ground of the small number of documented places for which the Gaelic terms *caistél* and *caisléan* – both now translated as 'castle' – were specifically used during the twelfth century. The very fact that the word 'castle' is used might suggest that we could simply transpose our vision of contemporary Norman castles in England and France (or later Anglo-Norman castles in Ireland), as well as our understanding of their functions, on twelfth-century Gaelic Ireland. But such a transposition would assume that the word had a consistent cross-cultural meaning, an assumption which is now being challenged;[17] in any case, the problem of knowing what to say about these types of place is exacerbated by a host of other terms, such as *daingean* and *longphort*, which may sometimes have been used to indicate a different sort of place or which may have been used as a simple alternative to *caistél* or *caisléan*. All we can say with confidence is that pre-colonial-era Ireland, especially in those Ó Conchobhair

lands, did have at least some monuments of contemporary European motte-castle type in the early 1100s, such as the now-destroyed *Caistél Dúin Leódha* (Ballinasloe), Co. Galway, which was mentioned in 1124, and the *Dún Mór*, now identifiable as the castle-mound visible today beneath an Anglo-Norman tower at Dunmore, Co. Galway, which was demolished in 1133.[18] It is easy to imagine that Ruaidhri Ó Conchobhair's *caislén ingantach*, a large castle, erected in 1164 in Tuam, the centre of the western archbishopric from 1152, was of stone.[19] It is also easy to imagine that these 'castles', whether of timber or stone, had Romanesque forms here and there throughout them.[20]

Feudalism is also, of course, a highly contested construct.[21] The Irish historical and archaeological literature[22] does not yet reflect this; perhaps the feudal model is proving so useful in what is still an on-going project of demonstrating continuity of practices between pre- and post-1169 Ireland that the stage of a closer interrogation of its meaning and value has yet to be reached. Nonetheless, the point being made here is that both the reform of the Gaelic-Irish Church and the appearance of Romanesque forms need to be understood ultimately in the context of changes which include the landscape as well as the political and the institutional arenas. It is another challenge for future research.

EPILOGUE: SOME REFLECTIONS ON ROMANESQUE RESEARCH FOR THE NEW MILLENNIUM

A good starting point for any study of any single item or cumulative body of material from the past, whether it is a written text, a building, an artefact, or a work of art, is to concede that it is silent, that it actually tells us nothing. We do the talking for it, and the stories we construct as its biographers are ones that also say something about who we are and where our interests lie. By offering our services as translators or interpreters – there is a difference, but both roles are about unravelling and conveying *meaning* – we naturally become a part of the material's story, and the more the material has been decontextualized by the passage of time the more apparent it is that we are the authors of its biography, not the translators or interpreters of its autobiography. This book, *Romanesque Ireland*, is no less a product of its time and of my predilections than, say Harold Leask's book, or an article by any number of other scholars in the field. Consequently, I had no compunction about using the personal pronoun throughout, nor even about ending the book with a commentary which is less an epilogue to what precedes it than a prologue to a radically different book in which this book could itself be the subject of a philosophical and methodological critique.

While no claim can or should be made that the discipline of Archaeology has primacy over any other discipline, all of the material examined in this book is archaeological in the most catholic sense of that term. It is 'material culture', and as such it falls within the embrace of a contemporary, progressive, archaeological enquiry, even if it belongs simultaneously within the constituencies marked out by art historians ('works of art'), architectural historians (buildings) and, as Moreland has convincingly argued,[23] historians (written texts). The phrase 'material culture' should not conjure up an image of a random and passive collection of material things; rather, 'material culture' refers to the set of material things through which social relations are actively constituted and society itself is actualized.[24] It is through material culture that 'man makes himself', to borrow Gordon Childe's celebrated phrase.[25]

The range of questions which is asked of Romanesque material for the purpose of writing its biography is, I think, more limited than it needs to be. Matters of origin, formal comparanda and chronology, of technology in the case of architecture, of stylistic categorization and iconography in the case of both architecture and art, and of patronage and the movement of artists/masons, are necessary foci for research, and have been pursued with considerable rigour. They are issues discussed in this book. Significantly, some of them are issues which one could easily imagine being resolved to some degree by simple technology. Is it far-fetched to envisage, within ten years perhaps, a computer programme capable of processing basic data and creating maps (looking like enormous circuit-board diagrams) of their stylistic interconnections? Computers cannot interpret, of course, but they can show up the inherent weakness in one key aspect of our practice: our dependency on *memory* – on remembering where we saw another example of the same thing, or something rather similar – when we write about Romanesque.

Perusal of the literature which is specifically about Romanesque also reveals a general avoidance of more probing questions about social context, and more specifically about the *active* role of this particular body of material culture in the construction of society. This book is, to a large degree, no different, and I make that confession with slight embarrassment, coming from a discipline, Archaeology, in which such issues are now explored as a matter of course. This general avoidance can be attributed to the historic evolution of Romanesque scholarship around the principle of formalism, in which 'information extrinsic to the experience of the work on its own terms is relegated to auxiliary status – whether this information is biographical, historical or *sociological*,'[26] and around somewhat narrow principles of technological or iconographical functionalism. Romanesque scholars have, of course, every right not to consider matters of social context below the levels of patrons and masters if they so wish. Most define their project

as exclusive of such issues, so it would be unfair to criticize books such as *Medieval Architecture, Medieval Learning: Builders and Masters in the Age of Romanesque or Gothic or Medieval Architecture and its Intellectual Context* [27] for not considering the roles of these buildings in, for example, the construction of contemporary social identity below the level of the intellegensia. Equally, it would be unfair to criticize document-historians for not crossing into the area of architectural history. Nonetheless, the historic evolution of a Romanesque scholarship of such exclusivity is intrinsically interesting as a reflection of ideas about both art and society within the academy (the professional intellectual community); it is also, it should be said, a matter quite separate from that historiography of Romanesque so skilfully mapped by Waldeier Bizzarro.[28] My own view is that the evolution of a Romanesque scholarship so hermetically sealed as to discourage any social-theoretical critique of its subject matter is rooted in a series of loaded and difficult-to-break-down polarizations – art over craft, high culture over low culture, high intellectual ideals and technological achievements over the mundane – which the academy, descended from the medieval centres of learning, has successfully (even if somewhat unconsciously) promoted. In this perspective, Romanesque has retained the place set for it within the ideology of twelfth-century renaissance 'high culture': it does not really belong to the everyday, it is not a part of social history, it is more meaningful to the élite than to the non-élite.

The matter of *meaning* raises the matter of language, bringing us back to where we started by reminding us of those Romanesque scholars of the first generation who attached enormous significance to the geographical co-incidence of the distributions of Romance languages and Romanesque, and to their apparent parallel devolutions from purer Roman forms. Their enquiries placed the relationship between Romanesque and language at the very heart of Romanesque historiography. Ironically, while the field of Romanesque studies remains untouched by developments in theory in the humanities, the modern study of its old dancing partner, language, is heavily theorized.

When students of architecture speak about language it is usually in the sense of architecture having a language rather than with respect to some body of architecture being related to a particular group of languages. The idea of 'a language of architecture' has a long history and wide currency in architectural history, with Sir John Summerson's 1963 book, *The Classical Language of Architecture* being, perhaps, its best-known expression. There is a subtle difference between architecture being a language and being like a language; in the case of the former, architecture is viewed as syntactic, as having rules equivalent to grammar, and in the case of the latter it is viewed as semantic, as having meaning. The syntactic view often leads to a history which is fundamentally lexicographic, categorizing techniques and motific combinations, and reconstructing the regional

'voices' which they constitute,[29] but not really tackling meaning. By contrast, the view which stresses meaning offers a route by which Romanesque might be incorporated within a 'cultural studies' perspective on the middle ages.[30]

Thinking about architecture as a communicator of meaning might lead us to see it as a form of text into which is encoded a set of signs or signals which can be 'read'; hence we would regard the elements of a building as having been designed to signify in combination, if not also individually, certain ideas about, say, social class, patron identity, or political allegiance. Romanesque seems an ideal subject for this sort of structuralist[31] critique, in that it was created for an élite using selected elements of Roman form which, by virtue of their very use, can easily be understood by us as articulations of power and authority equal to their antique models. And the point that we can claim to understand this meaning is crucial to the structuralist position: meaning is intrinsic, fixed, static; meaning, once encoded within the material object, remains thereafter. But viewing any architecture as a system of signs with prescribed domains of signification actually closes down its range of meanings. It can privilege a dominant meaning, and the dominant meaning which it invariably privileges is that which élite society itself wished to be attached to the architecture as part of its hegemonic ideological discourse. It can thereby continue to fulfill that ideological project, long after the need for that project has ended; this explains, in my view, why Romanesque continues to be studied as art not craft, as high culture not low culture, as a high intellectual ideal and technological achievement, and as a topic in Art History not in Archaeology. It can fail to recognize the potential for very subtle forms of cultural subversion or ideological resistance built into architecture itself or articulated by the ways in which people interacted with the architecture. And it can fail to recognize that architecture can have as many meanings as there are spectators, regardless of their social class. Therein perhaps lies the route to an alternative Romanesque scholarship for the twenty-first century. These buildings belonged within the lived experiences of all medieval people. They were not just part of the *text* of medieval life; they were part of its *texture*.

Glossary

abacus (plural **abaci**): the horizontal and projecting band of stone at the top of a capital.

angle-shaft: a shaft set in the angle of a pier, a respond, or a jamb.

anta (plural **antae**): a pilaster-like projection of a side wall past an end wall. The term is borrowed for the Irish context from the lexicon of Classical architecture where it describes a pilaster which projects from the sides of a portico.

apse: the eastern termination of a church, semi-circular or polygonal in plan and usually vaulted.

arcade: a row of arches carried on piers or columns which are either free-standing or are 'engaged' (connected) to a wall.

architrave: the moulded frame around a door or window.

archivolt: now widely used to refer to an arch-ring, especially one which is moulded, here it is used in its original sense of the outer face of an arch-ring (see, for example, R. Sturgis et al, *Sturgis' Illustrated Dictionary of Architecture and Building* (New York 1901–2), pp 12–3, 145–6).

arcuated façade: a façade which is comprised of arches or arcades.

arris: the sharp-edged junction of two surfaces.

ashlar masonry: masonry which is comprised of blocks of regularly-cut stone.

astragal: a small moulding, usually semi-circular in profile, between a capital and column.

baldacchino: a canopy above an altar, either suspended from above or supported by columns.

bar-and-lozenge: this refers to a decorative scheme in which carved lozenges are arranged in sequence but separated from each other by short stretches (bars) of moulding.

barrel vault: a continuous vault of semi-circular section.

batter: a slope or inclination inwards from the foundation to the wall-head, or from the base to the top of an architectural member.

bay: a unit of width or length along a wall which is defined by articulating (emphasising) features such as engaged columns and contains an opening, either a door or window.

beakhead: an elongated (beak-like) animal (or more rarely a human) head biting on a roll moulding; classically regarded as a feature of English Romanesque.

billet moulding: a moulding consisting of raised square blocks placed at intervals.

blind arcade: an arcade engaged to a wall and containing no openings.

bowtell moulding: a roll-moulding of three-quarters section.

capital: the architectural member at the top of a column, pier or pilaster which separates the supporting member (the column, pier or pilaster) from whatever it supports, which is usually an arch. A **cushion capital** is square at the top and cylindrical at the bottom and has inverted-D shapes on each face. A **scalloped capital** is similar but with several small inverted-D shapes on each face. A **head-capital** simply has a head at each corner. A **voluted capital** has a scrolled feature at each corner.

chamfer: a bevel which is usually cut at 45°. **Top-chamfered** and **bottom-chamfered** refer here to chamfers which are cut at the top and bottom surfaces of horizontal members like abaci or imposts. A **hollow chamfer** is a chamfer of concave section.

chancel: the east end of a church which contains the principal altar.

chevron: zig-zag ornament. **Saw-tooth chevron** refers to chevron which projects three-dimensionally from a surface. **Archivolt saw-tooth chevron** refers here to chevron which projects from the archivolt (the face of the arch-ring) towards the viewer; **intrados saw-tooth chevron** refers to chevron which is carved on the archivolt but which points downwards to the underside or intrados of the arch-ring.

choir: the east end of a church, so-named because it accommodated the choir; often used interchangeably but incorrectly with chancel, the choir stops short of the furthest eastern part of a church where the high altar is located.

clerestorey (or **clearstorey**): the upper, fenestrated, part of a wall immediately beneath the wall-head or the vaults. Generally used only in the context of large buildings with complex wall elevations.

colonnade: a row of columns carrying an entablature or arches.

corbel table: a series of corbels, sometimes connected by small arches, positioned directly beneath a cornice.

crossing: the junction of the east-west (nave-chancel) and north-south (transept) axes of a cruciform-plan church.

diaper work: all-over surface decoration using motifs of regular shape, formed either by the simple arrangement of ashlar blocks (as on Ardfert Cathedral façade) or by actual carving of stones (as on Clonfert Cathedral portal).

engaged columns: a column of which half is embedded in a wall.

false column: a column-form which appears to be separate from the stonework around it but is actually cut out of that stonework, rather like a large roll-moulding.

fascia: a horizontal band in an architrave, or the outward-facing flat surface of a horizontal member.

fillet: a narrow, flat-surfaced, raised band on a moulding.

finial: an ornamental device at the top of a gable.

fret: a geometrical ornament of horizontal and vertical lines.

frieze: a sculpturally-embellished horizontal band of masonry on a wall surface.

giant order: a column or pier rising through two storeys

groin vault: a vault formed by the intersection of two barrel vaults.

hood-moulding: a projecting moulding above an opening which enframes the opening and diverts rain.

impost: a horizontal moulding along a wall surface which supports some architectural member such as an arch; sometimes be used interchangeably with **abacus**, impost is used with respect to an arched opening where there is no capital but a simple band of masonry separating the upright and the arch itself.

intrados: the soffit or underside of an arch.

keel moulding: a moulding with the profile of a ship's keel.

keystone: the top stone of an arch.

label-stop: the generally-decorated end stone of a hood moulding.

lunette: a framed semi-circular area.

nave: the congregational area which forms the larger western part of a church.

oculus: a round window.

pilaster: a pier or rectangular column engaged to a wall and of shallow projection.

quirk: a V-shape incision in a moulding or between mouldings.

quoin: a corner stone. A **quoin-column** is a columnar feature at the corner of a building.

rebate: a recessed surface to accomodate a door or shutter.

relieving arch: an arch above a lintel which serves to relieve the weight of masonry from above.

respond: a half-pier bonded into a wall and carrying one end of an arch. A **respond pilaster** refers to an outward-facing pilaster flanking a doorway but also carrying an arch.

return: a corner formed by a wall turning at 90° in a different direction.

rib-vault: a vault comprised of diagonally-placed ribs of stone with cells of masonry between them.

roll moulding: a moulding of semi-circular section.

rubble masonry: undressed, uncoursed masonry.

scotia: a concave moulding.

skew-back: the part of an abutment which supports the arch.

spandrel: a triangular space on either side of an arch. It is also applied to the triangular space formed at the junction of two chevrons or lozenges.

springer: a stone from which an arch springs.

squinch: an arch spanning a corner and carrying a cylindrical superstructure on a square plan.

spur: a spur-like moulding on the corner of a base of a column.

string-course: a thin horizontal band, often moulded, projecting from a wall surface.

torus: a convex moulding, usually at the base of a column.

triforium: an arcade, usually with a wall passage behind it, positioned beneath the clerestorey but above an open arcade in a complex wall elevation.

trumeau: a vertical support for a lintel; it is placed centrally between the jambs of the opening thereby creating two doorways under the one lintel.

tympanum: the D-shaped slab above a doorway and within the inner arch-ring.

voussoir: an arch stone.

Abbreviations

1: PRIMARY SOURCES

AB	A.C. Freeman (ed.), 'Annals of Boyle', *Revue celtique* xlii (1925), pp. 287–301.
AFM	J. O'Donovan (ed. & trans.), *Annala Rioghachta Eireann; Annals of the kingdom of Ireland by the Four Masters from the earliest period to the year 1616.* 7 vols (Dublin 1851).
A. Boyle	A.C. Freeman (ed.), 'Annals of Boyle', *Revue celtique* xlii (1925).
A. Clon.	D. Murphy (ed.), *The annals of Clonmacnoise, being annals of Ireland from the earliest period to AD 1408* (Dublin 1896).
AI	S. Mac Airt (ed. & transl), *The annals of Innisfallen (MS Rawlinson B.503)* (Dublin 1951).
AT	W. Stokes (ed.), 'The annals of Tigernach', *Revue celtique* xvi–xviii (1895–7).
AU	S. Mac Airt & G. Mac Niocaill (eds), *Annals of Ulster (to AD 1131)* (Dublin 1983)
CS	W.M. Hennessy (ed.), *Chronicon Scotorum, a Chronicle of Irish Affairs, from the earliest times to AD 1135* (London 1886).
MIA	S. Ó hInnse (ed.), *Miscellaneous Irish annals, AD 114–1437)* (Dublin 1947).

2: SECONDARY SOURCES

AAAHP	*Acta ad Archaeologia et Atrium Historiam Pertinentia*
AB	*Art Bulletin*
AESC	*Annales: Économies, Sociétés, Civilisations*
AH	*Analecta Hibernica*
AHR	*American Historical Review*
AI	*Archaeology Ireland*
ANS	*Anglo-Norman Studies*
Ant J	*Antiquaries Journal*
Arch	*Archaeologia*
Arch Hib	*Archivium Hibernicum*

Arch Hist	*Architectural History*
Arch J	*Archaeological Jnournal*
Art H	*Art History*
BHS	*British Journal of Sociology*
BM	*Bulletin Monumental*
CCC	*Citeaux Commentarii Cistercienses*
CCM	*Cahiers de Civilisation Médiévale*
CMCS	*Cambrian Medieval Celtic Studies*
CStMC	*Cahiers de St Michel de Cuxa*
CR	*Clogher Record*
DHR	*Dublin Historical Record*
DUR	*Dublin University Review*
ESTMA	*European Symposium for Teachers of Medieval Archaeology*
GASJ	*Galway Archaeological Society Journal*
Hist Today	*History Today*
IAR	*Irish Arts Review*
IADS	*Irish Architectural and Decorative Studies*
IER	*Irish Ecclesiastical Record*
IHS	*Irish Historical Studies*
JBAA	*Journal of the British Archaeological Association*
JCAHS	*Journal of the Cork Archaeological and Historical Society*
JGAHS	*Journal of the Galway Archaeological and Historical Society*
JKAHS	*Journal of the Kerry Archaeological and Historical Society*
JKAS	*Journal of the Kildare Archaeological Society*
JKSEIAA	*Journal of the Kilkenny and South-East Ireland Archaeological Association*
JRSAI	*Journal of the Royal Society of Antiquaries of Ireland*
JSAH	*Journal of the Society of Architectural Historians*
JWCI	*Journal of the Warburg and Courtauld Institutes.*
JWSEIAS	*Journal of the Waterford and South-east Ireland Archaeological Society*
MA	*Medieval Archaeology*
MSAN	*Mémoires de la Société des Antiquaries de Normandie*
NMAJ	*Journal of the North Munster Archaeological Society*
OKR	*Old Kilkenny Review*
PRIA	*Proceedings of the Royal Irish Academy*
PSAS	*Proceedings of the Society of Antiquaries of Scotland*
RA	*Revue Archéologique*
RM	*Ríocht na Midhe*
SA	*Seanchas Ardmhacha*
SAHJ	*Society of Architectural Historians Journal*
THJ	*Tipperary Historical Journal*
TWAS	*Transactions of the Worcestershire Archaeological Society.*
UJA	*Ulster Journal of Archaeology*

Notes

CHAPTER 1: THE ROMANESQUE CONSTRUCT: HISTORY AND HISTORIOGRAPHY

1 P. Wolff, *Histoire de Toulouse* (Toulouse 1974).

2 For classic statement on the churches of the pilgrimage roads see K.J. Conant, *Carolingian and Romanesque architecture, 800–1200* (revised edition, London 1978), pp. 157–75.

3 M.F. Hearn, *Romanesque sculpture. The revival of monumental stone sculpture in the eleventh and twelfth centuries* (Oxford 1981), pp. 69–80.

4 R. Stalley, 'Sailing to Santiago: medieval pilgrimage to Santiago de Compostela and its artistic influence in Ireland', in J. Bradley (ed.), *Settlement and society in medieval Ireland* (Kilkenny 1989), pp. 397–420. Rome seems to have been the preferred destination for pilgrims in the 1000s and 1100s: see A. Gwynn, 'Ireland and the Continent in the eleventh century', *IHS*, viii (1953), pp. 193–216.

5 C.H. Haskins, *The Renaissance of the twelfth century* (Cambridge, Mass. 1927). For the historiography of renaissance see W.K. Ferguson, *The Renaissance in historical thought: five centuries of interpretation* (Boston 1948), and for explorations of the meanings and relationships of various renaissances see E. Panofsky, *Renaissance and renascences in Western Art* (Stockholm 1960), and W. Treadgold (ed.), *Renaissances before the Renaissance. Cultural revivals of late antiquity and the middle ages* (Stanford 1984).

6 T. Waldeier Bizzarro, *Romanesque architectural criticism. A prehistory* (Cambridge 1992).

7 This was de Gerville's formulation: see H. Bober, 'Editor's foreword', to E. Mâle, *Religious art in France: the twelfth century. A study of religious iconography* (Princeton 1978 [Paris 1953]), p. viii.

8 W.A. Nitze, 'The so-called twelfth-century renaissance', *Speculum*, xxiii (1948), pp. 464–71; U.T. Holmes, 'The idea of a twelfth-century renaissance', *Speculum*, xxvi (1951), pp. 643–51; E.M. Sandford, 'The twelfth century – renaissance or proto-renaissance?', *Speculum*, xxvi (1951), pp. 635–42. R.L. Benson & G. Constable (eds), *Renaissance and renewal in the twelfth century* (Oxford 1982).

9 For the architecture see, for example, P. Frankl, *Die frühmittelalterliche und romanische Baukunst* (Potsdam 1926), A.W. Clapham, *Romanesque architecture in Western Europe* (Oxford 1936), H. Focillon, *Art d'Occident* (Paris 1939), Conant, *Carolingian and Romanesque architecture*, H.E. Kubach, *Romanesque architecture* (New York 1975), X. Barral I Altet, *The Romanesque. Churches, monasteries and abbeys* (Cologne 1997), R. Toman, *Romanesque. Architecture, sculpture, painting* (Cologne 1997), and R. Stalley, *Early medieval architecture* (Oxford 1999).

10 R.N. Swanson, *The twelfth-century Renaissance* (Manchester 1999), p. 6.

11 Ibid., p. 10.

12 See S.G. Nichols, *Romanesque signs. Early medieval narrative and ionography* (New Haven and London 1983), for this idea.

13 R. Landes, 'The fear of the apocalyptic year 1000: Augustinian historiography, medieval and modern', *Speculum,* lxxv (2000), pp. 97–145.

14 A. de Caumont, 'Essai sur l'architecture religieuse de moyen âge', *MSAN,* i (1824), pp. 537–677, at p. 539. For more recent explorations of this idea see R. Salvini, 'Pre-Romanesque Ottonian and Romanesque', *JBAA,* 3rd ser. xxx (1970), pp. 1–20, and W. Dynes, 'Art, language and Romanesque', *Gesta,* xxvi (1989), pp. 3–10.

15 J. Quicherat, 'De l'architecture romane', *RA,* viii (1851), pp. 145–58.

16 P. Frankl, *The Gothic. Literary sources and interpretations through eight centuries* (Princeton 1960).

17 G. Zarnecki, *Romanesque* (London 1989), p. 5.

18 Quoted by S. Chaplin, 'Towards a history of medieval architecture', *Art H,* ix, 3 (1986), pp. 385–95, at p. 3.

19 *Romanesque architecture in Western Europe*, p. 155.

20 P. Harbison, 'The otherness of Irish art', in C. Hourihane (ed.), *From Ireland coming. Irish art from the early Christian to the late Gothic period and its European context* (Princeton 2001), pp. 103–20.

21 Françoise Henry was the only scholar to draw these different lines of evidence into a substantial synthesis – see her *Irish art in the Romanesque period (1020–1170 AD)* (London 1970) – although close examination of her work reveals that she actually cross-referenced comparatively little from one to another. A proper modern synthesis at an appropriate scale must wait.

22 This stone, which is 56cm wide in its broken state, 42cm high and 20cm thick, features an enthroned and haloed figure within an arched niche which is framed by small barley-twist columns and which is flanked by an upright lion on the left-hand site as one looks at it, and by a standing eagle on the right. The stone's dimensions, especially its thickness, indicate it was a work of architectural sculpture, probably part of a programmatic frieze. First impressions are that the central figure could be Christ or, more likely, St Paul, who is often represented as bearded, as is this figure, and whose martyrdom was often signified by a sword in medieval art. One unusual feature is that the arch does not spring from the capitals but is simply a bulge halfway along the horizontal impost which is supported by those capitals. Is this twelfth-century? Is it even Irish? I am very grateful to Mr Timoney for sending me a photograph in advance of his publication.

23 T.J. Westropp, 'Notes on the antiquities around Kilfenora and Lahinch, Co. Clare. Part II', *NMAJ,* I (1919), pp. 91–107, at 91–104.

24 F. Henry & G.L. Marsh-Micheli, 'A century of Irish illumination', *PRIA,* lxii (1962), pp. 101–64. For Ringerike and Urnes see S.H. Fuglesang *Some aspects of the Ringerike style* (Odense 1980), and 'Stylistic groups in late Viking and early Romanesque art', *AAAHP,* i (1981) pp. 79–125.

25 The enumeration is based on a survey of the literature. For a recent summary of the metalwork, and key references, see R. Ó Floinn, 'Innovation and conservatism in Irish metalwork of the Romanesque period', in C.E. Karkov, M. Ryan & R.T. Farrell (eds), *The insular tradition* (New York 1997), pp. 259–81.

26 The key source is now P. Harbison, *The high crosses of Ireland.* 3 vols (Bonn 1992). The classic article is L. de Paor, 'The limestone crosses of Clare and Aran', *JGAHS,* xxvi (1955–6), pp. 53–71. For an up-to-date discussion see R. Cronin, 'Late High Crosses in Munster: tradition and novelty in twelfth-century Irish art', in M.A. Monk & J. Sheehan (eds), *Early medieval Munster. Archaeology, history and society* (Cork 1998), pp. 147–63.

27 English Romanesque rood sculpture, as at Langford and Romsey, may have provided some of the inspiration; Henry compared the statuesque figures of Christ on the three Munster crosses of Cashel, Monaincha and Roscrea to the *Volto Santo* crucifix at Lucca, suggesting that the well-documented Irish pilgrimages to Rome in the eleventh century (see note 4 above) may have been the means by which the formal idea of a crucified Christ wearing a long robe came to Ireland (*Irish art in the Romanesque period*, pp. 127–8).

28 Throughout this book I use 'Norman Romanesque' with respect to Normandy, and 'English Romanesque' with respect to England (and the relevant and adjacent parts of Wales and

Scotland) after 1066; 'Anglo-Norman' is used here as an ethnic designation; one of the contexts in which it is used is to refer to those who made English Romanesque work. For the Norman and English buildings see R. Leiss, *Der frühromanischen Kirchenbau des 11 jahrhunderts in der Normandie* (Munich 1967), and especially E. Fernie, *The architecture of Norman England* (Oxford 2000). Also useful are L. Musset's four Zodiaque volumes, *Normande Romane. La basse-Normandie* and *Normande Romane. La haute-Normandie* (La Pierre-qui-Vire 1975, 1985), and *Angleterre Romane 1. Le sud de l'Angleterre* and *Angleterre Romane 2. Le nord de l'Angleterre* (La Pierre-qui-Vire 1983, 1988). Detailed studies are presented in M. Baylé (ed.), *L'Architecture Normande au moyen age*. 2 vols (Caen 1997). The best source of illustrations is probably V. Ruprich-Robert, *L'Architecture Normande*. 2 vols (Paris 1884–9), which includes England.

29 This was the view expressed by H.G. Leask, *Irish churches and monastic buildings* I. *The early phases and the Romanesque* (Dundalk 1955), p. 102.

30 H. Clover & M. Gibson (eds), *The letters of Lanfranc, archbishop of Canterbury* (Oxford 1979), pp. 50–1.

31 D.N. Dumville, *Councils and synods of the Gaelic early and central middle ages*, Quiggin Pamphlets on the Sources of Mediaeval Gaelic History 3 (Cambridge 1997), p. 35.

32 M.P. Sheehy (ed.), *Pontificia Hibernica: Medieval chancery documents concerning Ireland, 640–1261* (Dublin 1861), vol. 1, no. 2.

33 Clover & Gibson, *Letters of Lanfranc*, pp. 64–7.

34 Ibid., pp. 50–1. M.T. Flanagan, *Irish society, Anglo-Norman settlers, Angevin kingship: interactions in Ireland in the late twelfth century* (Oxford 1989), 14–18; see also D. Bethell, 'English monks and Irish reform in the eleventh and twelfth centuries', *Historical studies* viii (1971), pp. 111–35.

35 M. Richter (ed.), *Canterbury professions* (Beeston 1973), no. 51; J.T. Gilbert (ed.), *Chartularies of St Mary's Abbey, Dublin* (London 1884–86), vol. II, p. 250; Flanagan, *Irish society, Anglo-Norman settlers*, 19–21; S. Kinsella, 'From Hiberno-Norse to Anglo-Norman, c.1030–1300' in K. Milne (ed.), *Christ Church Cathedral, Dublin. A history* (Dublin 2000), pp. 25–52, at p. 38.

36 Clover & Gibson, *Letters of Lanfranc*, pp. 72–3.

37 D. Ó Corráin, 'Dál Cais: church and dynasty', *Ériu*, xxiv (1973), pp. 52–63, at p. 57.

38 M. Holland, 'Dublin and the reform of the Irish church in the eleventh and twelfth centuries' *Peritia*, xiv (2000), pp. 111–60, and 'The synod of Dublin in 1080', in S. Duffy (ed.), *Medieval Dublin III* (Dublin 2002), 81–94.

39 For details see A. Gwynn, *The Irish church in the eleventh and twelfth centuries* (Dublin 1992), pp. 99–115.

40 J.F. Kenney, *The sources for the early history of Ireland: ecclesiastical. An introduction and guide* (New York 1929 [rev. 1966; reprinted 1993]), pp. 749–63.

41 AFM; AI. See Landes, 'The fear of the apocalyptic year 1000', pp. 141–5, for the 'Peace of God' assemblies.

42 S. Hayes O'Grady & R. Flower, *Caithréim Thoirdhealbhaigh* (London 1929), vol. I, pp. 174–5, vol. II, 185–6; T. Ó Donnchadha, *An Leabhar Muimhneach* (Dublin 1940), p. 341.

43 K. Hughes, *The church in early Irish society* (London 1966), p. 263; J. Fleming, *Gille of Limerick (c.1070–1145). Architect of a medieval church* (Dublin 2001), pp. 32–4.

44 C. Etchingham, 'Episcopal hierarchy in Connacht and Tairdelbach Ua Conchobhair', *JGAHS*, lii (2000), pp. 15–18.

45 AT; AFM; CS s.a.1097.

46 For Muirchertach's career see A. Candon, 'Muirchertach Ua Briain, politics, and naval activity in the Irish sea', in G. Mac Niocaill & P.F. Wallace (eds), *Keimelia. Studies in medieval archaeology and history in memory of Tom Delaney* (Galway 1988), pp. 397–415.

47 Fleming, *Gille of Limerick*, pp. 41–2.

48 A. Gwynn, 'The diocese of Limerick in the twelfth century', *NMAJ*, v (1946–7), pp. 35–48.

49 Flanagan, *Irish society, Anglo-Norman settlers*, p. 22.

50 A. Gwynn, 'Bishop Samuel of Dublin', *IER*, 5th ser. lx (1942), pp. 81–8, 87–8.

51 Gwynn, 'The diocese of Limerick in the twelfth century'.

52 AU; AFM; Fleming, *Gille of Limerick*, 33. Cellach even died in Munster in 1129 and was buried 'in the tomb of the bishops' at Lismore, Co. Waterford, as he had requested (AU).

53 CS s.a.1144.

54 J. McErlean, 'Synod of Ráith Breasail. Boundaries of the dioceses of Ireland', *Arch Hib*, iii (1914), pp. 1–33. A. Candon, 'Ráith Bressail: a suggested identification', *Peritia*, iii (1984), pp. 326–9. D. Ó Murchadha, 'Where was Ráith Breasail?', *THJ* 1999, pp. 151–61.

55 D. Comyn & P.S. Dinneen (eds), *The history of Ireland by Geoffrey Keating, D.D.* (London 1902–14), vol. III, pp. 298–307.

56 *Council and synods of the Gaelic early and central middle ages*, pp. 38, 44 n166.

57 K. Simms, 'The origins of the diocese of Clogher', *CR*, x (1980), pp. 180–98, at p. 186.

58 J. Brady, 'The origin and growth of the diocese of Meath', *IER*, lxxii (1949), pp. 1–13, 166–76; B. Nic Aongusa, 'The monastic hierarchy in twelfth century Ireland: the case of Kells', *RM*, viii (1990–91), pp. 3–20.

59 AFM.

60 AT; R.A.S. Macalister, *Corpus inscriptionum insularum Celticarum* (Dublin 1949; reprinted 1996), vol. II, pp. 15–16.

61 Etchingham, 'Episcopal hierarchy in Connacht', pp. 23–5.

62 C. McNeill (ed.), *Calendar of Archbishop Alen's Register c.1172–1534* (Dublin 1950), pp. 38–40.

63 Gwynn, *The Irish church, eleventh and twelfth centuries*, pp. 199, 227.

64 AFM.

65 AI; Henry, *Irish art in the Romanesque period*, pp. 97–8.

66 For monastic rules of the middle ages in general see C. Lawrence, *Medieval monasticism* (London 1984), and for Ireland Hughes, *The church in early Irish society*, passim.

67 W. Braunfels, *Monasteries of western Europe. The architecture of the orders* (London 1972).

68 Bethell, 'English monks and Irish reform'; Kinsella, 'From Hiberno-Norse to Anglo-Norman', esp. pp. 35–36.

69 A. Gwynn & N.D. Hadcock, *Medieval religious houses: Ireland* (London 1970), pp. 102–9.

70 Stalley, *The Cistercian monasteries of Ireland*. Cistercian monasteries, by contrast, were usually new foundations, although occasionally occupying older sites: see G. Carville, *The occupation of Celtic sites in medieval Ireland by the canons regular of St Augustine and the Cistercians* (Kalamazoo 1982).

71 L. Verheijen, *La régle de Saint Augustin*. 2 vols (Paris 1967). M. Jackson, 'St Augustine and the monastic experiment', in S. Kinsella (ed.), *Augustinians at Christ Church: the canons regular of the cathedral priory of Holy Trinity, Dublin* (Dublin 2000), pp. 9–22.

72 For the architecture see T. O'Keeffe, *An Anglo-Norman monastery. Bridgetown priory, Co. Cork, and the architecture of the Augustinian canons regular in medieval Ireland* (Kinsale 1999). For the history see S. Preston, 'The canons regular of St Augustine: the twelfth-century reform in action', in S. Kinsella (ed.), *Augustinians at Christ Church: the canons regular of the Cathedral priory of Holy Trinity, Dublin* (Dublin 2000), pp. 23–40.

73 AFM; AT; A Boyle; A. Clon.

74 Bethell, 'English monks and Irish reform'; Flanagan, *Irish society, Anglo-Norman settlers*, pp. 32–7; Gwynn, *The Irish church, eleventh and twelfth centuries*, pp. 218–33.

75 Holland, 'Dublin and the reform of the Irish church', pp. 153–5.

76 Comyn & Dinneen, *The history of Ireland by Geoffrey Keating*, vol. III, pp. 314–17.

77 T. O'Keeffe, 'Romanesque as metaphor: architecture and reform in twelfth-century Ireland', in A.P. Smyth (ed.), *Seanchas. Studies in early and medieval Irish archaeology, history and literature in honour of Francis J. Byrne* (Dublin 2000), pp. 313–22.

78 J.F. O'Doherty, 'Rome and the Anglo-Norman invasion of Ireland', *IER*, 5th ser. xlii (1933), pp. 131–45, and 'The Anglo-Norman invasion, 1167–71', *IHS*, i (1938–9), pp. 154–7.

79 G. Petrie, *The ecclesiastical architecture of Ireland anterior to the Anglo-Norman invasion, comprising an essay on the origin and uses of round towers of Ireland* (Dublin 1845); for a discussion

of Petrie's work in its contemporary cultural-historical context see J. Leersen, *Remembrance and imagination. Patterns in the historical and literary representation of Ireland in the nineteenth century* (Cork 1996), esp. pp. 68–156.

80 Lord Dunraven, *Notes on Irish architecture.* 2 vols (London 1875–7).

81 M. Stokes, *The early Christian architecture of Ireland* (London 1875); R.R. Brash, *The ecclesiastical architecture of Ireland* (Dublin 1875).

82 A. Champneys, *Irish ecclesiastical architecture* (London 1910).

83 Among the papers on individual buildings or groups of buildings around this time Charles McNeill's 1912 paper advocating a German origin for the towers of Cormac's Chapel ('The affinities of Irish Romanesque architecture', *JRSAI*, 42 (1912), pp. 140–7) is especially noteworthy.

84 F. Henry, *La sculpture Irlandais* (Paris 1933).

85 H. Focillon, *Art d'occident* (Paris 1939), *La vie des forms* (Paris 1948), and *L'Art des sculpteurs romanes* (Paris 1964). J. Baltrušaitis, *La stylistique ornementale dans la sculpture Romane* (Paris 1931); we do not know how Henry regarded the work of Baltrušaitis, whose line drawings were not unlike her own, but a familiarity with Meyer Schapiro's 1933 denunciation of Baltrušaitis's 'discovery' of formal rules informing Romanesque sculptural compositions may have dissuaded her from pursuing such an angle later in her career; originally in German, Schapiro's review-article is published in English as 'On geometrical schematicism in Romanesque art', *Romanesque art* (New York 1977), pp. 265–84.

86 *Irish churches and monastic buildings* I.

87 F. Henry & G. Zarnecki, 'Romanesque arches decorated with human and animal heads', *JBAA,* 3rd ser. xx–xxi (1957–8), pp. 1–34.

88 *Art Irlandais.* 3 vols (La-Pierre-qui-Vire 1963–64). *Irish art in the early Christian period (to 800 A.D.)* (London and Ithaca 1965); *Irish art during the Viking invasions (800–1020 A.D.)* (London and Ithaca 1967); *Irish art in the Romanesque period (1020–1170 A.D.)* (London and Ithaca 1970). P. Harbison, *The golden age of Irish art* (London 1999), is a single-volume updating of Henry's three-volume survey.

89 *Irish art in the Romanesque period*, p. 155.

90 Ibid., pp. 162, 170.

91 He reports this in *Irish churches and monastic buildings* II. *Gothic architecture to A.D. 1400* (Dundalk 1966), i (unpaginated preface).

92 'The characteristic features of Irish architecture from early times to the twelfth century', *NMAJ,* i (1936), pp. 10–21.

93 *Irish churches and monastic buildings* I, p. 82.

94 A similar three-phase model was used on a European scale by Paul Frankl, *Die frühmittelalterliche und romanische Baukunst* (Potsdam 1936).

95 *Irish churches and monastic buildings* I, pp. 87–8.

96 Ibid., p. 82.

97 L. de Paor, 'Cormac's Chapel: the beginnings of Irish Romanesque', in E. Rynne (ed.), *North Munster studies* (Limerick 1967), pp. 133–45.

98 N. Pevsner, *An outline of European architecture* (London 1943), p. 15.

99 'Cormac's Chapel', p. 142.

100 R. Stalley, *The Cistercian monasteries of Ireland* (Yale 1987).

101 B. Kalkreuter, *Boyle Abbey and the school of the West* (Bray 2001).

102 'How old is Gallarus Oratory?', *MA,* xiv (1970), pp. 34–59.

103 See most recently T. O'Keeffe, 'Architectural traditions of the early medieval church in Munster', in M.A. Monk & J. Sheehan (eds), *Early medieval Munster* (Cork 1998), pp. 112–24, at p. 114.

104 Stalley is also the Irish representative on the project committee in The Corpus of Romanesque Sculpture in Britain and Ireland (http://www.crsbi.ac.uk/), established in 1987 and funded by the British Academy and other bodies. Publication on CD-Rom is promised (R. Stalley, 'In search of Romanesque sculpture', *AI,* viii, no. 30 (1994), pp. 7–9) but has not yet materialized,

and there is no on-line access to Irish material. One hopes that this valuable corpus will soon become freely available to the wider intellectual community.

105 T. Garton, 'A Romanesque doorway at Killaloe', *JBAA*, 134 (1981), pp. 31–57.

106 'Irish Romanesque architecture', in T. Bartlett (ed.), *History and environment* (Dublin 1998), pp. 52–69.

CHAPTER 2: ROMANESQUE GENESIS: IRISH ECCLESIASTICAL ARCHITECTURE TO AD 1100

1 A good general survey is C.A.R. Radford, 'The earliest Irish churches', *UJA*, xl (1977), pp. 1–11. For Round Towers see G.L. Barrow, *The round towers of Ireland* (Dublin 1979) and B. Lalor, *The Irish round tower* (Cork 1999).

2 For their dating see M. Herity, 'The Antiquity of *an Turas* (the Pilgrimage Round) in Ireland', in A. Lehner & W. Berschin (eds), *Lateinische kultur im VIII jahrhundert* (St Ottilien 1989), pp. 95–143.

3 P. Harbison, 'Early Irish churches', in H. Löwe (ed.), *Die Iren und Europe im früheren Mittelalter* (Stuttgart 1982), pp. 618–29.

4 M. Hare with A. Hamlin, 'The study of early church architecture in Ireland: an Anglo-Saxon viewpoint, with an appendix on documentary evidence for Round Towers', in L.A.S. Butler & R.K. Morris (eds), *The Anglo-Saxon church. Papers on history, architecture and archaeology in honour of Dr H.M. Taylor* (London 1986), pp. 131–45.

5 F.E. Warren, *The liturgy and ritual of the Celtic Church* (Oxford 1881), pp. 85–8; Radford, 'The earliest Irish churches', p. 1; A. Hamlin, 'The study of early Irish churches', in P. Ní Chatháin & M. Richter (eds), *Irland und Europa: die kirche im frühmittelalter/Ireland and Europe: the early church* (Stuttgart 1984), pp. 117–26, at p. 118.

6 C. Manning, 'References to church buildings in the annals', in A. Smyth (ed.), *Seanchas. Studies in early and medieval Irish archaeology, history and literature in honour of Francis J. Byrne* (Dublin 2000), pp. 37–52, at Table 1.

7 The Church Island (Valentia) example is still the classic site (M.J. O'Kelly, 'Church Island, near Valentia, Co. Kerry', *PRIA*, lix (1959), pp. 57–136).

8 S. Connolly & J.–M. Picard, 'Cogitosus: Life of Saint Brigit', *JRSAI*, cxvii (1987), pp. 5–27, at pp. 25–6. One hestitates to add a sceptical note to the interpretation of this most famous of passages but, given that we would disbelieve that the miracles described and attributed to Brigit by Cogitosus actually took place in the 'real' world, should we not apply the same critical faculties in reading the description of the church? Did Cogitosus describe a building he knew, or did he create the Kildare church as described from an assortment of buildings, some of which he had only heard about or read about?

9 R. Gem, 'Towards an iconography of Anglo-Saxon architecture', *JWCI*, xlvi (1983), pp. 1–18.

10 H.J. Lawlor, *St Bernard of Clairvaux's life of St Malachy of Armagh* (London and New York 1920), p. 32.

11 D. Kelly, 'The heart of the matter: models for Irish High Crosses', *JRSAI*, cxxi (1991), pp. 105–45.

12 R. Stalley, 'The Romanesque sculpture of Tuam', in A. Borg & A. Martindale (eds), *The vanishing past* (Oxford 1981), pp. 179–95, and 'The mason and the metalworker', lecture, Romanesque Sculpture symposium, Trinity College Dublin (13 May 1995); T. O'Keeffe, 'Diarmait Mac Murchada and Romanesque Leinster: four twelfth-century churches in context', *JRSAI*, cxxvii (1997), pp. 52–79, at p. 70.

13 P. Harbison, 'The Clones sarcophagus – a unique Romanesque style monument', *AI* xiii, no. 49 (1999), pp. 12–16.

14 M. Herren, *The Hisperica-Famina 1. The A-Text* (Toronto 1974).

15 Harbison, 'Early Irish churches'; N. Brady, 'De Oratorio: Hisperica Famina and church building', *Peritia* xi (1997), pp. 327–35. For a discussion along the lines presented here see T. O'Keeffe, 'Form and content in pre-Romanesque architecture in Ireland', *ESTMA*, iv (Seville 2001), pp. 65–83.

16 See M. Smyth, *Understanding the universe in seventh-century Ireland* (Woodbridge 1996), passim, but esp. p. 115.

17 A good parallel is provided by John Scottus Eriugena's poem, *Aulae Sidereae*, written for the dedication of Charles the Bald's new church at Compiègne, in which the structure of the church is clearly described as a Christological metaphor; see M. Foussard, 'Aulae Siderae: vers de Jean Scot au Roi Charles', *Cahiers Archéologiques*, xxi (1971), pp. 79–88.

18 Hamlin, 'Study of early Irish churches', p. 118.

19 Manning, 'References to church buildings'.

20 C. Manning, 'Clonmacnoise Cathedral', in H.A. King (ed.), *Clonmacnoise studies*, I (Dublin 1994), pp. 57–86, at p. 60.

21 H.G. Leask, *Fore, County Westmeath* (Dublin, no date), pp. 4–5.

22 For the view that Gallarus represents a stylistic cul-de-sac see O'Keeffe, 'Architectural traditions', p. 114. See, however, V. Fauler, 'The "Glattjoch-chapel in honour of St. Virgil" – an Irish oratory in Austria/central Europe?', *JKAHS*, XXVII (1994), pp. 126–33.

23 Their use and most appropriate translations have been discussed by Manning 'References to church buildings'; see also C. Thomas, 'Early medieval Munster: thoughts upon its primary Christian phase', in M.A. Monk & J. Sheehan (eds), *Early medieval Munster* (Cork 1998), pp. 9–16.

24 'Reiclés in the Irish annals to AD1200', *Peritia*, xiii (1999), pp. 259–75.

25 C. Doherty, 'The basilica in early Ireland', *Peritia*, iii (1984), pp. 303–15.

26 See A. Grabar, *Matryrium*. 2 vols (Paris 1946) for the context.

27 M. Herity, 'The forms of the tomb-shrine of the founder saint in Ireland', in R.M. Spearman & J. Higgitt (eds), *The age of migrating ideas* (Stroud 1993), pp. 188–95.

28 R. Berger, '14C dating mortar in Ireland', *Radiocarbon*, xxxiv (1992), pp. 880–9.

29 O'Keeffe, 'Architectural traditions'.

30 Leask, *Irish churches and monastic buildings* I, p. 56.

31 T. O'Keeffe, 'La façade romane en Irlande', *CCM*, xxxiv (1991), pp. 357–65, at p. 359. Of special interest is the wooden church excavated at Rivenhall, where a single posthole suggested some sort of west-end annexe of the same width of the church, while foundation trenches at the east end of the nave suggested antae overlapping the walls of the chancel (W. J. Rodwell & K.A. Rodwell, *Rivenhall: investigation of a villa, church and village, 1950–1977* (London 1986), pp. 85–90).

32 C. Manning, *Early Irish monasteries* (Dublin 1995), p. 15.

33 C. Thomas, *The early christian archaeology of North Britain* (Oxford 1971), pp. 141–2.

34 This is not the appropriate place in which to discuss the early history of the parish in Ireland and the parochial status of pre-Romanesque churches, but it would be perverse to deny that most of the (non-tomb-) churches of the early middle ages served pastoral needs. Their size might not, of course, reflect the sizes of the populations which they served. On the contrary, if we reconceptualize the early medieval Irish church as an 'open-air church' with a focal sanctuary in which the priest performs some of his liturgical functions in relative privacy, the size of the areas immediately outside the actual buildings may be more reliable guides to population sizes.

35 For these proportional systems see E. Fernie, 'Historical metrology and architectural history', *Art H*, i (1978), pp. 383–99, and 'A beginner's guide to the study of architectural proportions and systems of length', in E. Fernie & P. Crossley (eds), *Medieval architecture and its intellectual context* (London 1990), pp. 229–238, and N. Coldstream, *Masons and sculptors* (London 1991), pp. 37–8. These proportions could be achieved by the simple practical method of laying out a square and extending it to a rectangle by using the length of the diagonal of that square (for $1:\sqrt{2}$) or of half the square (for the Golden Section) as the length of the rectangle.

36 Hamlin, 'Study of early Irish churches', p. 119.

37 Manning, 'References to church buildings', p. 40.

38 Kenney, *Sources for the early history of Ireland*, p. 11.

39 Petrie, *The eclesiastical architecture of Ireland*, p. 440. Radford, 'Earliest Irish churches', p. 4. Hamlin, 'Study of early Irish churches', p. 119.

40 A. Klukas, *Altaria Superiora: the function and significance of the tribune-chapel in Anglo-Norman Romanesque* (Ann Arbor 1978), p. 21, attributes the medieval west porch with its upper altars, whether at Monkwearmouth or in later churches, to Bede's exegesis of the Book of Kings.

41 T. O'Keeffe, 'The Romanesque portal at Clonfert Cathedral and its iconography', in C. Bourke (ed.), *From the isles of the north* (Belfast 1995), pp. 261–9, at pp. 267–8.

42 For a bibliography see R. Stalley, 'Sex, symbol, and myth: some observations on the Irish Round Towers', in C. Hourihane (ed.), *From Ireland coming. Irish art from the early Christian to the late Gothic period and its European context* (Princeton 2001), pp. 27–48, at p. 43 n. 1. The principal modern works are Barrow, *round towers of Ireland* and Lalor, *The Irish round tower*.

43 AU.

44 Lalor, *The Irish round tower*, pp. 166–266.

45 O'Keeffe, 'Architectural traditions', p. 121. For a slightly different view of chronology see E. Rynne 'The Round Towers of Ireland: a review article', *NMAJ*, xxii (1980), pp. 27–32, at p. 28, where it is claimed that a significant number of the extant towers date from the twelfth century; Stalley adds that this view is 'generally agreed' ('Sex, symbol, and myth', p. 30).

46 C. Bourke, 'Early Irish hand-bells', *JRSAI*, cx (1980), pp. 52–66.

47 In the late eighteenth century 'pieces of oak' were recorded inside the tower at Ardmore, as were channels cut through the door cill to allow a ringer, standing outside the tower, to ring the bells (Stalley, 'Sex, symbol, and myth', p. 46 n. 60). However, these might not have been survivals from the twelfth century, as there was work carried out at the site in the seventeenth century.

48 Ibid., pp. 40–2.

49 Lalor, *The Irish round tower*, pp. 166–266.

50 Manning, *Clonmacnoise*, p. 25: 'The high doorways in these towers would have served as defensive features'.

51 The view that people killed inside towers were hiding there still persists, even among scholars who disregard the defensive function: Stalley ('Sex, symbol, and myth', p. 30, emphasis added) offers the view that 'they were certainly regarded as a good place to *hide*'.

52 AU; AFM.

53 Walter Horn made such a suggestion on the basis of the evidence of the Carolingian-era Plan of St Gall (W. Horn & E. Born, *The plan of St Gall* I (Berkeley 1979), pp. 129, 166; Stalley describes this, unfairly I think, as a 'red herring' ('Sex, symbol, and myth', p. 29).

54 A. Kehnel, *Clonmacnoise – the church and lands of St Ciaran. Change and continuity in an Irish monastic foundation (6th to 16th Century)* (Münster 1997), p. 152.

55 *Ireland's round towers: buildings, rituals and landscapes of the early Irish church* (Stroud 2003).

56 M. Audovy, B. Dix & D. Parsons, 'The tower of All Saints' Church, Earls Barton, Northampton-shire: its construction and context', *Arch J*, clii (1995), pp. 73–94.

57 A. Williams, 'A bell-house and a burh-geat: lordly residences in England before the Norman conquest', in C. Harper-Bill & R. Harvey (eds), *Medieval knighthood*, IV (Woodbridge 1992), pp. 221–40, at 233–4; see also D. Renn, '*Burgheat* and *gonfanon*: two sidelights from the Bayeux Tapestry', *ANS*, xvi (1994), pp. 177–98.

58 The search for origins presupposes that the first towers looked like those which stand today; such an assumption – which is not an unreasonable one – underpins the oft-stated argument for a Mediterranean origin, as suggested originally by Stokes, *Early Christian architecture in Ireland* (see also H. McDonnell, 'Margaret Stokes and the Irish Round Tower: a reappraisal', *UJA*, lvii (1994), pp. 40–50) and revived using new data by Peter Harbison, *Pilgrimage in Ireland: the monuments and the people* (London and Syracuse 1992), p. 170. Stalley, reiterating the likelihood of a relationship with the Italian campaniles ('Sex, symbol, and myth', p. 30) but pointing out some problems with Italy as a place of origin (ibid., p. 44 n. 25), makes the same assumption. If the first towers were indeed tall, free-standing structures such as those we see today, an origin north of Alps,

in Carolingian architecture of the ninth century and in the tenth-century Ottonian architecture of Lotharingia, might make more sense. See my *Ireland's round towers*, for a discussion of possible indigenous elements in the conceptual genealogy of the towers.

59 See O'Keeffe, 'Architectural traditions', Fig. 12.4, for examples.

60 Berger. '14C dating mortar in Ireland', p. 172.

61 Round-arched church doorways without Romanesque devices like roll mouldings or imposts cannot be dated to before the eleventh century, if not the twelfth. One possible – and potentially very significant – exception is Teach Chiaráin at Clonmacnoise; the dating of this is contingent on the date of a cross-fragment which was built into it (but is now removed); see Manning 'Clonmacnoise Cathedral', pp. 76–7.

62 CS s.a. 1120; C. Manning, 'The date of the Round Tower at Clonmacnoise', *AI,* xi, 2 (1997), pp. 12–13.

63 The stones below the doorway are also a different colour-tone, but this is actually a result of differential cleaning.

64 For Glendalough in general see R. Cochrane, 'The ecclesiastical remains at Glendalough, Co. Wicklow', Appendix E, *Eightieth report of the commissioners of the public works in Ireland* (Dublin 1912), H.G. Leask, *Glendalough, Co. Wicklow* (Dublin n.d.), and G. Mettjes, *Frühmittelalterliche klöster in Irland. Studien zu baugeschichtlichen problemen am beispiel der ruinen von Glendalough* (Frankfurt 1977).

65 The only other examples I know are Inchbofin on Lough Ree and Inchagoill on Lough Corrib; for these sites see respectively H.S. Crawford, 'The churches and monuments of Inis Bó Fine, county Westmeath', *JRSAI,* clvii (1917), pp. 139–52, and J. Fahey, 'The shrines of Inis-an-Ghoill, Lough Corrib', *JRSAI,* 31 (1901), pp. 236–45.

66 See O'Keeffe, 'Architectural traditions', Fig. 12.4c, d.

67 P. Rahtz, *Glastonbury* (London 1993), pp. 77–9.

68 D. Parsons, 'Sacrarium: ablution drains in early medieval churches', in L.A.S. Butler & R.K. Morris (eds), *The Anglo-Saxon church. Papers on history, architecture and archaeology in honour of Dr H.M. Taylor* (London 1986), pp. 105–20, at pp. 106–7.

69 T. O'Keeffe, 'The church and castle at Confey, Co. Kildare', *JKAS,* xvi (1987), pp. 108–18.

70 Similar stones are preserved in the fabric of the nave of Glendalough Cathedral.

71 The largest of the Oughtmama churches is another example from the far side of the country.

72 See, in this context, the so-called Fishermen's Chapel in Jersey, a small pointed barrel-vaulted building, dated by Warwick Rodwell to between the second quarter of the eleventh century and the mid or late twelfth century: *The Fishermen's chapel, Saint Brelade, Jersey* (Saint Brelade/ Stroud 1990), p. 99.

73 R. Gem, 'St Flannán's church at Killaloe and the beginnings of Romanesque architecture in Ireland', lecture, *Reform and renewal: Ireland and Europe in the twelfth century* conference, Cork, 13 October 2001.

74 *Irish art in the Romanesque period*, p. 150.

75 M. Herity, 'The forms of the tomb-shrine'.

76 AU; Leask, *Irish churches and monastic buildings* I, p. 33.

77 Berger. '14C dating mortar in Ireland', p. 282.

78 P. Harbison, 'St Doulagh's Church', *Studies* 71, pp. 27–42, at p. 33.

79 The pre-removal investigations are recorded in R.A.S. Macalister, 'On some excavations recently conducted on Friar's Island, Killaloe', *JRSAI,* lix (1929), pp. 16–24, and H.G. Leask, 'Further notes on the church', *JRSAI,* lix, 25–8; the clarifications of the building's history is recorded in H.G. Leask, 'The church of St Lua, or St Molua, Friar's Island, Co. Tipperary, near Killaloe. Further notes', *JRSAI,* lx (1930), pp. 130–6.

80 P. Harbison, 'The double-armed cross on the church gable at Killinaboy, Co. Clare', *NMAJ,* xviii (1976), pp. 7–12.

81 See O'Keeffe, 'Architectural traditions', Fig. 12.4. For Killeenemer see T. O'Keeffe, 'Killeenemer Church and its archaeological importance', *Ogham: Ballindangan and district review* 4 (1998),

pp. 23–5. Peter Harbison describes an irregularly-curved monolithic arch with a cross-in-panel above a band of defaced decoration, on the west doorway of the small church at Fallmore on the Mullet Peninsula ('A crucifixion plaque in stone', *AI*, ix, no. 32 (1995), pp. 11–12). Although the monolithic arch separates this rather remote example from the others, stylistically if not also chronologically, the principle is the same.

82 D. Waterman & A. Hamlin, 'Banagher Church, Co. Derry', *UJA*, xxxix (1976), pp. 25–41. At Templemartin, at the far end of the country, is a not-dissimilar, but entirely unrelated, portal with a recessed architrave and what seems to be a roll border facing outwards on the edge of the door opening (see J. Cuppage, *Archaeological survey of the Dingle peninsula* (Ballyferriter 1986), pp. 277–8).

83 Harbison suggests it is Christ's tomb ('The Romanesque passion lintel at Raphoe, Co. Donegal', in A. Bernelle (ed.), *Decantation. A tribute in honour of Maurice Craig* (Dublin 1992), pp. 73–9, at p. 74).

84 F. Henry, *Irish art during the Viking invasions (800–1020 A.D.)* (London 1967), p. 189; P. Harbison, 'The biblical iconography of Irish Romanesque architectural sculpture', in C. Bourke (ed.), *From the isles of the north* (Belfast 1995), pp. 271–80.

85 See W.R. Wilde, 'Memoir of Gabriel Beranger, and his labours in the cause of Irish art, literature, and antiquities, from 1760 to 1780, with illustrations', *JRSAI*, xi (1870), pp. 33–64.

86 *Irish art in the Romanesque period*, p. 183. This is the Giving of the Law to Peter, in which Christ hands over the Law – actually the New Covenant, in contradistinction to the Old Covenant – to St Peter. In art it is often associated with the *traditio clavium*, Christ giving the keys of Heaven to Peter.

87 There is very little chevron in northern Ireland: see Waterman & Hamlin, 'Banagher Church', p. 39 n. 8. Indeed, there is very little non-figural Romanesque decoration of any description in that region: period churches remain at Inishmacsaint and White Island, the latter having a portal of the end of the 1100s, but we have lost the 'great church' of Flaithbertach Ó Brolcháin from 1164 at Derry (AU), and there are only tantalizing fragments from Devinish (see Stalley, 'In search of Romanesque sculpture') to go along with its Round Tower which has a cornice, decorated with beads, discs, and heads with interlaced beards, high ears and curling hair. Apropos of figural sculpture, it is not inconceivable that *some* of the sculpture from the northern part of Ireland, as at Armagh most obviously, which has been identified as Iron Age (see E. Rynne, 'Celtic stone idols in Ireland', in C. Thomas (ed.), *The Iron Age in the Irish sea province* (London 1972), pp. 79–98), is actually twelfth century.

88 Henry wondered if Maghera might be later eleventh century in date and she suggested a date in the late 800s or early 900s for Raphoe (*Irish art during the Viking invasions*, p. 189). Waterman and Hamlin suggested a date in the first half of the twelfth century for Maghera ('Banagher Church', p. 34); A. Hamlin & R.G. Haworth, 'A Crucifixion plaque reprovenanced', *JRSAI*, cxii (1982), pp. 112–16, also supported a twelfth-century date for Maghera but their argument here relied on the contentious dating of bronze crucifixion plaques to the 1100s; see now R. Johnson, 'Irish crucifixion plaques – Viking or Romanesque', *JRSAI*, cxxviii (1998), pp. 95–106, for a convincing argument for an earlier date for the plaques. The most recent statements place both works in the twelfth century: see especially S. McNab, 'The Romanesque figure sculpture at Maghera, Co. Derry and Raphoe, Co. Donegal', in J. Fenlon, N. Figgis & C. Marshall (eds), *New perspectives. Studies in art history in honour of Anne Crookshank*, (Dublin 1987), pp. 19–33. Peter Harbison ('The Romanesque passion lintel at Raphoe', p. 77) suggests a date for Raphoe in the third quarter of the twelfth century. Returning briefly to the Romanesque lintels without figure sculpture, it might be noted here that Banagher is also in the northern half of Ireland, and that Aghowle, although located in Leinster, belonged within the federation of monasteries associated with St Finnian, and rivalled Clonard for seniority within that federation (O'Keeffe, 'Diarmait Mac Murchada and Romanesque Leinster', p. 54).

89 S. McNab, 'Styles used in twelfth century Irish figure sculpture', *Peritia*, vi–vii (1987–8), pp. 265–97, at p. 274.

90 *Irish art during the Viking invasions*, pp. 188–9.

91 The decoration at Donaghmore is unquestionably of the Irish Romanesque tradition, although the traditional architraved form survives underneath the Romanesque decoration. Donaghmore compares favourably with the entrance into the Round Tower at Brechin which also had Romanesque details (see E. Fernie, 'Early church architecture in Scotland', *PSAS*, cxvi (1986), pp. 393–412, at Fig.5).

92 *Irish art during the Viking invasions*, p. 189; the evidence for the door uprights is not at all clear, particularly on the more incomplete of the two stones. It is also identified as a lintel in B. Lacy (ed.), *Archaeological survey of County Donegal* (Lifford 1983), p. 284 and by Harbison, 'The Romanesque passion lintel at Raphoe'.

93 Ibid.

94 S. McNab, 'Romanesque figure sculpture at Maghera and Raphoe', p. 30.

95 Dulane is worth mentioning here: simple roll mouldings on the jambs suggest that this church, ostensibly pre-Romanesque, suggest that this portal might be included within the group of northern twelfth-century lintels, even though it lacks figural sculpture. Its relative proximity to Donaghmore (Meath) and Dunshaughlin might also be noted.

96 Ibid., p. 33 n. 20.

97 F. Salet, 'St-Paul-lés-Dax', *Congrès archéologique,* cii (1939), pp. 372–9. It is worth noting that Henri Focillon compared the individual panels here to pre-Romanesque metopes, temple friezes and sarcophagus panels, and thus characterized them as a continuation of a 'tradition ancienne' (*L'Art des sculpteurs romanes* (Paris 1964), p. 121). I suggested elsewhere the possibility that 'the greater, direct, external influence on the built-environment of pre-Norman Christianity in north-eastern Ireland had actually come – and was known in the twelfth century to have come – from the south, from France and the Mediterranean, rather than from England amd northern Continental Europe: Mediterranean architectural forms may have been deployed in Armagh in the seventh century, as they had been in Kildare, and it is not inconceivable that southern French influence is reflected in the conception and iconography of the Maghera and Raphoe lintels' ('Romanesque as metaphor', p. 317).

CHAPTER 3: HIBERNO-SCANDINAVIAN AND CISTERCIAN ROMANESQUES

1 Fuglesang *Some aspects of the ringerike style*, p. 22.

2 English Romanesque art Urnes is represented but it is used for isolated motifs (S.H. Fuglesang, 'The relationship between Scandinavian and English Art from the late eight to the mid-twelfth century', in P.E. Szarmach (ed.) *Sources of Anglo-Saxon culture* (Kalamazoo 1986), pp. 203–42, at 236, 238) in much the same way as Ringerike is used in Ireland; indeed it has even been suggested that the Urnes style reached England from Ireland: L. Stone *Sculpture in Britain. The middle ages* (London 1972), p. 67.

3 The most up-to-date account of the architecture is R. Stalley, 'The construction of the medieval cathedral, *c.*1030–1250', in K. Milne (ed.), *Christ Church Cathedral, Dublin. A history* (Dublin 2000), pp. 53–74; a less substantial history which differs in some interpretations is T. O'Keeffe, 'Architecture and regular life in Holy Trinity Cathedral, 1150–1350', in S. Kinsella (ed.), *Augustinians at Christ Church: the canons regular of the cathedral priory of Holy Trinity, Dublin* (Dublin 2000), pp. 23–40. For the sculpture see R. Stalley, 'The medieval sculpture of Christ Church Cathedral, Dublin', *Arch,* cvi (1979), pp. 107–22. For the restoration see G.E. Street & E. Seymour, *The cathedral of the Holy Trinity, commonly called Christ Church Cathedral, Dublin: an account of the restoration of the fabric* (London 1882), and R. Stalley (ed.), *George Edmund Street and the restoration of Christ Church Cathedral* (Dublin 1997).

4 T. Drew, 'Street as a restorer – the discoveries at Christ Church Cathedral', *DUR* (June 1886), pp. 518–31.

5 D.M. Waterman, 'Somersetshire and other foreign building stone in medieval Ireland, *c*.1175–1400', *UJA* xxxiii (1970), pp. 63–75, at p. 71.

6 The record of this is preserved in a late fourteenth or early fifteenth-century source: see A. Gwynn, 'Some unpublished texts from the Black Book of Christ Church, Dublin', *AH*, xvi (1949), pp. 281–337, at p. 309.

7 The attribution of this work to Cumin was originally made by Street and Seymour, *Cathedral of the Holy Trinity*, p. 109; now see Stalley, 'Construction of the cathedral', esp. pp. 61–2.

8 The width of a bay in the Gothic nave determined demonstrably the proportions of its elevations, and so the influence of the crypt extended not just to the Romanesque transepts but to the determination of the actual height of the Gothic rib vaults (see O'Keeffe, 'Architecture and regular life').

9 Kinsella, 'From Hiberno-Norse to Anglo-Norman', pp. 27–31.

10 Ibid., pp. 28–31.

11 Could this chapel have been the now-destroyed church of St Michael le Pole, located immediately south-west of Dublin Castle? This church is famous for having had a Round Tower attached to its west end, a feature suggestive of a twelfth-century, possibly even eleventh-century, date; excavations indictated a construction date 'around the twelfth century' (M. Gowen, 'Excavations at the site of the church and tower of St Michael le Pole, Dublin', in S. Duffy (ed.), *Medieval Dublin II* (Dublin 2001), pp. 13–52, at p. 28.). While the Round Tower certainly raises the exciting possibility of some form of royal patronage, as we saw above, it also suggests patronage which is native, Gaelic-Irish, rather than Hiberno-Scandinavian. Moreover, St Michael le Pole's location in the southern suburb of the city is not consistent with it belonging to a Hiberno-Scandinavian royal palace complex.

12 Stalley, 'Construction of the medieval cathedral', pp. 55–6.

13 A. Gwynn, 'Some unpublished texts from the Black Book of Christ Church, Dublin', *AH*, xvi (1946), pp. 281–337, at p. 333.

14 Reported by H.B. Clarke, 'Conversion, church and cathedral: the diocese of Dublin to 1152', in J. Kelly & D. Keogh (eds). *History of the catholic diocese of Dublin* (Dublin 2000), pp. 19–50, at p. 48 n. 205.

15 Stalley, 'Construction of the medieval cathedral', p. 66. For Winchester see Fernie, *Norman England*, pp. 117–21. The crypt plan here is fairly unique, although there were other *échelon* plans in Norman England *c*.1100, as at Durham and Peterborough, while geographically close to Winchester itself there were *échelon* east ends associated with right-angled ambulatories at Romsey and probably also Old Sarum.

16 Stalley, 'Construction of the medieval cathedral', pp. 66–7. Stuart Kinsella, by contrast, follows Aubrey Gwynn in attributing the crypt to Gilla Pátraic, bishop from 1074 to 1084 ('From Hiberno-Norse to Anglo-Norman', p. 36).

17 For the historical dimension see F. Barlow, *The English church, 1066–1154* (London & New York 1992), pp. 22, 45–6, and J. Barrow, 'A Lotharingian in Hereford: Bishop Robert's reorganization of the church of Hereford 1079–1095', in D. Whitehead (ed.), *Medieval art, architecture and archaeology at Hereford* (Leeds 1995), pp. 29–49; for the architecture see Fernie, *Norman England*, esp. pp. 235–6. Polygonal or three-sided apses arranged *en échelon* in Lotharingia include, for example, the Utrecht churches of Saints Paul, Johann and Peter, and St Georg in Cologne: see H.E. Kubach & A. Verbeek, *Romanische baukunst an Rhein und Maas.* 3 vols (Berlin 1976), passim, for Lotharingia in general.

18 Christ Church certainly had relics worthy of veneration, some of them having been brought back from Rome in the early twelfth century. Its principal relics were a fragment of the True Cross and the *Bacall Iosa*, the Staff of Jesus (see M.V. Ronan, 'St Patrick's staff and Christ Church', *DHR*, v (1942–3), pp. 121–9, and J. Lydon, 'Introduction', in *Account roll of the priory of the Holy Trinity* (ed. J. Mills), reprinted Dublin 1996).

19 Unfortunately, medieval Waterford Cathedral itself was destroyed in 1773, and only a few medieval fragments remain. Both a plan of 1739, and a near-contemporary painting in the Bishop's Palace, Kilkenny, suggest a building not entirely unlike Limerick Cathedral (see below, pp. 204–5) and

probably of the same general *c.*1200 date: at least three bays at the west end of the church were defined by square piers, an adjacent fourth bay within the choir was defined on its east side by somewhat cruciform piers, and there was no triforium between the arcade and the round-arched clerestorey windows. An undated eighteenth-century drawing of the cathedral's south-east aspect shows a simply-elaborated south portal. This is probably Romanesque though it should be noted that from the undated drawing the west jamb appears to have been 'banded', which is a thirteenth-century feature. The most comprehensive published work on the medieval incarnation of this important building is R. Stalley, 'Three Irish buildings with West Country origins', in N. Coldstream & P. Draper (eds), *Medieval art and architecture at Wells and Glastonbury* (Leeds 1981), pp. 62–80, at 66–71.

20 M.F. Hurley & S.W.J. McCutcheon, 'St Peter's church and graveyard', in M.F. Hurley & O.M. B. Scully (with S.W.J. McCutcheon), *Late Viking and medieval Waterford: excavations 1986–1992* (Waterford 1997), pp. 198–205, and B. Murtagh, 'The architecture of St Peter's church', in ibid., pp. 228–243.

21 Hurley & Scully, 'St Peter's church and graveyard', pl. 16.

22 Parsons, 'Sacrarium: ablution drains in early medieval churches'.

23 The width of the nave is equal to twice the internal length of the apse; the internal length of the apse is equal to the distance between the west wall of the apse and the sacrarium.

24 M. Thurlby, *The Herefordshire school of Romanesque sculpture* (Logaston 1999), chapter 4.

25 C.F. Davidson, 'Change and change back: the development of English parish church chancels', in R.N. Swanson (ed.), *Continuity and change in Christian worship* (Woodbridge 1999), pp. 65–77, at p. 67.

26 Hurley & Scully, 'St Peter's church and graveyard', p. 200.

27 M. Biddle, 'Excavations at Winchester, 1971, 10th and final interim report', *Ant J,* lv (1975), pp. 295–337, at 312–15.

28 Stalley, 'Sculptured stone', in Hurley & Scully, *Late Viking and medieval Waterford*, pp. 400–3, at p. 403.

29 Gwynn & Hadcock, *Medieval religious houses: Ireland*, pp. 153–6.

30 Actually the remains of this are incorporated in the church at Marlfield, near the original site, and include a fine late Romanesque doorway.

31 W. Horn, 'On the origins of the medieval cloister', *Gesta,* xii (1973), pp. 13–52.

32 Preston, 'The canons regular of St Augustine', pp. 27–8. For a depiction of it in ruined condition in the seventeenth century (by Robert Bartlett) see National Library of Ireland MS 2656, III, reproduced in N. Edwards, *The archaeology of early Medieval Ireland* (London 1990), Fig. 51. If this depiction is accurate, this was a triple-aisled church, with a triple arch separating the nave from the chancel, entrances on the west and north sides, and a small building, possibly a sacristy, projecting from the east end of the south wall. Even if accurate, none of this need be of early twelfth-century date. Improbably, the depiction suggests a building not unlike the later seventh-century Anglo-Saxon church of Reculver (see E. Fernie, *The architecture of the Anglo-Saxons* (London 1983), pp. 35–6), a Kentish minster church of appropriately Italianate design which was erected within two generations of the Augustine mission to bring Christianity back to England.

33 Its history and architecture are discussed below, pp. 235–6. The lack of alteration is easily explained: 'most Augustinian houses adopted the liturgical customs and practices of the local diocese, making minor adaptations for observances kept by the Order. [The] liturgical Use of an Augustinian church was scarcely distinguishable from "secular" Use' (J. Harper, *The forms and orders of Western liturgy from the tenth to the eighteenth century* (Oxford 1991), pp. 29–30).

34 Lawrence, *Medieval monasticism*, p. 148.

35 C. Waddell, 'The reform of the liturgy from a renaissance perspective', in R.L. Benson & G. Constable (eds), *Renaissance and renewal in the twelfth century,* (Oxford 1982), pp. 88–112, at 106.

36 Braunfels, *Monasteries of Western Europe*, p. 82.

37 R. Halsey, 'The earliest architecture of the Cistercians in England', in C. Norton & D. Park (eds), *Cistercian art and architecture in the British Isles* (Cambridge 1986), pp. 65–85.

38 K.–H. Esser, 'Les fouilles à Himmerod et le plan Bernardin', *Mélanges St Bernard* (Dijon 1953), 311–15.

39 M. Schapiro, 'On the aesthetic attitude in Romanesque art' [1947], in *Romanesque art. Selected papers* (New York 1977), pp. 1–27, at p. 6.

40 C. Brooke, 'St Bernard, the patrons and monastic planning', in C. Norton & D. Park (eds), *Cistercian art and architecture in the British Isles* (Cambridge 1986), pp. 12–20, at p. 19.

41 Ibid., p. 21.

42 C.H. Talbot, 'The Cistercian attitude toward art: the literary evidence', in C. Norton & D. Park (eds), *Cistercian art and architecture in the British Isles* (Cambridge 1986), pp. 56–64, at p. 60.

43 H.V. Beuer-Szlechter, 'Les débuts de l'art Cistercian en Irlande d'après les vestiges des abbayes de Mellifont (Louth) et de Baltinglass (Wicklow)', *CCC*, xxi (1970), pp. 201–18.

44 See B.W. O'Dwyer, *The conspiracy of Mellifont, 1216–1231: an episode in the history of the Cistercian order in medieval Ireland* (Dublin 1970). A tightly organized pan-national organization, the Cistercian Order had a central bureaucracy, the General Chapter, and it was sufficiently concerned about rumoured abuses within Mellifont and its affiliates that it arranged a visitation in 1216. Mellifont shut its gates against the visiting party, and violence erupted when other monasteries were visited. Subsequent visitations provoked similar responses. Not until the late 1228, when Stephen of Lexington led a visitation, was some order restored, with the Mellifont affiliation dismantled, English monasteries newly granted mother-house status for Irish monasteries, Gaelic-Irish abbots suspended from holding office for three years, nuns (the cause of 'indecent disorder'!) barred, and French and Latin installed as the working languages of Cistercian business. Ethnic tensions lay at the root of many of the problems, just as they had back in the 1140s when Robert of Clairvaux and his French brethren felt compelled to abandon Mellifont within a few months of arriving. The Cistercian Order in Ireland represents Ireland's ethno-colonial history in microcosm.

45 R. Stalley, 'Decorating the lavabo: late Romanesque sculpture from Mellifont Abbey, *PRIA*, xcvi (1996), pp. 237–64.

46 *Cistercian monasteries of Ireland*, p. 81.

47 Ibid., pp. 84–7.

48 Ibid., pp. 79–80.

49 O'Keeffe, 'Diarmait Mac Murchada and Romanesque Leinster', pp. 71–7.

50 Stalley, *Cistercian monasteries*, p. 247; *Irish churches and monastic buildings* II, pp. 28–32.

51 This choice of position for the clerestorey windows was very common in Irish Cistercian houses, giving all them lower roofs than would be possible if the windows were above the arches, and denying them any pretence of bay-division.

52 Stalley, *Cistercian monasteries*, p. 243; *Irish churches and monastic buildings* II, pp. 32–5; 61–3; Kalkreuter, passim.

53 *Boyle Abbey and the school of the west*, pp. 63–4.

54 For the sequence see Stalley, *Cistercian monasteries*, pp. 87–91, and Kalkreuter, *Boyle Abbey*, passim.

55 *Irish churches and monastic buildings* II, pp. 53–76.

56 *Irish ecclesiastical architecture*, p. 145.

57 For critiques of 'transition' as concept, especially with respect to this period, see J. Bony, 'Introduction', *Studies in western art* I. *Acts of the twentieth international congress of the hsitory of art* (Princeton 1963), 81–4, and W. Sauerlander, 'Style or transition? The fallacies of classification discussed in the light of German architecture 1190–1260', *Arch Hist*, xxx (1987), pp. 1–29.

58 List is taken from her 'Appendix: Catalogue of Buildings' (*Boyle Abbey*, pp. 189–204). There are also smaller parish churches which could be included in a study of this topic, such as Kilronan and Noughaval, where one can see influence from Cong and Corcomroe respectively.

59 The exterior east end has 'quoin-colums' similar to those at Tuamgraney (p. 66), perhaps suggesting that Killaloe builders had worked on Tuamgraney a couple of decades earlier.

60 A master sculptor has been identified as the 'Ballintober master' by Peter Harbison, who has attributed the east window of Clonfert Cathedral to him ('The 'Ballintober master' and a date for the Clonfert Cathedral chancel', *JGAHS*, xxxv (1976), pp. 96–9).

NOTES TO PAGES 118–28 / 313

61 Stalley, *Cistercian monasteries*, pp. 186–7.
62 Ibid., p. 244.
63 R.A. Stalley & C.E. Nelson, 'Medieval naturalism and the botanical carvings at Corcomroe Abbey (county Clare), *Gesta* xxviii (1989), pp. 165–74.
64 Ibid., p. 240; *Irish churches and monastic buildings* II, pp. 37–9.
65 Stalley, *Cistercian monasteries*, pp. 248–9; *Irish churches and monastic buildings* II, pp. 35–8.
66 *Cistercian monasteries of Ireland*, p. 58.
67 See T. O'Keeffe, *Fethard, County Tipperary*, Irish Historic Towns Atlas Fascicle 13 (Dublin 2003), p. 1.

CHAPTER 4: BUILDING AUTHORITY IN SOUTHERN IRELAND: CASHEL IN THE EARLY TWELFTH-CENTURY

1 See, for example, D. Ó Cróinín, *Early medieval Ireland, 400–1200* (London 1995), p. 265.
2 Stalley, 'Three Irish buildings', p. 62.
3 See, for example, T.M. Charles-Edwards, *Early Christian Ireland* (Cambridge 2000), pp. 475, 481.
4 M. Dillon, 'The story of the finding of Cashel', *Ériu*, xvi (1952), pp. 61–73.
5 See Todd, *Cogadh Gaedhel re Gallaibh*, pp. 140–1.
6 It might be noted that Muirchertach may have maintained a house at Cashel after 1101: A. Candon, 'Barefaced effrontery: secular and ecclesiastical politics in early twelfth century Ireland', *SA* 14 (1991), pp. 1–25, at p. 9 (but see Ó Cróinín, *Early medieval Ireland*, p. 282 n. 38).
7 B. Hodkinson, 'Excavations at Cormac's Chapel, Cashel, 1992–1993: a preliminary statement', *THJ* (1994), pp. 167–74; P. Harbison, 'A High Cross base from the Rock of Cashel', *PRIA*, xciii (1993), pp. 1–20.
8 For summaries see Edwards, *The archaeology of early medieval Ireland*, pp. 22–7, and Ó Cróinín, *Early medieval Ireland*, pp. 71–4.
9 For Stephen see O'Dwyer, *The conspiracy of Mellifont*, p. 31. C. Doherty, 'The Vikings in Ireland: a review', in H.B. Clarke, M. Ní Mhaonaigh & R. Ó Floinn (eds), *Ireland and Scandinavia in the early Viking age* (Dublin 1998) pp. 288–330, at p. 329.
10 Flanagan, *Irish society, Anglo-Norman settlers*, pp. 202–7, esp. p. 203.
11 K. Simms, 'Native sources for Gaelic settlement: the house poems', in P.J. Duffy, D. Edwards & E. FitzPatrick (eds), *Gaelic Ireland. Land, lordship and settlement c.1250–c.1650* (Dublin 2001), pp. 246–67 at p. 250.
12 R. Stalley, 'The original site of St Patrick's cross, Cashel', *NMAJ*, xxvii (1985), pp. 8–10, and 'The Rock of Cashel (Tipperary)', *Arch J*, cliii (1996), pp. 308–14.
13 J. Bradley, 'The sarcophagus at Cormac's Chapel, Cashel', *NMAJ*, xxvi (1984), pp. 14–35.
14 For evidence that the cross was moved after the twelfth century see A. Lynch, 'Excavations at the base of St Patrick's cross, Cashel', *NMAJ*, xxv (1983), pp. 9–19.
15 'A labyrinth on the twelfth-century High Cross base on the Rock of Cashel, Co. Tipperary', *JRSAI*, cxxviii (1998), pp. 107–11.
16 Henry pointed out the comparison between the Lucca Christ and the representations of Christ on the High Crosses at Cashel, Monaincha and Roscrea (*Irish art in the Romanesque period*, pp. 127–8). For Lucca see E. Mâle, *Religious art in France*, pp. 253–7. For an example of an exact copy see the mid-twelfth-century Brunswick Cathedral crucifix, illustrated in V. Sekules, *Medieval art* (Oxford 2001), p. 69. The *Volto Santo* has been suggested as the model for the later Anglo-Saxon rood at Langford (D.T. Rice, 'The iconography of the Langford rood', in *Mélanges René Crozet*, I (Poitiers 1966), 169–172, at p. 170), though German comparanda (see the sources cited by Stone, *Sculpture in Britain*, p. 240 n. 30) may be pertinent for the English roods.
17 C. Manning, *Rock of Cashel, Co. Tipperary* (Dublin 2000), p. 34, suggests Muirchertach as builder.
18 AI.

19 Misc. Ir. Annals; Lawlor, *St Bernard of Clairvaux's Life of St Malachy*, p. 22; see also H.A. Jeffries, 'Desmond: the early years and the career of Cormac Mac Carthy', *JCAHS,* lxxxviii (1983), pp. 81–99; Ó Corráin, '*Caithréim Cellacháin Chaisil*: history or propaganda', p. 58; Gwynn, *The Irish church, eleventh and twelfth centuries*, p. 207.

20 C. Ó Cuileannáin, 'The Dublin Annals of Innisfallen', in S. Pender, *Féilscríbhinn Tórna* (Cork 1947), pp. 183–202. For *The Book of McCarthy* see MIA.

21 For example, AT; AFM; AI; MIA.

22 Lecture, 'Architecture and ideology: the architecture and decoration of Cormac's Chapel at Cashel', *Reform and renewal: Ireland and Europe in the twelfth century* conference, Cashel 14 October 2001.

23 This was argued by McNeill, 'The affinities of Irish Romanesque architecture', and later again by Leask, *Irish churches and monastic buildings* I, p. 114.

24 Stalley, *Cistercian monasteries*, p. 40.

25 P. Breathnach, *Die Regensburger Schottenlegende: Libellus de fundacione ecclesiae Consecrati Petri* (Munich 1977), and 'The origins of the Irish monastic tradition at Ratisbon (Regensburg)', *Celtica* xiii (1980), pp. 58–77. For the necrologies see D. Ó Riain-Raedel, 'Irish kings and bishops in the memoria of the German Schlottenklöster', in Ní Chatháin & M. Richter (eds), *Irland und Europa: die kirche im frühmittelalter / Ireland and Europe: the early church* (Stuttgart 1984), 390–404. See also N. Bulst, 'Irisches Mönchtum und cluniazensische Klosterreform', in H. Löwe (ed.) *Die Iren und Europe im früheren Mittelalter* (Stuttgart 1982), pp. 958–69.

26 F.J. Byrne, *Irish kings and high-kings* (Dublin 1973; reprinted Dublin 2002), p. 191; Ó Corráin, '*Caithréim Cellacháin Chaisil*', p. 69.

27 Fernie, *Norman England*, p. 233.

28 T. O'Keeffe, 'Lismore and Cashel: reflections on the beginnings of the Irish Romanesque', *JRSAI,* cxxiv (1994), pp. 118–50, at p. 120, at p. 141.

29 For *doppelkappelen* in general see Kubach, *Romanesque architecture*, pp. 366, 378. The literature on the Bishop's Chapel at Hereford and its context is considerable: see, for example, R. Gem, 'The Bishop's Chapel at Hereford: the roles of patron and craftsman', in S. Macready & F.H. Thompson (eds), *Art and patronage in the English Romanesque* (London 1986), 87–96, and H. Böker, 'The Bishop's Chapel at Hereford Cathedral and the question of architectural copies in the middle ages', *Gesta,* xxxvii (1998), pp. 44–54.

30 Fernie, *Norman England*, pp. 236–42.

31 J. Sheehan, 'A bronze bell-crest from the Rock of Cashel, Co. Tipperary', *NMAJ,* xxx (1988), pp. 3–13.

32 J. Bradley, 'Killaloe: a pre-Norman borough', *Peritia* viii (1994), pp. 170–9.

33 For example, when king Toirrdelbach Ua Briain's wife died at Killaloe in 1076 she was brought to the island for burial (AI; AT). R.A.S. Macalister, 'The history and antiquities of Inis Cealtra', *PRIA,* xxxiii (1936), pp. 93–174; L. de Paor, 'The history of the monastic site of Inis Cealtra, Co. Clare', *NMAJ,* xxxvii (1996), pp. 21–33.

34 AI; AFM.

35 Hughes, *The church in early Irish society*, p. 244.

36 CS s.a. 1059; A. Clon. 169, 178.

37 For 1118 see AT.

38 Fernie, *Norman England*, pp. 276–7.

39 Michael Herity ('The layout of Irish early Christian monasteries', in P. Ní Chatháin & M. Richter (eds), *Irland und Europa: die kirche im Frühmittelalter/Ireland and Europe: the early church* (Stuttgart 1984), pp. 105–16, especially 108–9) has remarked that the *platea* is 'so widespread that it seems to have been established at an early stage, if not with the coming of Christianity'.

40 Roger Stalley ('The original site of St Patrick's cross') identified the cross as being associated with the cathedral, whereas here it is suggested that it was associated with Cormac's Chapel; he also described the cross's original site as being 'somewhere in the area of the crossing and the western

choir of the later cathedral', locating it on the site plan in almost the same position as is suggested here.

41 If Herity's 'The layout of Irish early Christian monasteries' nailed the myth that the elements of early Irish monasteries were arranged haphazardly, this evidence nails another myth, which is that Cistercian architecture introduced a 'complex geometry and order of space not previously witnessed in Irish ecclesiastical architecture' (C. Corlett, 'Boyle Abbey – order and space', *AI*, xii, no. 45 (1998), p. 17.

42 R. Samson, 'Carolingian palaces and the poverty of ideology', in R. Samson (ed.), *The social archaeology of houses* (Edinburgh 1990), pp. 99–131.

43 'Solving a mystery at Cashel: the Romanesque painting in Cormac's Chapel', *IAR*, xviii (2001), pp. 25–9.

44 For Lismore see pp. 167–71 below.

45 Before the conservation work revealed the full complexity of the painted images Gerald Crotty argued ('A Romanesque fresco in Cormac's Chapel', *THJ* (1988), pp. 155–8), that Solomon and Sheba were represented. We can probably forget Sheba: the Ardmore sculpture shows us that Solomon can be represented on his own.

46 See Connolly & Picard, 'Cogitosus: Life of Saint Brigit'.

47 H.G. Leask & R.A.S. Macalister, 'Liathmore-Mochoemog (Leigh), County Tipperary', *PRIA*, li (1948), pp. 1–14.

48 For an early published survey see A. Hill, *Monograph on Kilmalkedar* (Cork 1870). A similar feature was suggested at the east end of the originally-unicameral church of Dungiven, but it is now suggested that in the twelfth century the east window of this church was flanked by blind arcading similar to that at Cashel: see Waterman & Hamlin, 'Banagher church', p.34.

49 It seems unlikely that it was left in this condition when the new chancel was built; instead, its back (east) wall was probably removed so that it formed a short tunnel between the nave and chancel, and it frayed with the passage of time

50 *Irish churches and monastic buildings* I, p. 116.

51 Inside the chapel, the southernmost capital and arch-ring of the chancel arch are cut across by the east end of the nave wall, and one would imagine that had the builder designed the present plan of the chapel at the outset he would have found a better solution to the problem of having a lateral wall converge on a multi-ordered chancel arch. On the exterior south side of the chapel there is irregularity in the coursing one metre above ground level and immediately west of the tower on the wall of the nave; Malcolm Thurlby noted this irregularity (as well as another, less convincing, irregularity on the west jamb of the north portal, behind where there would once have been a column) and dismissed it as an example of the sort of the coursing irregularities common in coeval medieval fabric ('The Romanesque priory church of St Michael at Ewenny', *SAHJ*, xlvii (1988), pp. 281–94, at p. 228 n. 24.) There are two other irregularities: the string courses on the lower stages of the south tower are continuous with those of the chancel and altar projection, but the lower string on the south wall of the nave is at a different level, and the string-course at the impost level of the second register on the south wall of the nave starts a metre along the nave wall from its return with the south tower.

52 'Cormac's Chapel', p. 142.

53 *Irish ecclesiastical architecture*, pp. 116, 121.

54 McNeill, The affinities of Irish Romanesque architecture'; Leask, *Irish churches and monastic buildings* I, p. 114.

55 *Irish art in the Romanesque period*, pp. 169–75.

56 De Paor, 'Cormac's Chapel', p. 142.

57 'Three Irish buildings with West Country origins', pp. 62–5.

58 It is appropriate to note here that R. Ó Floinn, 'Innovation and conservatism in Irish metalwork', pp. 272–5, sees parallels for the cast appliqué figures on St Machan's shrine in Herefordshire sculpture (including Kilpeck), and observes that a thirteenth-century relic list in

Leominster included the relics of no less than twelve Irish saints. It might also be noted that on the twelfth-century Breac Maodhóg shrine there is a plant scroll beside David the Harpist which can be paralleled on *ex situ* capitals at Glastonbury and on the tympanum at Kilpeck.

59 See, for example, Henry, *Irish art in the Romanesque period*, p. 171; P. Harbison, 'Twelfth- and thirteenth-century stonemasons in Regensburg (Bavaria) and the end of the 'School of the West' in Connacht', *Studies* lxiv (1975), pp. 333–46, at p. 345 n. 2 & 4. For slighly later material see H. Brakspear, 'A west country school of masons', *Arch*, lxxxi (1931), pp. 1–18.

60 'Three Irish buildings with West Country origins', pp. 62, 64.

61 For Rochester see R. Gem, 'The significance of the eleventh-century rebuilding of Christchurch and St Augustine's, Canterbury', in N. Coldstream & P. Draper (eds), *Medieval art and architecture at Canterbury before 1200* (Leeds 1982), pp. 1–19, at 11–12. R. Gem 'The first Romanesque Cathedral at Old Salisbury', in E. Fernie & P.Crossley (eds), *Medieval architecture and its intellectual context. Studies in honour of Peter Kidson* (London 1990), pp. 9–18; a plan of Old Sarum prepared by Montgomerie during the excavation of the site shortly before 1914 leaves open the question of the apse's interior (ibid., pl. 1).

62 R. Stroebel, 'St. Jakob zu Regensberg. Architektur und Geschichte', *Romanik in Regensberg. Kunst-geschichte-denkmalpflege* (Regensburg 1997), pp. 147–53. For a brief comment on St James's and its context in German Benedictine architecture see G. Binding & M. Untermann, *Kleine kunstgeschichte der mittelalterlichen ordensbaukunst in Deutschland* (Darmstadt 2001), esp. pp. 145–8, and for the context of its towers see A. Fink, *Romanische klosterkirchen des heiligen bischofs Otto von Bamberg (1102–1139): Studien zu bauherr und architektur* (Petersberg 2001), pp. 187–90.

63 *Irish ecclesiastical architecture*, p. 121. For Exeter see M. Thurlby, 'The Romanesque cathedral of St Mary and St Peter at Exeter', in F. Kelly (ed.), *Medieval art and architecture at Exeter Cathedral* (Leeds 1991), pp. 13–34.

64 For the towers see A.W. Clapham, *English Romanesque architecture after the Conquest* (Oxford 1934), p. 61, and N. Pevsner & P. Metcalf, *The cathedrals of England: midland, eastern and northern England* (London 1985), p. 158.

65 R. Gem, 'The first Romanesque Cathedral at Old Salisbury', p. 19.

66 *English Romanesque architecture after the conquest*, p. 12; for the contrary view see Gem 'The first Romanesque Cathedral at Old Salisbury', p. 12.

67 Fernie, *Norman England*, pp. 264–8.

68 J. Bony, *French Gothic architecture of the 12th and 13th centuries* (Berkeley 1983), Fig. 12.

69 X. Barral I Altet, X, *The early middle ages. From late antiquity to A.D. 1000* (Köln 1997), pp. 194–209.

70 *Irish art in the Romanesque period*, p. 172; note that she misreads the orientation of Kenneth Conant's cross-section of this church (*Carolingian and Romanesque achitecture*, Fig. 125A) and confuses the choir for the nave.

71 Timber barrel vaults are also not unknown, as at St Peter's, Rowlstone, Herefordshire (see M.F. Hearn and M. Thurlby, 'Previously undetected wooden ribbed vaults in British medieval architecture', *JBAA*, cl (1997), pp. 48–58, 54–5).

72 U. Bangert, A. Czuchra, W. Dilthey, B. Laule, M. Mannewitz & H. Wischermann, *Die romanische kirchenbaukunst der Normandie: ein entwicklungsgeschichtliches Versuch* (Freiburg-im-Breisgau 1982).

73 C. Wilson, 'Abbot Serlo's church at Gloucester, 1089–1100: its place in Romanesque architecture', in T.A. Heslop & V. Sekules (eds), *Medieval art and architecture at Gloucester and Tewkesbury*, British Archaeological Association Conference Transactions (Leeds 1985), pp. 52–83.

74 The Pershore evidence is unequivocal; Gloucester and Tewkesbury require detective work and a sympathetic mind. See J.P. McAleer, 'The Romanesque transept and choir elevation of Tewkesbury and Pershore', *AB*, lxiv (1982), pp. 549–58; Thurlby, 'St Mary at Tewkesbury and St Peter at Gloucester'; Wilson, 'Abbot Serlo's church at Gloucester, 1089–1100'; M. Thurlby, 'The abbey church, Pershore: an architectural history', *TWAS*, 3rd ser. xv (1996), pp. 147–210. A barrel

vault over Chichester Cathedral has also been suggested (M. Andrew, 'Chichester Cathedral: the problem of the Romanesque choir vault', *JBAA,* cxxxv (1982), pp. 11–22).

75 See R. Halsey, 'Tewkesbury Abbey: some recent observations', in T.A. Heslop & V. Sekules (eds), *Medieval art and architecture at Gloucester and Tewkesbury,* British Archaeological Association Conference Transactions (Leeds 1985), pp. 16–35 for a discussion of the giant order.

76 M. Thurlby, 'The Romanesque priory church of St Michael at Ewenny', *JSAH,* xlvii (1988), pp. 281–94. Stalley, 'Three Irish buildings', was the first to draw attention to the comparison with Cormac's Chapel.

77 It might be noted here that crypt chapels beneath transepts in the little-studied Christchurch in Dorset were barrel-vaulted with rib-vaulted apses.

78 C.A.R. Radford, *Ewenny Priory* (London 1976), offers a rather complicated structural history for the building, isolating several phases of building activity, but Thurlby argued instead that the church is of one period, regardless of apparent irregularities in the coursing.

79 The evidence is that the supports of the outer orders of the crossing arches are recessed into the western transept walls.

80 In this respect Ewenny is less typical than Cashel within an English Romanesque context. Rather, it compares well with some contemporary (1120s) Norman work, such as the Chapter House at Jumièges and the choir at Evreux, as described by J. Bony, 'Diagonality and centrality in early rib-vaulted architectures', *Gesta* xv (1976), pp. 15–25, at p. 18.

81 J. Bony, 'La technique Normande du mur épais', *BM,* xcviii (1939), pp. 153–88.

82 We might reconstruct Cashel's exemplar as having an elevation in which a cornice or string-course at the wall-head separates the triforium from the vault, as has been reconstructed by McAleer ('The Romanesque transept and choir elevation') at Tewkesbury.

83 J.F. King, 'Possible West Country influences on twelfth-century architecture and its decoration in Normandy before 1150', *JBAA,* cxxxix (1986), pp. 22–39, identified Old Sarum as the crucial building in understanding connections between England and Normandy in the twelfth century

84 For the rosettes see R. Stalley, 'A twelfth century patron of architecture: a study of the buildings erected by Roger, Bishop of Salisbury', *JBAA,* 3rd ser. xxxiv (1971), pp. 62–83, at pl. xix, 3. The trefoil-shaped shafts at Cashel are missing from the north portal, but see Stalley, 'The Rock of Cashel', p. 310, for the observation that they can be paralleled at Old Sarum.

85 Fernie, *Norman England,* p. 41.

CHAPTER 5: FROM ARDFERT TO ARDMORE: THE ROMANESQUE CENTURY IN MUNSTER

1 J. Bradley & H. King, 'Romanesque voussoirs in Cormac's Chapel, Cashel', *JRSAI,* cxv (1985), pp. 146–51.

2 We might note that central Munster is missing from this list, and that it is also fairly empty in Fig. 5, suggesting that potential patrons in central and south-western Cork turned a blind eye to the attractions of the new architecture. This distributional void would certainly repay closer study.

3 S. Sanderlin, 'The monastery of Lismore, 636–1111', in W. Nolan & P. Power (eds), *Waterford: history and society* (Dublin 1992), pp. 27–48, esp. 27, 34; P. O'Dwyer, *Célí Dé. Spiritual reform in Ireland, 750–900* (Dublin 1981), p. 176.

4 See O'Keeffe, 'Lismore and Cashel', pp. 120–1 and pp. 148–9, for references for what follows.

5 Ibid., colour pl. 1.

6 For Henry II's stay in Lismore see F.X. Martin, 'Allies and an overlord, 1169–72', in A. Cosgrove (ed.), *A new history of Ireland.* Vol. ii *Medieval Ireland, 1169–1534* (Oxford 1987), pp. 67–97, at p. 89; Stalley, 'Solving a mystery at Cashel'.

7 R.A.S. Macalister, 'The Lismore corbel', *JRSAI,* cxviii (1938), pp. 298–300; see also F. Henry, 'Figure in Lismore Cathedral', *JRSAI,* cxvii (1937), pp. 306–7.

8 E. Okasha & K. Forsyth, *Early Christian inscriptions of Munster: a corpus of inscribed stones* (Cork 2001), pp. 347–51, at p. 348.

9 I originally suggested that it was a caryatid ('Lismore and Cashel', p. 123) but now think that a less likely identification.

10 Lord Killanin & M. Duignan, *The shell guide to Ireland* (London 1967), p. 357; W.H. Grattan Flood ('St Carthage of Lismore', *JWSEIAS*, iv (1898), pp. 228–37, at p. 235) identified its location as the field on the left of the avenue leading towards the castle.

11 I know of only one entrance to an ecclesiastical enclosure in Ireland which had a gate embellished with Romanesque sculptural detail – Inchcleraun. This seems to have been two-ordered, the outer order having small arris lozenges and the inner a small roll flanked by pellets on both sides; the latter may, judging by *ex situ* fragments preserved in the sacristy of the Augustinian church on the island, have supported an arch with human heads at intervals. My thanks to Dr Harman Murtagh for bringing me to see the island in 1996.

12 It seems almost pointless to list examples, but to support the point anyway one might look at the windows in the west façade of Rochester Cathedral (Kent), the tower arch in St Peter's in Northampton (Northamptonshire), or the niches flanking the west portal at Chepstow (Monmouthshire).

13 Examples, again chosen randomly, include Stanley St Leonard (Gloucestershire), Dinton (Buckinghamshire), and Wisset (Suffolk).

14 C. Smith, *Ancient and present state of the county and city of Waterford* (Dublin 1746), p. 53.

15 For Kilmolash see P. Power, 'Ancient ruined churches of Co. Waterford', *JWSEIAS*, iv (1898), pp. 89–91, at pp. 90–1; for Coole see P. Power, 'The churches of Coole', *JRSAI*, xcix (1919), pp. 47–54, and P.E.W. Waters, 'Coole', *JCHAS*, xxxii (1927), pp. 52–3. The Romanesque elements are discussed in O'Keeffe, 'Lismore and Cashel', pp. 129–34.

16 Leask, *Irish churches and monastic buildings* I, pp. 124–6; see also de Paor, 'Cormac's Chapel', pp. 134–5, and Henry, *Irish art in the Romanesque period*, p. 176.

17 T.W. Lyman, 'L'intégration du portail dans la façade méridionale', *CStMC*, viii (1977), pp. 55–68.

18 The exception is T. O'Keeffe, 'La façade romane en Irlande', *CCM*, xxxiv (1991), pp. 357–65.

19 In fact, Ardfert's origin within Romanesque traditions outside Ireland is difficult to pin down: the detailing is largely of English Romanesque type, but five-bay façades are so rare in English Romanesque contexts – Lindisfarne priory church is the only one – that its format can hardly have come from there. Is it possible that we are seeing French influence here, with, say, the five-bay façade of St-Paul-de-Varax as a possible parallel? And is it significant that two features of the Ardfert façade – the diaper work in the flanking bays and the spiralling on a half-column – can be paralleled in France at, for example, Echellais in the case of the former and the Abbaye-aux-Dames in Saintes for the latter?

20 Leask, *Irish churches and monastic buildings* I, p. 104; Stalley, 'A twelfth century patron of architecture', p. 79.

21 See O'Keeffe, 'Lismore and Cashel', pp. 143–9 for references.

22 A parallel of sorts is the small, undated but presumably pre-Romanesque, church on Saint MacDara's Island, where the antae do not stop at the wall head but rise up the sloping sides of the gables, all the time maintaining their width.

23 MIA.

24 E. Rynne, 'Evidence for a tympanum at Aghadoe, Co. Kerry', *NMAJ*, xxix (1987), pp. 3–6.

25 It has been dated elsewhere to a later stage in the twelfth century and attributed to Bishop Domnall Ó Connairche who died in 1193 (C. Toal, *North Kerry archaeological survey* (Dingle 1995), p. 251), but his kinsman, Bishop Gille Críost, bishop and papal legate from 1152 to 1179, would be a better candidate.

26 The inscribed stone in question has been identified as a twelfth-century voussoir: Okasha & Forsyth, *Early Christian inscriptions of Munster*, pp. 133–6.

27 Henry & Zarnecki, 'Romanesque arches'.

28 T. Garton, 'Masks and monsters: some recurring themes in Irish Romanesque sculpture', in C. Hourihane (ed.), *From Ireland coming. Irish art from the early Christian to the late Gothic period and its European context* (Princeton 2001), pp. 121–40, at p. 130.

29 See K. Watson, *French Romanesque and Islam* (Oxford 1989).

30 A. O'Sullivan & J. Sheehan, *The Iveragh peninsula. An archaeological survey of South Kerry* (Cork 1996), pp. 316–22.

31 Ibid., Pl. 80.

32 'A Romanesque doorway at Killaloe', pp. 53–5.

33 Dysert O'Dea falls outside this date-bracket: Henry's dating of to 1125–35 (*Irish art in the Romanesque period*, p. 164 is surely incorrect, and nearer the truth is Garton's suggested mid-century date ('A Romanesque doorway at Killaloe', p. 56) or Stalley's suggested late century date ('Three Irish buildings', p. 77, n. 18).

34 L. de Paor, 'St Caimin's Inis Cealtra: reconstruction of the doorway', *NMAJ*, xxxvi (1995), pp. 87–103.

35 For the seventeenth-century work at this site see P. Harbison, 'Dysert O'Dea', *Arch J*, cliii (1996), pp. 335–8. See also his 'Two Romanesque carvings from Rath Blathmaic and Dysert O'Dea, Co. Clare', *NMAJ*, xxix (1987), pp. 7–11.

36 See, for example, P. Harbison, 'Some Romanesque heads from Co. Clare', *NMAJ*, xv (1972), pp. 3–7.

37 M. Clyne, 'Romanesque carvings at Killodiernan, Co. Tipperary', *NMAJ*, xxvii (1984), pp. 44–53.

38 This is now kept in the churchyard in Ballyconnell. See S. McNab, 'From Tomregan to Iniscealtra: Irish twelfth century sculpture', *IAR*, xiii (1997), pp. 32–34, for a discussion.

39 Garton, 'A Romanesque doorway at Killaloe'.

40 Leask, *Irish churches and monastic buildings* I, pp. 151–2; Henry, *Irish art in the Romanesque period*, p. 167.

41 'A Romanesque doorway at Killaloe', p. 53.

42 See Hewson, R.F. (1944) 'St Mary's Cathedral, Limerick. Its development and growth', *NMAJ*, iv 55–67, and L. Mulvin, 'St Mary's Cathedral, Limerick: unpublished correspondence on the cathedral restoration in the nineteenth century', *IADS*, iv (2001), pp. 179–219.

43 Stalley, 'Three Irish buildings', p. 78 n. 30.

43a I have followed Francis John Byrne's map of Ireland *c*.1169 (in A. Cosgrove (ed), *A new history of Ireland*. Vol. ii *Medieval Ireland 1169–1534* (Oxford 1987), Fig. 1) in describing this region as Ormond.

44 P. Power, 'The "Rian Bó Phádraig" (the ancient highway of the Decies)', *JRSAI*, xxxv (1905), pp. 110–29; Sanderlin, 'The monastery of Lismore', p. 92.

45 H.S. Crawford, 'Donaghmore church, Co. Tipperary', *JRSAI*, xxxix (1909), pp. 261–4.

46 An *ex situ* jambstone with a roll moulding and a U-shaped animal head with its tongue wrapped around the roll may originally have been part of the outer order; the only parallel for this motif on a jambstone is Temple Finghin at Clonmacnoise.

47 D. Sweetman, 'Archaeological excavations at Kilcash church, Co. Tipperary, *NMAJ*, xxvii (1984), pp. 36–43.

48 According to Killanin & Duignan (*Shell guide to Ireland*, p. 345) the late medieval tower over the chancel 'appears to be imposed on a stone-roofed chancel of earlier date' but there is no evidence to support this idea.

49 P. Harbison, 'Carved stones from the twelfth century predecessor of St Canice's Cathedral, *OKR*, i (1974), pp. 26–9.

50 J. Bradley, *Kilkenny*, Irish Historic Towns Atlas 10 (Dublin 2000), p. 1.

51 Macalister, *Corpus inscriptionum insularum Celticarum*, p. 24.

52 *Irish churches and monastic buildings* I, p. 155.

53 W. Carrigan, *The history and antiquities of the diocese of Ossory* (Dublin 1905), pp. 5–6. Mr Johnny Meagher, Windgap, Kilkenny, first brought this to my attention and kindly provided the photographs which are reproduced here.

54 Recent literature includes J.T. Smith, 'Ardmore Cathedral', *JRSAI,* cii (1972), pp. 1–13; S. McNab, 'The Romanesque sculptures of Ardmore Cathedral, Co. Waterford', *JRSAI,* cxvii (1987), pp. 50–68; T. O'Keeffe, 'Romanesque architecture and sculpture at Ardmore', in W. Nolan (ed.), *Waterford: history and society* Dublin 1992), 73–104; P. Harbison, 'Architectural sculpture from the twelfth century at Ardmore', *IAR,* xi (1995), pp. 96–102.

55 D. Ó Riain-Raedel, 'The question of the 'pre-Patrician' saints of Munster', in M.A. Monk & J. Sheehan (ed.), *Early medieval Munster* (Cork 1998), pp. 17–22.

56 R. Sharpe, *Medieval Irish saints' lives: an introduction to Vitae Sanctorum Hiberniae* (Oxford 1991). Gwynn & Hadcock, *Medieval religious houses: Ireland,* p. 62.

57 AI.

58 It is even possible that part of the missing frame of the southern lunette (discussed below) is incoporated in the haunches of the chancel arch.

59 This is the term used by Smith, 'Ardmore Cathedral'.

60 *Irish ecclesiastical architecture,* pp. 130, 153. This view was reiterated by Leask, *Irish churches and monastic buildings* I, pp. 164–5.

61 Smith, 'Ardmore Cathedral'; McNab, 'The Romanesque sculptures of Ardmore Cathedral'.

62 'Architectural sculpture from the twelfth century at Ardmore'. Harbison also offers the imaginative suggestion that the original iconographic programme centred on Solomon and the building of his temple.

63 This was first published in O'Keeffe, 'Romanesque architecture and sculpture at Ardmore'.

64 Forsyth concludes that 'Mary presided over the reception of the gifts ... as the Mother of the Saviour and as the Throne of Solomon' (I. Forsyth, *The throne of wisdom: wood sculpture of the Madonna in Romanesque France* (Princeton 1972), p. 59). Although she does not consider the lunettes to have been the original context in which the sculpture was displayed, McNab, citing Mâle (*Religious art in France*), recognizes that the images were placed together because the journey of the Magi 'was considered the successor of the visit of the Queen of Sheba to Solomon' ('The Romanesque sculptures of Ardmore Cathedral', p. 66).

65 See M.D. Costen & C. Oakes, *Romanesque churches of the Loire and Western France* (Stroud 2000), pp. 94–108.

66 Surprisingly, McNab makes no reference to Smith's attribution of the design to western France. Instead, she offers parallels for some individual elements of the architecture and sculpture; she compares, for example, the lunettes at Ardmore to arcading on the west wall of Fountains Abbey, and some of the sculptural motifs to Insular pre-Romanesque ones. Considering her analysis of Raphoe (see pp. 94–95 above), her thesis that the sculpture in the lunettes may originally have taken 'the form of frieze decoration as at Modena' suggests an over-eagerness to find Italian comparanda, if not connections, in Irish Romanesque work.

67 *Songs of glory* (Chicago 1976), pp. 44–5

68 Musset, *Angleterre Romane* I, p. 221.

69 Another church which may have had a scheme comparable with that at Ardmore is Ste-Radegonde in Poitiers. Camus has suggested that the *ex situ* sculpted slabs of tympanum shape which are preserved in the west tower were part of 'un assemblage d'au moins trois dalles de forme grossièrement arrondie, encastré dans le mur occidental du clocher entre l'arc d'entré et la cornice séparant le rez-de-chaussée du premier étage' (M.-T. Camus, 'Le personnage sous arcade dans la sculpture sur la dalle du Poitou roman: premières expériences', in A.C. Quintavalle (ed.) *Romanico padano, romanico europea: recueil d'études présentés lors du Convegno internazionale di studi du même nom* (Modene et Parme 1977), pp. 370–9, at p. 378). In addition to the formal comparanda of the settings for the sculpture, one could point to many French instances in which appear the iconographic motifs used in Ardmore: for example, a small Adam and Eve within a a D-shaped frame adorn the outer arch-ring of the west portal of St-Martin, Besse (Dordogne); an Adoration of the Magi with the enthroned virgin and child beneath an arch on the north side and each magus under his own arch to the south is found on the west

façade of Perse (Aveyron); the scheme is reversed on the west portal tympanum of Pompierre (Vosges), with the magus nearest the virgin depicted in half-kneeling profile.

70 O'Keeffe, *Medieval Ireland*, chapter 5, passim.

CHAPTER 6: THE POLITICS OF PATRONAGE AND THE ROMANESQUE DIFFUSION, 1140–1200

1 Aghacross was dismantled at the end of the middle ages and its stonework recycled mainly in a new, crudely-constructed, west end. See T. O'Keeffe, 'The Romanesque portal', in J. Monk, K. Hanley & M. Weaver (eds), *An archaeological survey of St Molagga's church, Aghacross, Mitchelstown, Co. Cork* (Cork 1995), pp. 24–7. Further material has turned up in conservation work at this site since 1995; my thanks to Judith Monk for this formation. For Ballyhea see Leask's illustration, *Irish churches and monastic buildings* I, Fig. 100.

2 For the intersection of the secular and sacred see Swanson, *The twelfth-century renaissance*, 89–93. On buildings and landscapes see, for example, R. Liddiard, *Landscapes of lordship. Norman castles and countryside in medieval Norfolk* (Oxford 2000), and L. Marten-Holden, 'Dominion in the landscape: early Norman Castles in Suffolk', *Hist Today* (April 2001), pp. 46–52.

3 For the relationships between patrons and builders see Stalley, *Early medieval architecture*, chapter 5. See P. Kidson, 'Panofsky, Suger and St Denis', *JWCI*, c (1987), pp. 1–17, is specifically about Suger and the debate surrounding his patronage at St Denis, but raises other issues.

4 For example, Máel Sechnaill Mór, king of Míde, purchased the *Eneclar* for the altar of Clonmacnoise in 1007 (CS s.a. 1005 [*recte* 1007]); it is later described as *cairrecan* of Solomon (AT 1129; CS s.a. 1125; AFM 1129). In 1115 Toirrdelbach Ua Conchobair donated to Clonmacnoise a drinking horn, a goblet and a paten of copper, all inlaid with gold (AT 1115; CS s.a. 1111). See Kehnel, *Clonmacnoise*, pp. 118, 128.

5 For the organization of the early medieval Irish Church see R. Sharpe, 'Some problems concerning the organization of the church in early medieval Ireland', *Peritia*, 3 (1984), pp. 230–70, and C. Etchingham, *Church organisation in Ireland, AD 650–1000* (Maynooth 1999).

6 See T. O'Keeffe, 'Diarmait Mac Murchada and Romanesque Leinster', for references to what follows.

7 The regnal list in the Book of Leinster indicates that he had already been king for six years prior to that.

8 For an account of this see F.X. Martin, 'Diarmait Mac Murchada and the coming of the Anglo-Normans', in A. Cosgrove (ed.), *A new history of Ireland*. Vol. ii *Medieval Ireland, 1169–1534* (Oxford 1987), pp. 43–66.

9 AU.

10 For the history of the site see E. Bhreathnach, 'Killeshin: an Irish monastery surveyed', *CMCS*, xxvii (1994), pp. 33–47, at pp. 45–6. For its architecture and sculpture see, most recently, O'Keeffe, 'Diarmait Mac Murchada and Romanesque Leinster', and R. Stalley, 'Hiberno-Romanesque and the sculpture of Killeshin', in P.G. Lane & W. Nolan (eds), *Laois: history and society* (Dublin 1999), pp. 89–122.

11 For a history of their transcription see O'Keeffe, 'Diarmait Mac Murchada'.

12 Cellachán has been identified as the mason, which seems reasonable (H.S. Crawford & H.G. Leask, 'Killeshin church and its Romanesque ornament', *JRSAI*, cv (1925), pp. 83–94, at p. 92).

13 Remains have been identified tentatively at the Anglo-Norman castle (P.D. Sweetman, 'Archaeological excavations at Ferns Castle, County Wexford', *PRIA*, lxxix (1979), pp. 217–45, at pp. 218, but these are not convincing: see T. O'Keeffe & M. Coughlan, 'The chronology and formal affinities of the Ferns *donjon*, Co. Wexford', in J. Kenyon & K.D. O'Conor (eds), *The medieval castle in Ireland and Wales* (Dublin 2003), pp. 133–48, at p. 135.

14 See R.P. Wilcox *Timber and iron reinforcements in early buildings* (London 1981) for the use of tie-rods in medieval buildings.

15 There is a Romanesque window in the south wall of St Peter's church in Ferns, which is an early post-medieval building. Its original provenance is claimed to be Clone (Leask, *Irish churches and monastic buildings* I, p. 163). The zig-zag decoration on the uprights of its rear-arch is more consistent with a source in Clone, where a doorway with similar decoration remains, than from St Mary's.

16 Henry incorrectly illustrated them as windows (*Irish art in the Romanesque period*, Fig. 27).

17 R. Cochrane, 'Ferns, Co. Wexford', *Seventy-eighth report of the commissioners of the public works in Ireland* (Dublin 1910).

18 The 'clouds' may indicate an Ascension iconography for this piece of sculpture, while the use of three disks in the composition of the image may represent the Trinity.

19 AFM 1163.

20 AT 1041

21 Leask & Crawford, 'Killeshin church and its Romanesque ornament'; O'Keeffe, 'Diarmait Mac Murchada'; Stalley, 'Hiberno-Romanesque and the sculpture of Killeshin'.

22 See below, pp. 246–8.

23 H.S. Crawford, 'Carvings from the doorway of Killeshin church, near Carlow', *JRSAI*, xcviii (1918), pp. 183–4.

24 It is worth noting that the Leinster genealogies which are preserved in the early twelfth-century codex Oxford, Bodleian Library, Rawlinson B 502, may have been compiled at Killeshin, even though the manuscript was actually written in Glendalough: see Bhreathnach, 'An Irish monastery surveyed', p. 43.

25 H.G. Leask, 'Carved stones discovered at Kilteel, Co. Kildare', *JRSAI*, cxv (1935), pp. 2–8.

26 C. Manning, 'Kilteel revisited', *JKAS*, xviii (1996–7), pp. 297–300.

27 I find Harbison's suggestion of elements of *David's battle with Goliath* in the lunettes at Ardmore ('Architectural sculpture from the twelfth century at Ardmore', pp. 97–8) unconvincing.

28 'Early Irish sculpture' p. 169.

29 H.M. Roe, 'The "David Cycle" in early Irish art', *JRSAI*, cxxix (1949), pp. 39–59, at pp. 47, 50; McNab, 'Styles used in twelfth century Irish figure sculpture', p. 270.

30 H.S. Crawford, 'The Round Tower and Castle of Timahoe, Queen's County', *JRSAI*, civ (1924), pp. 31–45.

31 O hIceadha, G. 'Excavation of a church site in Old Kilcullen townland, Co. Kildare', *JRSAI*, cxxi (1941), pp. 148–51.

32 *Irish art in the Romanesque period*, p. 183.

33 Hickey, H.M. 'A Romanesque arch and font at Wicklow', *JRSAI*, cii (1972), pp. 87–104.

34 Hore, P.H. *History of the town and county of Wexford*. Vol. 6 (London 1911), pp. 655–8.

35 Ibid., pp. 584–87.

36 *Irish churches and monastic buildings* I, p. 163

37 E. FitzPatrick & C. O'Brien, *The medieval churches of County Offaly* (Dublin 1998), chapter 2, lists and describes the major monuments in present-day Offaly, as well as Romanesque fragments at a number of other sites.

38 Leask, H.G. 'Monaincha church. Architectural notes', *JRSAI*, l (1920), pp. 24–35.

39 Okasha & Forsyth, *Early Christian inscriptions of Munster*, pp. 206–8.

40 'A Romanesque doorway at Killaloe'.

41 Kehnel, *Clonmanoise*, p. 151.

42 AU; AFM; CS s.a.1107.

43 CS s.a. 1113.

44 CS s.a. 1120.

45 AT; CS s.a. 1114.

46 AT.

47 AT; CS s.a. 1118; these were stolen along with a range of other objects, including a model of Solomon's Temple, in 1129 but were recovered a year later (AFM).

48 Kehnel, *Clonmanoise*, p. 154

49 AFM.

50 AFM; Manning, 'Clonmacnoise Cathedral', pp. 78–9.

51 There may even have been a new doorway built as part of the programme of work around the site, which included the roofing of the cathedral itself, begun by abbot Cormac Mac Cuinn na mBocht and completed by his successor, Flaithbertach Ó Loingsigh: A. Clon 1100; AFM 1104.

52 J. O'Donovan, 'The Registry of Clonmacnoise', in *JKSEIAA*, i (1856–7).

53 Ibid., pp. 478–9.

54 FitzPatrick & O'Brien suggest that one Finghin Mac Diarmata (†1208: AFM), scion of another family listed among the donors in the Registry, is 'likely' to be the patron (*The medieval churches of County Offaly*, p. 49), but this is unconvincing given the church's Mac Cárrthaigh associations.

55 CS s.a. 1013; A well at Clonmacnoise named 'Tiprait Finghin' is mentioned in 758 (AT 757); whereas the Munster anchorite was probably named Finian of the Carraige, this well's dedicatee could conceivably be Finian of Clonard, a church with which Clonmacnoise had close connections.

56 AI 900; AFM 895

57 O'Donovan, 'The Registry of Clonmacnoise', pp. 457–8.

58 Ibid., p. 448.

59 AFM.

60 Kehnel, Clonmacnoise, p. 155.

61 AFM; A. Clon; the abduction lasted a year (AFM)

62 Davies, O. (1948) 'The churches of county Cavan', *JRSAI*, lxxviii (1948), pp. 73–118, at 99–110.

63 P. Dubourg-Noves, 'Remarques sur les portails romans à fronton de l'ouest de la France', *CCM*, xvii (1974), pp. 25–39.

64 O'Keeffe, 'The Romanesque portal at Clonfert Cathedral', p. 264. For an earlier study of the portal see H.S. Crawford, 'The Romanesque doorway at Clonfert', *JRSAI*, xlii (1912), pp. 1–7.

65 *Angleterre Romane* I, p. 218

66 D. Kahn, 'The west doorway at Rochester Cathedral', in N. Stratford (ed.) *Romanesque and Gothic. Essays for George Zarnecki*, (Woodbridge 1987), pp. 129–34, at p. 132.

67 In his discussion of this Worcestershire group of portals James Bond has drawn attention to the use of blind arcading on church elevations in England, and among the examples he mentions is the west wall of Tewkesbury Abbey in Gloucestershire: 'Church and Parish in Norman Worcestershire', in J. Blair (ed.), *Minsters and parish churches. The local church in transition, 900–1200* (Oxford 1988), pp. 119–58, at 145–6. We should note that this portal type is not exclusively a Worcestershire phenomenon: there is another example at Dalmeny in southern Scotland: see L.E.M. Walker, 'Culture and contacts in the Scottish Romanesque', in T.R. Liszka & L.E.M. Walker (eds), *The North Sea world in the middle ages* (Dublin 2001), pp. 127–63, at 148–53. Thus Bond's suggestion that the design was 'almost certainly invented … in the Teme valley by an unknown builder who perhaps had a second- or third-hand knowledge of Spanish prototypes' (p. 147) should be treated with caution.

68 G. Zarnecki, *Later English Romanesque sculpture, 1140–1210* (London 1953), pp. 40–3.

69 *Irish art in the Romanesque period*, p. 162.

70 J. Adhémar, *Influences antiques dans l'art du moyen age Française* (London 1939), passim.

71 H. Richardson & J. Scarry, *An introduction to Irish high crosses* (Cork 1990), pp. 24–6.

72 C. Heitz, 'The iconography of architectural form', in L.A.S. Butler and R.K. Morris (eds), *The Anglo-Saxon church. Papers on history, architecture and archaeology in honour of Dr H.M. Taylor* (London 1986), pp. 90–100, at 96–7.

73 J. Gardelles, 'Recherches sur les origines des façades à étages d'arcatures des églises médiévales', *BM*, cxxxvi (1978), pp. 113–33.

CHAPTER 7: ROMANESQUE CONTEXTS AND MEANINGS: SOME REFLECTIONS

1 'Romanesque as metaphor'. J. Puig Y Cadalfalch, *Le premier art Romane: l'architecture en catalogne et dans l'occident Méditerranéen aux dixième et onzième siècles* (Paris 1928), and *La géographie et les origines du premier art Roman* (Paris 1935).

2 Lawlor, *St Bernard of Clairvaux's Life of St Malachy*, p. 41.

3 See F. Jameson, 'Architecture and the critique of ideology', in J. Oakman (ed.), *Architecture, criticism, ideology* (Princeton 1985), pp. 51–87, for an articulation of this view, and see his *The political unconsciousness: narrative as a socially symbolic act* (Ithaca 1981), passim, for a parallel discussion of how 'the political' is located in the form and content of literary works.

4 O'Keeffe, 'Romanesque and metaphor'.

5 Peter Harbison articulated a not unrelated idea when he suggested that native monasteries, fearing the affects of the new dioceses, consciously preserved in manuscript older traditions of law and learning, and promoted pilgrimage as a means of retaining lay contributions to their upkeep: 'Church reform and Irish monastic culture in the twelfth century', *GASJ*, lii (2000), pp. 1–12.

6 This, then, answers Roger Stalley's question: 'was the vogue for ornate doorways bound up with ecclesiastical politics?' ('Hiberno-Romanesque and the sculpture of Killeshin', at p. 117 n. 28).

7 Stalley, 'The Romanesque sculpture of Tuam'.

8 For an important critiques see E.A.R. Brown, 'The tyranny of a construct: feudalism and historians of medieval Europe', *AHR,* lxxix (1974), pp. 1063–88, and A. Guerreau, 'Fief, féodalité, féodalisme: enjeux sociaux et réflexion historienne', in *AESC* lxv (1990), pp. 137–66.

9 For important statements see D. Ó Córráin's *Ireland before the Normans* (Dublin 1972) and 'Aspects of early Irish history', in B.G. Scott (ed.), *Perspectives in Irish archaeology* (Belfast 1974), pp. 64–75.

10 Doherty, 'The Vikings in Ireland', at pp. 322–4.

11 J.H. Todd, *Cogadh Gaedhel re Gallaibh* (London 1867); A. Bugge (ed.), *Caithréim Cellachain Caisil* (Oslo 1905); for discussion see D. Ó Corráin, '*Caithréim Cellacháin Chaisil*: history or propaganda', *Ériu*, xxv (1974), pp. 1–69, and M.T. Flanagan, 'Irish and Anglo-Norman warfare in twelfth-century Ireland', in T. Bartlett & K. Jeffery (eds), *A military history of Ireland* (Cambridge 1996), pp. 52–75.

12 T. O'Keeffe, 'Rural settlement and cultural identity in Gaelic Ireland, 1000–1500', *Ruralia I* (Prague 1996), pp. 142–53.

13 C. Doherty, 'Settlement in early Ireland: a review', in T.B. Barry (ed.), *A history of settlement in Ireland* (London 2000), pp. 50–80.

14 See M. Stout, *The Irish ringfort* (Dublin 1997), Fig. 2.

15 J.J. O'Meara, *The first version of the topography of Ireland by Giraldus Cambrensis* (Dundalk 1951), p. 103.

16 H.G. Leask, *Irish castles and castellated houses*, 1st ed. (Dundalk 1941). For recent views of the archaeological evidence see B.J. Graham, 'Timber and earthwork fortifications in western Ireland', *MA* xxxii (1988), pp. 110–29; T. O'Keeffe, 'The fortifications of western Ireland, AD 1100–1300, and their interpretation', *JGAHS,* l (1998), pp. 184–200.

17 See T. O'Keeffe, *Castles in Britain and Ireland, AD 1050–1300* (London 2004), chapter 1.

18 For Ballinasloe see K. Nicholls, 'Anglo-French Ireland and after', *Peritia,* i (1982), pp. 370–403, at p. 389; for Dunmore see Graham, 'Timber and earthwork fortifications', p. 115.

19 See P. Gosling, 'Tuam', in A. Simms & J.H. Andrews (eds), *More Irish country towns* (Cork 1995), pp. 119–31, at p. 126; a fairly non-descript fragment of masonry in the town is commemorated as a part of this castle.

20 Interestingly, the Anglo-Normans retained Romanesque forms in some of their earliest stone castles in Ireland, even though their contemporary churches were frequently of early Gothic style; see T. O'Keeffe, 'Angevin lordship, colonial Romanesque: some castle halls and great towers

in Ireland, 1170–1220', in M. Thurlby (ed.), *Romanesque architecture in Great Britain and Ireland*, (Oxford forthcoming).

21 S. Reynolds, *Fiefs and vassals* (Oxford 1994), and *Kingdoms and communities in Western Europe, 1000–1300*, 2nd edition (Oxford 1997), pp. xi–lxvi; M. Chibnall, *The debate on the Norman conquest* (Manchester 1999), 79–96.

22 See, for example, D. Ó Cróinín, *Early medieval Ireland, 400–1200* (London 1995), chapter 10, and T. O'Keeffe, *Medieval Ireland*, chapters 1, 3.

23 J. Moreland, *Archaeology and text* (London 2001).

24 M.B. Schiffer & A.R. Miller, *The material life of human beings: artefacts, behaviour, and communication* (London 1999).

25 V.G. Childe, *Man makes himself* (London 1936).

26 M.A. Holly, *Panofsky and the foundations of art history* (Ithaca 1984), p. 24; emphasis added.

27 C.M. Radding & W.W. Clark, *Medieval architecture, medieval learning: builders and masters in the age of Romanesque or Gothic* (Yale 1992); E. Fernie & P. Crossley (eds), *Medieval architecture and its intellectual context. Studies in honour of Peter Kidson* (London 1990).

28 *Romanesque architectural criticism.*

29 For example, Stalley, *Early medieval architecture*, chapter 9: 'The Language of Architecture'.

30 'Culture studies proponents of all sorts contend that culture is … a region of serious contest and conflict over *meaning*': B. Agger, *Cultural studies as critical theory* (London 1992), p. 9 (emphasis added). See W. Cahn, 'Romanesque sculpture and the spectator', in D. Kahn (ed.), *The Romanesque frieze and its spectator* (London 1992), pp. 45–60 for a sensitive – though still mainly focused on literati – attempt to address the role of the spectator. For an interesting set of perspectives on the cultural meaning of 'the Gothic cathedral' as a type see V. Chieffo Raguin, K. Brush & P. Draper (eds), *Artistic integration in Gothic buildings* (Toronto 1995), esp. Brigette Bedos-Rezak, 'Towards a cultural biography of the Gothic cathedral: reflections on history and art history', pp. 262–74.

31 Given the particular popularity of structuralism in the 1960s it is appropriate to cite a contemporary work: W.G. Runciman, 'What is structuralism?', *BJS*, xx (1969), pp. 253–64.

Select bibliography

Bethell, D. 'English monks and Irish reform in the eleventh and twelfth centuries', *Hist. studies* viii (1971), pp. 111–35.

Beuer-Szlechter, H.V., 'Les débuts de l'art Cistercian en Irlande d'après les vestiges des abbayes de Mellifont (Louth) et de Baltinglass (Wicklow)', *CCC,* xxi (1970), pp. 201–18.

Bhreathnach, E. 'Killeshin: an Irish monastery surveyed', *CMCS,* xxvii (1994), pp. 33–47.

Bradley, J. 'The sarcophagus at Cormac's Chapel, Cashel', *NMAJ,* xxvi (1984), pp. 14–35.

—— 'Killaloe: a pre-Norman borough', *Peritia* viii (1994), pp. 170–9

Bradley, J. & H. King, 'Romanesque voussoirs in Cormac's Chapel, Cashel', *JRSAI,* cxv (1985), pp. 146–51.

Brakspear, H. 'A west country school of masons', *Archaeologia,* lxxxi (1931), pp. 1–18.

Breathnach, P. *Die Regensburger Schottenlegende: Libellus de fundacione ecclesiae Consecrati Petri* (Munich 1977).

—— 'The origins of the Irish monastic tradition at Ratisbon (Regensburg)', *Celtica* xiii (1980), pp. 58–77.

Candon, A. 'Barefaced effrontery: secular and ecclesiastical politics in early twelfth century Ireland', *Seanchas Ardmhacha,* xiv (1991), pp. 1–25.

Champneys, A. *Irish ecclesiastical architecture* (London 1910).

Clapham, A.W. *English Romanesque architecture after the conquest* (Oxford 1934).

—— *Romanesque architecture in western Europe* (Oxford 1936).

—— 'Some minor Irish cathedrals', *Arch J,* cvi (1952) *Supplement: memorial volume to Sir Alfred Clapham,* pp. 16–39.

Clyne, M. 'Romanesque carvings at Killodiernan, Co. Tipperary', *NMAJ,* xxvii (1984), 44–53.

Cochrane, R. 'The ecclesiastical remains at Glendalough, Co. Wicklow', Appendix E, *Eightieth report of the commissioners of the public works in Ireland* (Dublin 1912).

Conant, K.J. *Carolingian and Romanesque architecture, 800–1200* (revised edition, London 1978).

Connolly, S. & J.-M. Picard, 'Cogitosus: Life of Saint Brigit', *JRSAI,* cxvii (1987), pp. 5–27.

Crawford, H.S. 'Donaghmore church, Co. Tipperary', *JRSAI,* xxxix (1909), pp. 261–4.

—— 'The Romanesque doorway at Clonfert', *JRSAI,* xcii (1912), pp. 1–7.

Crawford, H.S. & H.G. Leask, 'Killeshin church and its Romanesque ornament', *JRSAI,* cv (1925), pp. 83–94.

Cronin, R. 'Late high crosses in Munster: tradition and novelty in twelfth-century Irish art', in M.A. Monk & J. Sheehan (eds), *Early medieval Munster. Archaeology, history and society* (Cork 1998), pp. 147–63.

Davies, O. 'The churches of county Cavan', *JRSAI,* lxxviii (1948), pp. 73–118.

De Paor, L. 'The limestone crosses of Clare and Aran', *GASJ,* xxvi (1955–6), pp. 53–71.

—— 'Cormac's Chapel: the beginnings of Irish Romanesque', in E. Rynne (ed.) *North Munster Studies* (Limerick 1967), pp. 133–45.

Doherty, C. 'The Vikings in Ireland: a review', in H.B. Clarke, M. Ní Mhaonaigh & R. Ó Floinn (eds), *Ireland and Scandinavia in the early Viking age* (Dublin 1998), pp. 288–330.

Dumville, D.N. *Councils and synods of the Gaelic early and central middle ages* (Cambridge 1997).

Edwards, N. *The archaeology of early medieval Ireland* (London 1990).

Etchingham, C. 'Episcopal hierarchy in Connacht and Tairdelbach Ua Conchobhair', *GASJ,* lii (2000), pp. 15–18.

FitzPatrick, E. & C. O'Brien, *The medieval churches of county Offaly* (Dublin 1998).

Fernie, E. *The architecture of Norman England* (Oxford 2000).

Flanagan, M.–T. *Irish society, Anglo-Norman settlers, Angevin kingship: interactions in Ireland in the late twelfth century* (Oxford 1989).

Fleming, J. *Gille of Limerick (c.1070–1145). Architect of a medieval church* (Dublin 2001).

Fuglesang, S.H. *Some aspects of the ringerike style* (Odense 1981).

—— 'Stylistic groups in late Viking and early Romanesque art', *AAAHP i* (1981) pp. 79–125.

Garton, T. 'A Romanesque doorway at Killaloe', *JBAA* 134 (1981), pp. 31–57.

—— 'Masks and monsters: some recurring themes in Irish Romanesque sculpture', in C. Hourihane (ed.), *From Ireland coming. Irish art from the early Christian to the late Gothic period and its European context* (Princeton 2001), pp. 121–40.

Gem, R. 'The first Romanesque Cathedral at Old Salisbury', in E. Fernie & P. Crossley (eds), *Medieval architecture and its intellectual context. Studies in honour of Peter Kidson* (London 1990), pp. 9–18.

Gwynn, A. *The Irish church in the eleventh and twelfth centuries* (Dublin 1992).

—— & N.D. Hadcock, *Medieval religious houses: Ireland* (London 1970).

Hamlin, A. 'The study of early Irish churches', in P. Ní Chatháin & M. Richter (eds), *Irland und Europa: Die kirche im frühmittelalter/Ireland and Europe: the early church* (Stuttgart 1984), pp. 117–26.

Harbison, P. 'How old is Gallarus Oratory?', *MA,* xiv (1970), pp. 34–59.

—— 'Twelfth- and thirteenth-century stonemasons in Regensburg (Bavaria) and the end of the 'School of the West' in Connacht', *Studies,* lxiv (1975), pp. 333–46.

—— 'The "Ballintober master" and a date for the Clonfert Cathedral chancel', *GASJ,* xxxv (1976), 96–9.

—— 'Early Irish churches', in H. Löwe (ed.), *Die Iren und Europe im früheren mittelalter* (Stuttgart 1982), pp. 618–29.

—— 'Two Romanesque carvings from Rath Blathmaic and Dysert O'Dea, Co. Clare', *NMAJ,* xxix (1987), pp. 7–11

—— 'The Romanesque passion lintel at Raphoe, Co. Donegal', in A. Bernelle (ed.), *Decantation. A tribute in honour of Maurice Craig* (Dublin 1992), pp. 73–9,

—— 'Architectural sculpture from the twelfth century at Ardmore', *IAR* xi (1995), pp. 96–102.

—— 'The biblical iconography of Irish Romanesque architectural sculpture', in C. Bourke (ed.), *From the isles of the north* (Belfast 1995), pp. 271–80.

—— 'Church reform and Irish monastic culture in the twelfth century', *GASJ*, lii (2000), pp. 1–12.

—— 'The otherness of Irish art', in C. Hourihane (ed.), *From Ireland coming. Irish art from the early Christian to the late Gothic period and its European context* (Princeton 2001), pp. 103–20.

Hare, M. with A. Hamlin, 'The study of early church architecture in Ireland: an Anglo-Saxon viewpoint, with an appendix on documentary evidence for Round Towers', in L.A.S. Butler & R.K. Morris (eds), *The Anglo-Saxon Church* (London 1986), pp. 131–45.

Haskins, C.H. *The Renaissance of the twelfth century* (Cambridge, Mass. 1927).

Henry, F. *Irish art in the Romanesque period (1020–1170 AD)* (London 1970).

Henry, F. & G.L. Marsh-Micheli, 'A century of Irish illumination', *PRIA,* lxii (1962), sect. C, pp. 101–64

Henry, F. & Zarnecki, G. (1957–8) 'Romanesque arches decorated with human and animal heads', *JBAA*, 3rd ser. 20–1, 1–34.

Herity, M. 'The forms of the tomb-shrine of the founder saint in Ireland', in R.M. Spearman & J. Higgitt (eds), *The age of migrating ideas* (Stroud 1993), pp. 188–95.

Hickey, H. 'A Romanesque arch and font at Wicklow', *JRSAI*, cii (1972), pp. 97–103.

Hodkinson, B. 'Excavations at Cormac's Chapel, Cashel, 1992–1993: a preliminary statement', *THJ* (1994), pp. 167–74.

Holland, M. 'Dublin and the reform of the Irish church in the eleventh and twelfth centuries' *Peritia*, xiv (2000), pp. 111–60,

—— 'The synod of Dublin in 1080', in S. Duffy (ed.), *Medieval Dublin III* (Dublin 2002), pp. 81–94.

Hurley, M.F. & S.W.J. McCutcheon, 'St Peter's church and graveyard', in M.F. Hurley & O.M.B. Scully (with S.W.J. McCutcheon), *Late Viking and medieval Waterford: excavations, 1986–1992* (Waterford 1997), pp. 198–205.

Kalkreuter, B. *Boyle Abbey and the school of the west* (Bray 2001).

Kehnel, A. *Clonmacnoise – the church and lands of St Ciaran. Change and continuity in an Irish monastic foundation (6th to 16th Century)* (Münster 1997).

Kenney, J.F. *The sources for the early history of Ireland: ecclesiastical. An introduction and guide* (New York 1929 [rev. 1966]).

Kinsella, S. 'From Hiberno-Norse to Anglo-Norman, c.1030–1300' in K. Milne (ed.), *Christ Church Cathedral, Dublin. A history* (Dublin 2000), pp. 25–52.

Lalor, B. *The Irish round tower* (Cork 1999).

Landes, R. 'The fear of the apocalyptic year 1000: Augustinian historiography, medieval and modern', *Speculum*, lxxv (2000), pp. 97–145.

Lawrence, C.H. *Medieval monasticism* (London 1984).

Leask, H.G. 'Monaincha church. Architectural notes', *JRSAI*, l (1920), pp. 24–35.

—— 'The church of St Lua, or St Molua, Friar's Island, Co. Tipperary, near Killaloe. Further notes', *JRSAI*, lx (1930), pp. 130–36.

—— 'Carved stones discovered at Kilteel, Co. Kildare', *JRSAI*, lxv (1935), pp. 2–8.

—— *Irish churches and monastic buildings*. I. *The early phases and the Romanesque* (Dundalk 1955).

—— *Irish churches and monastic buildings*. II *Gothic architecture to AD 1400* (Dundalk 1960).

Mac Shamhráin, A. *Church and polity in Pre-Norman Ireland: the case of Glendalough* (Maynooth 1996).

Macalister, R.A.S. *Corpus inscriptionum insularum Celticarum* (Dublin 1949).

Mâle, E. *Religious art in France: the twelfth century. A study of religious iconography* (Princeton 1978 [Paris 1953]).

Manning, C. *Clonmacnoise* (Dublin 1994).

—— 'Clonmacnoise Cathedral', in H.A. King (ed.), *Clonmacnoise studies*, I (Dublin 1994), pp. 57–86.

—— *Rock of Cashel, Co. Tipperary* (Dublin 2000).

—— 'References to church buildings in the annals', in A. Smyth (ed.), *Seanchas. Studies in early and medieval Irish archaeology, history and literature in honour of Francis J. Byrne* (Dublin 2000), pp. 37–52.

McAleer, J.P. 'The Romanesque transept and choir elevation of Tewkesbury and Pershore', *AB* lxiv (1982), pp. 549–58

McErlean, J. 'Synod of Ráith Breasail. Boundaries of the dioceses of Ireland', *Arch Hib,* iii (1914), pp. 1–33.

McNab, S. 'The Romanesque figure sculpture at Maghera, Co. Derry and Raphoe, Co. Donegal', in J. Fenlon, N. Figgis & C. Marshall (eds), *New perspectives. Studies in art history in honour of Anne Crookshank* (Dublin 1987), pp. 19–33.

—— 'The Romanesque sculptures of Ardmore Cathedral, Co. Waterford', *JRSAI,* cxvii (1987), pp. 50–68;

—— 'Styles used in twelfth century Irish figure sculpture', *Peritia,* vi–vii (1987–8), pp. 265–97.

—— 'Early Irish sculpture', *IAR,* vi (1990), pp. 164–71.

—— 'From Tomregan to Iniscealtra: Irish twelfth century sculpture', *IAR,* xiii (1997), pp. 32–4.

—— 'Celtic antecedents to the treatment of the human figure in early Irish art', in C. Hourihane (ed.) *From Ireland coming. Irish art from the early Christian to the late Gothic period and its European context* (Princeton 2001), pp. 161–82.

McNeill, C. 'The affinities of Irish Romanesque architecture', *JRSAI,* xlii (1912), pp. 140–7.

—— 'Monaincha, Co. Tipperary', *JRSAI,* l (1920), 19–24

Murtagh, B. 'The architecture of St Peter's church', in M.F. Hurley & S.W.J. McCutcheon, 'St Peter's church and graveyard', in M.F. Hurley & O.M.B. Scully (with S.W.J. McCutcheon), *Late Viking and medieval Waterford: Excavations, 1986–1992* (Waterford 1997), pp. 228–43.

Musset, L. *Angleterre Romane* I. *Le sud de l'Angleterre* (La Pierre-qui-Vire 1983, 1988).

Ó Corráin, D. 'Foreign connections and domestic politics: Killaloe and the Uí Briain in twelfth-century hagiography', in D. Whitelock, R. McKetterick & D. Dumville (eds), *Ireland in early medieval Europe: studies in memory of Kathleen Hughes* (Cambridge 1982), pp. 213–31.

Ó Cróinín, D. *Early medieval Ireland, 400–1200* (London 1995).

O'Dwyer, B.W. *The conspiracy of Mellifont, 1216–1231: an episode in the history of the Cistercian order in medieval Ireland* (Dublin 1970).

Ó Floinn, R. 'Schools of metalworking in eleventh- and twelfth-century Ireland', in M. Ryan (ed.) *Ireland and insular art AD 500–1200* (Dublin 1987), pp. 179–87.

—— 'Irish Romanesque crucifix figures', in E. Rynne (ed.), *Figures from the past* (Dun Laoghaire 1987), pp. 168–88.

—— 'Innovation and conservatism in Irish metalwork of the Romanesque period', in C.E. Karkov, M. Ryan & R.T. Farrell (eds), *The insular tradition* (New York 1997), pp. 259–81.

E. Okasha & K. Forsyth, *Early Christian inscriptions of Munster: a Corpus of inscribed stones* (Cork 2001).

O'Keeffe, T. 'La façade romane en Irlande', *CCM*, xxxiv (1991), pp. 357–65.

—— 'Romanesque architecture and sculpture at Ardmore', in W. Nolan (ed.), *Waterford: history and society* (Dublin 1992), pp. 73–104.

—— 'Lismore and Cashel: reflections on the beginnings of the Irish Romanesque', *JRSAI*, cxxiv (1994), pp. 118–5.

—— 'The Romanesque portal at Clonfert Cathedral and its iconography', in C. Bourke (ed.), *From the isles of the north* (Belfast 1995), pp. 261–9.

—— 'Diarmait Mac Murchada and Romanesque Leinster: four twelfth-century churches in context', *JRSAI*, cxxvii (1997), pp. 52–79.

—— 'Irish Romanesque architecture', in T. Bartlett (ed.), *History and environment* (Dublin 1998), pp. 52–69.

—— 'Architectural traditions of the early medieval church in Munster', in M.A. Monk & J. Sheehan (eds), *Early medieval Munster* (Cork 1998), pp. 112–24.

—— *An Anglo-Norman monastery. Bridgetown Priory, Co. Cork, and the architecture of the Augustinian canons regular in medieval Ireland* (Kinsale 1999).

—— *Medieval Ireland: an archaeology* (Stroud 2000).

—— 'Romanesque as metaphor: architecture and reform in twelfth-century Ireland', in A.P. Smyth (ed.), *Seanchas. Studies in early and medieval Irish archaeology, history and literature in honour of Francis J. Byrne* (Dublin 2000), pp. 313–22.

—— 'Architecture and regular life in Holy Trinity Cathedral, 1150–1350', in S. Kinsella (ed.), *Augustinians at Christ Church: the canons regular of the cathedral priory of Holy Trinity, Dublin* (Dublin 2000), pp. 23–40.

—— 'Form and content in pre-Romanesque architecture in Ireland', *ESTMA* iv (Seville 2001), pp. 65–83.

Ó Riain-Raedel, D., 'Irish kings and bishops in the memoria of the German Schlottenklöster, in P. Ní Chatháin & M. Richter (eds), *Irland und Europa: die kirche im frühmittelalter / Ireland and Europe: the early church* (Stuttgart 1984), pp. 390–404.

Parsons, D. 'Sacrarium: ablution drains in early medieval churches', in L.A.S. Butler & R.K. Morris (eds), *The Anglo-Saxon church. Papers on history, architecture and archaeology in honour of Dr H.M. Taylor* (London 1986), pp. 105–20.

Petrie, G. *The ecclesiastical architecture of Ireland anterior to the Anglo-Norman Invasion, comprising an essay on the origin and uses of round towers of Ireland* (Dublin 1845)

Preston, S. 'The canons regular of St Augustine: the twelfth-century reform in action', in S. Kinsella (ed.), *Augustinians at Christ Church: the canons regular of the cathedral priory of Holy Trinity, Dublin* (Dublin 2000), pp. 23–40.

Radford, C.A.R. *Ewenny priory* (London 1976).

Radford, C.A.R. 'The earliest Irish churches', *UJA*, xl (1977), pp. 1–11.

Rynne, E. 'Evidence for a tympanum at Aghadoe, Co. Kerry', *NMAJ*, xxix (1987), pp. 3–6.

Smith, J.T. 'Ardmore Cathedral', *JRSAI*, cii (1972), pp. 1–13.

Stalley, R. 'A twelfth century patron of architecture: a study of the buildings erected by Roger, Bishop of Salisbury', *JBAA*, 3rd ser. xxxiv (1971), pp. 62–83.

—— 'The medieval sculpture of Christ Church Cathedral, Dublin', *Arch,* cvi (1979), pp. 107–22.

—— 'Three Irish buildings with West Country origins', in N. Coldstream & P. Draper (eds), *Medieval art and architecture at Wells and Glastonbury* (Leeds 1981), pp. 62–80.

—— 'The Romanesque sculpture of Tuam', in A. Borg & A. Martindale (eds), *The vanishing past* (Oxford 1981), pp. 179–95.

—— 'The original site of St Patrick's cross, Cashel', *NMAJ*, xxvii (1985), pp. 8–10.

—— *The Cistercian monasteries of Ireland* (Yale 1987).

—— 'The Rock of Cashel, Tipperary', *Arch J*, cliii (1996), pp. 308–14.

—— *Early medieval architecture* (Oxford 1999).

—— 'Hiberno-Romanesque and the sculpture of Killeshin', in P.G. Lane & W. Nolan (eds), *Laois: history and society* (Dublin 1999), pp. 89–122.

—— 'The construction of the medieval cathedral, *c.*1030–1250', in K. Milne (ed.), *Christ Church Cathedral, Dublin. A history* (Dublin 2000), pp. 53–74.

—— 'Solving a mystery at Cashel: the Romanesque painting in Cormac's Chapel', *IAR* xviii (2001), pp. 25–29.

—— 'Sex, symbol, and myth: some observations on the Irish Round Towers', in C. Hourihane (ed.), *From Ireland coming. Irish art from the early Christian to the late gothic period and its European context* (Princeton 2001), pp. 27–48.

Stokes, M. *The early Christian architecture of Ireland* (London 1875).

Stone, L. *Sculpture in Britain. The middle ages* (London 1972).

Swanson, R.N. *The twelfth-century Renaissance* (Manchester 1999).

Thurlby, M. 'The Romanesque priory church of St Michael at Ewenny', *SAHJ*, xlvii (1988), pp. 281–94.

Waterman D. & A. Hamlin, 'Banagher Church, Co. Derry', *UJA*, xxxix (1976), pp. 25–41.

Index of places

Pages with illustrations are given in italics.